TEXAS

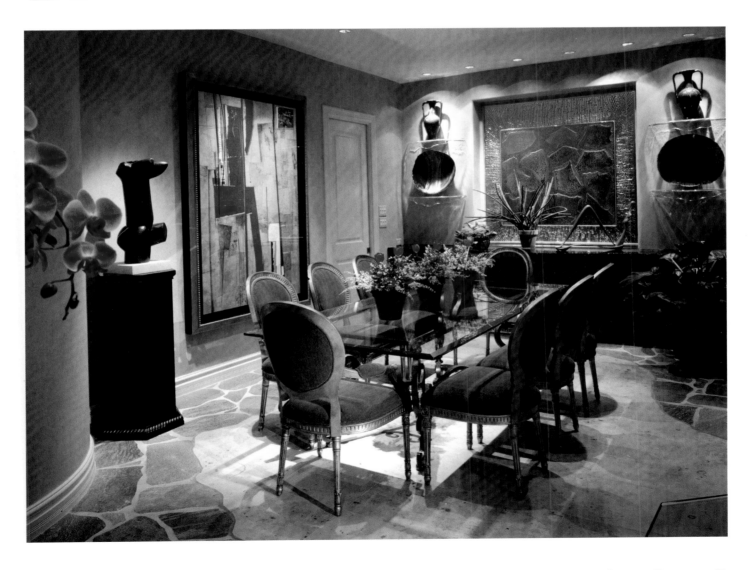

FEATURING THE FINEST INTERIOR DESIGNERS FROM THE ASID TEXAS AND TEXAS GULF COAST CHAPTERS

Published by

dsa
Publishing & Design Inc.
2809 Sunset Ridge
McKinney, Texas 75070
972-562-6966
FAX 972-562-7218
www.dsapubs.com

Author and Editor: Ginger Ebinger

Designer: Dawn Lyon

All images in this book have been reproduced with the knowledge and prior consent of the designers concerned and no responsibility is accepted by the producer, publisher, or printer for any infringement of copyright or otherwise arising from the contents of this publication. Every effort has been made to ensure that credits accurately comply with the information supplied.

Printed in Canada

PUBLISHER'S DATA

Designed in Texas

Library of Congress Control Number: 2005936387

ISBN Number: 0-9774451-1-9

First Printing 2005

10 9 8 7 6 5 4 3 2 1

Front cover: David Cadwallader, ASID.
See page 55. *Photo by Brian McWeeny.*

Front flap: Orville Carr, FASID, and Charles A. Forster, ASID.
See page 287. *Photo by Danny Piassick.*

Back cover: Julie Evans, Allied ASID.
See page 17. *Photo by Thomas McConnell.*

Previous page: Barbara Schlattman, FASID
See page 251. *Photo by Rob Muir.*

This page: Susie Johnson, ASID
See page 21. *Photo by Mark Knight.*

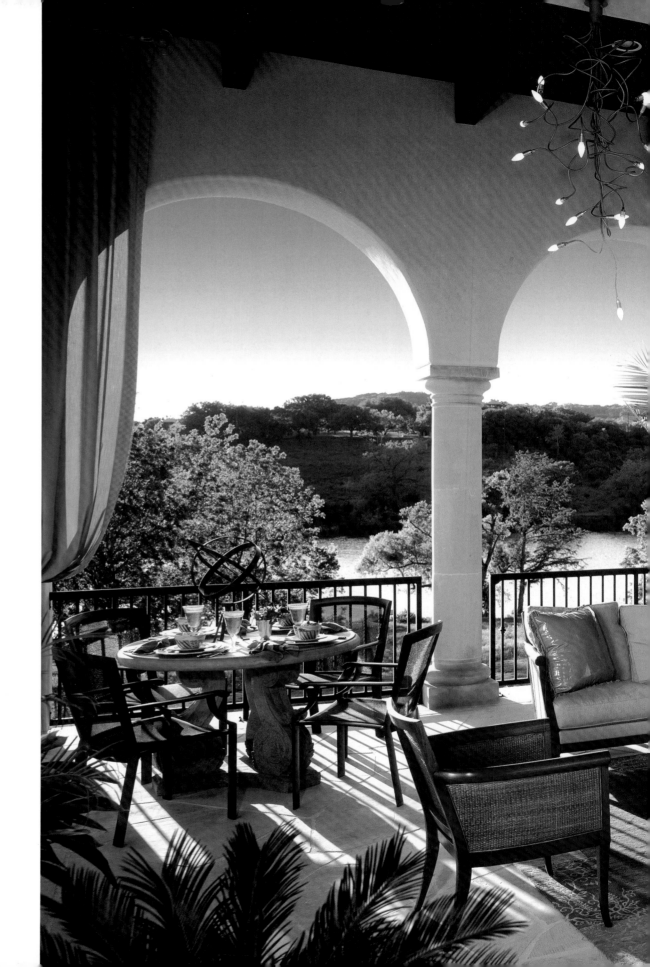

Designed in
TEXAS

Featuring the Finest Interior
Designers from the ASID Texas
and Texas Gulf Coast Chapters

Introduction

This book features the work of notably talented designers throughout Texas. The diversity of scale and style is as vast and varied as the state itself. Each of these wonderful projects reflects a communication process in which the client expresses his or her needs and desires and the designer skillfully crafts an environment that upholds high design standards and function. A Dallas high-rise, a Houston office suite and a South Padre Island home each reflect the alchemy of a highly developed client/designer relationship.

The photographs in *Designed in Texas* showcase the skillful use of beautiful fabrics, cherished heirlooms, custom furniture, interior finishes and details. Originality and creativity are evident in every room by the use of contrasting textures, luminous colors and the organization of space. The creation of these well-orchestrated rooms not only requires a highly developed eye for good design and impeccable taste, but a continuous education in the use of technology and the awareness of the health and safety needs of each client.

The designers represented in this book are members of the Texas and Texas Gulf Coast Chapters of the American Society of Interior Designers, the largest professional organization of interior designers in the United States and Canada. The society promotes the highest ethical and professional standards. Through research and numerous educational opportunities, it assists its membership in keeping on the cutting edge of such important areas as aging in place, accessibility and sustainable design. The Texas Gulf Coast and Texas chapters are two of the largest ASID chapters in the nation. They are highly involved in their communities through such projects as designer showhouses, fine arts fundraisers, designs for charities and student activities, which assures the future of the profession.

Designed in Texas illuminates the work of accomplished designers creating beautiful places in which we live and work. Each of these educated, creative and talented professionals illustrates how interior design enhances the quality of life on every level of our culture and society.

Making the world a better place to live,

J.D. Carter, ASID

The Designers

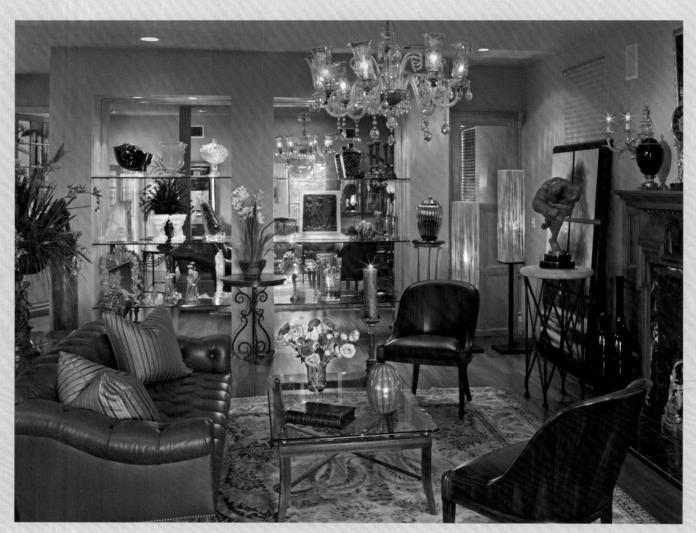

JOE BURKE, ASID & MARK W. SMITH, ASID

Austin

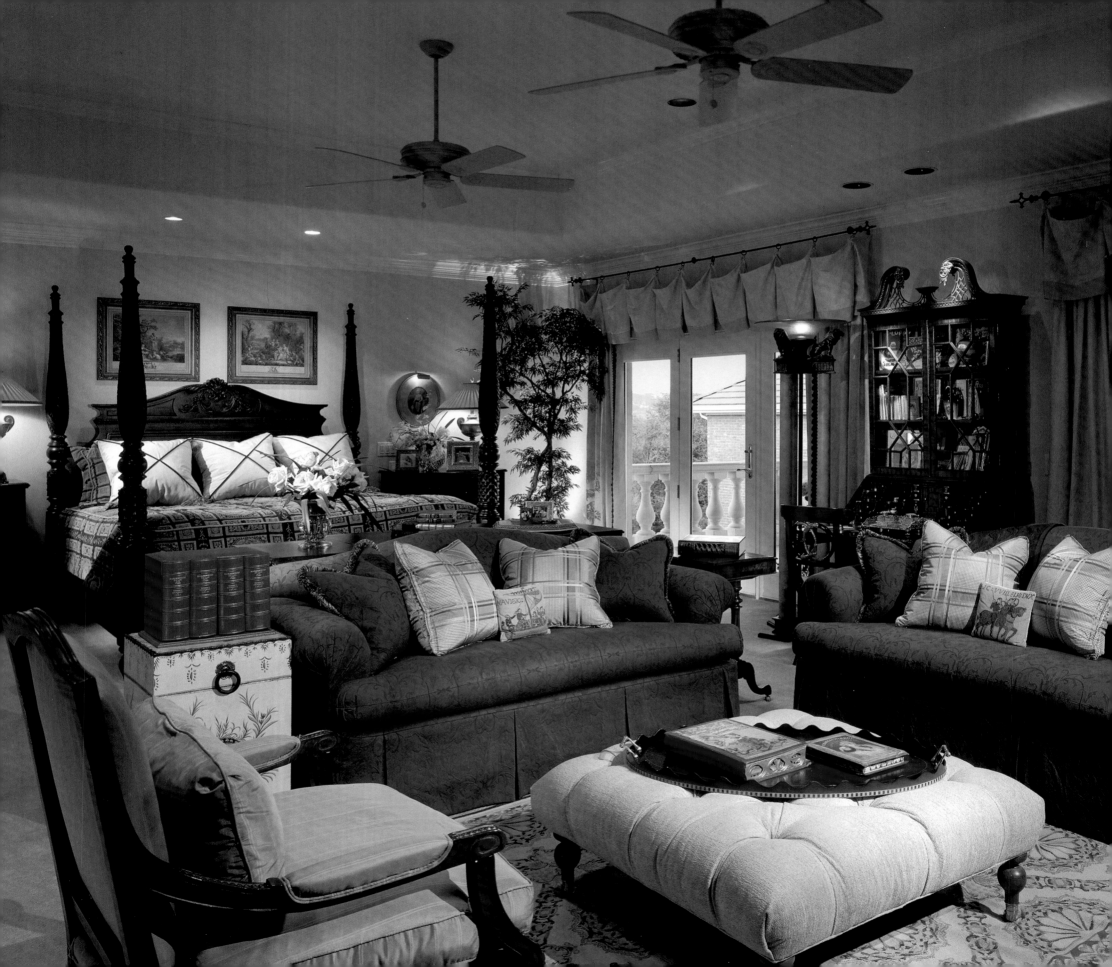

Kimball Bonamici, Allied ASID

KIMBALL BONAMICI DESIGNS

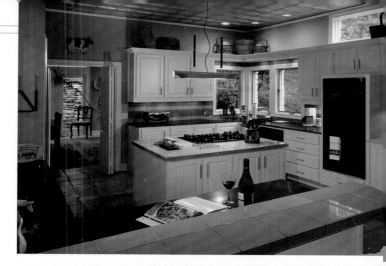

Austin designer Kimball Bonamici has a refreshing outlook on life that's reflected in her award-winning designs. "My joy for life and my passion for interior design enable me to enjoy the projects and the people I work with."

This positive approach greets Kimball's valued clients who primarily live in the Austin area. Seeking remodels of existing homes and concepts for new ones, homeowners flock to the doorstep of the savvy designer with 16 years' experience. Through careful listening, she creates designs representative of each client. And with skillful organization and reassuring calm, she puts each piece together, magically transforming spaces into inviting interiors.

"It's all about the client," she revealed. "I use my talent and training to devise interiors that reflect their personalities." Though Kimball's mark is evident in the clean, uncluttered designs that are sometimes described as "transitional," she insists that she does not have a signature style. "Many clients desire traditional looks, while a growing number prefer contemporary. Whatever the request, I apply the principles of good design to create environs in which they will be happy."

The New Jersey native originally sought a degree in art, but discovered that design fit her love of interiors that began as a child. "I started clipping pictures of rooms at age eight," she confessed. A degree from the Fashion Institute of Technology in New York City gave Kimball the education she needed to become a licensed designer.

Today, she enjoys the rewards of her investment. With recognition and awards from the ASID Design Excellence board, the Texas Capital Area Builders Association and the *Austin Business Journal's Book of Lists*, Kimball has been asked to participate in multiple Parade of Homes and Symphony Showhouse tours. These accolades have increased the demand for her services, but the talented designer remains rooted in her driving philosophy: "Life is too short. Enjoy every moment, regardless of the design challenge." ∎

LEFT: An elegant master suite evokes a touch of English refinement with its soft, tapestry like fabrics accompanied by Chippendale antiques.

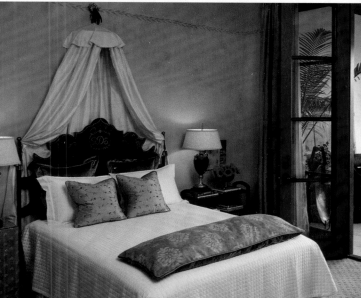

TOP: A kitchen remodel juxtaposes the client's folk-art collection against their desire for a more simplified modern design.

ABOVE: This Austin Symphony League Showhouse guest bedroom exudes a light Italianate flavor. Plastered walls with frescoed, bay leaf detail and fresh, clear colors welcome any guest.

KIMBALL BONAMICI, ALLIED ASID
KIMBALL BONAMICI DESIGNS
4510 HYRIDGE DRIVE
AUSTIN, TEXAS 78759
512.795.8618
WWW.BONAMICIDESIGNS.COM

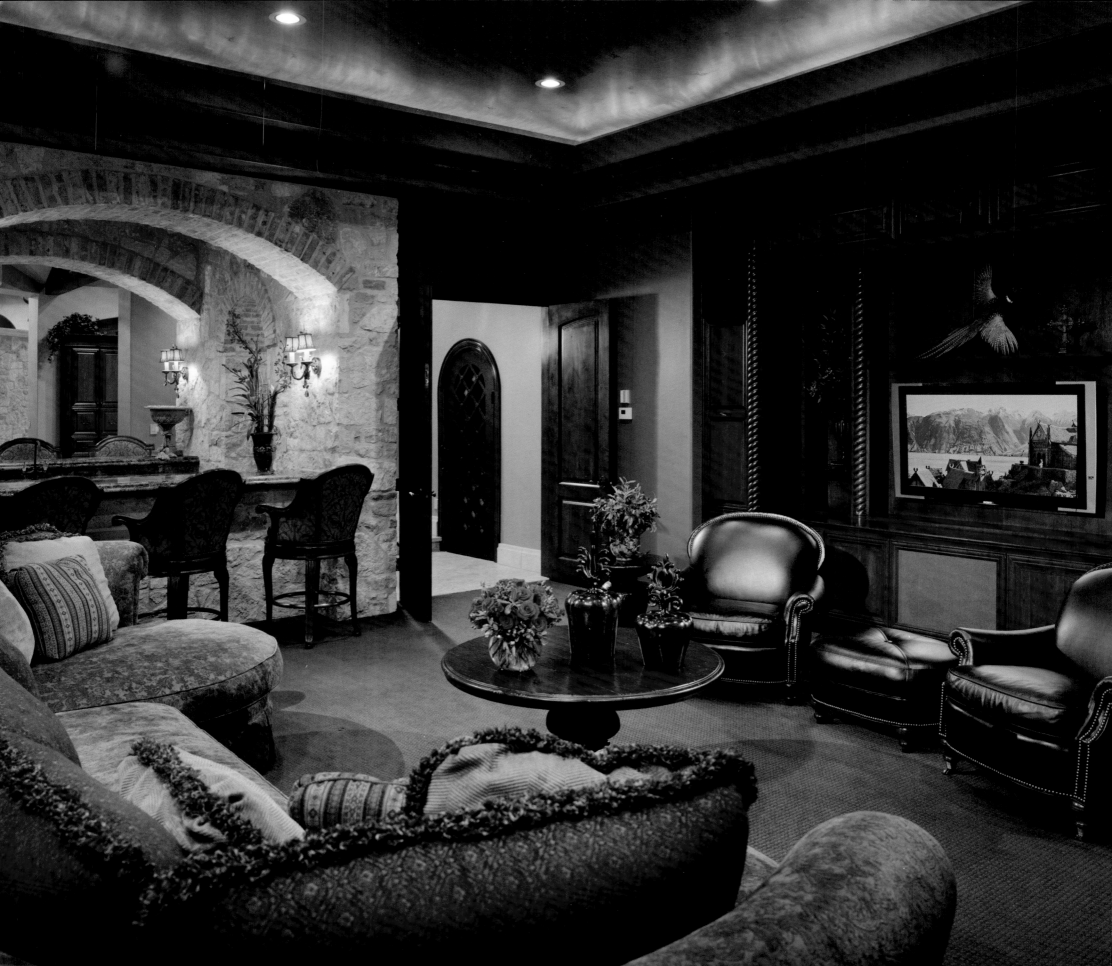

David Bravo, Allied ASID

JOHN-WILLIAM INTERIORS

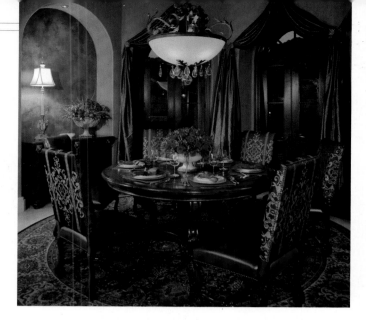

*I*nterior designer David Bravo has the innate ability to look at a blueprint and see a finished interior as if it were on the cover of a magazine. Expertly envisioning all the elements together before transferring them to paper helps the award-winning Austin designer when planning designs at all stages of construction.

While David has outfitted nearly every style of interior during his 17-year career, he's at home designing high-end residences with an Old-World charm. "I don't have a signature style, but I'm frequently asked to design Mediterranean-style residences," he said. And while other designers also excel at the look, David's interiors are refreshingly different. "I honor the architecture of a home while juxtaposing sophisticated elements like colorful silks and intricate trims with rustic finishes to create interesting and inviting spaces."

This approach has earned David features in several publications. It has also landed him numerous accolades including several ASID Design Excellence awards, the 2004 Best Interior Merchandising Parade Home award, the Home Builders Association of Greater Austin Showcase Home award and the Sales Excellence Award from John-William Interiors, where David has served discerning clients since 1995.

The 1988 University of Texas interior design graduate appreciates the industry acknowledgments, but confesses that true reward comes from his satisfied clients. "I listen to their needs and compose settings reflective of their unique personalities and tastes. I'm honored that they trust me with their homes." ∎

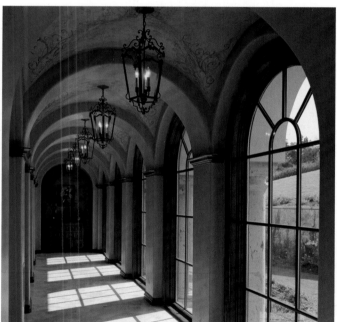

ABOVE: Inspired by the Tuscan countryside, this residence blends fabrics and finishes to create a rustic elegance. In the dining room, silk and leather, together with robust furnishings and bold colors, form this comfortable, yet lush, setting. Open pendant lanterns hang from the hand-painted, vaulted ceiling in the gallery.

LEFT: The media room features dark wood complemented by luxurious textures in a deep, rich palette. The custom wall unit hides a drop-down TV screen.

DAVID BRAVO, ALLIED ASID
JOHN-WILLIAM INTERIORS
3201 BEE CAVE ROAD, SUITE 1926
AUSTIN, TEXAS 78746
512.328.2902
WWW.JWINTERIORS.COM

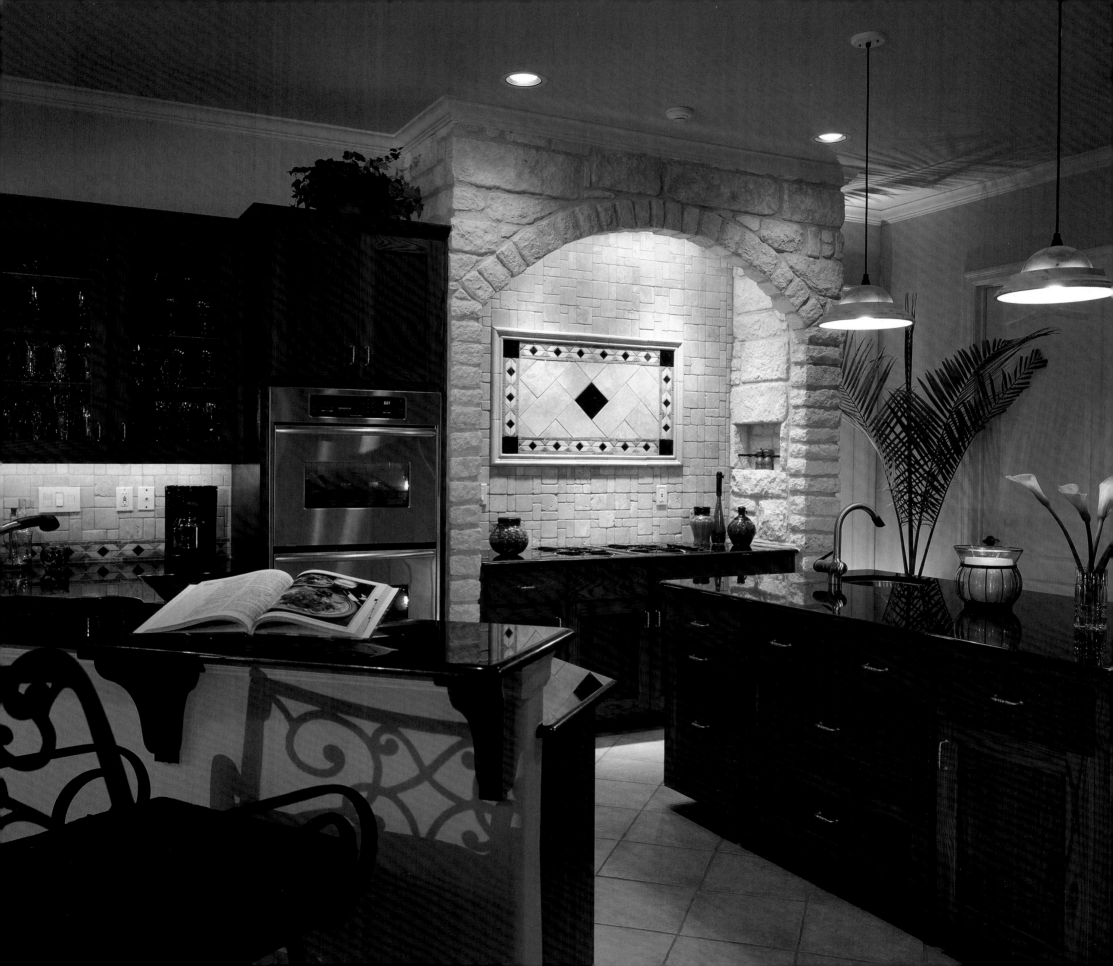

Barbara Brooks, ASID

BARBARA BROOKS INTERIORS

TOP: H_2O is the order of the day in this beautiful, aqua glass-tiled bathroom.

ABOVE: Lake Austin is the setting for this lovely enclosed game room.

When noted Austin designer Barbara Brooks isn't designing high-end residences, she's roaming the country looking for antiques. "Personally, I love collecting antiques," she declared. "Professionally, I look for antique furniture and accessories to incorporate into my designs. I think they bring depth and warmth to any setting."

While not every interior in Barbara's broad portfolio includes antiques, they do share a common quality—her designs reflect the unique personalities of her clients. "When interviewing clients, I learn about how they live in their homes," she said. "Knowing whether they frequently entertain, for example, can help me devise a space that meets their needs." Actually, Barbara says, that's the real reason clients hire her. "They depend on me to design beautiful rooms in which they can comfortably live."

Signature to Barbara's designs is timeless pieces and classic lines—and the element of surprise. "I love to mix things up," Barbara confessed. "Combining the unexpected—like pairing contemporary art with an English antique—can bring energy to a room." It also attracts clients.

Barbara and her firm, Barbara Brooks Interiors, are in high demand. From Austin to Atlanta, the firm is leaving its mark in new luxury developments and older, established neighborhoods, where the remodeling of kitchens and bathrooms is popular.

Regardless of the project, clients trust the designer with 21 years' experience to deliver designs that work. "I'm honest with my clients through every step of the process," Barbara said. "It eliminates surprises and prevents worry." The result? Designs that perfectly fit every satisfied client. ■

BARBARA BROOKS, ASID
BARBARA BROOKS INTERIORS
2808 BEE CAVE ROAD
AUSTIN, TEXAS 78746
512.330.9693

LEFT: Natural limestone, granite and iron are very complementary in this efficient kitchen.

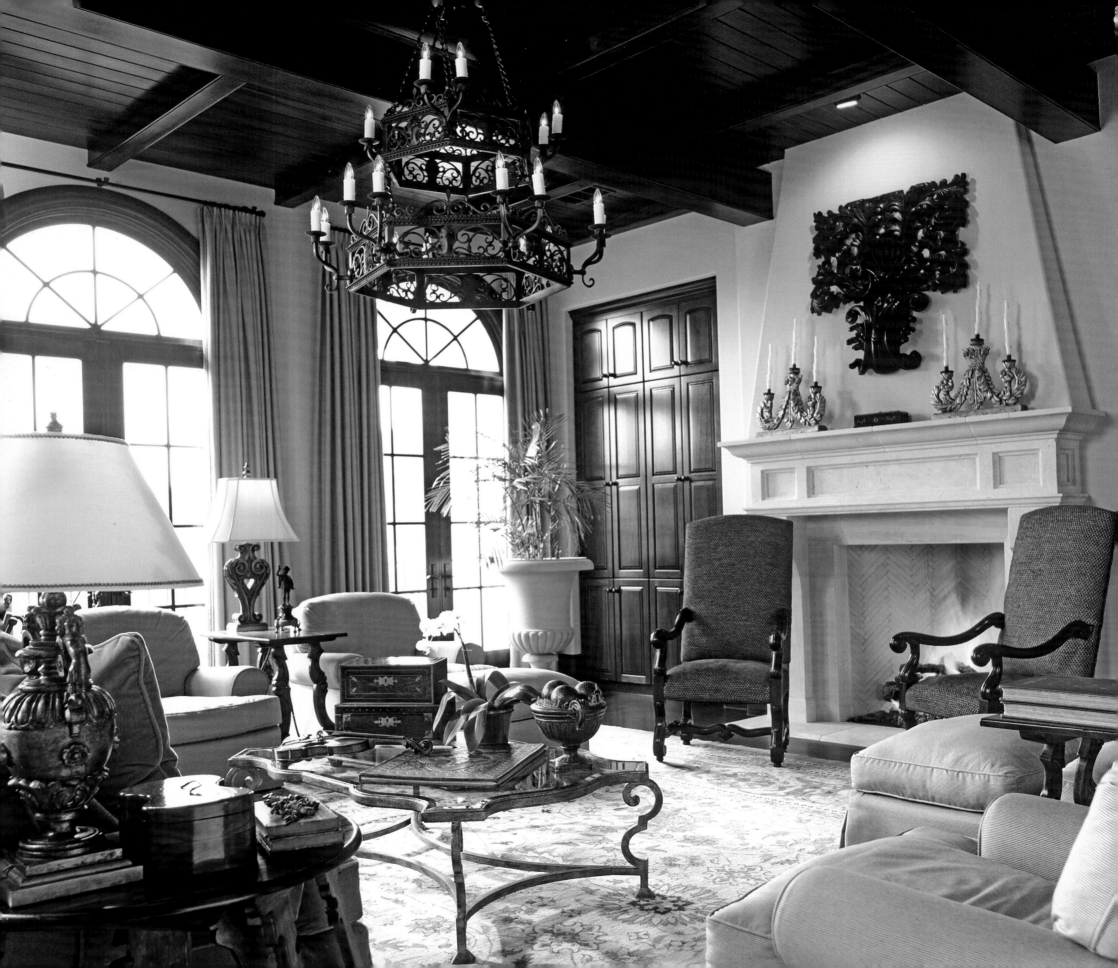

Nancy Bulhon, ASID

BULHON DESIGN ASSOCIATES, INC.

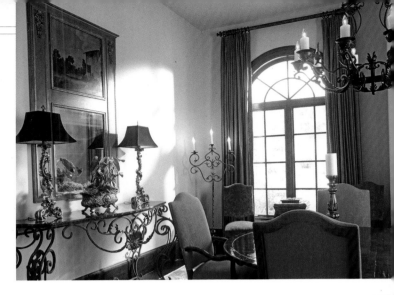

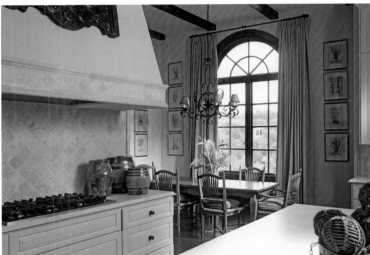

FAR LEFT AND ABOVE: This perfectly outfitted private residence in Austin, Texas, welcomes its occupants home.

Austin designer Nancy Bulhon receives inspiration for her one-of-a kind interiors from her world travels, where she's drawn to well-crafted, timeless architectural elements and decorative details. "As a designer, I have a trained eye for detail," she said. "I notice outstanding craftsmanship everywhere I go."

Relying on her extensive notes and sketches, Nancy adapts her collected observations for her projects. "I have a solid network of respected artisans who can create any element for use in any interior." Whether traditional or contemporary, each environment is not only rich with detail; every setting is surrounded with quality, swathed in color and enveloped with warmth using the best materials available.

This approach has won Nancy loyal clients since graduating from the University of Texas at Austin with a degree in interior design in 1976. "I'm proud to have served residential clients for 30 years," the experienced designer said. "Because of their trust, I am now designing their second residences both in and outside the United States."

Helping her craft the stunning interiors for which her firm, Bulhon Design Associates, is known are a team of three, including an occasional intern. Mentoring design graduates is one way the acclaimed designer gives back to her profession. Another is being active in her local ASID chapter, which she chaired in 2004-2005.

Although her involvement in the design community is important, the secret to Nancy's longevity lies in her relationships with her clients. "Innate ability and proper training are essential in this profession," she said. "But a close relationship with my clients is paramount to a project's success." ■

NANCY BULHON, ASID
BULHON DESIGN ASSOCIATES, INC.
712-C W. 14TH STREET
AUSTIN, TEXAS 78701
WWW.BULHON.COM

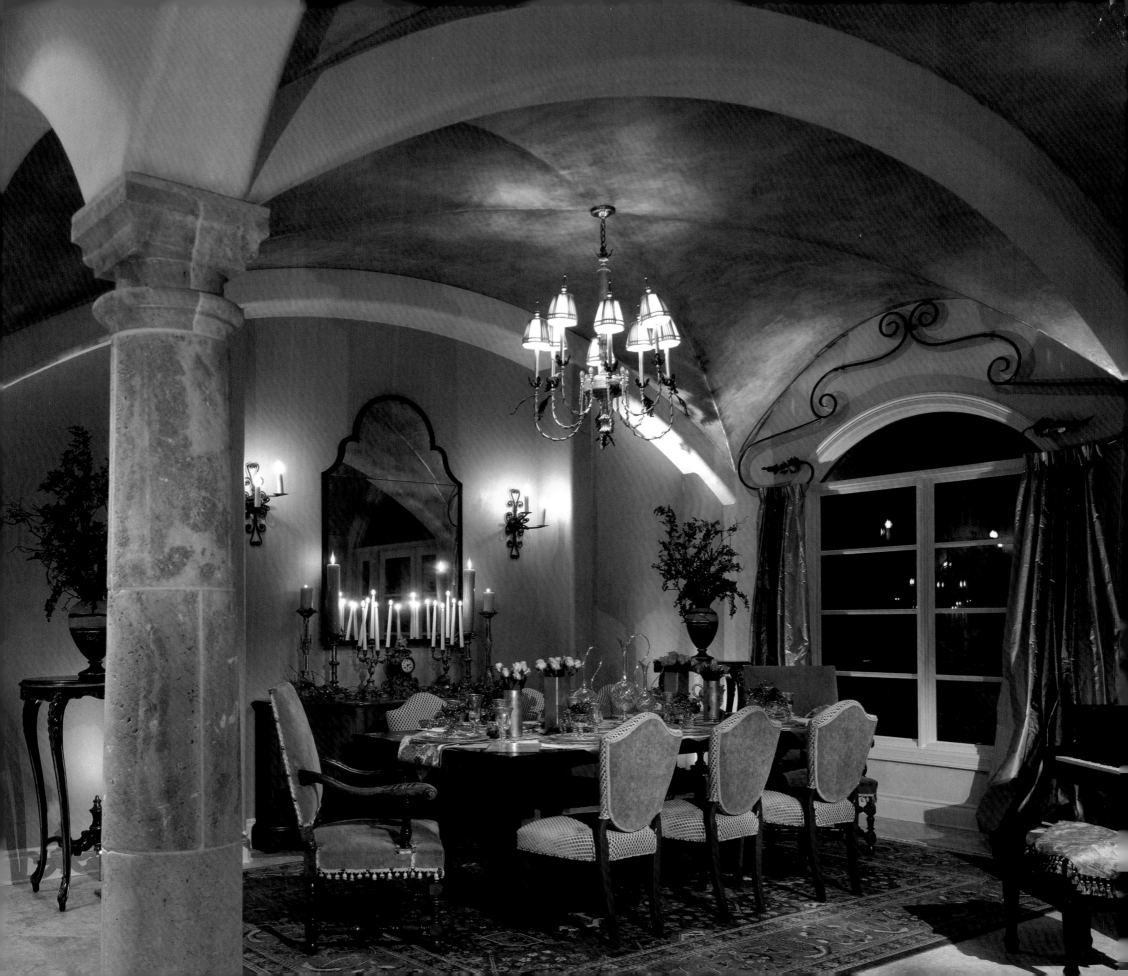

Julie Evans, Allied ASID

JEIDESIGN, INC.

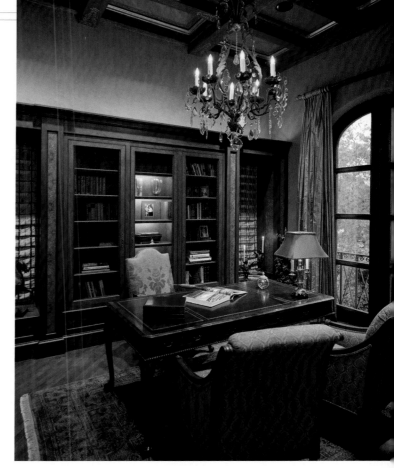

ABOVE: The hand-painted coffered ceiling, gilded trim and soft palette of sherbert colors create a welcome sanctuary in this gentleman's study.

LEFT: An expansive groin vault—under polished Venetian plaster and custom, hand-forged drapery hardware--sets the stage for relaxed elegance.

When Austin designer Julie Evans was a child, she used to hang out at home construction sites, where she was fascinated by the entire building process. Today, she still holds high regard for the craft of building—her husband owns a construction company, and Julie outfits interiors for high-end residences through her full-service firm, JEIDesign, Inc.

The noted company with a reputation for excellence employs a staff of four. Under Julie's guidance, they apply their unsurpassed organizational and planning skills to virtually every type of residential project. From the construction of a palatial Mediterranean estate overlooking Lake Travis to the refurbishing of a vacation cabin tucked in the Colorado mountains, Julie and team create interiors reflective of the people who live in them. "It's vital that clients' personalities, tastes and lifestyles are captured in their homes," the award-winning designer said. "Interpreting their tastes—even if the clients don't know what they are—is the first step in designing friendly, personalized spaces."

From conception through completion, Julie and team manage the entire project using the latest technology. This approach enables them to seamlessly install interiors fitting for every client. "Function is at the core of our designs," Julie said. "Not only do we ensure that their homes fulfill their current desires; we create spaces that will grow with our clients' needs." From constructing barrier-free environments for an aging couple to devising multi-use spaces for a growing family, Julie tackles every design challenge with aplomb. She anchors and edits every room's contents before expertly dressing them with obsessive detail, a dose of good taste and the proven principles of scale and balance. The result is warm and welcoming interiors of the highest quality.

JULIE EVANS, ALLIED ASID
JEIDESIGN, INC.
2808 BEE CAVE ROAD
AUSTIN, TEXAS 78746
512.330.9179
WWW.JULIEEVANS.NET

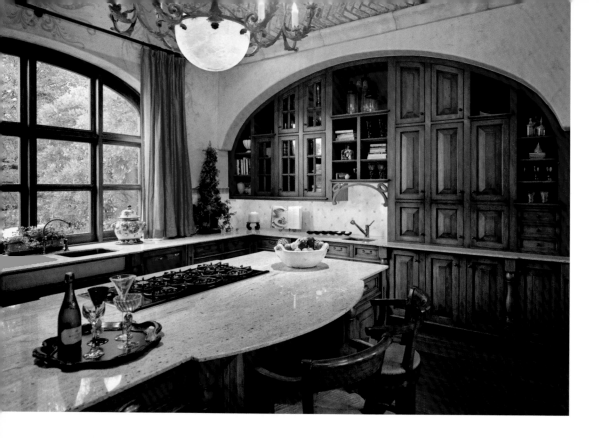

"I don't like my rooms to yell," Julie said of her designs. "Instead, I want them to entice people to stay awhile and relax."

Her alluring interiors have earned Julie's talented firm numerous accolades like several Austin ASID Design Excellence awards and top nods from the Texas Home Builders Association, from whom they received a record-breaking number of honors for their eight-week, total completion of an 8,000-square-foot Parade Home. "That was one of the most exhilarating—and exhausting—experiences," Julie recalled. The firm's body of work has also been featured on the "Designing Texas" and Home & Garden Television's "Generation Renovation" programs and in several local and national publications.

TOP LEFT: This stunning kitchen features a magnificent brick herringbone barrel vault and custom cabinetry inspired by a trip to Italy.

BOTTOM LEFT: An eclectic mix of rare antiques and carefully chosen accessories blend for the perfect combination of comfort and beauty.

BOTTOM RIGHT: Rich fabrics accent beautiful, gilded art niches that house hand-carved limestone friezes.

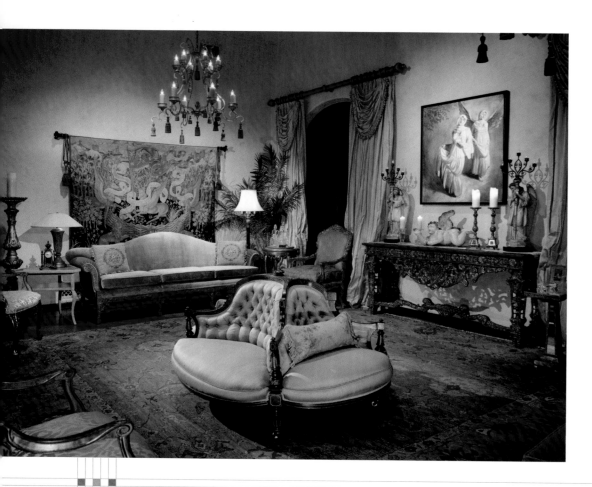

While her firm's designs have been widely viewed across the country, most of her projects remain rooted in Austin, where she applies her more than 25 years' experience that began after attending the University of Texas. "My first job was in a lighting studio in Australia," Julie said. Then Julie returned home to Texas and worked for another designer, gaining valuable hands-on knowledge that led to the opening of her own firm in 1983.

Today, Julie's company has grown to become a leader in the Austin design world. Residences of all styles—from eclectic and casual to formal and fun—line the pages of their impressive portfolio that includes new construction, remodels and historic preservation projects. Behind each successful installation is a cache of loyal clients who not only trust the respected firm to deliver stellar designs; they know them to live by their mantra: "Do unto others as you would have them do unto you." ∎

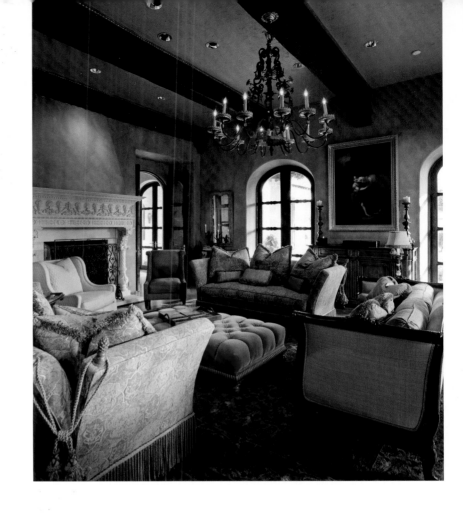

ABOVE: The hand-forged iron chandelier and carved stone fireplace surround compliment the luxurious fabrics chosen in this living room.

LEFT: The custom iron pot rack and antique, terra=cotta door frieze inset in the stove cave perfectly accent the alder-wood custom cabinetry with decorative ironwork insets.

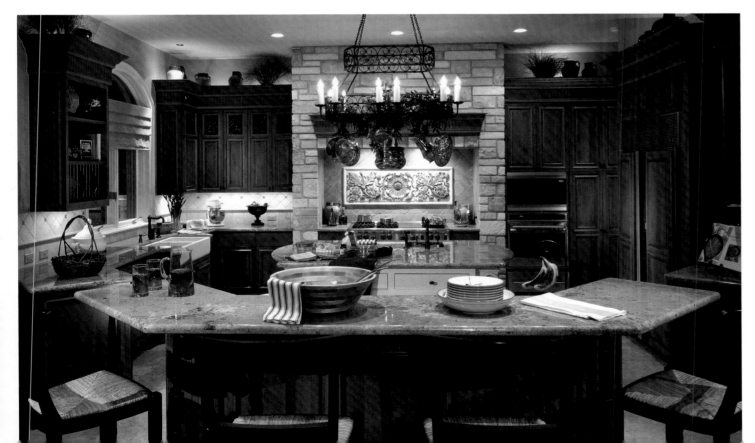

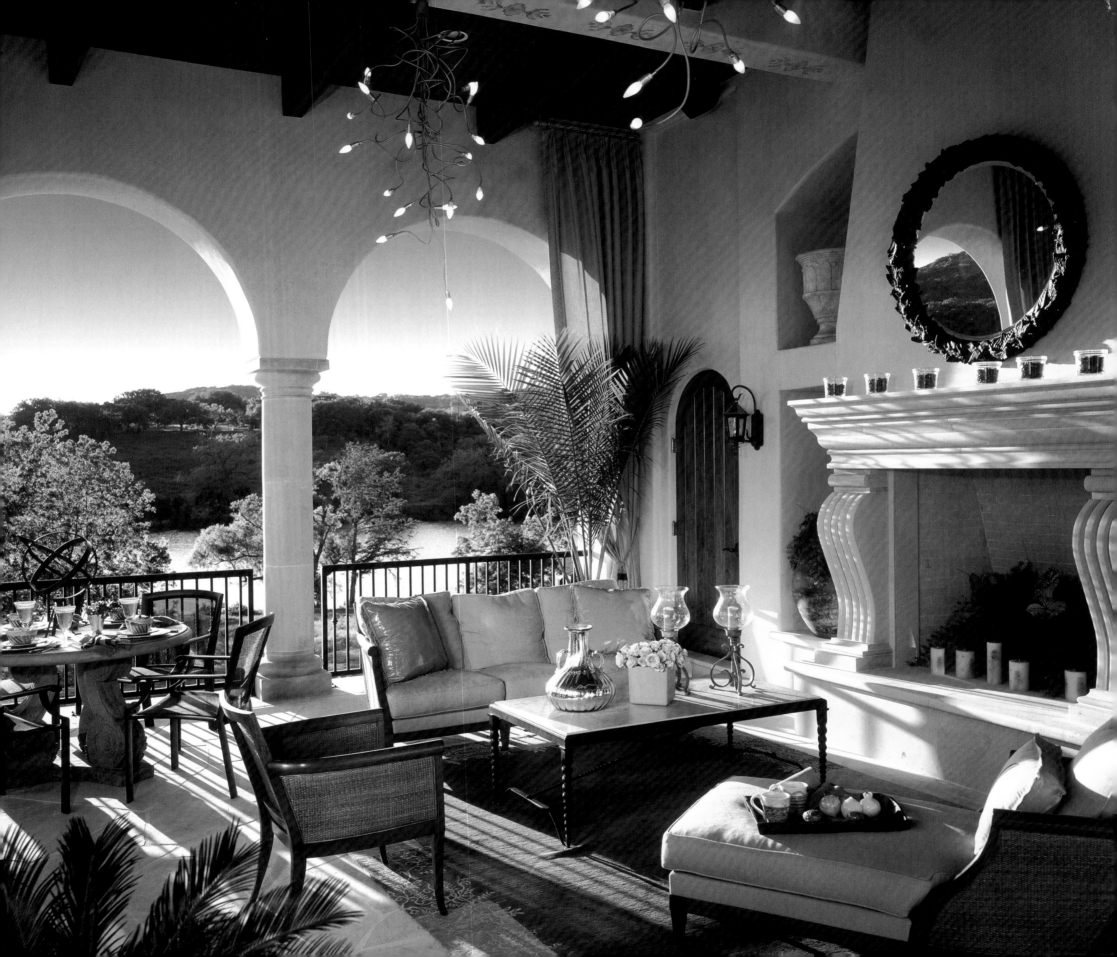

Susie Johnson, ASID

SUSIE JOHNSON INTERIOR DESIGN, INC.

ABOVE: A majestic custom mirror and carved limestone mantel overlook the Italiamate living room. The ornate iron railing of the library (above) adds visual texture.

LEFT: Drama and comfort characterize the cabana, featuring sophisticated outdoor fabrics for portiéres and furniture. A graceful cast-stone fireplace invites gathering.

Austin designer Susie Johnson's outlook on design is refreshingly simple. "Professional gratification comes to me from the successful interpretation of my clients' styles and personalities, rather than my leaving a trademark identifying my presence."

How does the award-winning designer craft the personalized interiors for which she's known? "The most important step in the design process is learning about clients' needs, lifestyles and desires," Susie explained. "In fact, I like to say that there are three initial steps: listen, listen, listen!" Ultimately, she says, it's her job to take what she hears, mix it with what she knows and come up with a design that surpasses her clients' visions.

Sometimes those visions are traditional in style, while others lean more contemporary or continental. All, however, possess the principles of good design. "Regardless of the style, proper scale, balance and appropriateness are essential to every interior," said Susie. And although there is no signature mark to her work, Susie says that each project shares a common goal. "I strive for timeless, tailored designs with a modern voice."

Her classic creations have graced homes in Central and Southern Texas since 1996 when she opened her full-service design firm, Susie Johnson Interior Design. Owning her firm was a dream born from Susie's childhood, where she grew up in a widely creative family. Obsessed with decorating and painting her room, Susie always wanted to become an interior designer. She achieved that goal when, after detouring into French the first time around in college, she returned to the University of Texas to study her first love, interior design. Today, Susie is an acclaimed designer with a still-burning passion for design that has earned her numerous high-end residential clients and noted accolades.

SUSIE JOHNSON, ASID
SUSIE JOHNSON INTERIOR DESIGN, INC.
2808 BEE CAVE ROAD
AUSTIN, TEXAS 78746
512.328.9642
WWW.SUSIEJOHNSON.COM

Included in Susie's brimming portfolio are several ASID Design Excellence awards, two prestigious ASID Texas Legacy of Design awards and a ten-year history of participating in Austin's showhouses and parades of homes. Frequently, area publications like *Austin Home & Living* and the *Austin Design Guide* feature Susie's work, while several books have published her projects, including *Spectacular Homes of Texas* and *Southern Rooms,* all of which have selected her stunning homes for their covers. Susie has also invested time in her profession by serving the ASID executive board in many capacities, including the role of representative to the Texas State Chapter.

Even though Susie is busily immersed in her profession, she finds time to volunteer at Manos de Cristo, a local mission. There, she relies on her knowledge of Spanish to teach weekly English-as-a-second-language classes.

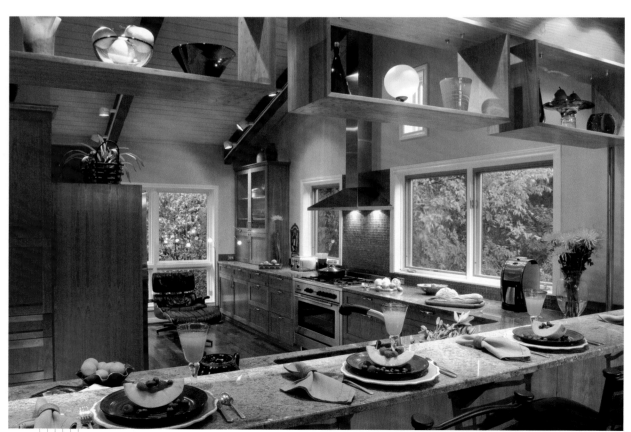

OPPOSITE PAGE:

TOP LEFT: An original oil painting by Spanish artist Borja Fernandez is the inspiration for the palette of this luxuriously appointed living room.

BOTTOM LEFT: The remodel of a '70s-era kitchen resulted in a contemporary, light-filled space that utilized natural materials and an efficient, open floor plan.

BOTTOM RIGHT: Asian influences and saturated color characterize this welcoming entry through curvaceous iron doors.

TOP RIGHT: The trompe l'oeil panting in the ceiling detail mimics the graceful, Italian mosaic-tile fascia of the master tub. Stone mantel completes the space.

TOP FAR RIGHT: A sunny, tone-on-tone faux finish on the walls and painted ceiling serve as a backdrop for the dramatic, iron tester bed.

BOTTOM RIGHT: Soft tones of taupe and pale chamois wrap this French-inspired master bedroom, where silk and velvet dress the stately four-poster bed and silk draperies frame the view.

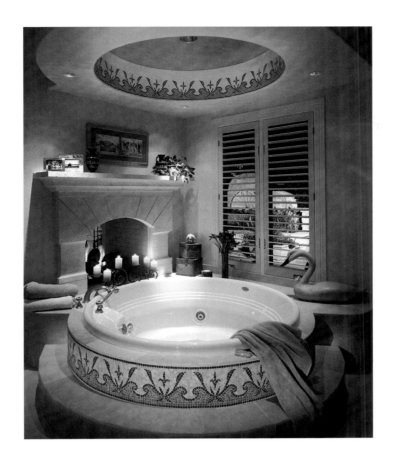

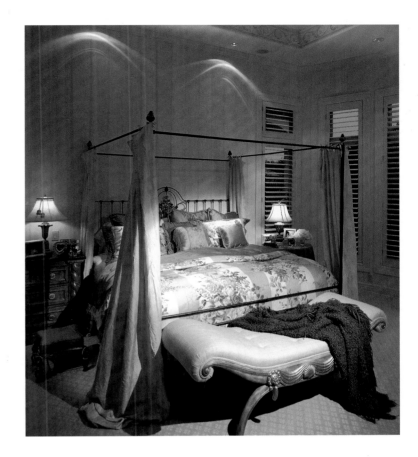

Spanish is only one of the many languages that Susie speaks. French, German and Farsi round out her global repertoire, which inspires her noted designs. "Exposure to other cultures brings ideas for color and detail, which are central in my designs," she explained. "I give strict attention to detail and to getting the background right." She also prefers to juxtapose disparate elements, like hanging abstract art over an antique console. Of this approach Susie says, "The mix is always more dynamic than adhering to one look."

To create environments as unique as the individuals who occupy them, the energetic designer calmly guides her clients to the inviting interiors of her finished designs. There, satisfied homeowners often declare, "With you, I knew things would always work out!" What better testament to the successful practice of trusted designer Susie Johnson. ∎

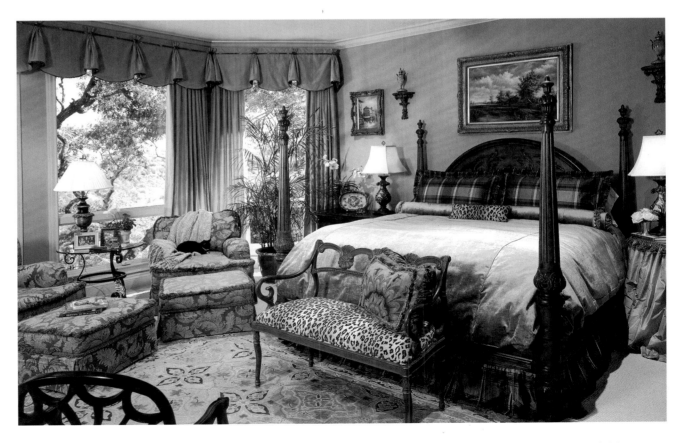

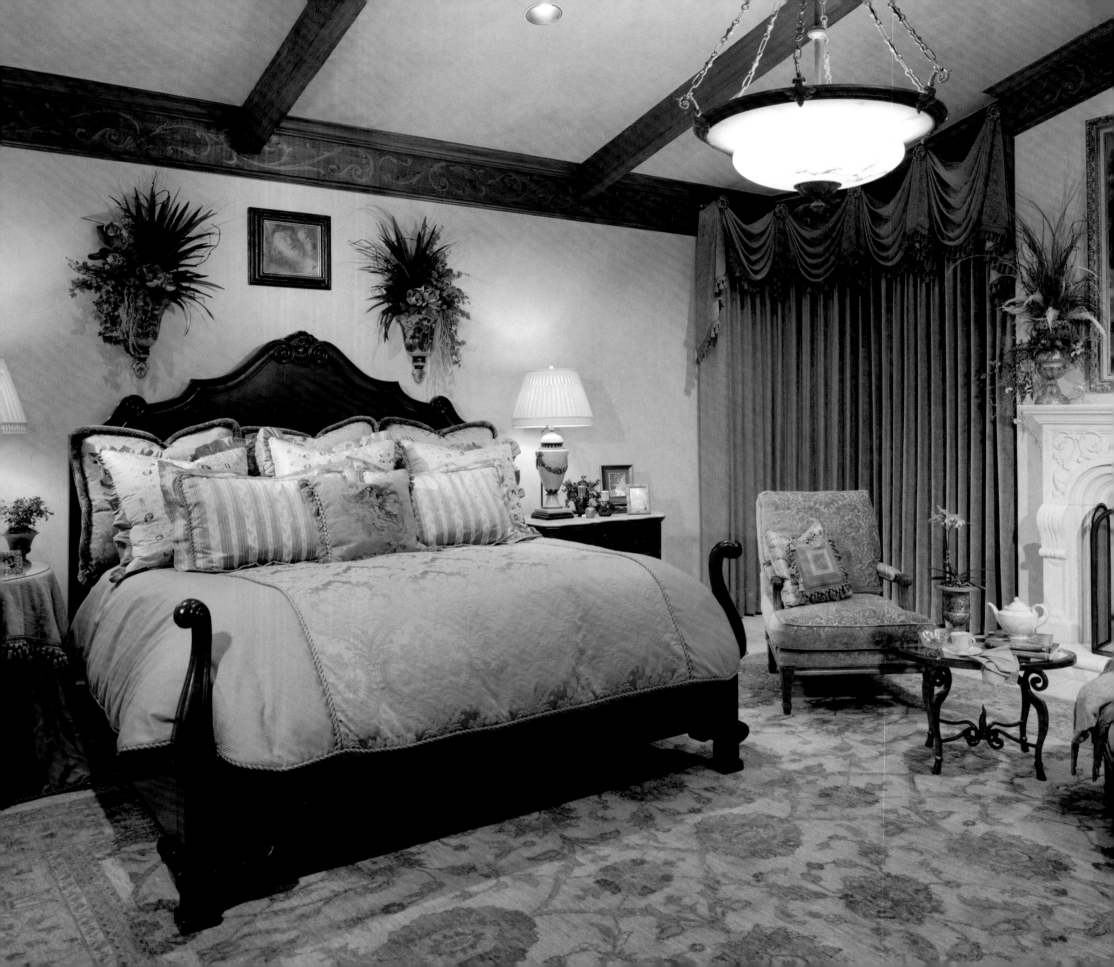

Linda McCalla, ASID

LINDA MCCALLA INTERIORS

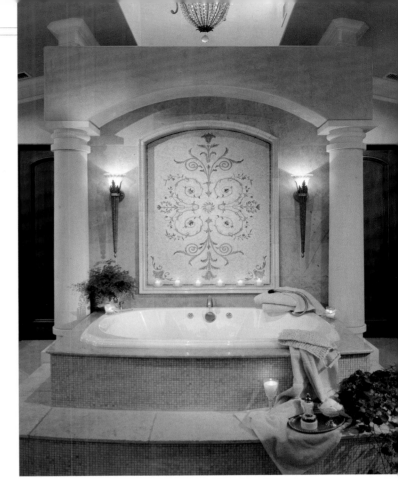

ABOVE: Hand-hewn limestone columns and an Italian-marble mosaic set against lustrous Venetian plaster walls create a dramatic focal point in this elegant, understated master bathroom.

LEFT: A grand bed in the Italian rococo style sumptuously dressed in silks and damask sets the tone of this soft, inviting master bedroom retreat.

Austin-area designer Linda McCalla was profoundly influenced by the Southern women who came before her in her family. "They took great pride in creating homes that reflected their heritage and their love of beauty," Linda explained. "They taught me to appreciate those things as well." Cooking and gardening are pastimes of the diverse designer who constantly explores new horizons. "I love to travel," Linda declared. "Whether I'm walking the streets of Santa Fe or perusing the antiques in Parma, Italy, I find things that inspire and delight me."

Fortunately for her clients, Linda melds her inspirations into award-winning designs through her firm, Linda McCalla Interiors. The respected company located near the heart of historic Georgetown offers a full range of interior design services including programming, space planning, interior design construction drawings, furniture specifications, construction supervision, purchasing and installation.

With historic preservation, extensive remodels and new construction lining the pages of its impressive portfolio, the firm tackles design challenges with an energetic passion and a well-honed skill. The result is stylishly elegant interiors that are warm and relaxing. "I layer the many architectural and interior elements of a space to give my clients richly detailed rooms that welcome them home," the noted designer said.

To craft the alluring spaces for which she is known, Linda adheres to a foundational belief that beauty and function are essential. "I believe that beauty is a spiritual gift that enhances our lives in significant ways," she explained. "My work is about the business of bringing order and beauty into the lives of my clients." She accomplishes this goal through careful listening and a discerning eye for detail. "I interpret my clients' dreams and open their eyes to the strengths of their spaces," she said. "Then I carefully dress every interior with color, furniture, fabrics, art and accessories that perfectly fit each client's lifestyle, personality and taste."

LINDA McCALLA, ASID
LINDA McCALLA INTERIORS
604 SOUTH CHURCH STREET
GEORGETOWN, TEXAS 78626
512.930.9987

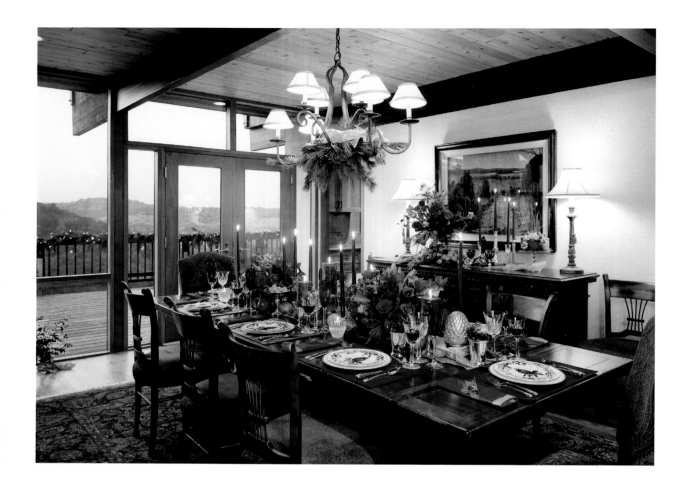

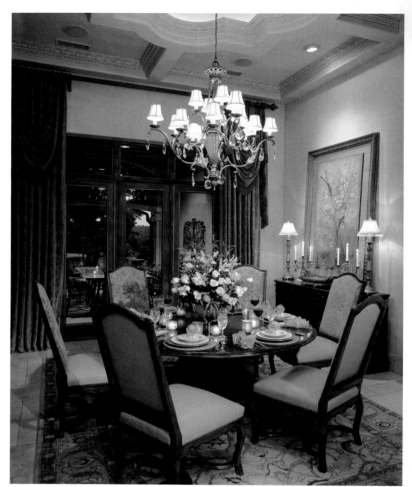

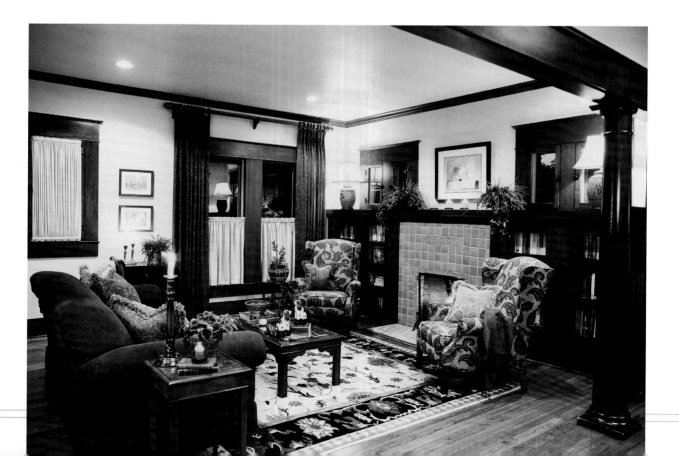

Linda's individualized approach has earned her several Design Excellence awards, a *Southern Living/*Southern Home award and frequent participation in numerous show houses. Linda has also been commissioned to design two *Southern Living Idea Houses* in Austin. A variety of local, regional and national publications have featured her work including *Southern Living, Austin Home & Living, U.S. News & World Report, USA Today* and *Texas Highways*.

TOP LEFT: Casual, but elegant, furnishings, carefully chosen to complement an expansive Hill Country view, provide a rich, warm backdrop for festive holiday celebrations.

TOP RIGHT: Soft hues, luxurious textures and European-inspired furniture are skillfully combined to create an intimate formal dining room in this country villa.

BOTTOM LEFT: Furnishings for this restored 1916 bungalow were selected to enhance the home's strong Craftsman-style architectural detailing, all of which is original to the house.

OPPOSITE PAGE:

RIGHT: A rustic Della Robbia-style plaque picture framed with polished travertine and terra-cotta molding accents the tumbled-stone backsplash above this commercial range.

FAR RIGHT: Crisp, white cabinetry is contrasted with warm granite countertops, an earthy tile floor and a richly stained pine ceiling to create a sophisticated farmhouse kitchen. The large island features furniture styling and an antiqued finish.

Linda arrived in the world of design after graduating with honors from the University of Texas at Austin in 1978. Armed with a degree in interior design, she moved first to Center City Philadelphia and then to Georgetown, where she assumed the role of director of the community's newly formed Main Street Project. During her tenure, Linda secured over $8 million in private sector reinvestment that delivered new economic life to the courthouse square and earned national recognition for extensive restoration of its historic commercial buildings.

Later, she returned to private practice and set up shop in an early 20th-century cottage just off the square in Georgetown. Because of her interest in preservation, she has helped restore several of the community's historic gems, which are frequently open to the public during their December tours.

And while she prides herself on her restorative efforts, Linda is quick to note that she handles a multitude of projects. From a rustic retreat in the mountains of New Mexico to the President's Home at Southwestern University, she's left an indelible mark in several settings. "While most of my work has been concentrated in high-end residential projects, I am occasionally asked to help with small commercial spaces like professional offices," she explained. "Regardless of style or size, the same basic principles apply—balance function with beauty and a space will always have an inviting feel." ■

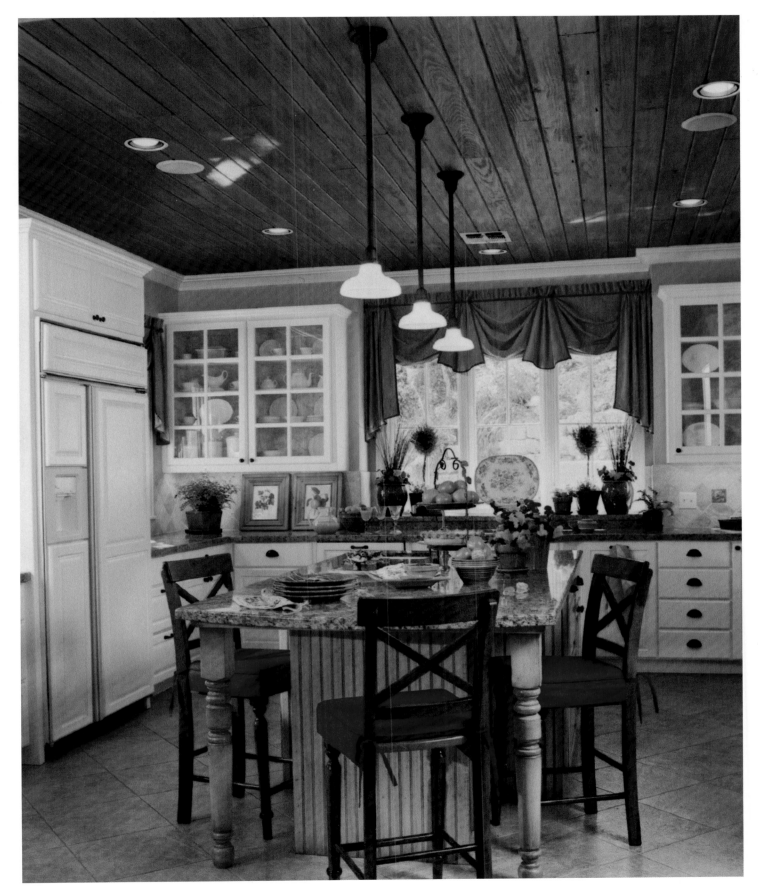

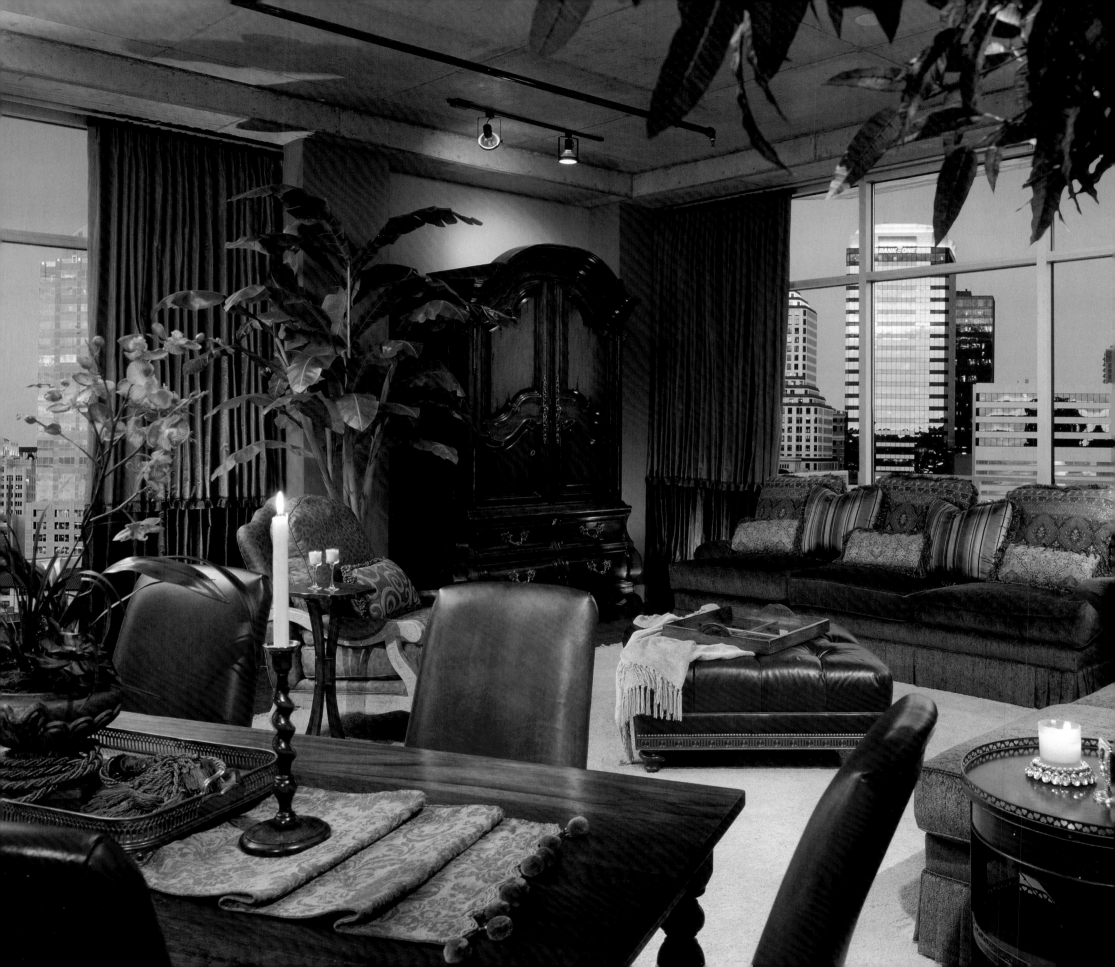

Babs McMaude, ASID

JOHN-WILLIAM INTERIORS

*A*ustin designer Babs McMaude views every day as an opportunity for adventure. "This is an exciting time to be an interior designer," she exclaimed. "Because my elite clients have sophisticated tastes and global views, they demand the unique and the extraordinary. I deliver exceptional designs in a variety of styles that perfectly fit their needs."

Babs, a seasoned designer with more than 25 years' experience, has an upscale mix of residential designs in her impressive portfolio. "The majority of my current projects are high-end estates in Central Texas, but I've begun outfitting private golf developments across the nation," she said.

Signature to each design is the essentials of balance and scale, topped by bold strokes of color, soothing fabrics and quality details. The result is warm, welcoming spaces and numerous accolades, including several ASID Design Excellence and TXCABA awards. Babs is also a frequent show home award winner, and her work is widely published in local and national design periodicals.

John-William Interiors benefits from Babs' commitment to design; the firm has enjoyed her notable talents for eight years. Prior to her joining the area's leading design and home furnishings firm, she was one of six designers who opened the highly successful Interiors of Austin. Her vast experience and remarkable designs has earned Babs respect from her peers and a bevy of loyal clients.

"I treat my clients with the utmost care, always looking out for their best interests," she said. "After all, I'm not here to impose my style on them. It's my job to listen to their dreams and transform them into beautiful, inviting settings." Judging by the demand for her services, Babs will enjoy a fruitful career for years to come. ■

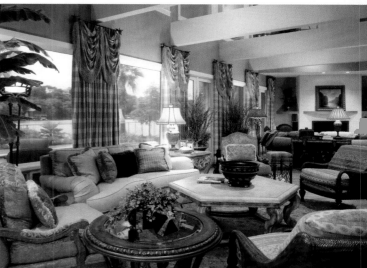

ABOVE TOP: Rich chocolate walls with heavy trim, eclectic influences show in light crackle dining table and side chairs. A touch of whimsey with french arm chairs covered in hair-on hide.

ABOVE BOTTOM: This Lake Austin home blends luxury of comfort and an open flow with waterfront views.

BABS MCMAUDE, ASID
JOHN-WILLIAM INTERIORS
3201 BEE CAVE ROAD
AUSTIN, TEXAS 78746
512.328.2902
WWW.JWINTERIORS.COM

LEFT: This contemporary loft in downtown Austin was transformed to a traditional space for the client.

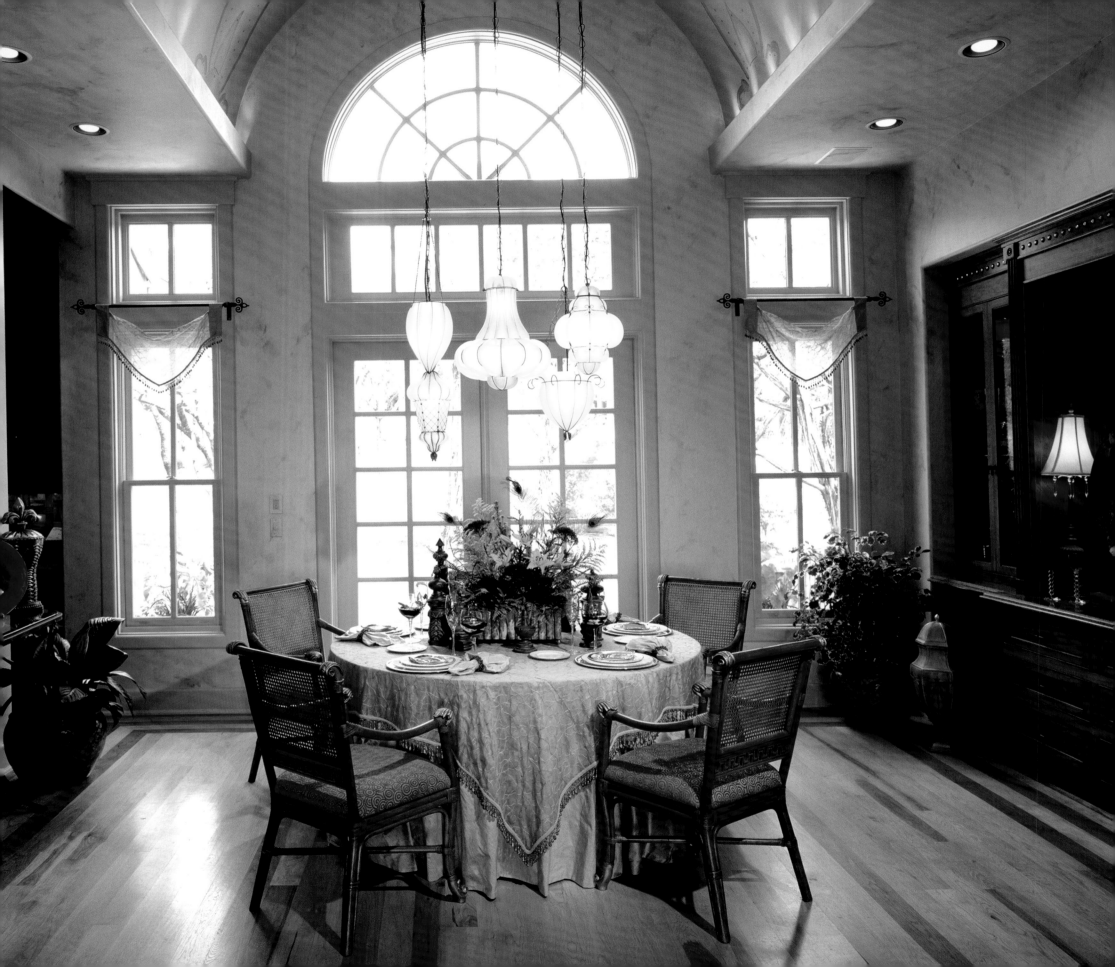

Jessica Nixon, ASID

JESSICA NIXON INTERIOR DESIGN

Clients seek Austin designer Jessica Nixon's fresh interiors with discriminating details. "Through my firm, Jessica Nixon Interior Design, we design high-end residential projects and small commercial ones that are best described as timeless," she said. "Regardless whether an interior is traditional or contemporary, we polish each space with finishing details that perfectly fit our clients' requirements for function and look."

Sometimes projects are remodels; mostly they are new construction. Regardless of the scope, Jessica's company offers a full range of interior design services. "From exterior concepts to interior touches, we take projects from concept to completion," she said.

To craft the award-winning designs for which Jessica is known, she relies on her relationships with local craftsmen. "When clients hire designers, they are hiring their contractors," Jessica explained. "Most professionals build successful businesses around the finest craftsmen and best manufacturers." This approach ensures successful results for the 1992 interior design graduate of the University of Texas at Austin. So does communicating with her clients. "I carefully listen to every client's needs, and then my team conducts research to identify the appropriate finishes, furniture and design."

The results have won her firm accolades from industry organizations including two Design Excellence awards. They've also led to leadership positions with her local ASID association—Jessica has chaired both the Austin Association and its Design Excellence committee.

Her glowing reputation earned Jessica a place on Home & Garden Television's "Designer's Challenge" program. Although she can't disclose whether she was selected to redesign the master bath for which she was solicited, she can say that being a mother may have impacted the homeowner's decision. "I could relate to her requirements for safety," said the mother of young sons Gabriel and Nathaniel.

While her experience and training has proven helpful, Jessica believes it's her innate sense of style that keeps clients coming back. "I don't stamp my designs with a Jessica Nixon signature," she said. "I willingly work within the clients' genres, incorporating what's important to them while applying the essentials of good design." ∎

TOP: The kitchen, built by Reynolds Custom Homes, Inc. with its granite countertops and stainless steel appliances favors modern conveniences.

ABOVE: This master bath, built by Reagan Reilly Luxury Estates, provides a soothing haven.

LEFT: The formal dining room of this Austin Symphony Showhouse built by Casa Bella Homes awaits expected guests.

JESSICA NIXON, ASID
JESSICA NIXON INTERIOR DESIGN
1700 S. LAMAR BLVD., SUITE 200
AUSTIN, TEXAS 78704
WWW.JESSICANIXON.COM

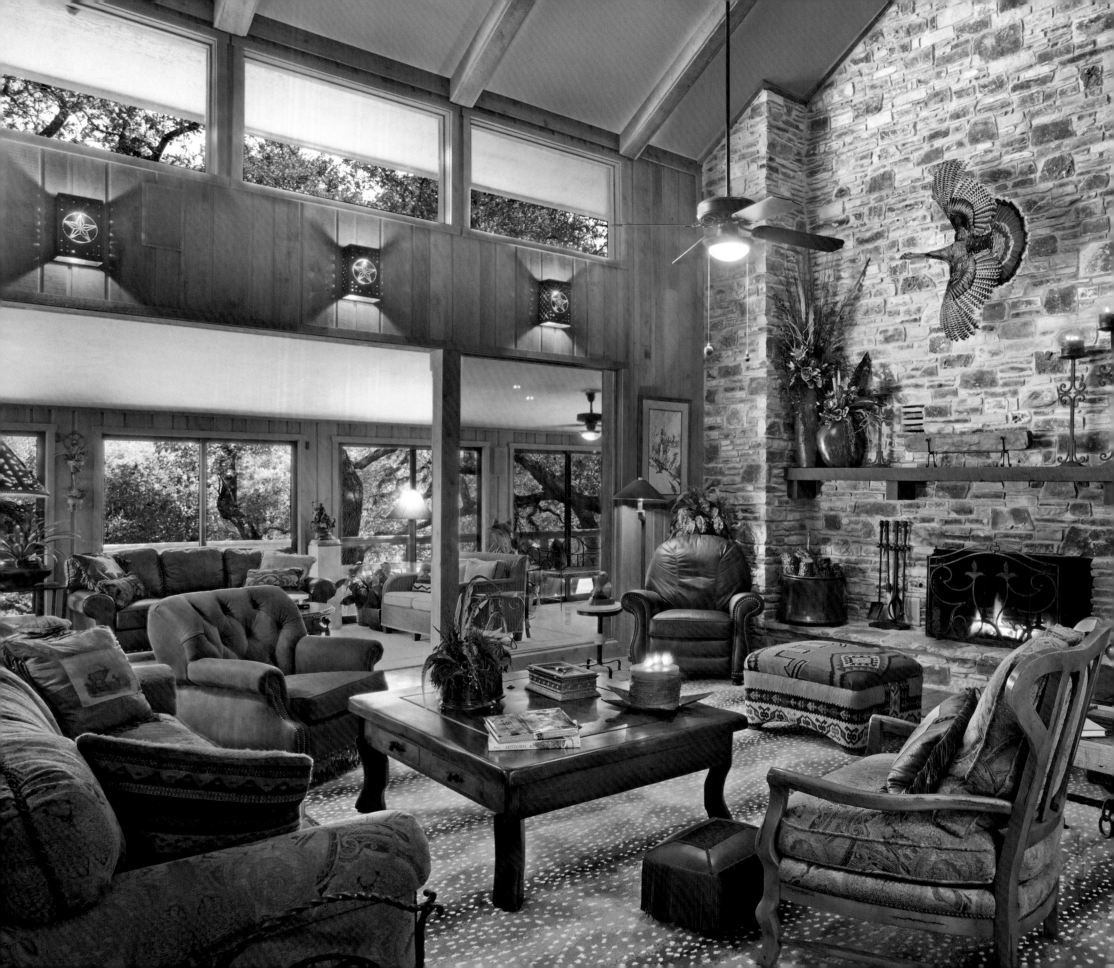

Patti Riley-Brown, ASID

RILEY-BROWN, INC.

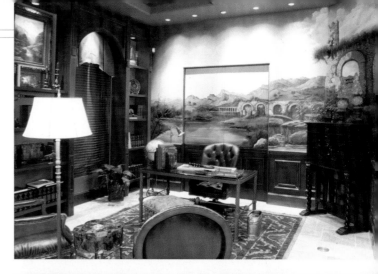

TOP: This private residence in the Western Davenport area features a study with an adjoining computer room and a mural by Debbie Blakely.

ABOVE: The informal, yet elegant, ceiling of recycled barn wood and the custom light fixture are right at home in this remodeled residence in the Austin Rob Roy area.

Patti Riley-Brown is a noted Austin designer with a global portfolio of award-winning designs and a long history of service to her profession.

"I was educated in design in the late '40s and '50s, then I took time off to raise my family, only occasionally helping design clients," Patti said. "In the '70s, I became fully accredited and opened a studio and a retail shop. Then in 1977, I incorporated and ran a successful design company until 2000, when I again opted to become a sole proprietor."

Today ,Patti is semi-retired, though the demand for her services keeps her steadily busy. She responds to clients' requests for new and remodeled homes and ranches, and occasionally she helps with an office or clinic, marking each with her signature sense of scale and proportion. Patti perfectly plans each interior according to her client's needs, budget and space. "Function is always my first consideration," she explained. "Once the structure is in place, I plan a room to achieve the desired effect."

Simplicity is the rule in Patti's designs, regardless of the style. "Whether a contemporary loft or large Texas ranch, I strive for the straightforward and uncluttered," she said. She finishes each interior with meticulous details, beautiful furnishings and the perfect dose of color. "Color is important to a design," she explained. "It sets the mood, defines the background and provides a fluid flow."

PATTI RILEY-BROWN, ASID
RILEY-BROWN, INC.
3837 STECK AVENUE
AUSTIN, TEXAS 78759
512.345.5047

LEFT: Warm, rustic and comfortable were the outcome of the exotic-game vacation home remodeled for a ranch in Central Texas.

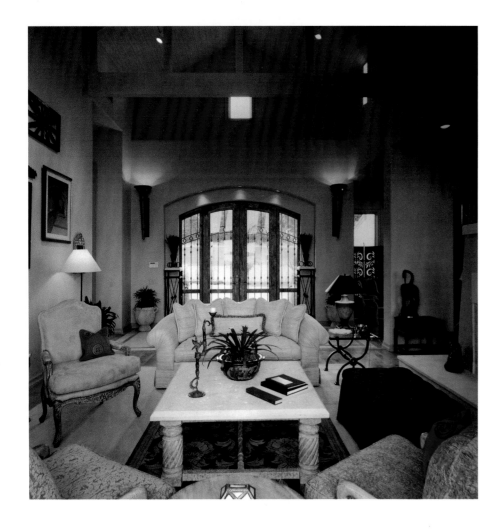

Patti's memorable designs live in 15 states and the District of Columbia, Mexico, England, Egypt and Saudi Arabia. In addition to residences and ranches, the impressive group includes everything from college housing and luxury hotels to financial institutions and medical facilities. Several publications have featured her body of work including *Designers West, Interior Design, Southern Living, Texas Homes, Austin Home & Living* and *Builder's Journal*. Industry giants have bestowed Patti with top accolades including the American Society of Interior Designers (ASID), who honored her with several Design Excellence awards. She is most proud to be a medalist of ASID since 1997.

Involved in professional organizations, Patti has sat on the national, state and local ASID boards and the Texas Association of Interior Design legislative board; she was a member of the Women's Architectural League and the National Home Fashions League; and she is a current member of Women in Construction and the Illuminating Engineering Society. In 1992, the University of Texas at Austin, where Patti received her degree in interior design, designated her a "Distinguished Alumna."

LEFT: This private residence in the Barton Creek area of Austin showcases Spanish and Eurasian influences and custom, oak light fixtures.

BOTTOM LEFT: In this University of Austin sorority living room, the organization's colors are prominent on the detailed remodeling.

BOTTOM RIGHT: Elegant, oriental influences in this Austin, Texas high-rise make a perfect setting for gracious entertaining.

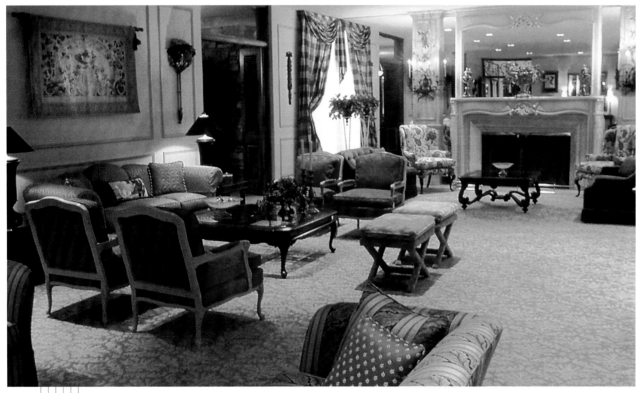

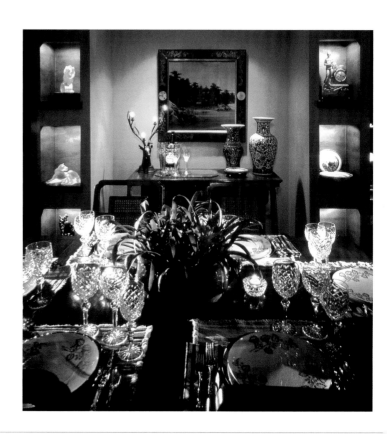

RIGHT: This older home near the University of Texas in Austin once was a showhouse project, but now it is a faculty bed and breakfast.

BOTTOM LEFT: Elegant, but casual, texture and warm, rich color prevail for comfort and interest in this master bedroom in a Central Texas ranch remodel.

BOTTOM RIGHT: An outdated powder bath is revitalized with a glass sink on a mesquite base, copper fixtures and a mirror on the existing mirror.

Another testament to Patti's esteemed career comes from an unlikely source—her registration number. It's the number three, which means that she was the third person in the state to be registered. Behind that low number is Patti's unwavering commitment to her profession—through the TAID she was instrumental in securing registration for interior designers in the state of Texas.

It's not surprising that Patti is finding it hard to retire. Her influences are legendary, her talents extraordinary and her desire unbridled. But when the sun finally sets on her career, the enthusiastic designer—who at an early age discovered her love for history and architecture and her talent for design—will be remembered for the indelible mark she's left on both her projects and her profession. ■

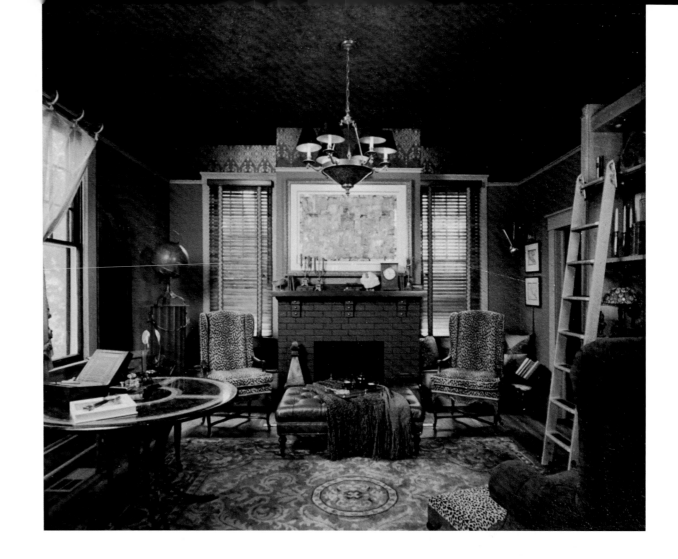

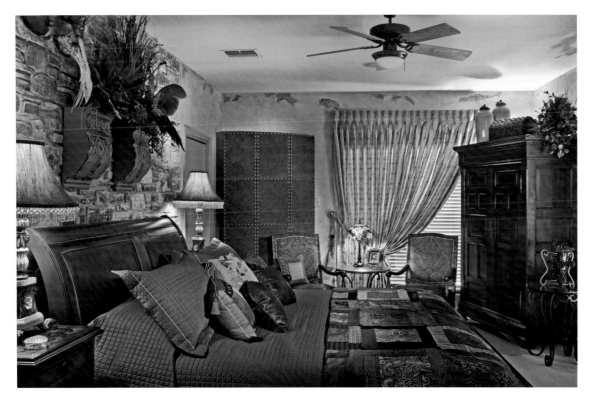

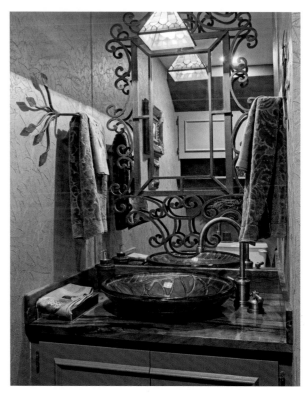

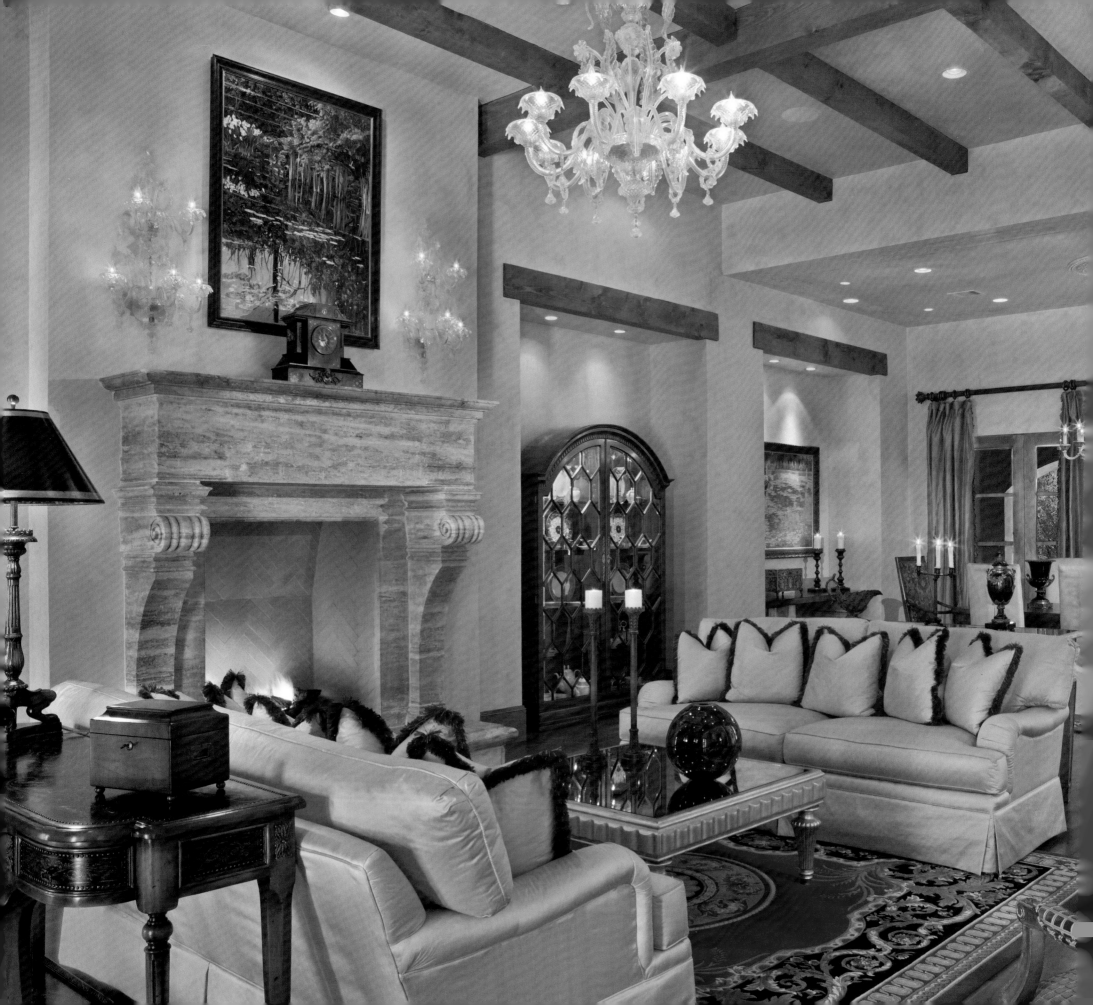

Joe Burke, ASID
Mark W. Smith, ASID

DESIGN CENTER

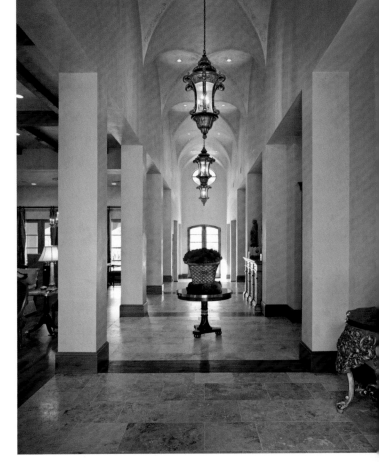

ABOVE: When Mark Smith designed the groin-vaulted great hall, which runs the entire length of the house, he created the hub of this home as it links the formal living room and dining room to the beautifully landscaped exteriors.

LEFT: Described by the designers as Tuscany Texas style, this lavish home designed by Mark Smith features a spacious living area anchored by a massive stone fireplace. This room is elegantly appointed with an antique, Venetian glass chandelier and sconces, which the designers purchased in Milan.

*A*ustin designers Mark Smith and Joe Burke have a refreshing outlook on life. "We like to have fun when we work," Mark said. "Otherwise, why do it?"

It's true that the delightful pair enjoy designing interiors. And while they search for the humor and joy in any situation, they are very serious about their designs. "People trust us with their lives. It's our job to take their dreams and make them real," Joe explained. "Good design isn't all about beauty. We work to improve our clients' lives."

How does the dynamic duo achieve this goal? "By spending quality time with our clients, listening to what they desire," Joe continued. "They'll tell you what they think they want, but often it's what they don't say that's most important." Once they've determined what makes the client happy, they roll up their sleeves and with the help of their trusted staff, they put down roots to ensure a successful project. "Projects can take months or years to complete," Mark explained. "By the time we're finished, our clients are like members of our family. In fact, our clients often become our friends."

The owners and staff of the noted Design Center in Austin have a large family of clients for whom they've designed everything from contemporary high-rises to opulent estates. Preferring to focus on residential interiors—with an occasional professional building or doctor office thrown in—the team tackles every design challenge with imaginative, workable solutions. "For example, last year we

JOE BURKE, ASID
MARK W. SMITH, ASID
DESIGN CENTER
4929 RANCH ROAD 2222
AUSTIN, TEXAS 78731
512.343.2222

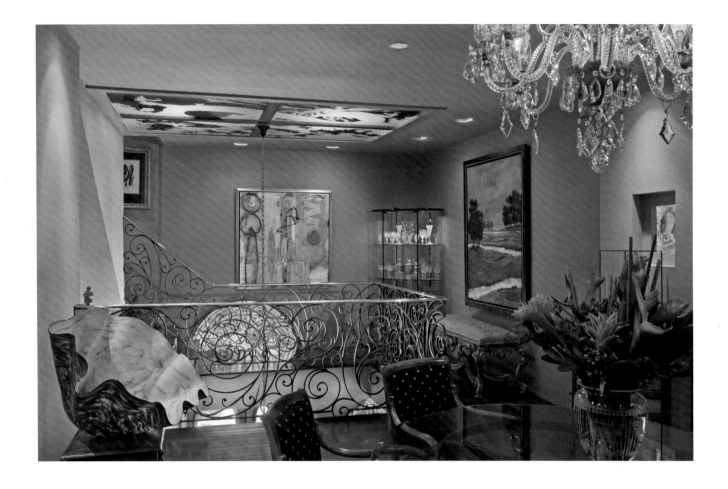

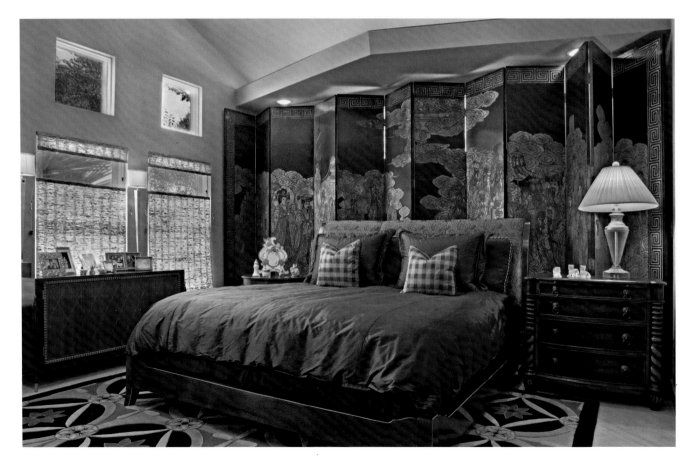

TOP LEFT: Inside the designers' own home, there is an elegant, etched-glass skylight illuminating the dining area that features an antique, ruby crystal chandelier and a custom, hand-blown glass sculpture by renowned glass artist Dale Chihuly.

BOTTOM LEFT: Using a subtle, sophisticated combination of persimmon, black and amber, the large Asian screen was the starting point in the design of this unique, sophisticated bedroom.

were asked to redesign a media room that was poorly lit and drab. The clients were looking for fun and function," Mark said. "So we revamped the entire room, adding bright, rich colors and a custom rug with metallic yarns that reflected the ambient lighting. The reflection serves as path lights during a movie."

At the core of Mark and Joe's versatile designs is an innate sense of scale and proportion. It is the foundation upon which everything else is built. "Having proper balance sets the rhythm of a room," Joe explained. "Without it, nothing else matters."

Topping the foundation of every interior is color. Joe and Mark are masters at combining rich, saturated hues to create stylishly elegant rooms. Ruby reds join gilded golds. Warm silvers linger near vibrant violets. Soothing ambers greet buttery yellows. Whatever the style—whether it's Texas chic, lake-house lazy, Italian Mediterranean or French flair—the bold strokes of the designers' palettes define a room's mood, staging a presence that's personalized for every client. "Some people find solace in sunny surroundings, while others respond to soft, muted tones," Mark said. "We take our cue from our clients…then we work our magic."

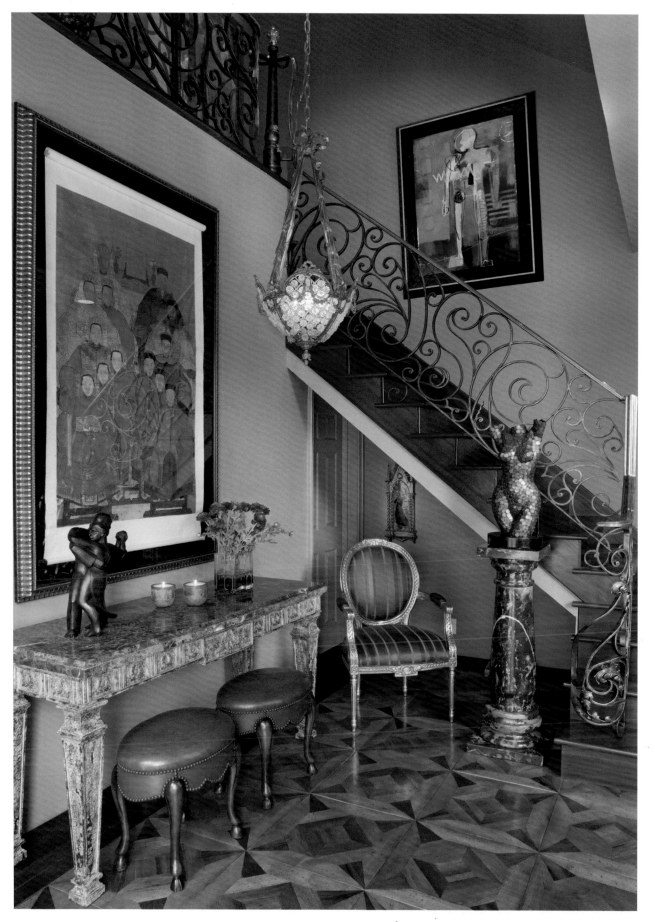

RIGHT: Also inside the designers' home, the entryway–with its elaborate Italian inlaid wood floors and family portrait from the Quoin Dynasty–also features custom, hand-forged iron balustrades.

Crisp details punctuate the final finishes, which lend quality and sophistication to every interior. Custom moldings and cabinetry, rugs and window treatments. These extras are standard in Mark and Joe's uncluttered designs. "We have unparalleled access to respected craftsmen and artisans," Mark said. "And we keep them busy." So do travels around the globe, where visits to culturally diverse destinations spark creative visions for future designs. "Whether we're fishing off the coast of Mexico or touring the Grecian ruins, we're always absorbing the simple and the extraordinary," remarked Joe.

The talented designers with an eye for the unique met 20 years ago at a social function, where Joe approached Mark after admiring his work. There was an instant connection between the two. Joe, who graduated with a degree in interior design from the University of Texas, was an established designer with 15 years' experience. Mark was still fairly new on the scene having recently graduated from Texas Tech University with an architectural degree. While both were enjoying individual successes, the marriage of their talents was overwhelmingly well-received, prompting the decision to forge a partnership, which has thrived for 20 years.

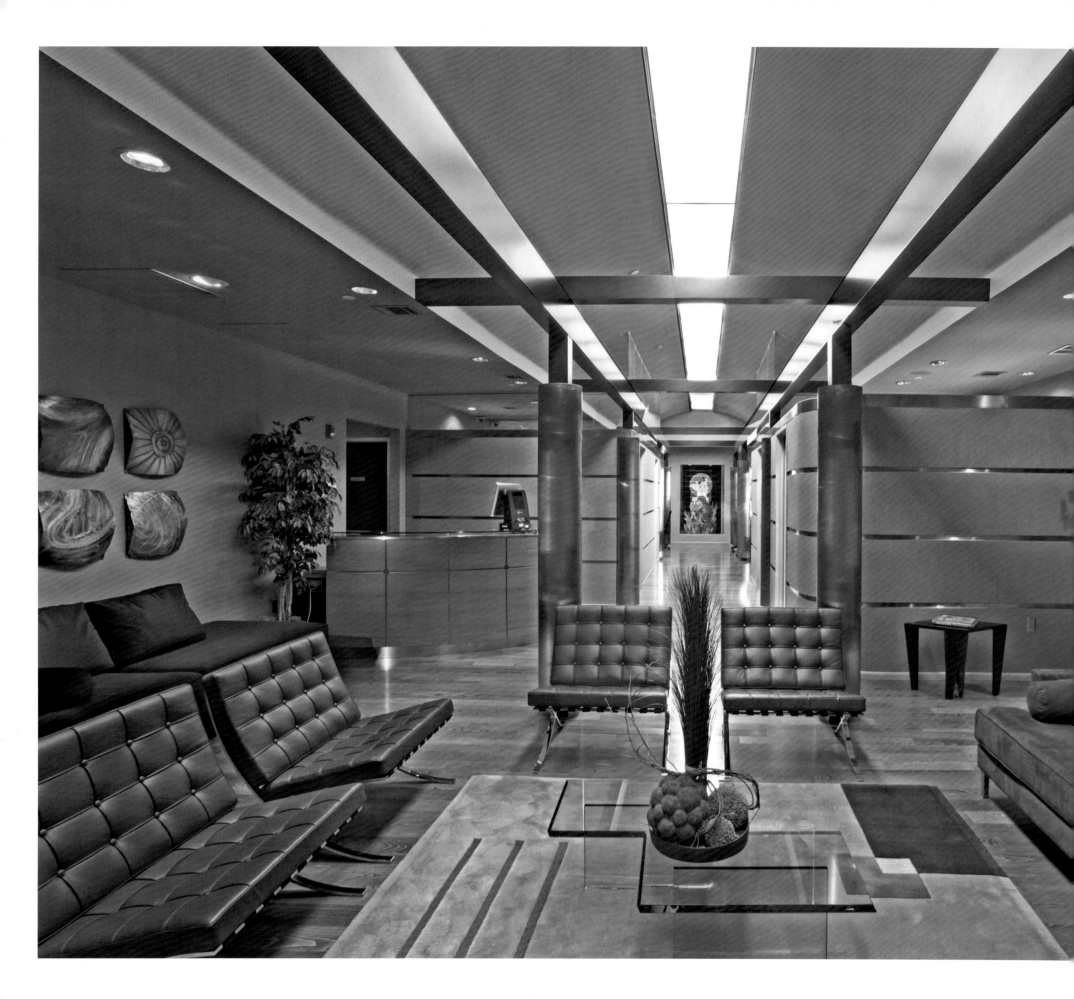

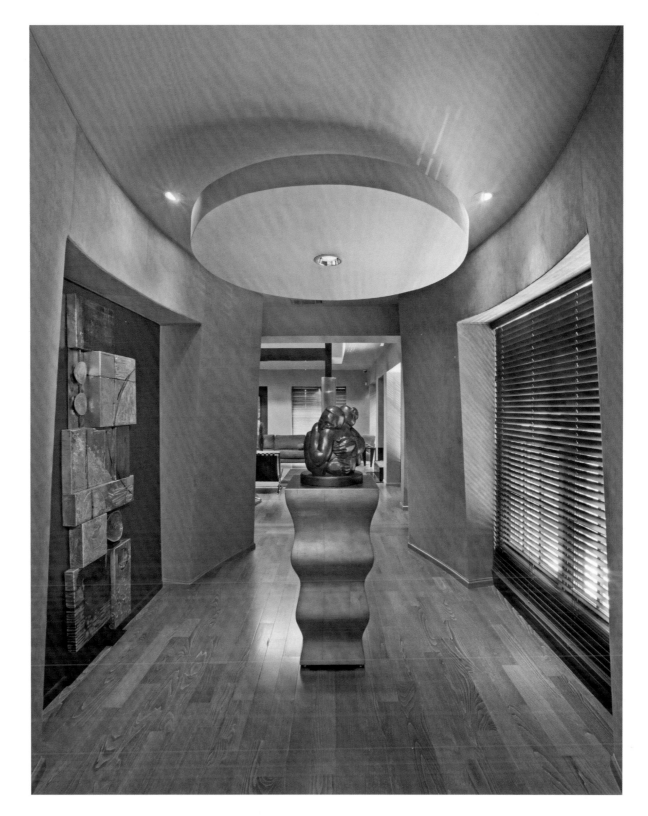

FAR LEFT: The contemporary, minimalist design of this physician's waiting area with architectural features, including stainless steel beams, columns and horizontal wall details, leads you into the private exam rooms. The room is embellished with colorful, handcrafted rugs and burgundy leather Barcelona chairs.

LEFT: The round, askew sculptural walls of the entry feature an Art Deco pedestal with an Edward Povey bronze, "The Couple."

The demand for their remarkable designs has led to numerous features in industry publications—which is great, the pair says. But the real thrill comes when a valued client declares a room "perfect." "After all," Joe proclaimed, "seeing that smile is what makes our work fun!" ∎

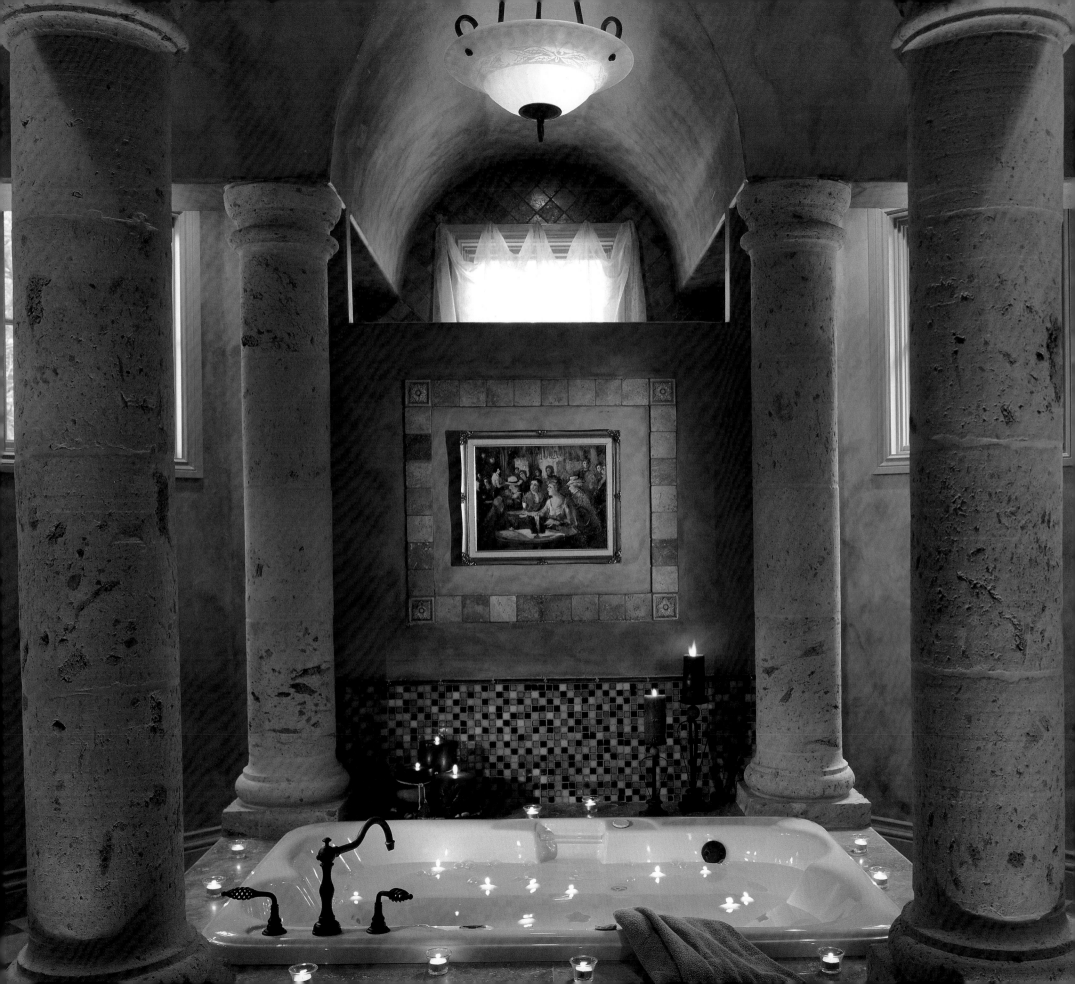

Stephanie Villavicencio, ASID

BELLA VILLA DESIGN STUDIO

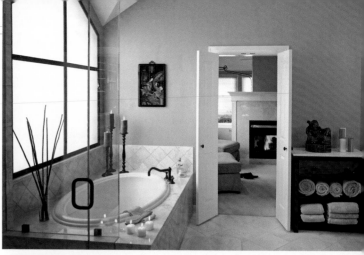

Award-winning designer Stephanie Villavicencio leapt to the top of her profession at an early age. "I worked for designer Jerri Kunz my senior year at the University of Texas in Austin," Stephanie explained. "Shortly after graduating in 1990 with a degree in interior design, I became a partner at Cohagan Hall Design Associates."

Learning first hand that quality is in the details, Stephanie honed her craft during her nearly 10-year stay at the noted Austin design firm. Her flair for color, innovative ideas and a strong sense of livable style won her a loyal following and numerous accolades, including several prestigious Design Excellence awards.

When the dot-com craze called, Stephanie responded to the challenge of becoming head designer for an online furniture retailer. There, she perfected her project management skills by supervising large projects across various departments. Armed with that valuable experience, Stephanie and a co-worker struck out on their own, opening the highly successful 3DC Design Studio. Through 3DC, Stephanie created beautiful residential spaces, spec homes, offices and a boutique hotel at the Mansion at Judges' Hill in Austin.

Today, Stephanie continues to provide extraordinary and excellent design through her firm, Bella Villa Design Studio. Using her artistic eye, her talent for creative lighting and her knowledge of the latest technology, she weaves memorable interiors for high-end residential, specialty hospitality and small commercial clients. She also participates in parades of homes while growing professionally through memberships in the TRID, the TAID and the ASID, for whom she's served on the local board. Industry awards continue to line the walls of her respected business.

With a signature mix of the elegant and classic, Stephanie's style is refreshingly unique and her approach stunningly simple. "I design for my clients, not myself," she explained. "Therefore, every space is distinct in its style and personality." Each is also warm and welcoming, which makes the Austin designer in high demand. "I value my clients and am delighted when they declare that their spaces fit perfectly," she said. "Their joy is my reward." ◼

TOP: A remodel transformed a typical tract home bath into a Zen retreat complete with a steam shower and special jacuzzi tub.

ABOVE: An eclectic mix of colors and cultures make this showhouse living room glow. Custom pieces and artwork were commissioned especially for this room.

STEPHANIE VILLAVICENCIO, ASID
BELLA VILLA DESIGN STUDIO
605 ACADEMY DRIVE
AUSTIN, TEXAS 78704
512.443.3200
WWW.BELLAVILLADS.COM

LEFT: This spectacular master bathroom in a spec home was created using extraordinary materials mixed with basic travertine for an opulent atmosphere.

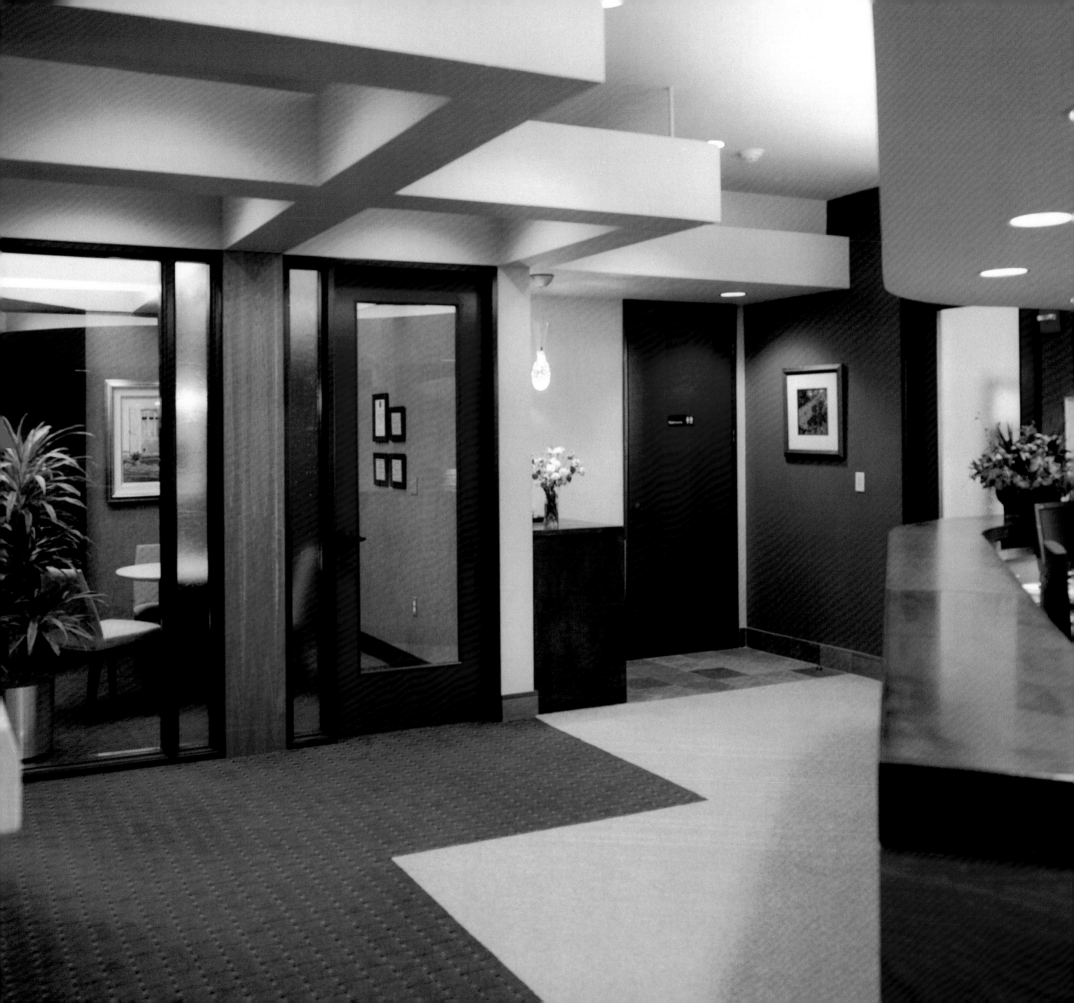

Donna Wetegrove, ASID, IIDA

WETEGROVE DESIGN SERVICES

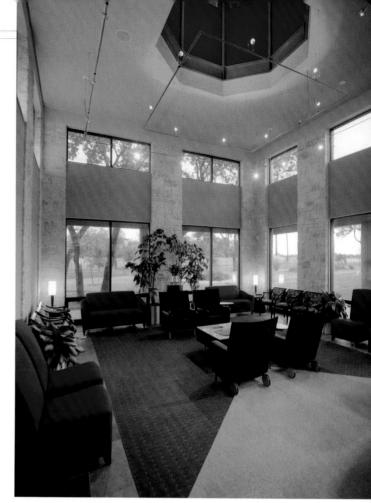

Austin interior designer Donna Wetegrove first discovered her desire to create in the top of a backyard tree. "I was a tomboy who loved to climb trees," the noted designer explained. "I wanted a space to escape, so I built myself a little sanctuary among the branches."

Years later she graduated from the University of Texas at Austin and started down her professional design path. Stopping early at a firm that specializes in dental office design, Donna spent 18 years designing highly functional spaces with spectacular details. She learned how to marry the aseptic functional surfaces with warm textures, and she honed her love and use of simple materials in creative ways. The result won her numerous national clients and a respected regard for creating harmonious, healthy and sustainable environments.

She opened Wetegrove Design Services in 2000, where with a reputation for integrity and a passion for pairing the unusual with the exceptional, Donna approaches each design with refreshing simplicity. "It's a joy to help my clients manifest their dreams," she said. Her positive approach and stellar designs earned her an ASID Design Excellence Award for Commercial Over 5,000 sq. ft.

Believing that collaboration, mentoring and creativity benefits society, Donna routinely donates her time to nonprofit organizations. Her contributions range from designing and procuring materials for nonprofit dental and medical clinics to annually adopting low income families who need a helping hand.

Donna is also founder of TIPS On Art (www.tipsonart.org), a service organization that is changing Austin's creative landscape. Using her business and life experience skills—along with her interests in metal working, mixed-media collage, cuisine, color theory and holistic thinking—Donna envisions TIPS as the cornerstone of a needed cohesive arts district and landmark destination for visitors.

No doubt Donna will realize this dream. After all, achieving lofty goals comes naturally for this visionary designer. From tree tops to dental office designs, Donna is leaving an indelible mark both personally and professionally. ■

ABOVE: When patients enter this dental office, they are greeted by the soothing color scheme and geometric elements of the waiting area.

LEFT: Using unique materials like concrete cast glass, slate and cherrywood, this reappointments area provides an open and dynamic transition space to and from the treatment areas.

DONNA WETEGROVE, ASID, IIDA
WETEGROVE DESIGN SERVICES
6019 ABILENE TRAIL
AUSTIN, TEXAS 78749
512.288.4897

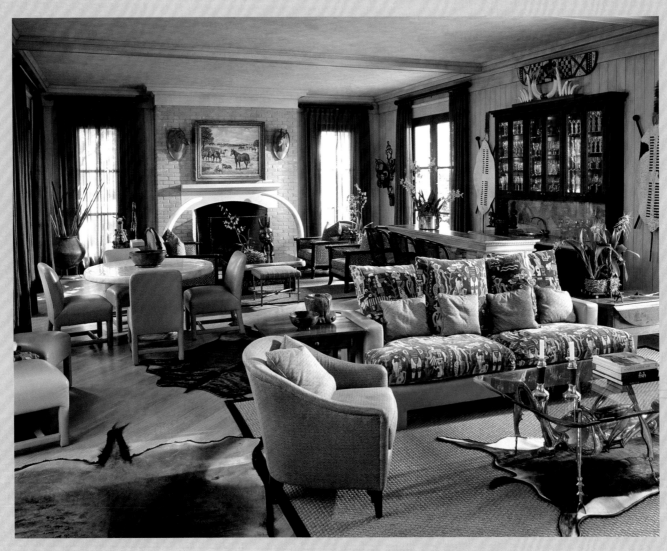

DAVID CORLEY, ASID

Dallas

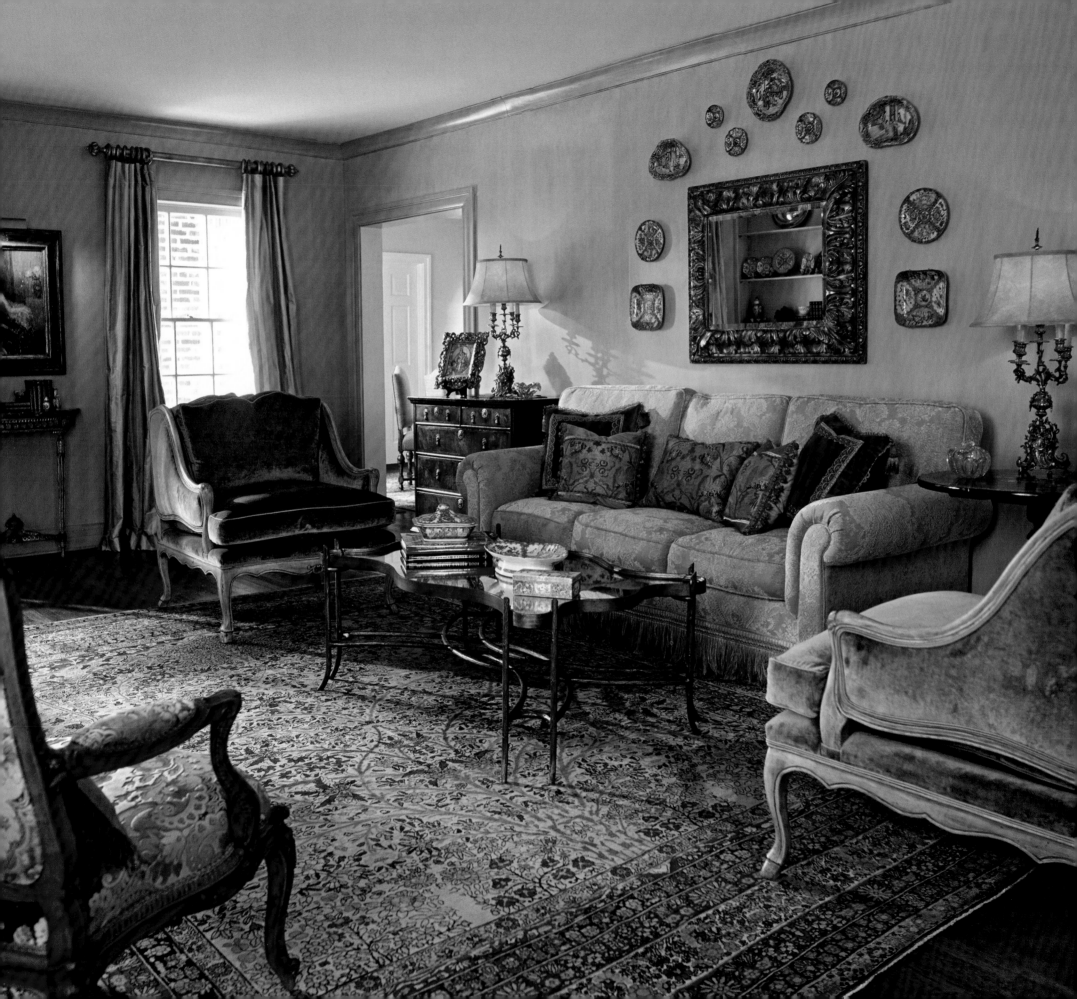

Paige R. Baten-Locke, ASID

PAIGE R. BATEN-LOCKE DESIGNS

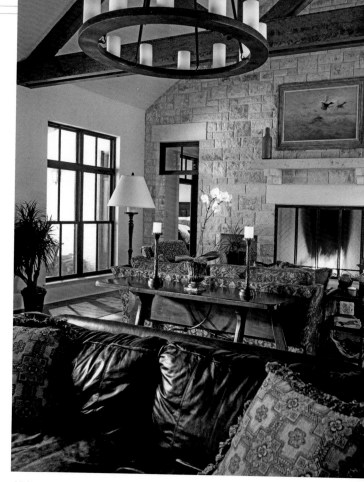

ABOVE: Light filters through this spacious ranch family room. Natural elements, such as the stone fireplace wall and large beams across the peaked ceiling, make this multi-conversation area a well-loved spot in this family's home.

LEFT: Antique treasures fill this elegant living room. From the rich, colorful tones in the antique rug, Chinese porcelains and beautiful oil paintings to the glazed yellow walls, the room sets the stage for warm, inviting gatherings.

"I enjoy designing places where memories are built," said Dallas designer Paige Baten-Locke.

Her designs are born from clients' necessities or hopes—like an addition to cradle aging parents, an office to house an established practice or a home to welcome expectant parents. Wrapped around the function of each interior are the personalities of the people who live or work there. Sometimes they are soft and subtle; other times they're bold and bright. Each reflects the client's dreams.

"I invest a lot of time in my clients, listening to what they want to accomplish and evaluating their non-verbal cues about their likes and dislikes," explained Paige. "Then I turn their dreams into reality by carefully guiding them through the design process, painting pictures for them with words and visual aids. Doing so ensures that they can see how a room or space will look."

At the center of Paige's award-winning designs is respect. She not only showers her clients with it; she purposely lets her subcontractors, contractors, architects and co-workers know that their contributions are valued. "I believe that if you truly treat everyone with respect, anything is possible."

Perhaps that explains the faithful clients and loyal craftsmen that have traveled with Paige through her 26-year career as an interior designer. It definitely accounts for the steadfast support of design associate Lisa Bennett. With her help, Paige has received recognition for her designs by industry organizations, and her work has been published in numerous national magazines and books.

Whether residential or commercial, traditional or contemporary, Paige's interiors are always inviting and warm. And although she doesn't subscribe to a specific design style, every space she conceives is clean and classic, standing the test of time for the people building memories there. ∎

PAIGE R. BATEN-LOCKE, ASID
PAIGE R. BATEN-LOCKE DESIGNS
4400 PURDUE BLVD.
DALLAS, TEXAS 75225
214.577.7327

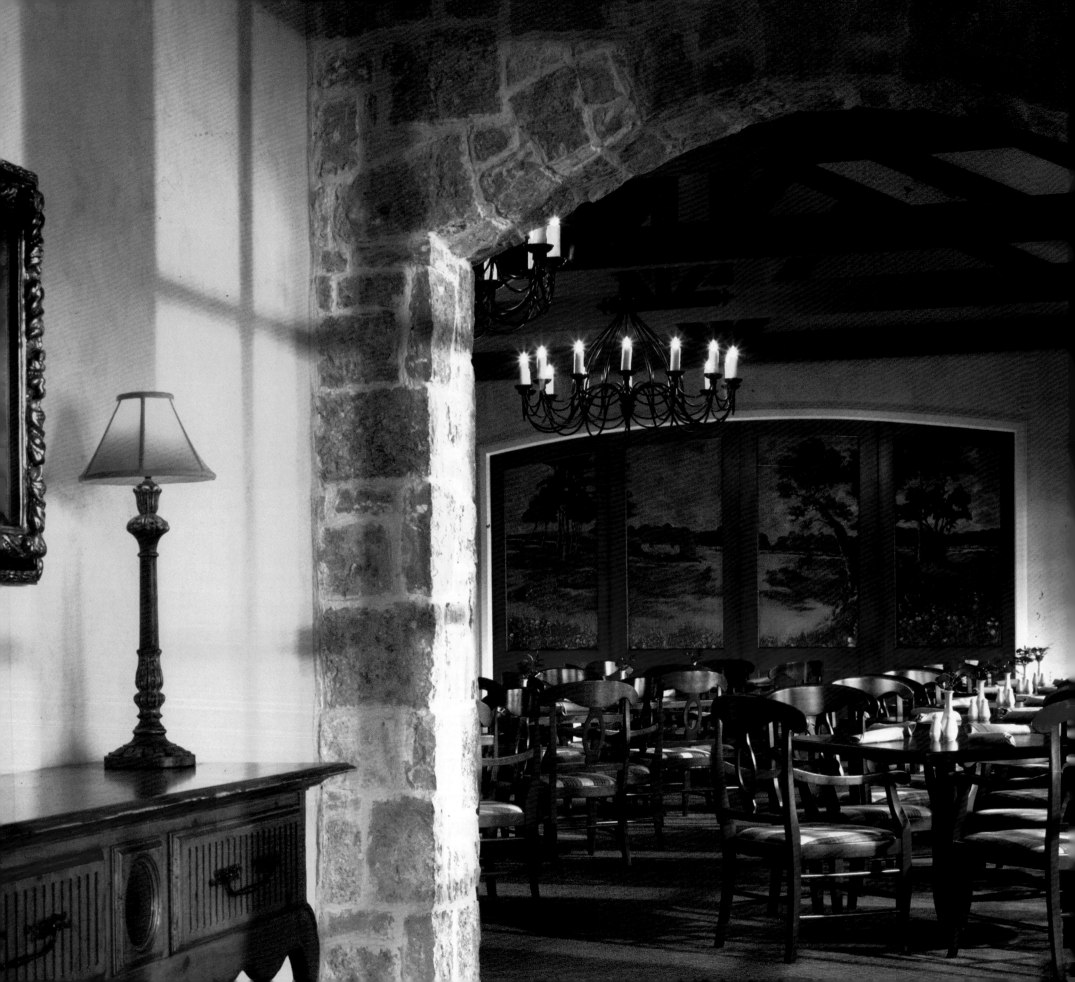

Jeannine Bazer-Schwartz, FASID
Irving D. Schwartz, AIA, FASID

IDS/B, INC.

ABOVE: A round rotunda and domed-ceiling, alabaster light fixture combine with art and a floral arrangement to create a sophisticated circulation transition in a Midwestern country club.

LEFT: The warmth of the Country French architecture in this country club is repeated in the interior with the use of stone and exposed trusses.

A design project works best when architect and interior designer establish a solid relationship and share common goals. But not every project is ideal. Sometimes an architect and a designer may not agree on the best way to solve a client's needs.

Fortunately for clients in the hospitality industry, there's an award-winning design firm based in Dallas that provides both exemplary architectural and interior design services—IDS/B, Inc. Led by the husband and wife team of Jeannine Bazer-Schwartz, FASID, and Irving Schwartz, AIA, FASID, this renowned company is a respected leader in designing and outfitting commercial properties across the nation.

The portfolio of this firm includes corporate and residential projects. But its true specialty lies in designing country clubs. "Since founding IDS/B in 1985, Jeannine and I have not only designed and decorated country clubs in Texas; we've extended our reach across the country," said Irving. With projects throughout the United States, the Schwartz' have left their mark in this global industry through their impressive clubhouse designs. "Our clients desire functional, yet comfortable, spaces that remind their club members of home," explained Jeannine. "By combining architecture and interior design into one discipline, we can deliver seamless solutions that meet their requirements for quality, design and budget."

This integrated approach to designing clubs has resulted in loyal clientele and an expansion of services. With strict requirements for integrity, the Navy turned to IDS/B because of its stellar reputation. Currently the firm is under contract to design banquet, nightclub and golf facilities at Naval installations in California, Maryland and Virginia. "We perform at the highest level of ethical and professional standards," said Irving. "And we listen to each client's needs. This approach enables us to establish trust, which is essential in creating successful designs."

JEANNINE BAZER-SCHWARTZ, FASID
IRVING D. SCHWARTZ, AIA, FASID
IDS/B, INC.
2777 N. STEMMONS FREEWAY, SUITE 1650
DALLAS, TEXAS 75207
214.630.6999

The decision to concentrate on clubhouses was based, in part, on the expertise of Irving. A licensed architect, he worked for, and later led, a company specializing in hospitality designs. Early in his practice he recognized the need to create "complete" projects, so he became an interior designer. "I was a rebel who thought interior design was as important as architecture," Irving said.

Through their involvement in national professional organizations, Irving met Jeannine, who owned her own interior design firm in Dallas. He recognized her extraordinary ability to create warm, livable interiors, and she noted his talent at designing beautiful, functional buildings. They decided to form a professional—and personal—partnership.

ABOVE: The elegance of this reception area, with its soaring ceiling and classic elements, is enhanced by fine art, sculpture and the warmth of wood.

RIGHT: Pilaster-framed mirrors in the cross axis of this country club reflect the bar's entry columns, creating the illusion of a continuous colonnade.

Now, some 20 years later, the Schwartz team applies their extensive experiences into crafting lasting designs. They travel the world for inspiration, visiting places like St. Petersburg, Russia, where on a recent trip they carefully studied the architecture and history. They translate what they learn from their travels into invigorating color combinations, interesting architectural details and inviting functional interiors. And they ensure that each element of the design not only weaves a masterful composition; it also complies with strict code regulations. The result? Beautiful buildings. Memorable interiors. And satisfied clients. ∎

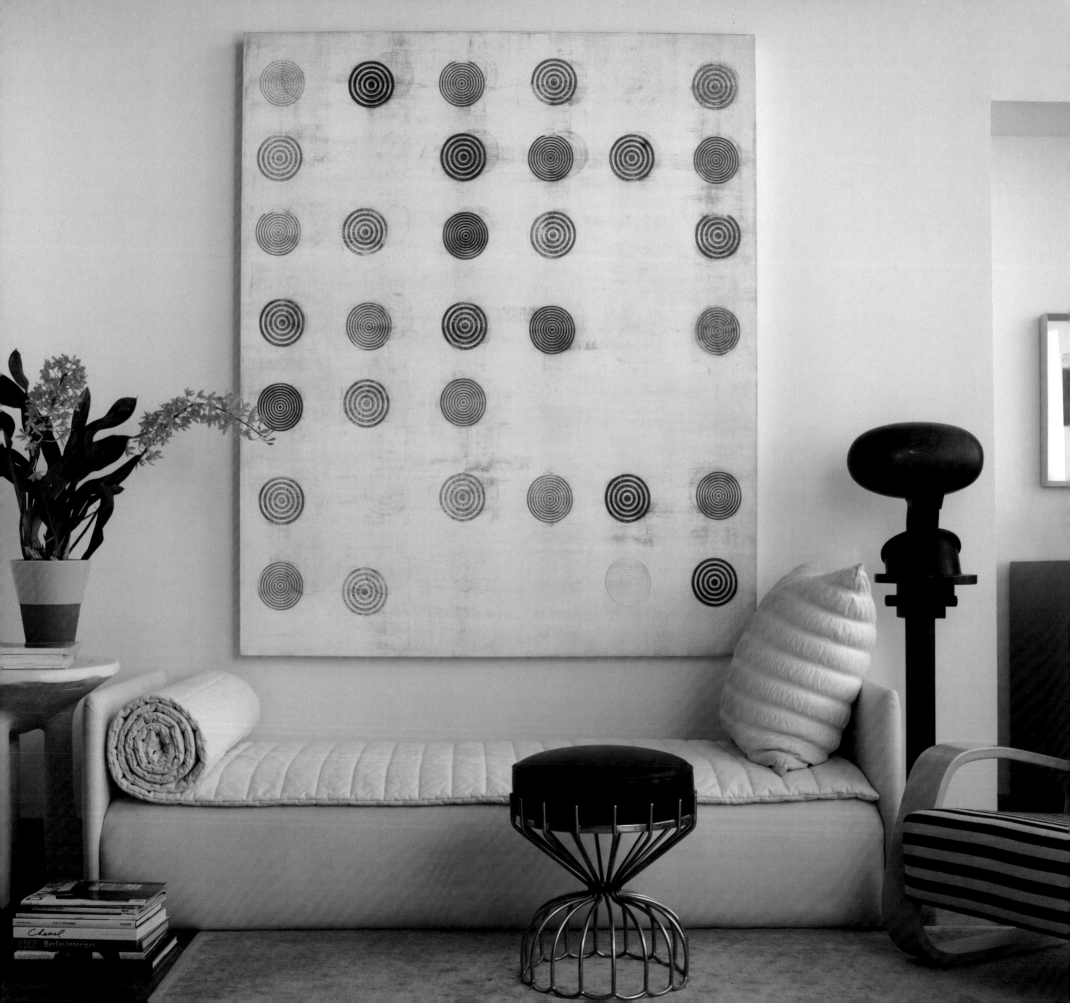

David Cadwallader, ASID

CADWALLADER DESIGN

ABOVE: David's inner city loft houses his collection of modern and vintage modern furnishings and art.

LEFT: A Dunbar Saladino daybed and a John Dickinson table provide a favorite spot for reading.

BELOW: His most loyal fan is Lukah, ready to go with David to the studio.

The hallmark of David Cadwallader's work is a practical, easy elegance that invites people to really live in their homes, rather than a stage set for some idealized or virtual life. His approach reflects a strong sensibility with a subtle flavoring of luxury and humor.

David's pragmatic approach began with a colorful, ascetic childhood in Guatemala, followed by his coming of age in the late '60s at the University of Texas in Austin. After a two-year design apprenticeship in New York, Cadwallader established his career in Dallas.

The designer's portfolio of modern interiors is distinct in the subtle mix of elements and clarity of function, every completed design reflecting the individuality of the client. He and his team approach clients with inquisitive minds to determine their needs and how they live—or how they would like to live. Then they set priorities so clients achieve environments that meet their lifestyles.

The punctuation for each of his livable interiors is art. He encourages clients to acquire art even before furniture saying, "…nothing personalizes a home more than good art. It expresses a client's inner self, which is fundamental to real comfort." So is having a cohesive environment, which is a distinguishing aspect of David's stunningly simple designs that have won him accolades from industry organizations and recognition in noted publications.

DAVID CADWALLADER, ASID
CADWALLADER DESIGN
1501 DRAGON STREET, SUITE 103
DALLAS, TEXAS 75207
214.880.1777

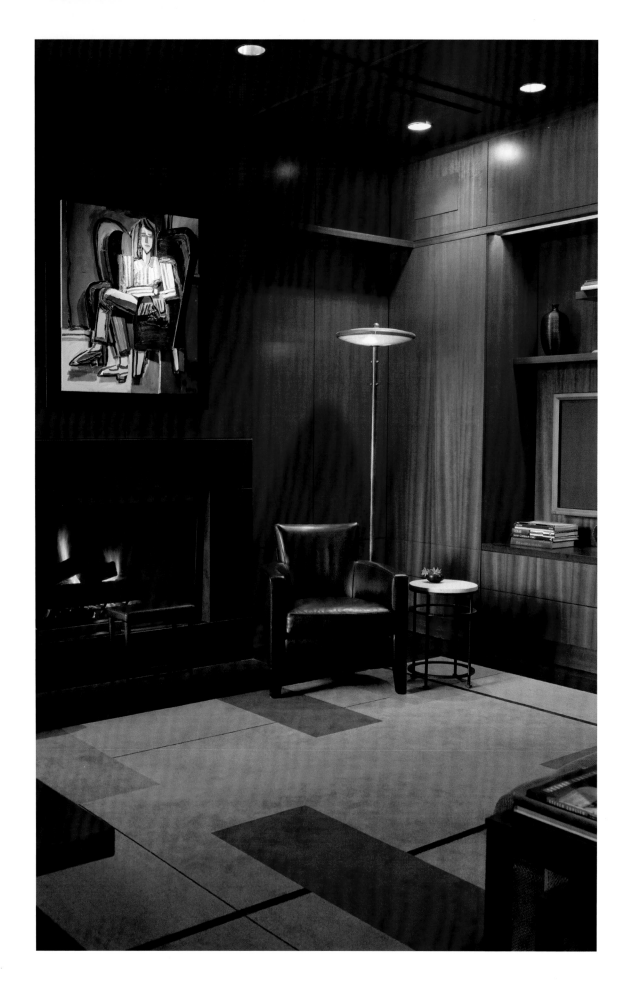

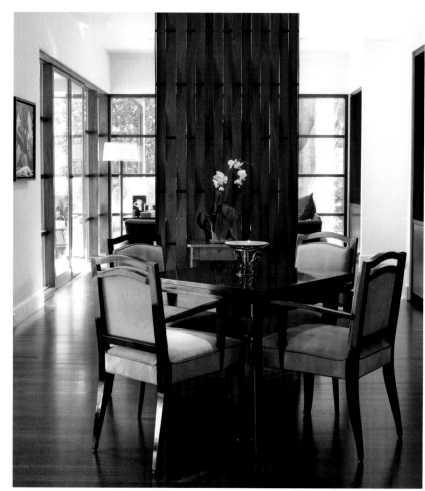

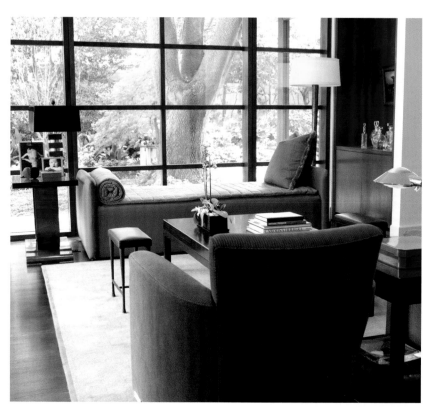

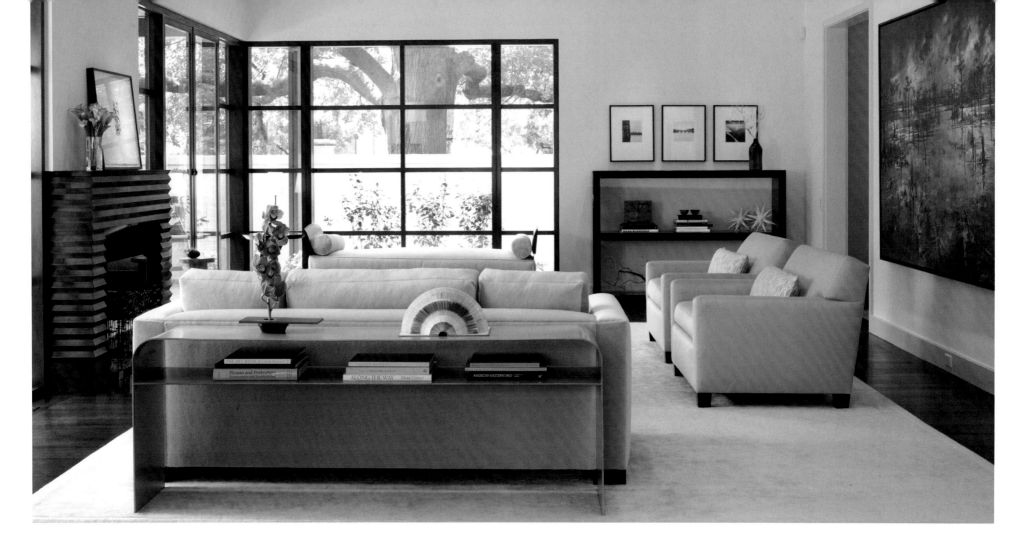

David's exposure to Latin American architecture and culture broadened his view of the world, while the structure of a religious upbringing provided discipline and ethics that are evident in his work. Also contributing to his quality interiors is David's fluency in Spanish, which enables him to communicate with artisans whose workmanship finishes his designs.

Continued global travels keep David's ideas fresh, but it's his 36 years of education and experience that speak to his professional integrity. "Design is a language that anyone can learn, but it takes years of immersion to speak it well." ■

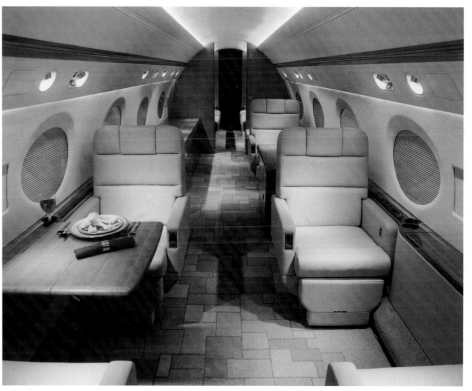

ABOVE: The spacious and elegant living room allocates their simple modern furnishings. Large painting by John Alexender.

RIGHT: A private Gulfstream 500 welcomes the client with a taste for subtle luxury.

OPPOSITE PAGE:

FAR LEFT: The library features Sapere paneling and a painting by David Bates.

TOP RIGHT: Loggia dining is furnished with vintage modern game table and chairs and custom mahogany screen.

BOTTOM RIGHT: A comfortable sitting room provides great views of the pool and gardens.

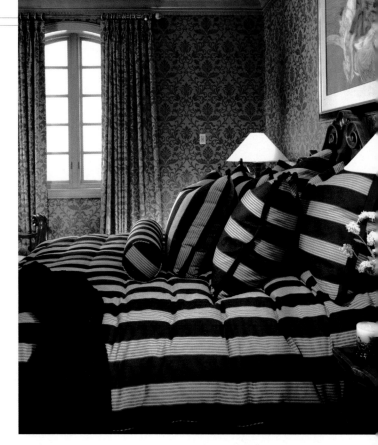

Judy Cody, ASID

JUDY CODY INTERIOR DESIGN

ABOVE: Rich fabric patterns from Clarence House—selected for the wall upholstery, drapery and bedspread treatments and fabricated by Jim Couch's workroom—create a warm and inviting atmosphere for an Aspen residence.

LEFT: Figured veneers of lacewood and inlaid Andirobe have been fabricated by Khoury, Inc. to create a functional bar area, as well as adding warmth to an exceptionally high ceiling height. Textured bronze metal and etched glass have been incorporated into the counter of the bar to reinforce the consistency of the design elements of the furnishings, area rug and accessories.

Since its establishment in 1975, Judy Cody Interior Design has had the opportunity to work on residences from Dallas, Texas, to Moscow, Russia. The firm's work also has entailed installations for Fortune 500 companies, corporate museums, financial institutions, restoration of historical courthouses and multi-family and retirement communities.

The philosophy of Judy Cody Interior Design is that each project is unique in its image, and each one demands personalized attention. Whether her clients are ranchers in Kerrville, Texas, or families with second homes on the island of Montserrat in the West Indies, Judy believes successful design solutions are obtained through the close working relationship between client and designer rather than the dictation of one to the other. This ideal client relationship facilitates an environment that allows the designer to select and install paint colors, fabrics and furnishings that reflect the client's personality and lifestyle.

The firm attributes much of its success to the contributions of the cadre of craftsmen and artists who have helped develop or assemble special products for residences in Aspen and Cabo San Lucas and for offices in London and Moscow. "It is very exciting to see the many facets of a design project, such as exotic veneers, glass and metals, come together to create a display cabinet, a custom conference table, a unique entertainment unit or an interesting wet bar. And seeing the clients' pleasure in utilizing these creations in their daily lives is very rewarding," said Judy.

JUDY CODY, ASID
JUDY CODY INTERIOR DESIGN
5922 BOCA RATON DRIVE
DALLAS, TEXAS 75230
214.739.4259

Judy Cody Interior Design is primarily concerned with answering human needs as they relate to physical surroundings and satisfying those needs in the most creative, economical and professional manner possible. "The result of this basic concern for our commercial clients has proven to benefit employee morale, thus increasing efficiency and production," said Judy. "Our residential clients' sense of well being is enhanced, and their children's self-esteem is promoted by the highly imaginative bedrooms and playrooms created for them."

The firm stays abreast of changing technologies and developments in new products, as well as codes for safer spaces. "For the business world," Judy said, "I believe that good interior design is just good business. It affects a person's well-being by creating an atmosphere that enhances the way a person works. I am proud of my ASID membership and of being a licensed designer in the state of Texas."

LEFT: Distinctive materials of absolute black marble, Australian walnut, Brazilian rosewood and silkwood veneers applied to the custom floor pattern, millwork and furnishings, along with Donghia fabrics and lamps, add a contemporary version of Art Deco-style for an executive corporate office.

RIGHT: Bold, black-and-white contemporary artwork from Conduit Gallery and the Simmonetti curl figured veneer that is referred to as "cross fire" from Pam Keller & Associates create interest in a "mono tone" alcove.

"The interior design profession is both very challenging and very rewarding," Judy added. "We would not have had so many wonderful opportunities had it not been for 'the quality of character' of our clients. Two of these have become my heroes: Mary Kay Ash, founder of Mary Kay Cosmetics, Inc., and Perry Brittain, past chairman of TXU Energy."

Judy Cody Interior Design is structured to handle a turnkey job from the initial concept to the completed installation, or it can assist a client with a single or specific area of need. The firm's aim is to create a custom project for each client whether the style is contemporary, traditional or an eclectic mix. Judy maintains that her firm's completed installations are inviting, comfortable, user-friendly, functional and strikingly and exceptionally unique.

Generating clientele exclusively through referrals, the firm has continued to grow for the past 30 years. ■

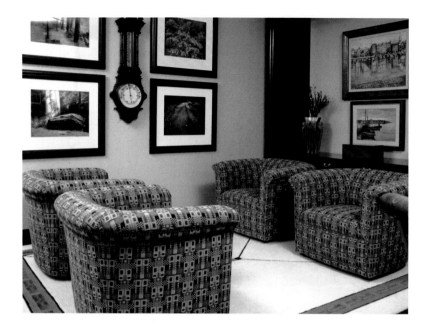

ABOVE: Kirk Brummel fabrics, a custom area rug by Edward Fields and "Old World photography methods" photographing forest woodlands in Atlanta, Georgia, combine to make this otherwise traditional corporate office an interesting blend of eclectic style.

LEFT: Glass artist Polly Gessell's etched and sand-carved collage of the founder's corporate culture, identify and faith doctrine creates a dramatic contrast for a corporate reception desk next to a background of textured gold metal.

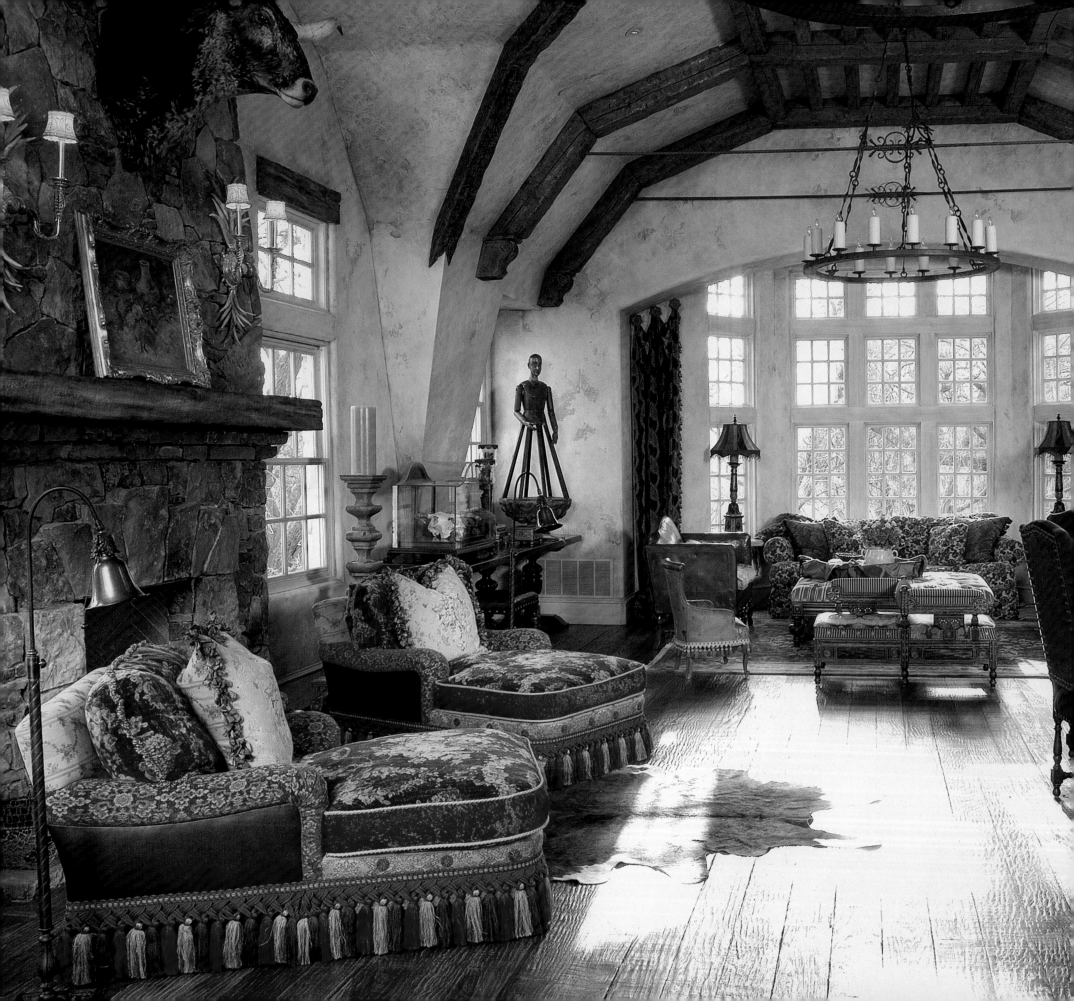

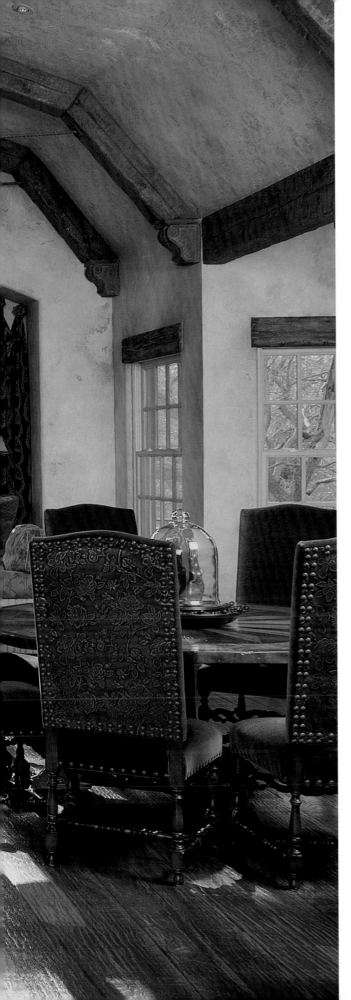

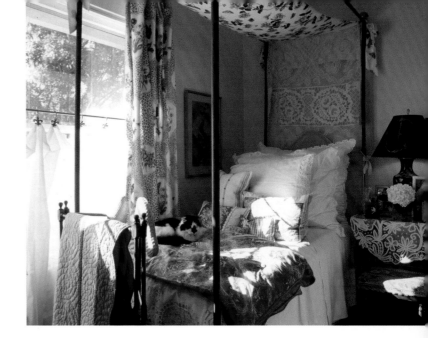

Charlotte Comer, ASID

CHARLOTTE COMER INTERIORS, INC.

Two experiences profoundly influenced Charlotte Comer's award-winning designs: her childhood relationship with her grandmother in North Carolina and her 10-year stint as docent with the Kimball Art Museum in Fort Worth.

The Dallas-based designer fell in love with textiles as a child. Her grandmother, an upholsterer in North Carolina, would routinely take Charlotte with her to buy fabric from the mill outlets. Charlotte would wander the rows of brightly colored bolts, absorbing the stimulating mix of patterns and colors. The experience proved inspirational for the budding designer. "I have been sewing since the age of five," she confessed. "My interest in fabrics grew from my early exposure to them in the outlets."

Today, Charlotte still loves textiles, which are evident in her widely acclaimed designs. "Textures add depth to a setting," she said. "Not only do I layer the finest fabrics, I juxtapose them, combining, for example, African Kuba cloths with vintage lace to achieve a warm mix." Add to that the basic principles of proportion, balance and color—Charlotte's specialty—and the results are stunningly simple and rich.

CHARLOTTE COMER, ASID
CHARLOTTE COMER INTERIORS, INC.
5609 VICKERY BLVD.
DALLAS, TEXAS 75206
214.953.0855
WWW.CHARLOTTECOMERINTERIORS.COM

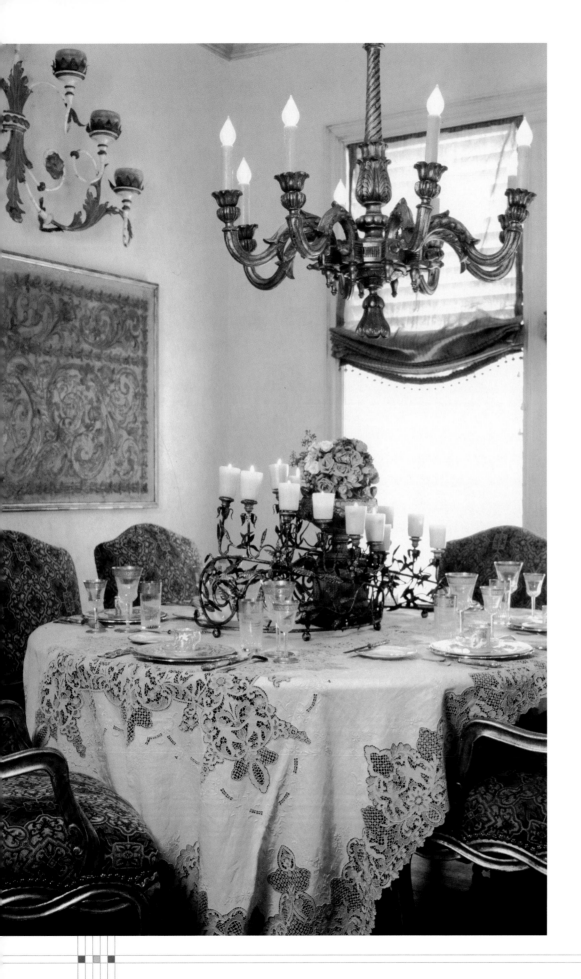

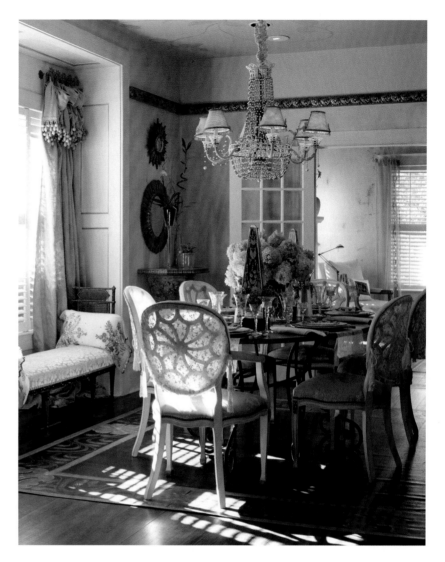

"My designs are complicated, yet clean; interesting, not busy," she explained. "Regardless of the style—traditional, contemporary or transitional—I achieve the look my clients desire while incorporating unique details that make their homes comfortable and livable."

To fashion the exceptional interiors for which she's known, Charlotte relies on her degree in interior design from Texas Christian University, her more than 30 years' experience and her valuable training as a museum docent.

LEFT: An antique tablecloth dresses the dining table in an elegant setting, while the antique marquetry panel hangs below an antique service.

RIGHT: The sheer back of dining chair slipcovers shimmer in this multi-textured dining room. The walls are waxed with a striped finish, and the rug is painted canvas.

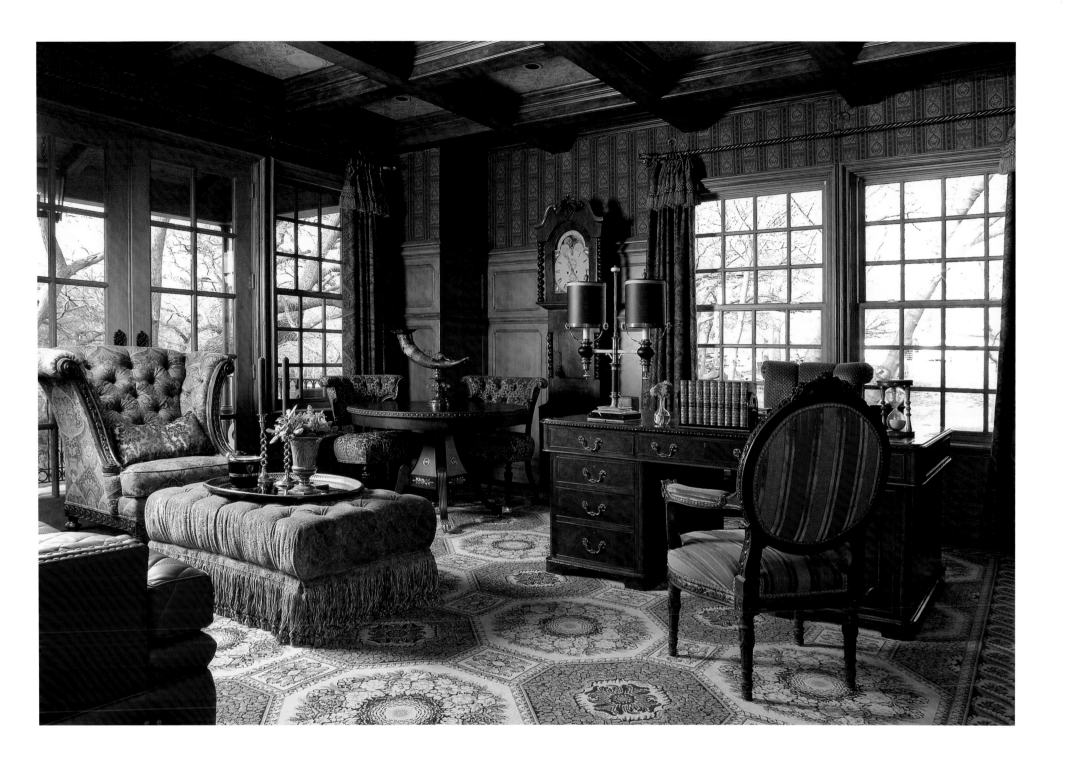

"I was a docent at the Kimball Art Museum for 10 years," Charlotte said. "During that time, I was introduced to a multitude of artists and their paintings." That exposure led to an understanding of the importance of totality. "I would carefully analyze each artist's work, studying their techniques to learn the reasons behind their compositions," she explained. "I came to appreciate and understand how each piece fits perfectly within the whole." Charlotte applies that knowledge to create the cohesive interiors that have not only won her loyal clients; they've earned her numerous accolades.

ABOVE: This ultimate home office has an antique desk, comfortable seating and plenty of natural light.

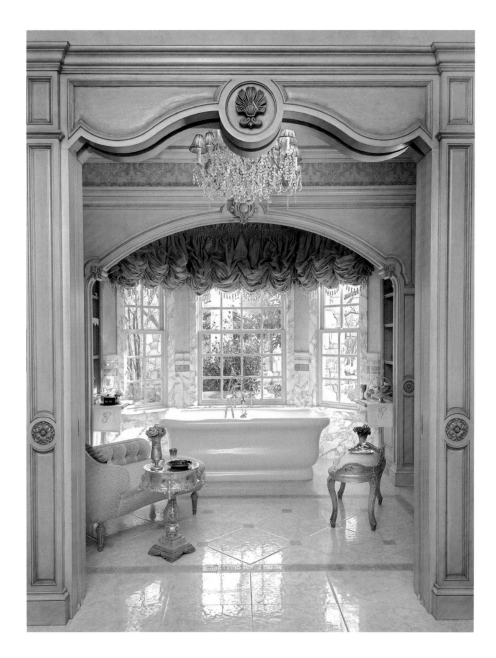

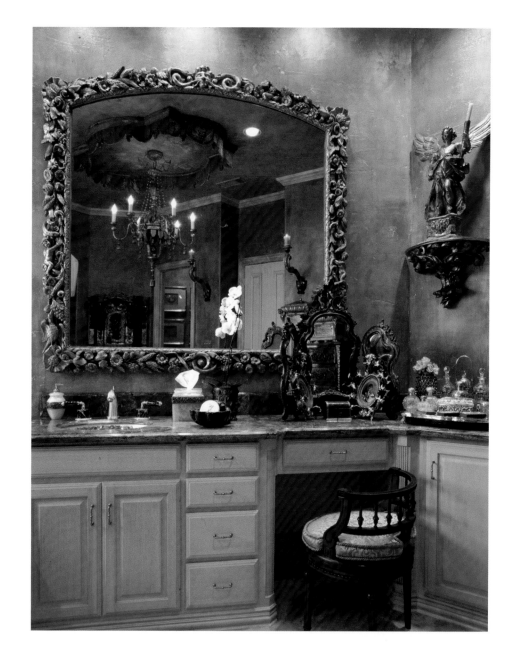

LEFT: Elegant simplicity lives in this beautiful bath with marble tiles, beautiful mill work, antiques and a sensuous tub.

RIGHT: An antique bed canape is reflected in the antique mirror of this elegant bathroom, where all accessories are antique.

The ASID has bestowed Charlotte with several top DesignOvation awards including the 2005 nods for best home office, residential remodel over 3,500 square-feet and best design over $25,000. She's also received three Silver Style awards from *Dallas Home* magazine, and *D Home* magazine declared her one of the best designers in Dallas in 2004 and 2005.

With clients in 13 states, Charlotte's reach extends beyond her base in Dallas. Referrals from satisfied clients generate the bulk of the business for her firm, Charlotte Comer Interiors, Inc. But being featured in noted publications has proven positive for Charlotte's innovative designs. She's enjoyed international recognition for everything from her distinctive color combinations and innovative kitchen designs to her stylish gardens and fashionable bedrooms in magazines like *Veranda, Better Homes and Gardens Special Interests Publications, British House*

& *Gardens, House Beautiful* and *La Mia Casa,* and in the books *Garden Style, Romantic Style* and *Porch and Deck.* Locally, Charlotte's work is a frequent fixture in outlets like *Dallas Home Design, The Dallas Morning News* and *Dallas/Fort Worth House & Home.*

Whenever possible, Charlotte escapes her busy life in Dallas. "I travel the world," she said of her adventures. Whether she's sailing the Mediterranean or exploring the streets of Paris, Charlotte is constantly invigorated by her surroundings. "I'm always searching for fresh ideas for my designs," she said.

While other cultures offer stimulating colors, artwork and architecture, Charlotte's clients are the driving force behind her inspirations. "I look out for my clients' best interests," Charlotte proclaimed. "Their complete happiness is my goal. Even if the process is seamless and the interior stunning, if my clients aren't satisfied, then I've not been successful." ■

LEFT: A bedroom for the little girl in every woman–antique bed linens and faux lace with over painted flowers make this the ultimate girl's bedroom.

RIGHT: The orion bed is trellised with metal flowers blooming with mineral centers. Antique linens float a bed perched on floorcloth with a faux bois planter as a table.

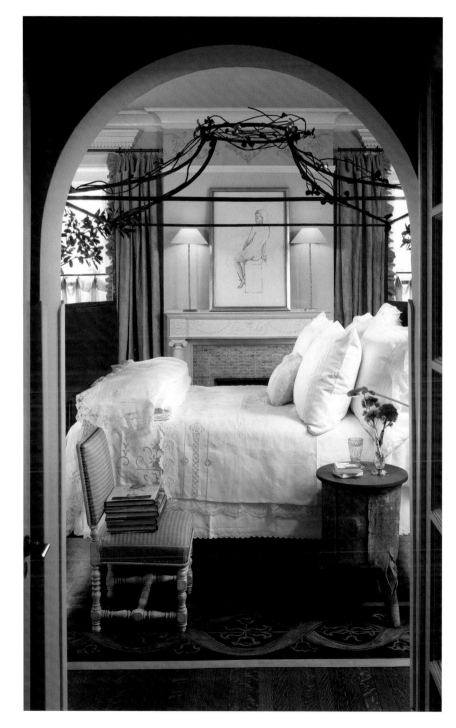

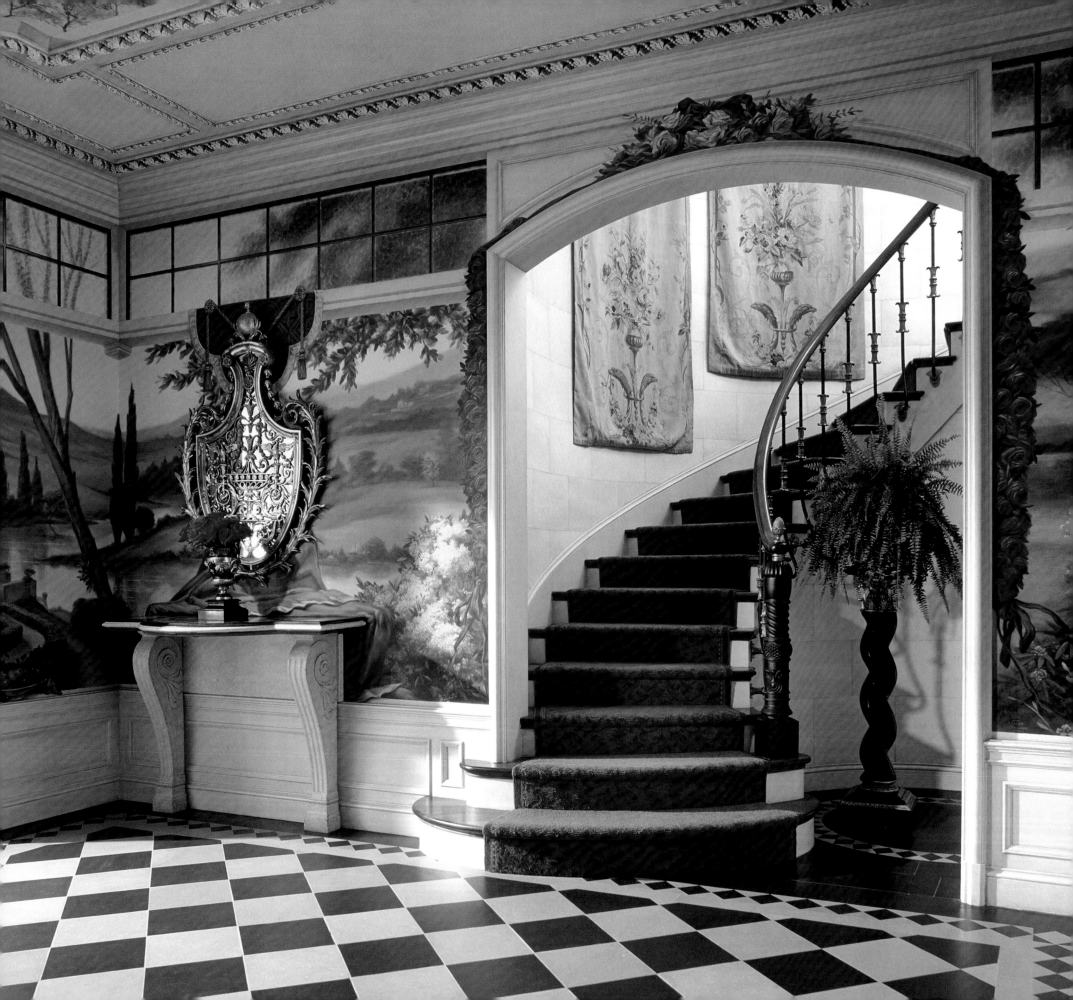

David Corley, ASID

DAVID CORLEY INTERIOR DESIGN

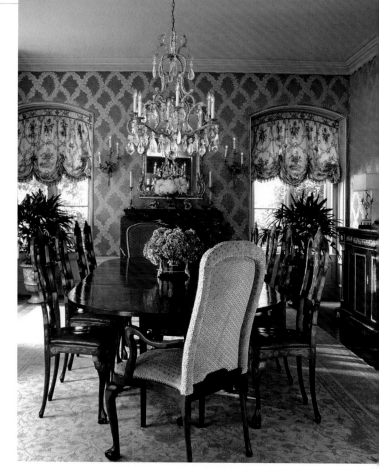

ew designers have left an indelible mark in the world like David Corley. Legendary for his distinctive designs and exquisite taste, Corley enlists his clients' support in the quest for comfort and clarity.

"I seek the input of my clients as to their lifestyles and desires," he explained. "I absorb every detail and envelop it into their designs."

The striking designs for which David Corley Interior Design is known incorporate the classic principles of scale, proportion, color and quality, never excluding the most important ingredient—people. "We design for the people who use the spaces," Corley said. "We put their likes and dislikes first, thus helping them to tastefully develop their own styles."

With the expertise of Julie Stryker and Dawn Bergan, the talented designers who have worked alongside Corley for more than 10 years, the firm provides its clients value by discouraging short-lived trends. "Instead," Corley explained, "we opt for quality and timelessness." The result? Ageless designs that ensure beauty, comfort and function in every room, regardless of the style.

From rustic mountain retreats and small studio apartments to contemporary metropolitan penthouses and sprawling French chateaus, Corley has left his signature around the world. Palm Springs. Los Angeles. Jackson Hole. Santa Fe. Paris. Jalapa, Veracruz. These cities are only a few in the brimming portfolio of David Corley Interior Design.

The acclaimed firm located in the heart of Dallas' Design District primarily focuses on residences, though Corley began his 47-year career in commercial design. "After graduating from Southern Methodist University with a degree in commercial art, I went to work

ABOVE: This elegant dining room has silk wall upholstery by Scalamandre and Clarence House printed taffeta on the windows.

LEFT: This entry in a formal French home showcases a magnificent pastoral mural by Eyecon of Dallas.

BELOW: Julie Stryker, assistant; David Corley, ASID; and Dawn Bergan, ASID.

DAVID CORLEY, ASID
DAVID CORLEY INTERIOR DESIGN
909 DRAGON STREET
DALLAS, TEXAS 75207
214.742.6767

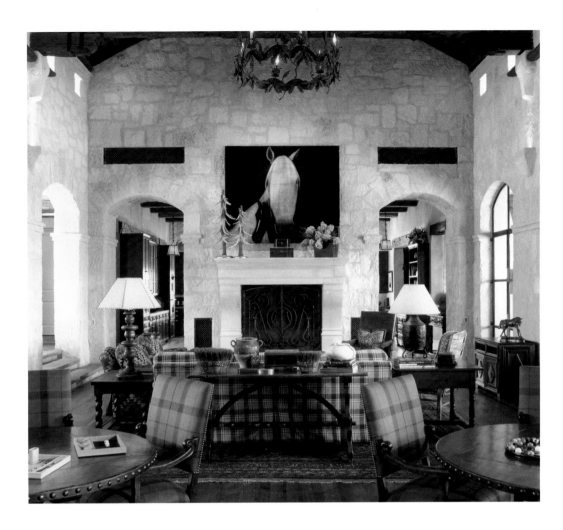

LEFT: The impressive great room of a North Texas ranch features a Joe Ando painting and antiques from Mary Corley Antiques of Santa Fe.

BELOW: This modern living room contains an eye-catching painting by Richard Phillips and a Christain Liaigre occasional chair.

designing executive offices," he said. "Soon those executives started asking me to design their homes." The demand for his distinctive designs quickly grew, so Corley opted to join forces with another area designer to serve the need. The two dressed the nation's finest interiors until they mutually decided to start their own firms in the early '90s.

Corley set up shop in Dallas, where he offers a full line of design services, along with in-house custom furniture finishing and antique restoration. He also owns a highly respected antiques store in Santa Fe, New Mexico, with his wife, Mary. The husband and wife team shop the world for the unique and exquisite in which to fill their store and outfit his designs.

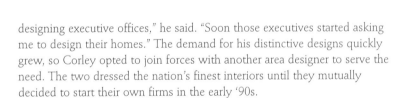

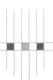

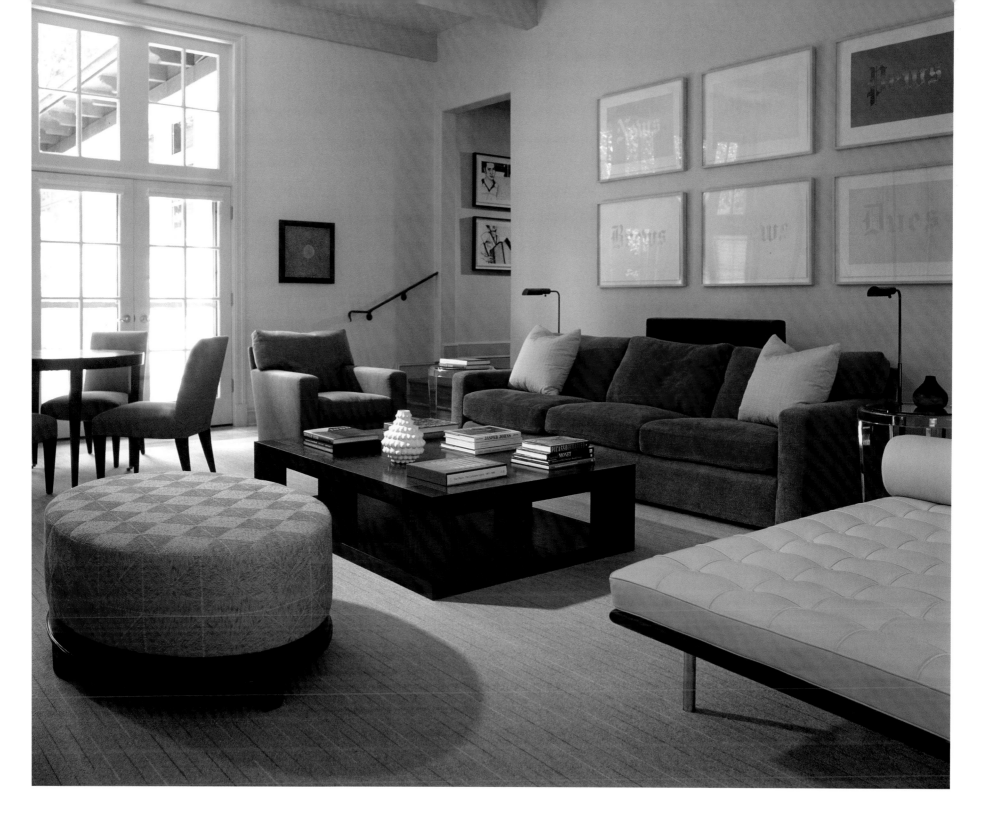

In addition to the European antiques offered in their store, Corley has unparalleled access to fine reproductions, new furnishings and exceptional fabrics. He also has developed lasting relationships with respected artisans, quality suppliers and the best subcontractors. When coupled with his extensive experience and trusted rapport, Corley is poised to tackle any design challenge. "Whether it's new construction or extensive remodeling, traditional styling or contemporary, each project is exciting," he said. "The opportunities for unique design that's tailor-made to the client's needs and expectations are practically endless."

ABOVE: A comfortable, contemporary family room is furnished with A. Rudin upholstery, a Christain Liaigre coffee table and Donghia game table and chairs. It is finished off with art by Ross Bleckner and Ed Ruscha, which is available through Runyon Fine Arts.

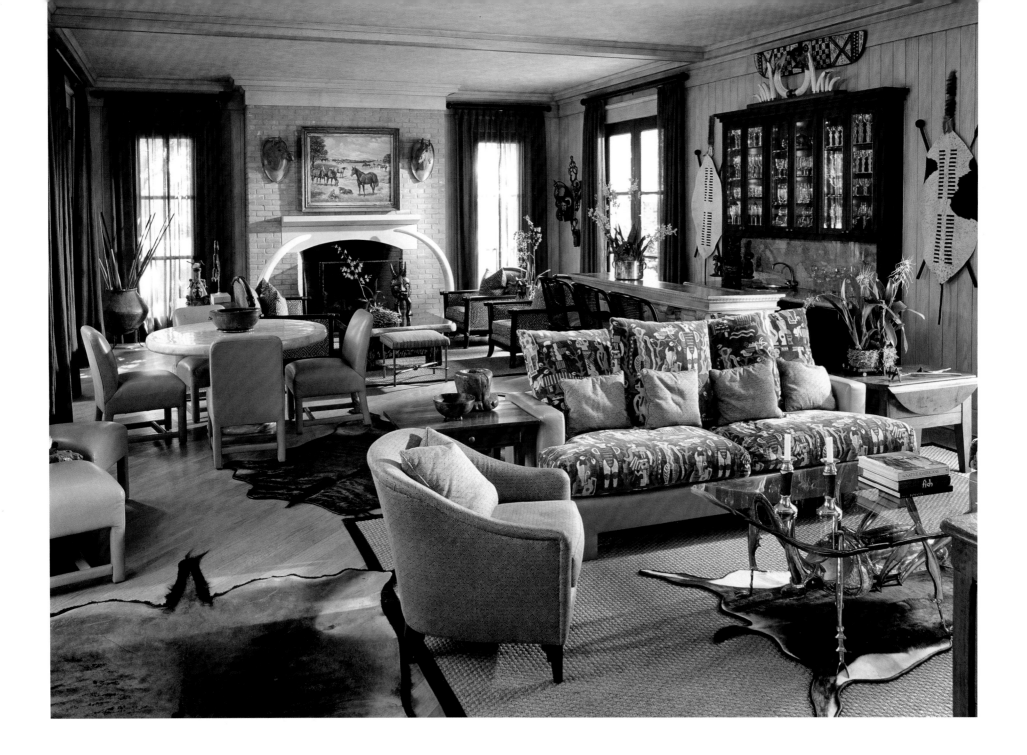

ABOVE: This vast living room was designed to display the client's collection of African artifacts. The sofa was upholstered in Clarence House's Zambezi and the wall and ceiling were finished by Ackermann Studio.

The excellent designs that have earned the renowned designer critical acclaim are well-documented. From periodicals to television, his reach extends beyond the boundaries of Dallas-Fort Worth. *Architectural Digest. Southern Accents. Paris Vogue. Designing Texas.* These are an abbreviated list from an impressive resume that includes a showering of industry accolades from organizations like the Fort Worth Historical Society, *Who's Who in Interior Design* and *Architectural Digest's* "The AD 100," where in 1990 he was noted as one of the world's finest interior designers.

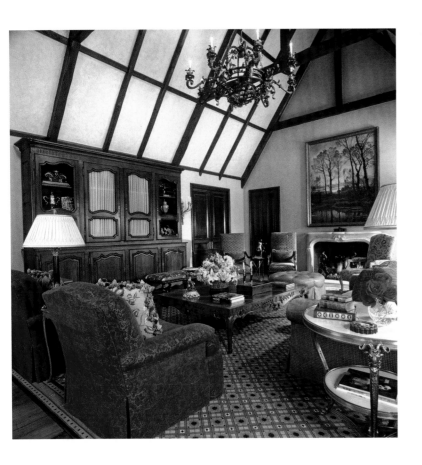

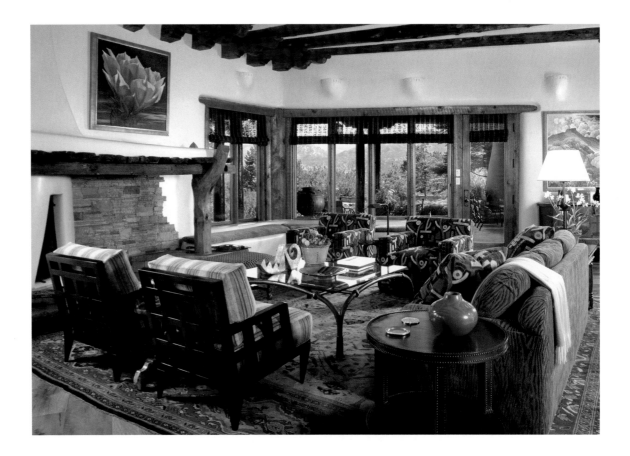

Corley, who quietly appreciates the applause for his body of work, continues to leave his mark in sophisticated residences across the nation. And with such reach, one might conclude that the designer who has touched many lives through his eye for the extraordinary may have lost sight of what's important. Not true. Corley remains rooted in the foundation that has led to his continued success: extraordinary designs, personalized interiors and respect for clients. ■

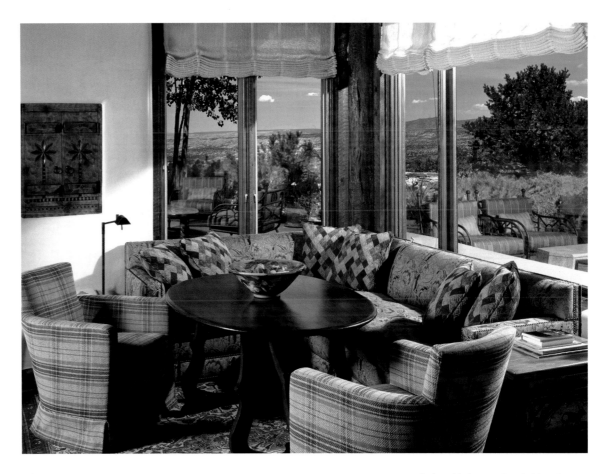

TOP LEFT: This warm, traditional family room has comfortable seating by Stark Carpet's Cameron Collection, art and antique furniture from Mary Corley Antiques and a chandelier from Naos Forge.

TOP RIGHT: This Santa Fe living room has modern Berman Rosetti chairs sitting atop a beautiful, antique Sultanabad rug from Farzin Rugs of Dallas. Clarence House's Velours Klee on Cameron Collection chairs blends perfectly with art by Ed Mell.

BOTTOM RIGHT: A room with a view, this Santa Fe breakfast area mixes Cowtain & Tout fabric on Christain Liaigre chairs with a seventeenth-century French table and an antique Konya rug.

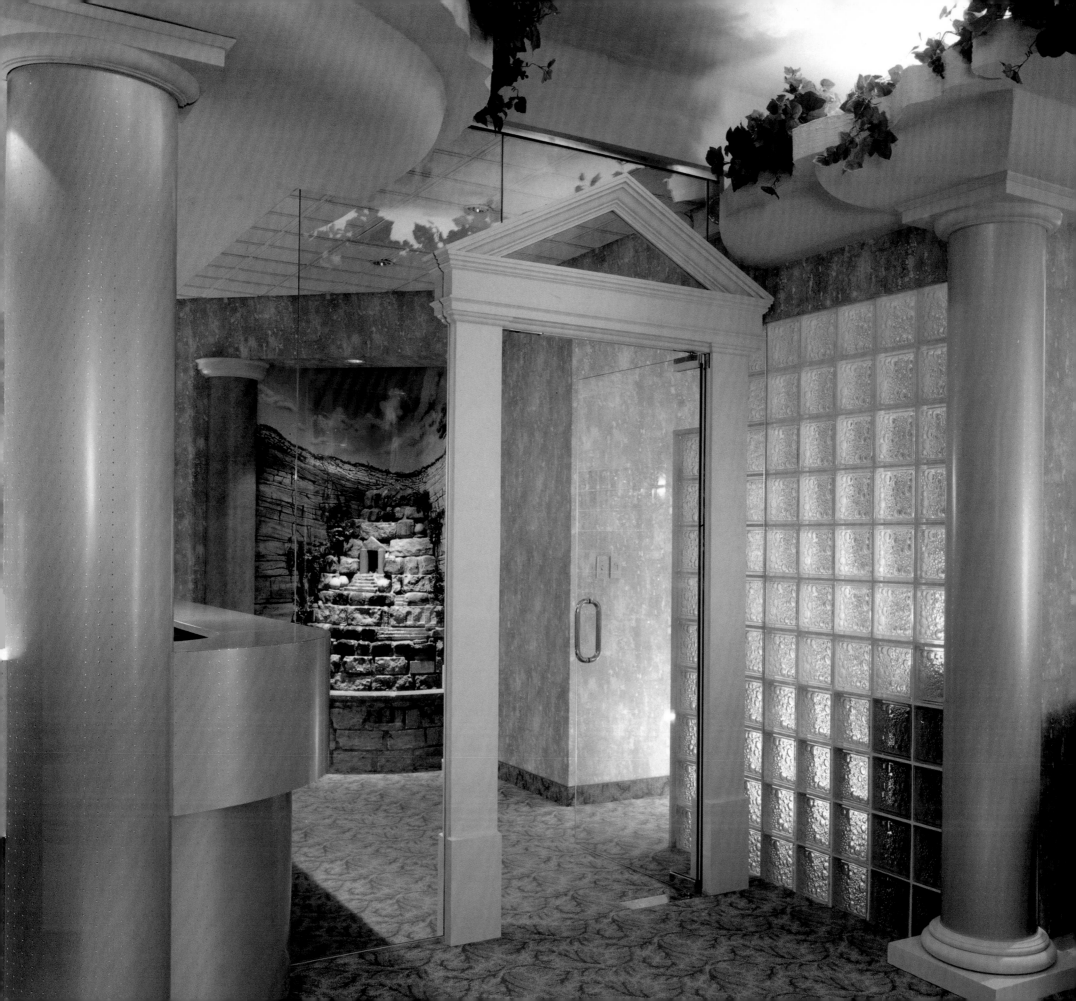

Sher Dye, ASID, Principal
Scott Dye, AIA, NCARB

SHER DYE & ASSOCIATES

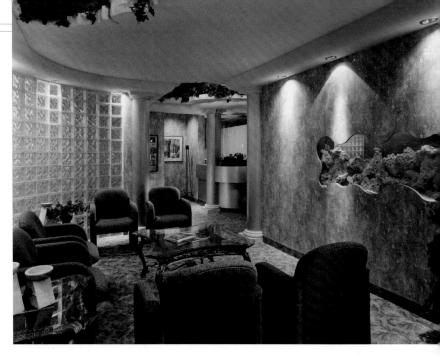

ABOVE: The patients of Drs. Kent Smith and Jeff Roy enjoy the soothing sounds of the large aquarium in the comfortable waiting area of 21st Century Dental.

LEFT: This view greets patients entering the patient clinic area of Drs. Kent Smith and Jeff Roy's 21st Century Dental.

BELOW: Sher Dye and Scott Dye with their beloved Yorkie, Sasha.

Sher Dye and Scott Dye not only share a passion for interior design and architecture; they both believe what Aristotle first penned centuries ago: "Quality is not an act; it is a habit."

Through their firm, SHER DYE & ASSOCIATES, the wife and husband team—along with treasured Yorkie, Sasha—habitually adopts a "quality first" approach with every client. Whether renovating an existing commercial property or constructing a new one, they offer comprehensive end-to-end professional services in the areas of interior design, architecture, programming and planning. Add to that a dose of charisma and an unparalleled work ethic—along with their 34 years of experience in the interior design and architecture industries—and the results are winning.

Founded in 1971, SHER DYE & ASSOCIATES ranks among the top design firms in the nation. Their expansive reach broadly sweeps across the nation in multiple industries like hospitality, health care, retail, corporate and transportation. Retail stores, children's hospitals, airline terminals, restaurants, jewelry stores, country clubs, corporate headquarters and military exchanges are but a few of the award-winning projects that fill the pages of the noted firm's portfolio.

Numerous publications have featured the Dyes' body of work including *Architectural Record, Dallas Design Guide, Texas Architect, Designers West, Form and Function, Doctor of Dentistry* and *D Magazine*. And industry giants have bestowed them with several accolades including the ASID First-Place Corporate Design Award, the ASID First-Place Healthcare Design Award, the AIA Citation Award, the AGC Summit Award, the Pittsburgh Corning Design Circle Award and the USG Interiors Outstanding Project Award.

SHER DYE, ASID, PRINCIPAL
SCOTT DYE, AIA, NCARB
SHER DYE & ASSOCIATES
5580 PETERSON LANE, SUITE 100
DALLAS, TEXAS 75240
972.934.9001

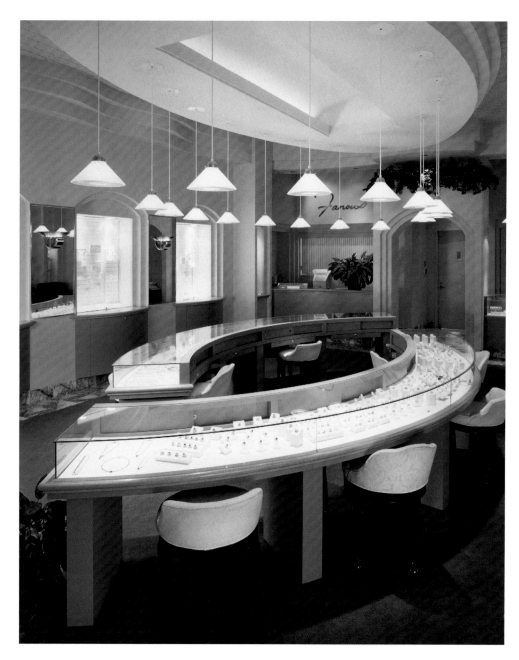

LEFT: The showroom of Fanous Jewelers, owned by Sam and Emil Fanous, envelopes shoppers in luxury.

RIGHT: The entrance to Sam and Emil Fanous' store, Fanous Jewelers, warmly welcomes customers.

Recognition for their efforts is appreciated, but the real reward comes from a job well done says Sher. "We don't pursue projects, but clients. We strive for lasting professional relationships where trust and candor come naturally, thereby eliminating the issues that can arise in large, lengthy projects."

Sher is an energetic "people-person" who easily conceptualizes interiors and expertly dresses them. Regardless of the style—which ranges from traditional to soft contemporary and everything in between—she applies her more than 30 years' design experience to create timeless, not trendy, interiors. "I take my cue from my clients," Sher said. "They have an idea of what they want. It's my job to understand their goals, then with a creative eye and professional flair, design a lasting interior that meets—and often exceeds—their expectations."

Scott, a registered architect, is the self-professed "nuts-and-bolts guy" in the firm. With more than 30 years' experience in construction management and architectural services and with considerable expertise in material uses, construction techniques, scheduling and budgeting, he aptly serves the firm as the chief architect who develops Sher's design concepts, manages projects and executes plans during construction.

TOP LEFT: The Acton Center for Pediatric Dentistry at Children's Medical Center of Dallas won an ASID First-Place Healthcare Design Award. This view shows the entrance to the clinic.

BOTTOM LEFT: This view of the award-winning Acton Center for Pediatric Dentistry at Children's Medical Center of Dallas features the clinic that Kathy Harper, PM, managed during construction.

BOTTOM RIGHT: This view shows the entrance to Nautilus Investments, LTD, office of Richard and Donna Fishel. This design won an ASID First-Place Corporate Design Award.

TOP LEFT: This view shows the entrance to the former office of Scott Dye Architects. This design won an AIA Merit Design Award.

TOP RIGHT: The colorful Plastic and Craniofacial Surgery offices at Children's Medical Center of Dallas waiting room. Kathy Harper, project manager of construction. This also won an AGC Summit Award.

BOTTOM LEFT: The simple, yet stunning, lobby of the former office of Scott Dye Architects was an AIA Merit Design Award winner.

Both Sher and Scott are committed to their professions and believe that their investment in industry organizations is time well spent. Sher, principal and registered interior designer for the firm she founded, is a member of the American Society of Interior Designers, Texas Association for Interior Designers, Dallas Association of the ASID and is a leader in the ASID, having served as chair of the Dallas Association of the ASID and as representative to the national ASID board. Scott is a member of the American Institute of Architects, the National Council of Architectural Registration Boards, the Dallas Institute of Architects and the Texas Society of Architects.

While the pair is appreciated for their contributions to their respective professional organizations, they are admired for their designs and respected for their integrity. Abiding by the mantra, "The extra mile is on our regular route," they approach each project with vigor from concept through completion—uncovering needs, exploring and evaluating options and applying a high degree of creativity and ingenuity until their client's goals are met.

"We're not satisfied until our clients are smiling," declared Sher whose innovative designs are legendary. "After all, we design for them, not us. Everything we do, from drawing the initial plans to applying the finishing touches, is for our clients. To them, our services are priceless!" ■

TOP LEFT: This lobby at the American Airlines city ticket office features a glass-block entrance with special lighting.

TOP RIGHT: Southwest Airlines' departure lounge at Gate Six in the Love Field Airport in Dallas received the *Form & Function* Magazine Outstanding Project Award and the Pittsburg Corning Design Circle Award.

BOTTOM LEFT: Evidence of the Dyes' innovative designs are seen across the nation in the American Airlines city ticket offices.

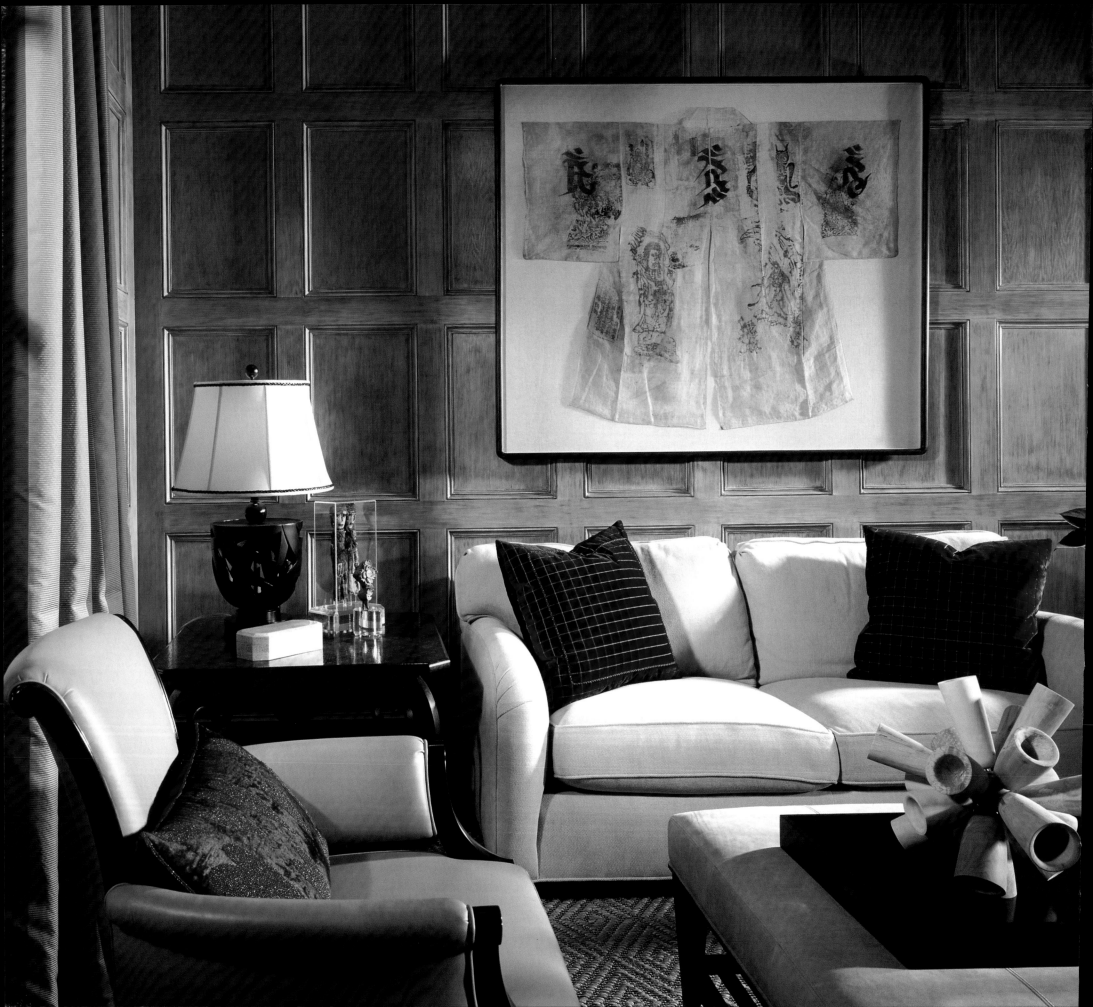

Sherry Hayslip, ASID, IIDA

HAYSLIP DESIGN ASSOCIATES, INC.

ABOVE: Blonde wood glows against the polished steel appliances in this elegant contemporary kitchen.

LEFT: An antique Japanese Pilgrim's Robe hovers over a sand-textured sofa, warmed with crimson accents in this simple, but inviting, study.

Dallas-based designer Sherry Hayslip is enjoying successes reserved for the world's finest interior designers.

In 2004, Sherry received the prestigious Andrew Martin Award and was published in the *Andrew Martin International Interior Design Review,* a renowned listing of the best interior designers in the world—an honor only realized by a handful of Americans. This year, the acclaimed designer was deemed the *House Beautiful/* Chrysler Corporation Interior Design Innovator of the Year. A New York awards dinner found her among the industry's premier professionals. "I was humbled to be in the presence of the country's most respected designers and architects," Sherry said of her experience. "It was amazing to be acknowledged with industry giants whose work I have always admired."

How did this recognized designer who grew up in Dallas land among the stars?

Sherry says that she didn't set out on the interior design path when attending college at Southern Methodist University. "After stretching the whole undergraduate degree out over 12 years, it finally occurred to me that interior design would be a blending of many of my interests in decorative arts, architecture, literature and philosophy." The eternal student with an honors degree in comparative studies and a love for learning traveled to Parsons School of Design in Italy, the Harvard Graduate School of Design, the National Institute of Design and the Cooper Hewitt graduate studies program in Italy to receive formal training in her newly declared career.

SHERRY HAYSLIP, ASID, IIDA
HAYSLIP DESIGN ASSOCIATES, INC.
2604 FAIRMOUNT STREET
DALLAS, TEXAS 75201
214.871.9106
WWW.HAYSLIPDESIGN.COM

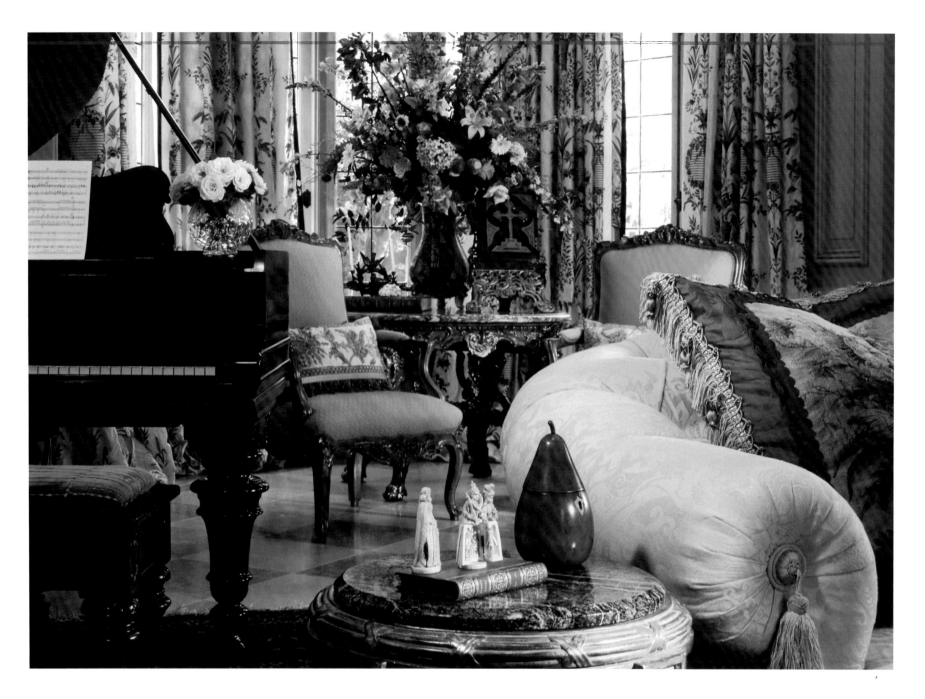

The investment paid off. Sherry Hayslip is now president and principal of Hayslip Design Associates, Inc. one of the largest residential interior design firms in Dallas with a brimming portfolio of homes, hotels, jets, yachts and other interiors for leading figures in the worlds of business, sports and the arts. Since 1976, the team of 16 has tackled every design challenge that has come their way. From palatial estates enveloped in classic trimmings to a tiny, imaginary bunny home in a tree trunk, the award-winning firm approaches each project with passion, heart and talent.

"We embody the unique tastes and values of every client in our designs," Sherry said. "We also involve our clients in all aspects of the project. Doing so enables clients to own their interiors." It also ensures that every stunning setting is refreshingly personal. "With each new project, I try to become a new designer," Sherry said of her approach to her creations. "I step away from preconceived ideas, freeing up the design process to see things with fresh eyes—the client's eyes in most cases."

ABOVE: A deep bay window provides the perfect niche for seating around an antique gilded table softened by flowing silk multi-colored draperies.

RIGHT: In this cozy breakfast area, a butterscotch cat purrs between the chair legs, not quite camouflaged against the brilliantly colored textiles and art.

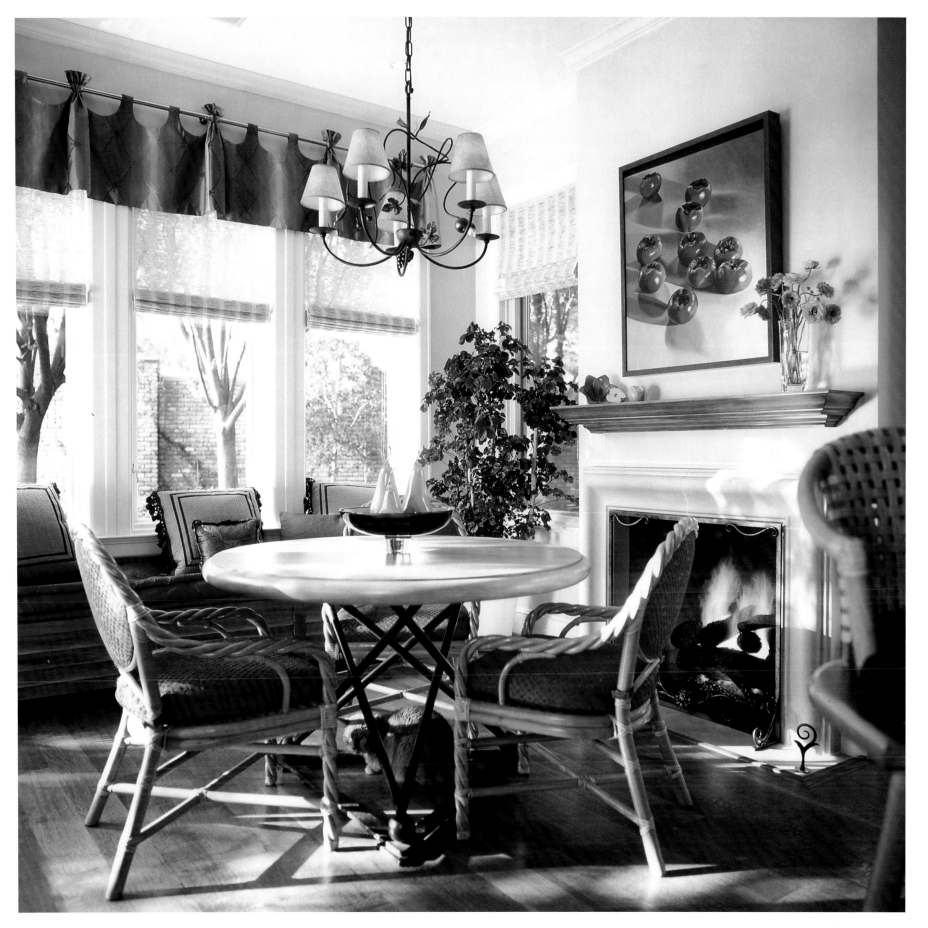

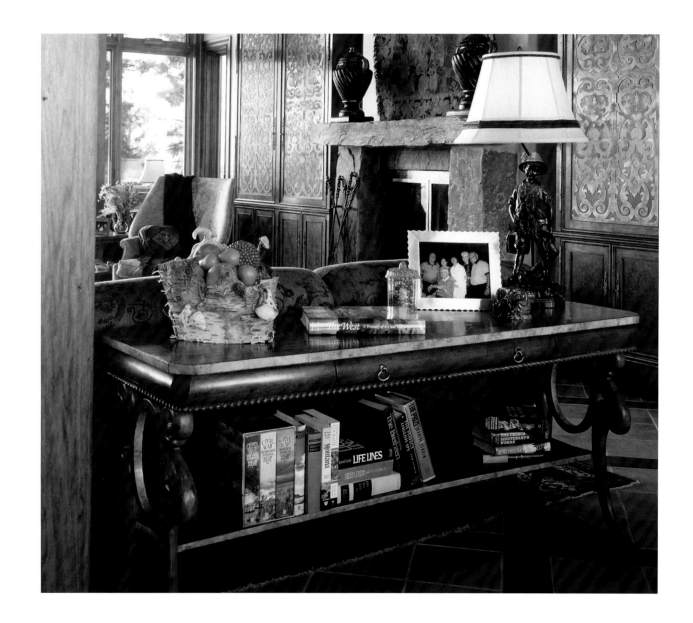

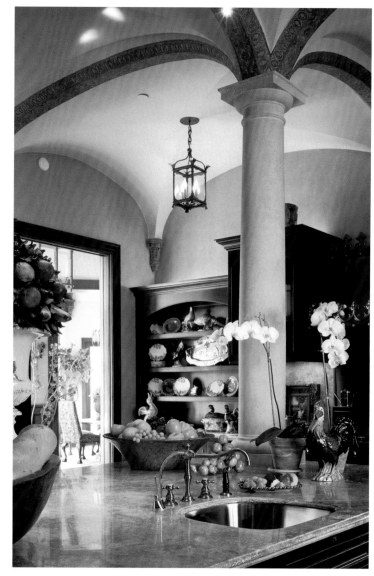

At the heart of Sherry's interiors is a finely honed mix of character and customization. "I weave fine antiques into an artistic blend of utterly new creations of my own design and those of the finest artists and craftsmen," Sherry explained. The result is an exceptional body of work that ranges from Zen-like simplicity to the most layered and voluptuously historic styles.

To envision the stellar spaces for which her firm is sought, Sherry and staff conduct extensive research before committing their thoughts to paper. Doing so ensures that their designs are rooted in authenticity. It also broadens their exposure to other cultures, as does their continuing education in the Unites States, London, Paris, Versailles and Italy. In fact, Sherry strongly believes that ongoing training is critical to her firm's success. "Our clients are accomplished, sophisticated travelers," she explained. "We must stay ahead of global trends and apply innovative solutions using the latest technologies to remain a viable choice for today's savvy consumer."

TOP LEFT: This White Fish, Montana, residence weaves rich woods, patinated aged steel filigree over walnut and natural materials to create a warm ambiance.

TOP RIGHT: In this kitchen, a soaring multiple groin-vaulted ceiling terminates in stone columns, which descend to Turkish gold marble counters.

OPPOSITE PAGE:

LEFT: The scrolling ironwork set into the stained arched entrance door introduces the counterpoint of curving lines and handmade materials in this zero lot line home.

RIGHT: Several small closets and a tiny bath have been combined to create a long barrel-vaulted bath in a 75-year-old home. The gleaming surfaces are enriched with antique furniture.

Her approach has proven positive. More than 100 publications and numerous television programs have featured Sherry or her work, and the renowned firm has more than 30 national and regional awards including a recent *Dallas Home* Design Silver Style Award, several first-place ASID national and regional awards and recent honors for five out of 13 designs at the annual ASID Texas meeting.

Her accolades, along with frequent writings and lectures regarding decorative arts and design, have contributed to the constant demand for Sherry's services on projects like the Dallas Ritz Carlton Residences. But she contributes her firm's success to its valued clientele. "We are only as good as our clients," she said. "And we've been blessed with extraordinary clients and exceptional projects." ■

Robert Preston Henry, ASID

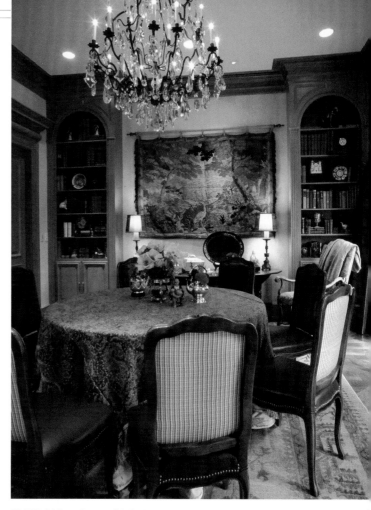

Acclaimed Dallas designer Robert Henry has served clients throughout the state for more than 40 years. From churches and banks to private clubs and homes, he's applied his interior design education from the University of Texas in Austin and the Parsons School of Design in New York City to create award-winning interiors. "My work knows no signature," the respected designer said. "I strive to apply the principles of balance, scale and proportion to create functional designs that work."

To ensure that his designs fit his clients, Henry spends time learning about their needs before devising a plan of action. This successful approach has earned him repeat business and satisfied clients since 1962, when he launched his Dallas practice after working with several leading designers. Specializing in residential and commercial interiors, Robert built a thriving business with the help of several assistant designers, some of whom—notably Deborah Lloyd Forrest, FASID, and John Tarr, ASID—went on to form their own successful firms.

In 1974, Robert moved his offices and family to Weatherford. After completely restoring an 1899 Victorian residence into his office/studio, he specialized in restoration and adaptive reuse. Robert restored many of the historic properties in Weatherford to their proper grandeur, giving them new lives as residences and businesses. For years he redesigned historic properties for his personal and professional use while continuing to create all types of interiors for clients throughout the Dallas-Fort Worth Metroplex.

ROBERT PRESTON HENRY, ASID
6335 W. NORTHWEST HIGHWAY, #712
DALLAS, TEXAS 75225
214.750.8711

LEFT: Attention to detail, such as the pickled-oak bookcases, wall fabric and Italian carved-walnut mantel, makes this Weatherford library a warm and cozy retreat.

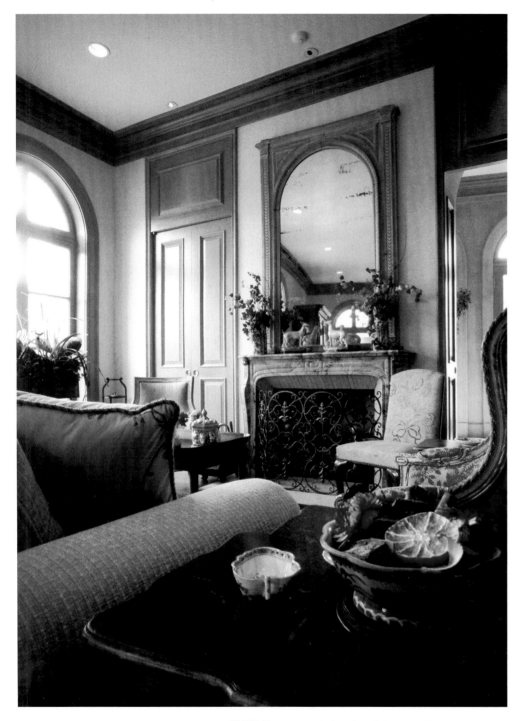

Before moving back to Dallas in 2001, Robert established lasting roots in his community. He served on the first advisory board for Weatherford's Main Street program, he judged interior planning projects for the Parker County 4-H program and he participated in Weatherford College's program for gifted middle school students. Robert also furnished the Weatherford City Hall, and he served as interior designer for the municipal utility building and the new education wing at the South Main Church of Christ, where he served as an elder.

Robert shared his skills for a number of years with noted institutions including the Parker County Heritage Society, where he served two terms as president, and the departmental visiting committee for the Home Economics/Family Studies Department at Abilene Christian University. At his college alma mater, Robert sat on the Textiles, Apparel and Interior Design Liaison Committee of the UT Department of Human Ecology, who in 1993 bestowed him with the respected Community Service Award for Ex-Students.

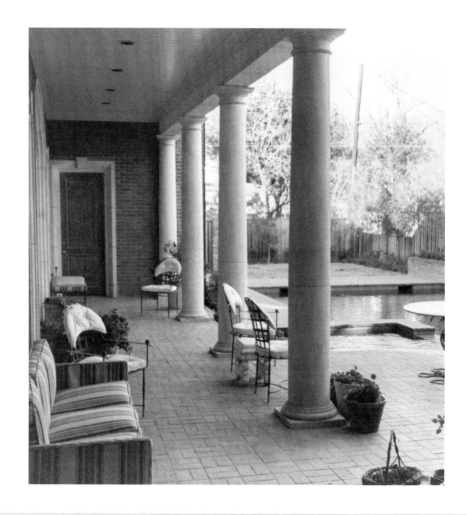

ABOVE: The secret is in the mix: tall doors, marble mantle and exquisite fabrics on traditional furnishings come together with verve in this Dallas Turtle Creek residence.

RIGHT: Casual but elegant, this outdoor poolside loggia in Dallas features limestone columns and iron furniture with emphasis on comfort without sacrificing beauty.

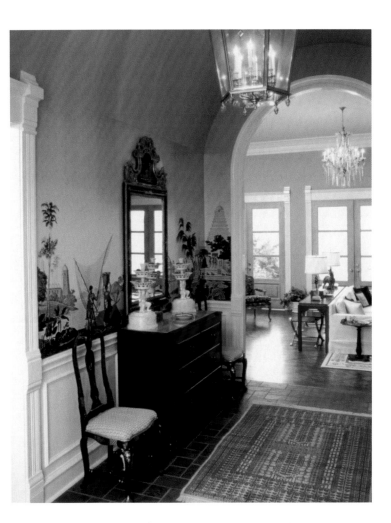

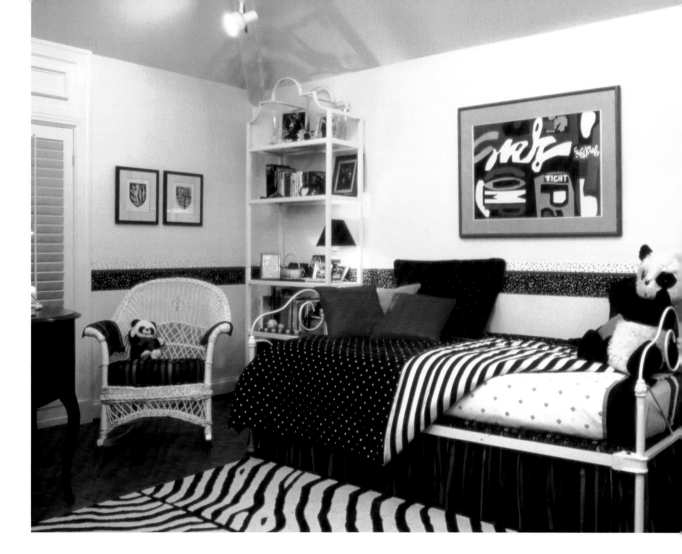

A long-standing member of the ASID, Robert has invested time in the organization that supports his profession. He has held several offices at both the local and state levels including the Texas Chapter positions of treasurer and president. In 1974, he was awarded the ASID Texas Chapter Honor Award, and in 1984, he was honored with the prestigious ASID Texas Chapter Medalist Award. In 2002, Henry received the designation of ASID Life Member. He is only one of two designers in the Texas Chapter holding this honor.

After a rewarding career, Henry has slowed into semi-retirement, though the energetic designer is still in demand by clients across the state. But whenever possible, Henry travels across the globe to places like Scotland, Mexico and South America, where he gathers inspiration and enjoys recreation.

And when his travels return him to his doorstep in Dallas, this designer breathes fresh ideas into the next generation of indelible designs for which he will be remembered. ■

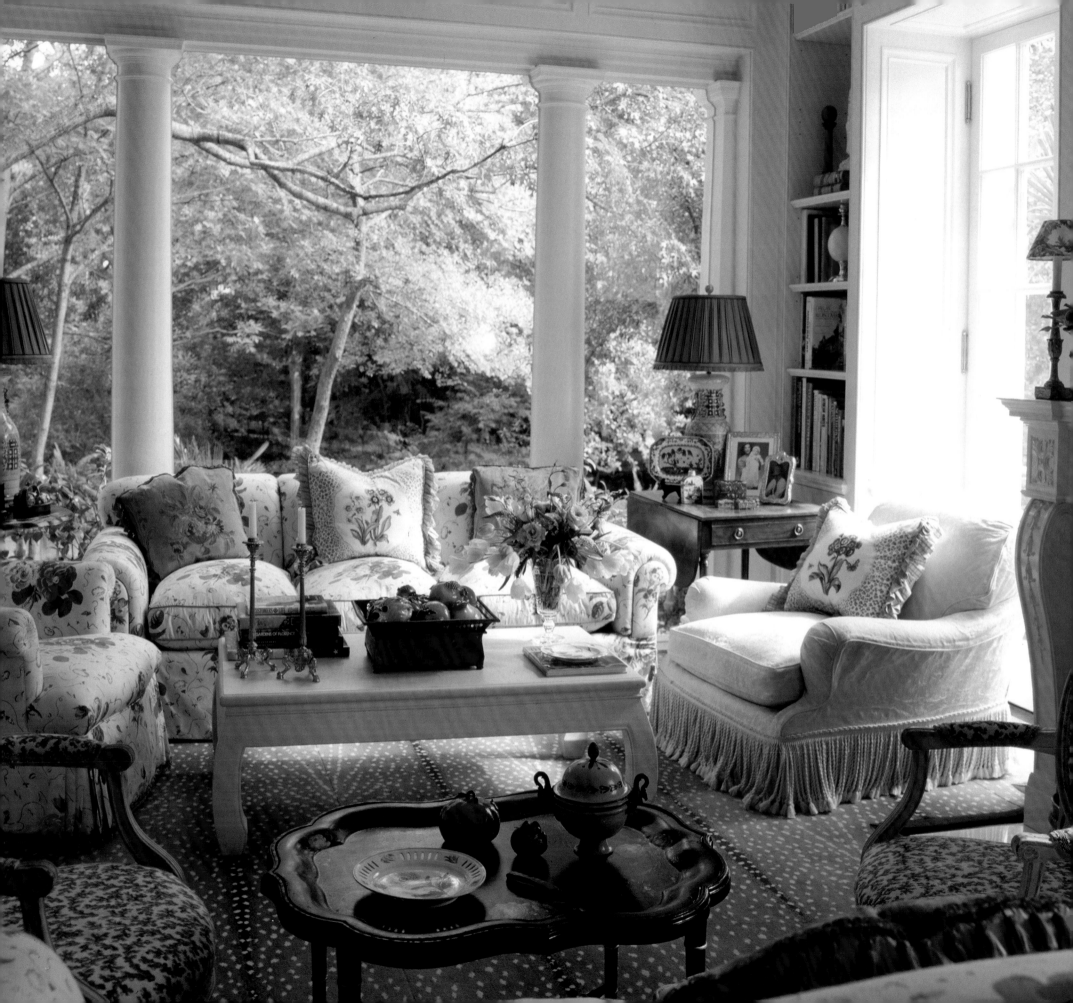

Cathy Kincaid, Allied ASID

CATHY KINCAID INTERIORS

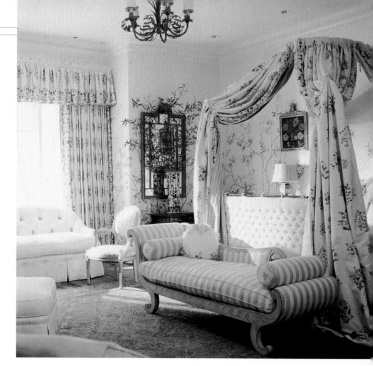

ABOVE: Fabrics from Chelsea Editions Wallpaper by De Gourney, an antique rug from Stark Upholstery's Cameron Collection and John Roselli antiques and light fixture provide a perfect backdrop for this comfortable bedroom, which is expertly finished with a daybed from Patina.

LEFT: A soothing calm in this inviting sitting area styled by Charles Birdsong finds floral carpet by Stark's Colefax & Fowler resting near a chair by Ralph Lauren and the client's collection of antiques and accessories.

Dallas designer Cathy Kincaid of Cathy Kincaid Interiors is known for her "dressmaker details." From drapery treatments with custom-colored fabrics to glazed wallpapers with fabric trims, her designs are rich in distinguishing touches. "I add something unexpected to each interior to keep it fresh," Cathy said of her approach to design. Often that means including an antique. "Whether furniture, porcelains or textiles, I search for an opportunity to add something with history. It grounds a design, adding certain weight or significance."

Although most of her firm's projects are residential, during her more than 30-year career Cathy has designed several law, real estate and doctor offices. But she always comes home to the traditional interiors she loves best. "I prefer to help clients with their houses," she said. "It's rewarding to take them from concept to completion and to see their smiles at the end of a well-run project."

Helping Cathy at her 28-year-old firm are designers Betsy Massey, Barb Kinney, Courtney Lanier, Anne Hillier and Kathleen Shelton. The trusted team tackles projects with aplomb, including a recent *Southern Accents* Showhouse. Theirs was the only firm tasked with the complete design. "We were responsible for every detail, from the color on the walls to the dishes on the tables," commented Cathy of the exhilarating experience. Their success led to a spread in *Southern Accents* magazine and local accolades by *D Home* as one of the "best designers in Dallas," a designation they've enjoyed for the past three years.

Cathy's reach extends beyond Texas, where she's left her signature in nearly every major city. Projects in Pebble Beach, Houston, Austin, Tulsa, Fort Worth and London—just to name a few—bear the colors, quality and tailor-made touches that make her designs distinct. And although the noted firm is busy, they always find time to donate their design skills to a worthy cause. One year a women's shelter benefited from their gift; last year it was a local animal clinic. Cathy says that giving back is "our way of saying thanks for the many successes we've enjoyed." ∎

CATHY KINCAID, ALLIED ASID
CATHY KINCAID INTERIORS
4504 MOCKINGBIRD LANE
DALLAS, TEXAS 75205
214.522.0856

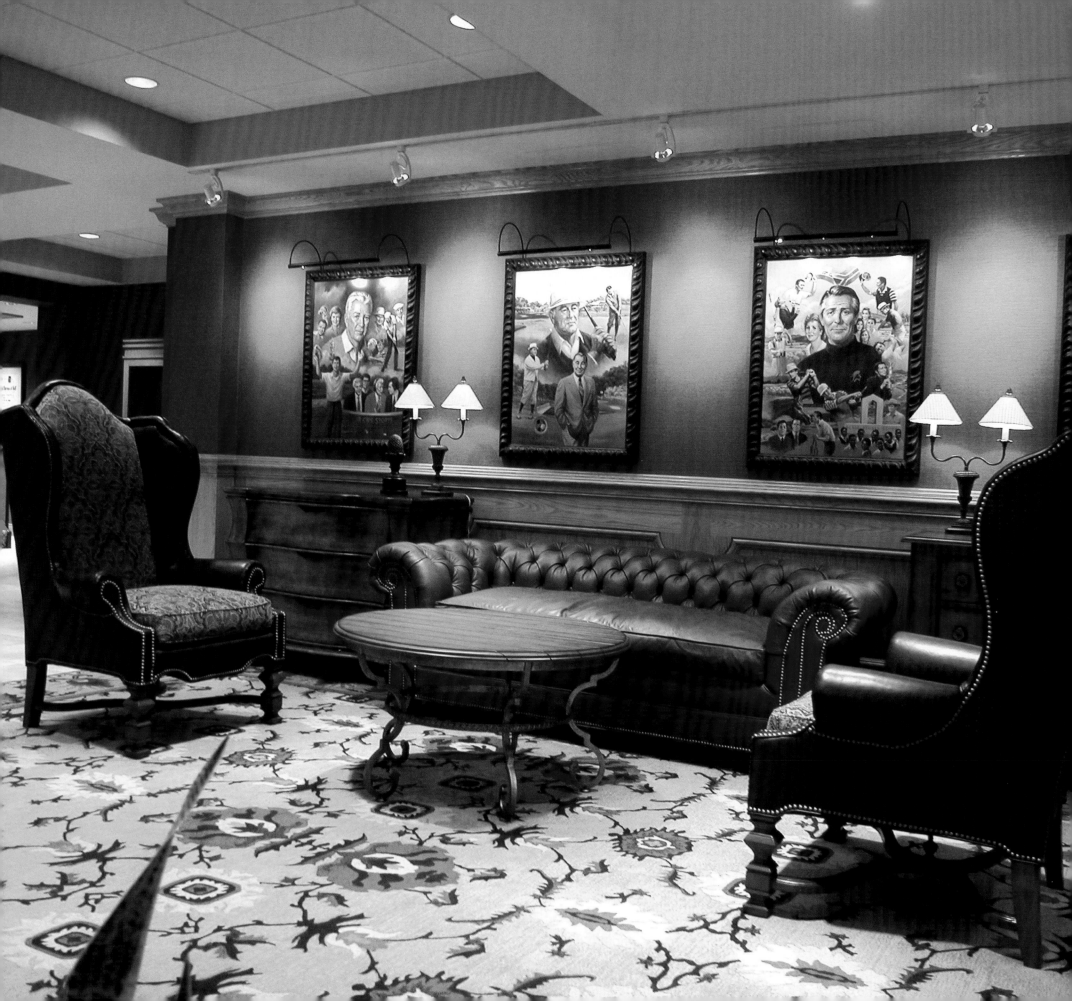

Alisa Kraemer, ASID, IIDA

AKA DESIGN, INC.

ABOVE: White-painted millwork and rumbled travertine tile infuse a sense of regional flavor to the Hilton Oceanfront Resort in Hilton Head, South Carolina.

LEFT: At the Firestone Country Club in Akron, Ohio, large, uniformly framed paintings give rhythm to the space, while the rich background provides each painting with importance.

Designer Alisa Kraemer not only creates award-winning interiors; she provides clients with business solutions through her extensive knowledge of hospitality design.

Relying on her more than 27 years' experience in the hospitality industry, where she's designed interiors for country clubs, business clubs and hotels, Alisa enables her clients to reposition their properties for increased revenue. "Typically my firm, AKA Design, renovates hospitality properties so that they can be repositioned within a market," she explained. "With a diverse staff of two licensed architects, four licensed interior designers and one purchasing specialist, we express an array of talents and a vastness of resources of 'interior architecture' and 'interior character and style' in the execution of our projects."

A respected architect father, an innate talent in art and music and a degree in interior design led Alisa to her chosen profession, where she has received accolades for her notable designs. "Recently my firm won first place in the Hospitality Division of the ASID Design Ovation Competition, and previously I won a top Institute of Business Designers award," she divulged. "Our projects have also been featured in numerous publications."

The Carrollton-based firm that serves clients across the nation has also seen its owner nominated for Woman of the Year by the Network of Executive Women in Hospitality. As a former president of this organization, Alisa has invested quality time leading the industry in which she provides innovative designs.

"We deliver fresh looks that transition spaces into places where people want to gather, live and socialize," Alisa explained. How do she and her trusted staff achieve this goal? "By mixing furnishings and architectural styles, stain colors, finishes and materials into an organic combination of solids and textures, geometric patterns and saturated colors. The result is an impactful contemporary stylization of traditional colors and lines that provide lasting comfort and harmony." ∎

ALISA KRAEMER, ASID, IIDA
AKA DESIGN, INC.
2515 TARPLEY ROAD, SUITE 100
CARROLLTON, TEXAS 75006
972.478.8299

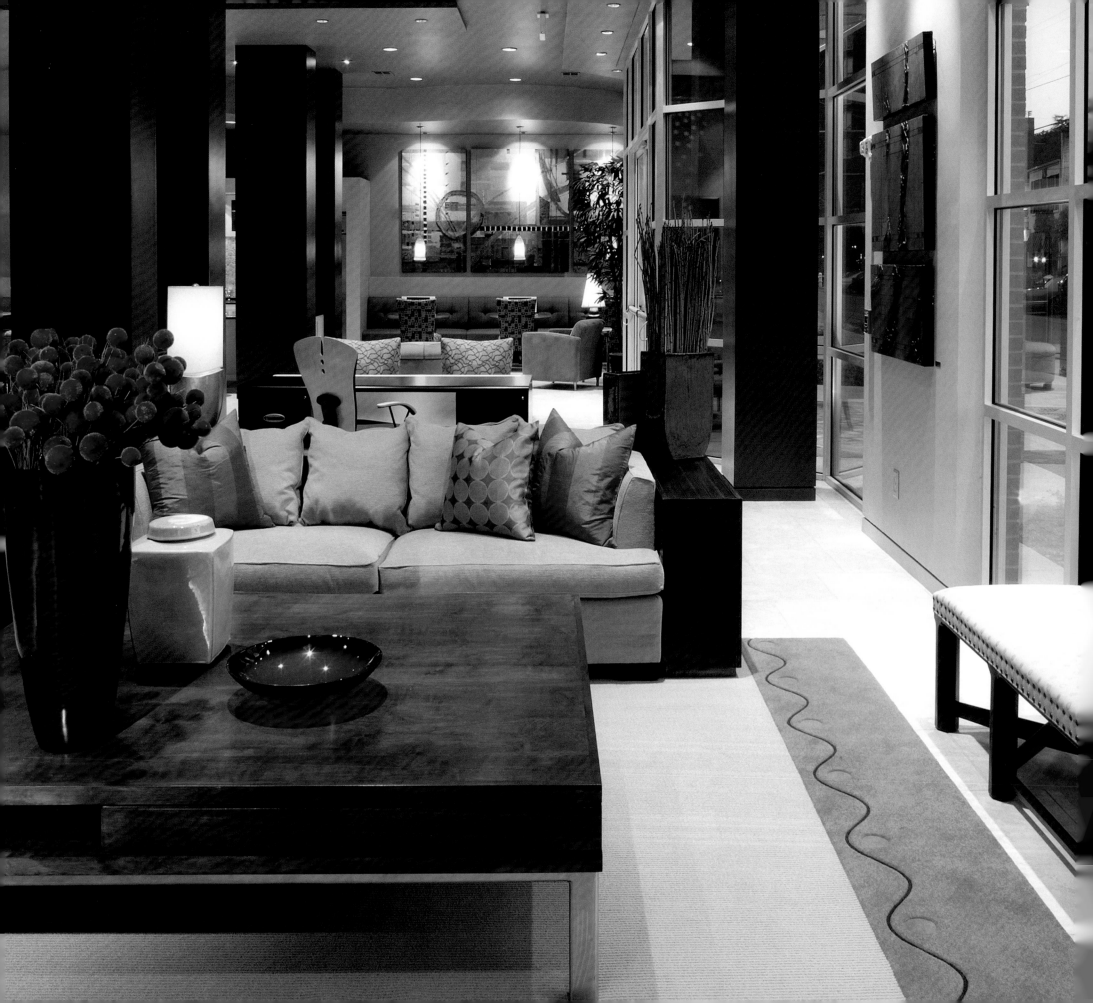

Stephanie Moore, Allied ASID

MOORE DESIGN GROUP, INC.

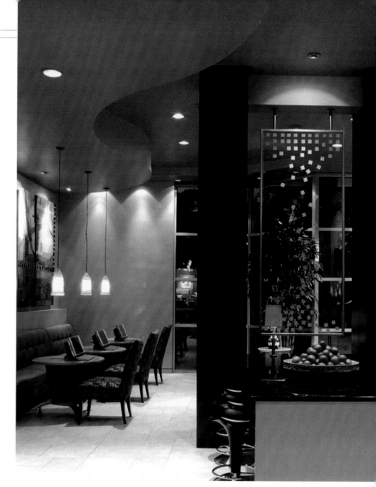

There's a distinct leader in the world of multifamily interior architecture and design.

Stephanie Moore, nationally recognized designer and president of the renowned Moore Design Group in Dallas, has a reputation for excellence that shines in her body of work, including high-rises, mid-rises, mixed-use, urban development and condominiums. Properties across the nation have benefited from the designer's innovative ideas, commitment to quality and unsurpassed design skills. "My staff and I are dedicated to meeting our clients' requirements for budget and delivery while integrating fresh designs that breathe life into any interior," Stephanie said.

The brimming portfolio of the noted design firm includes everything from luxury high-rises in metropolitan settings to mixed-use urban villages in historic downtowns. And while each design is dictated by location and logistics, the possibility for extraordinary interiors is not. "Our limitations are measured by our imaginations," Stephanie explained. "Each interior has its own personality based on its architectural details and geographical surroundings. Our goal is to strike the perfect balance between the desired aesthetic and the functional needs. Then we protect the vision throughout the project to ensure its integrity remains intact."

With a keen sense of space and scale, a sophisticated eye for color, a signature styling of textures and unparalleled access to global resources, the award-winning design team combines the unique and interesting to create the inviting. "Our designs lure people into worlds where dreams become reality," Stephanie said. To welcome discerning residents home to an upscale Dallas high-rise, the lobby was brightened with natural light, anchored by intimate gathering areas and punctuated with commissioned art. In the entertainment area of a Memphis low-rise, the firm invited tenants to socialize by evoking energy through playful colors and integrating the latest technology. With an urban development in historic downtown Austin, the team cleverly melded the old and the new in a modern lobby with retro curves designed to attract hip, young professionals.

ABOVE: Custom-made etched glass panels in a "falling rock" pattern separate the leasing area from the cyber café at the Marquis on McKinney.

LEFT: Four monumental pylons balance the soaring lobby space at the Marquis on McKinney high-rise in Dallas.

STEPHANIE MOORE, ALLIED ASID
MOORE DESIGN GROUP, INC.
2111 CLARK STREET, SUITE A
DALLAS, TEXAS 75204
214.651.7100
WWW.MOOREDESIGNGROUP.NET

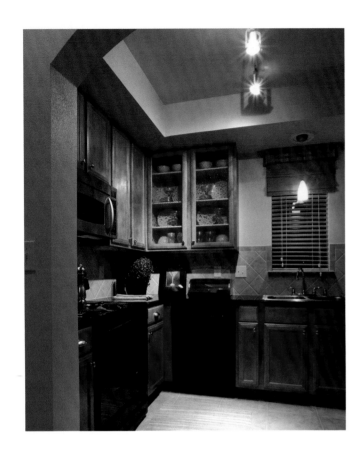

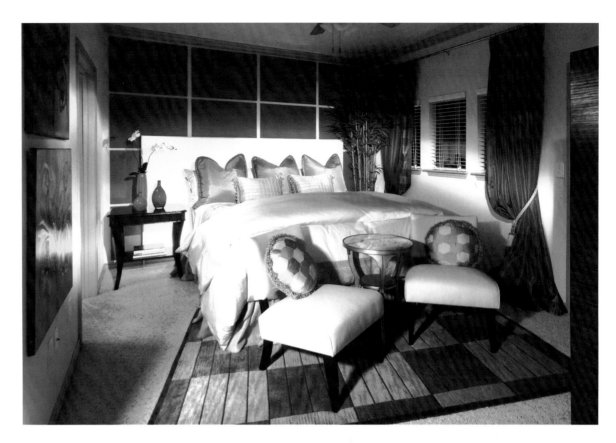

ABOVE LEFT: The warm cherry woodwork draws the eye into this contemporary kitchen in a residential unit at the Estancia Townhomes in Dallas.

ABOVE RIGHT: Applied wall panels are the backdrop for a backlit headboard, one of many rich features that enhances the Kreiss Italian classic bedding in the model unit at the Estancia Townhomes in Dallas.

RIGHT: Reclaimed iron elements from a historic Swiss Avenue home in Dallas are installed as a spectacular wall detail in Bristol on Union in Memphis.

FAR RIGHT: The lobby at Bristol on Union in Memphis features custom furnishings reflecting the edgy sensibility of that city.

To ensure that the entire process in every project is seamless, the firm collaborates with owners, architects and developers during conception, and they proactively engage every member of the project team through completion. This approach—along with Stephanie's extensive background in business management, her strong organizational skills and her almost 15 years' design experience—is a distinct advantage that the firm brings to every project, contributing to repeated successes and numerous accolades.

Legacy Texas Bank has honored Stephanie with the prestigious Leaders Building Legacies award, and her firm has received three National Association of Home Builders (NAHB) Pillars of the Industry awards, several ASID DesignOvation awards, a Legacy of Design award from the Texas chapter of the ASID and a Home Builders Association of Greater Dallas award. Several publications have featured the firm's work including *D Magazine, The Dallas Morning News, The Dallas-Fort Worth Design Guide, Architectural Digest, Southern Accents, Paper City, Multifamily Trends* and *Multifamily News.*

An active member of the ASID and the NAHB, Stephanie is a consummate professional who believes that quality of product should be exceeded only by quality of service. This belief, along with her unbridled passion for design, has earned her firm the impeccable reputation for which it is known within the design community. ■

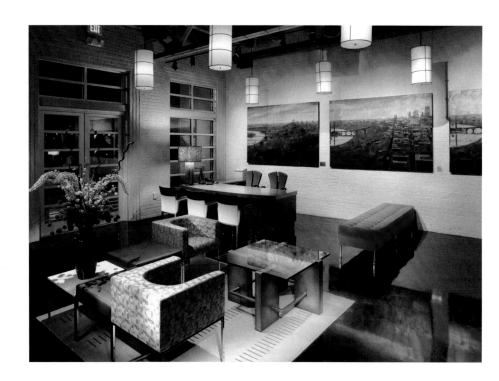

ABOVE RIGHT: The lobby in The Depot, a historic-designated site in Fort Worth, features commissioned art spanning 21 feet, depicting the city in 1870, 1948 and 2005.

BELOW LEFT: The interiors of AMLI Downtown in Austin utilize historic elements from the building that originally stood on the site. An example is this heavy galvanized warehouse door, which serves as a focal point in the lobby.

BELOW RIGHT: The cyber café at AMLI Downtown in Austin showcases Moore Design Group's contemporary flair with a warm and inviting sensibility.

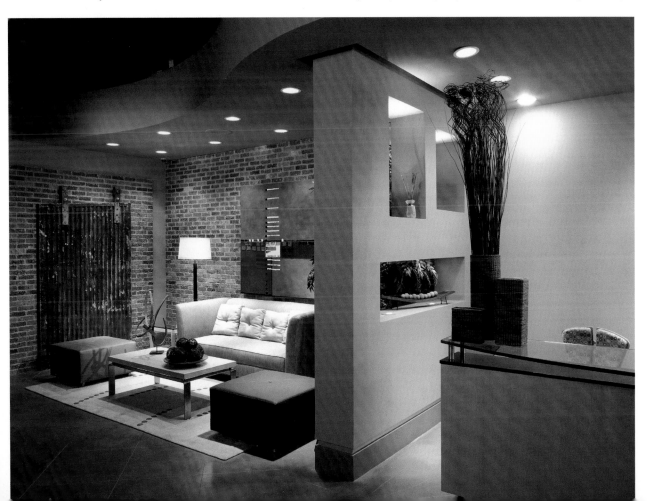

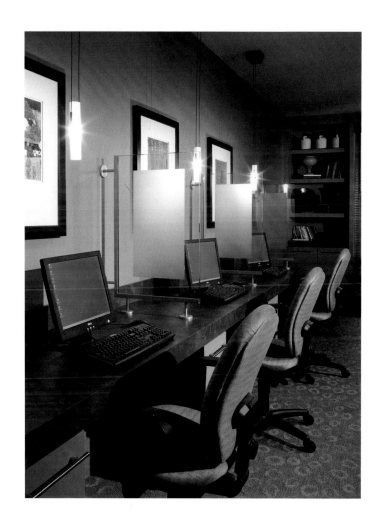

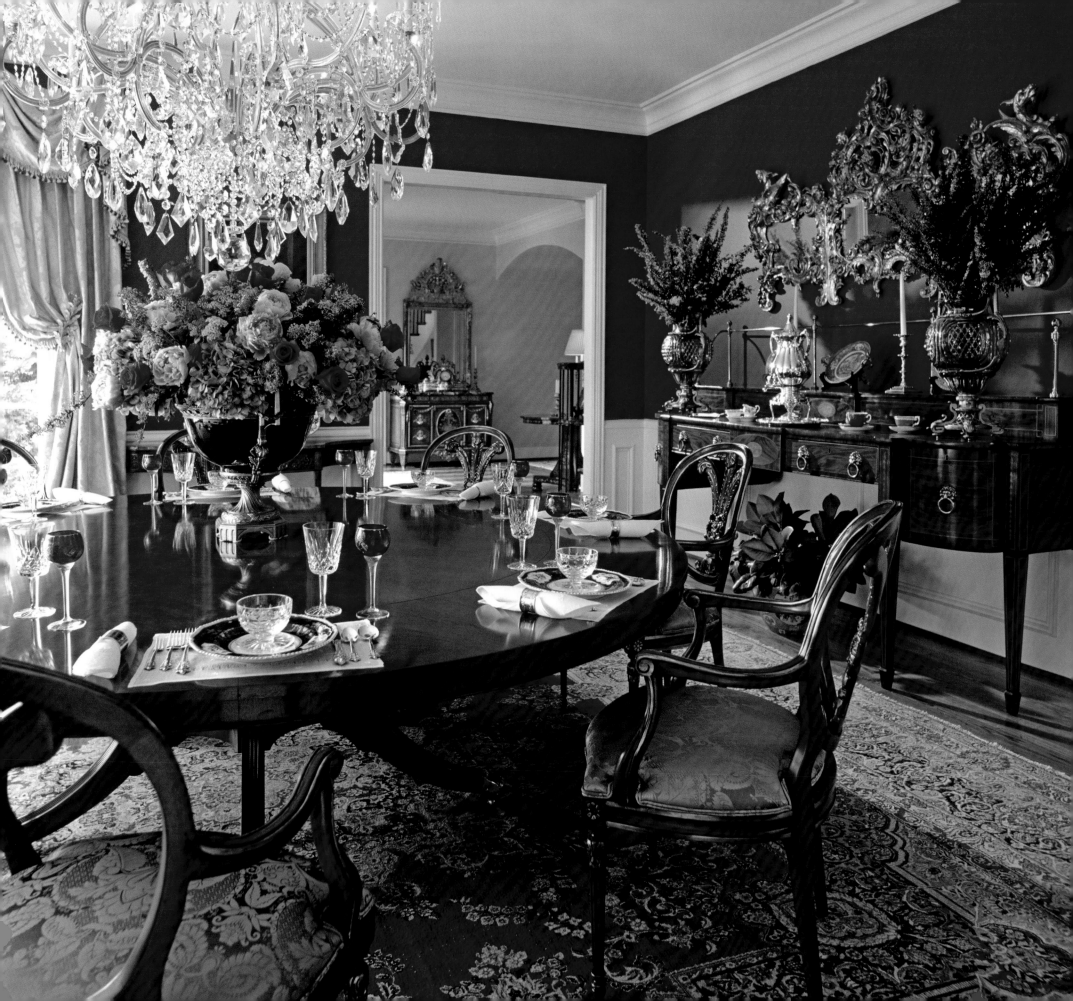

Pat Ratcliff, ASID

THE RATCLIFF COMPANY

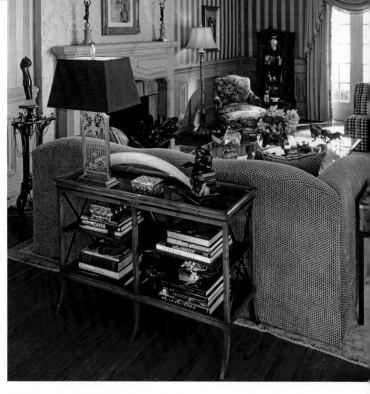

ABOVE: In this historic Dallas home, the living room with silk walls and hand-carved wainscoting provides a pleasing background for the client's impressive art and sculpture collection.

LEFT: Because of their love of entertaining and the combination of color, antiques, fabrics, crystal and flowers, the dining room became the absolute family favorite.

Pat Ratcliff's approach to interior design is simple: "I am beautifying America one room at a time." With traditional homes bearing his mark in Texas and in states like Florida, Michigan, California, New Mexico and Colorado, that statement rings true.

Ratcliff began his trek across the country in Dallas after graduating from the University of Notre Dame. "I designed, managed and purchased for another design firm in Dallas for 22 years before beginning my own company 10 years ago," Ratcliff explained. "Opening The Ratcliff Company in the Park Cities enabled me to personalize my services and provide creative solutions for discriminating homeowners."

Although a portion of his projects are commercial, the bulk of Ratcliff's business is residential. In every design he incorporates the basics of space planning, organization and balance to create neat, functional rooms unique to each client. From handsome studies packed with personal treasures to lively living areas wrapped in rich color, Ratcliff creates comfortable spaces in which people live. Doing so, he says, is fundamental to good design. "My goal is to create rooms that are respectful of a client's personality and lifestyle while meeting their demands for practicality."

So how does he achieve success? By gaining a client's trust. "I forge relationships with every client because I listen to their needs. Then together," he said, "we create common-sense solutions."

Wrap that up with a strong sense of style and a dose of good taste and the result is beautiful interiors that work…no matter where in the country they reside. ■

PAT RATCLIFF, ASID
THE RATCLIFF COMPANY
5956 SHERRY LANE, SUITE 1000
DALLAS, TEXAS 75225
214.368.5548

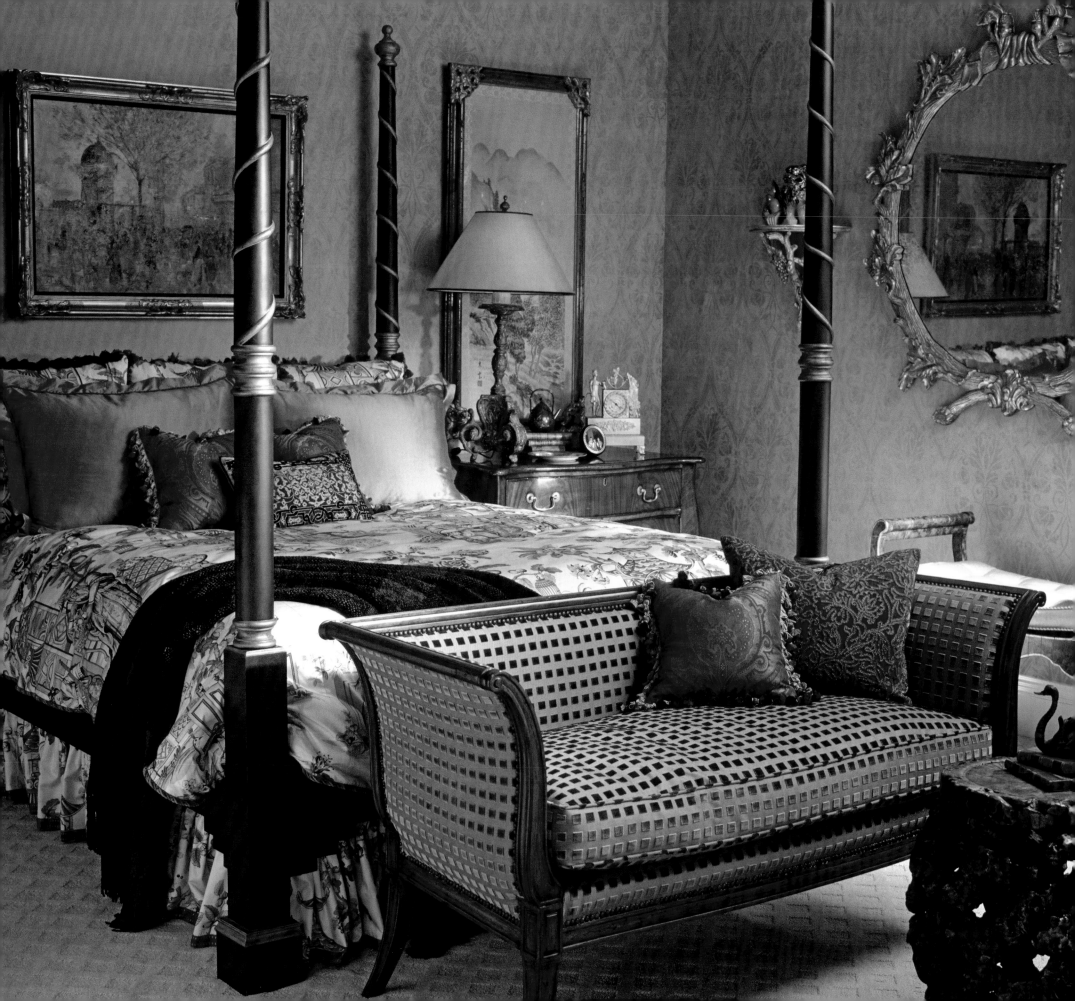

Marilyn Rolnick Tonkon, ASID

MARILYN ROLNICK DESIGN ASSOCIATES, INC.

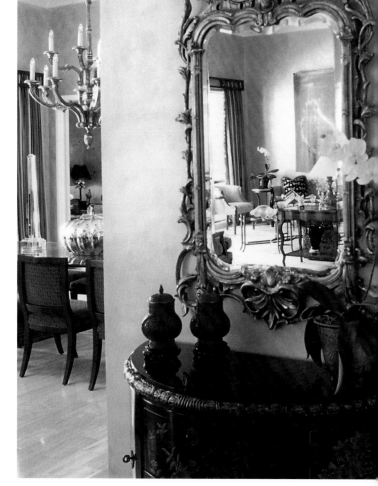

Building relationships. "That's the secret to creating livable interiors," said Marilyn Rolnick Tonkon, a legend among Dallas' top designers.

Marilyn ought to know. For more than 35 years, she's built sound relationships with families and corporations throughout the nation while designing award-winning interiors to suit their unique styles. "I'm actually assisting the third generation of some clients," she confessed.

So how does Marilyn form these lasting bonds? "By carefully listening to my clients' needs. Understanding their lifestyles and tastes enables me to seamlessly develop, detail and execute designs that will stand the test of time."

Although throughout her successful career Marilyn has designed both commercial and residential properties, today she primarily focuses on residences. Her well-crafted visions incorporate the finest fabrics, furniture and accessories to create warm, inviting rooms reflective of the people who live in them. "Always classic and never trendy," her appealing designs also embrace color. Whether boldly splashed on a wall or quietly draped across a sofa, Marilyn insists that color is key to fashioning a room. "I love color. It is mood-reflecting, it gives insight to personality and it is easy to change."

Quality is another essential ingredient to Marilyn's winning formula. "I am adamant about quality," she stressed. "Expensive does not always equal quality. I focus more on the value and the appropriateness of a design piece rather than its cost. It's one aspect of my job to know the difference." Another aspect is to ensure a quality finish. Marilyn tops every room—including the most formal settings—with a whimsical touch. "Humor is requisite; something lighthearted makes a serious room relax."

ABOVE: The Louis XV mirror reflects the living room's Venetian plastered walls and vibrant colors. A peek into the dining room echoes the color palette.

LEFT: The warm, custom-stenciled walls create a stunning envelope for the black-lacquered, four-poster bed, Chinoiserie-patterned bed cover and Georgian beside chests.

MARILYN ROLNICK TONKON, ASID
MARILYN ROLNICK DESIGN ASSOCIATES, INC.
2501 OAK LAWN AVENUE, SUITE 810
DALLAS, TEXAS 75219
214.528.4488
WWW.MARILYNROLNICKDESIGN.COM

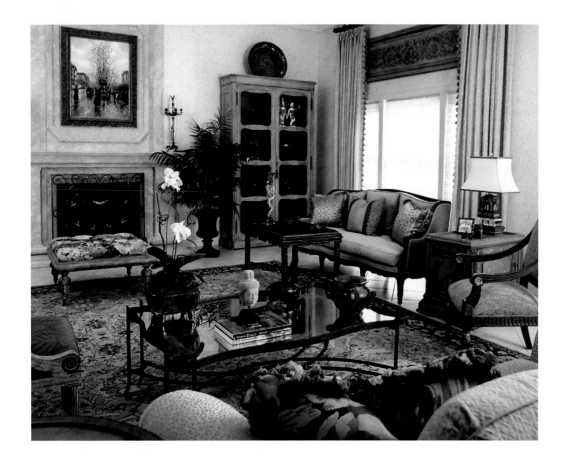

Marilyn attributes her sense of style to her mother, who had exquisite tastes. "She exposed my sister and me to the world of design through the way she artfully displayed beautiful items in our home. I was fascinated by the way things were arranged and constructed, and I knew early on that I wanted to become a designer." Why then did Marilyn attain a degree in psychology from the University of Texas in Austin? "When I attended college there was no interior design program available. And this profession is as much about the people as it is the design."

With an innate ability and the desire to succeed in a field she'd always loved, Marilyn began studying everything she could get her hands on. Soon she amassed a wealth of knowledge that led to her eventual interior design certification and the opening of her own firm, Marilyn Rolnick Design Associates, Inc.

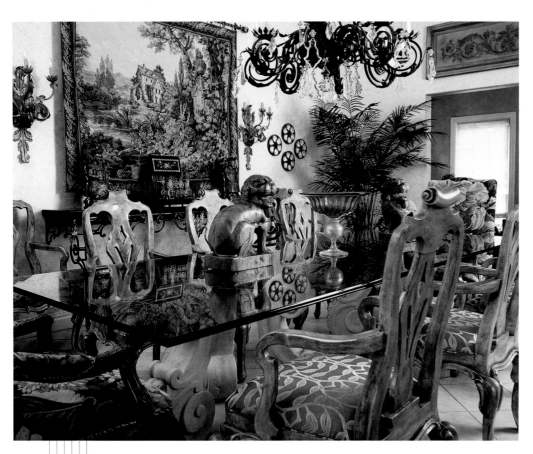

TOP LEFT: Display cabinets flank the fireplace and house a collection of Asian treasurers. The Tabriz rug defines the sitting area.

LEFT: A pair of antique Foo dogs graces a glass-top table supported by stone pedestals. A Belgian tapestry hangs over a custom iron-and-granite console.

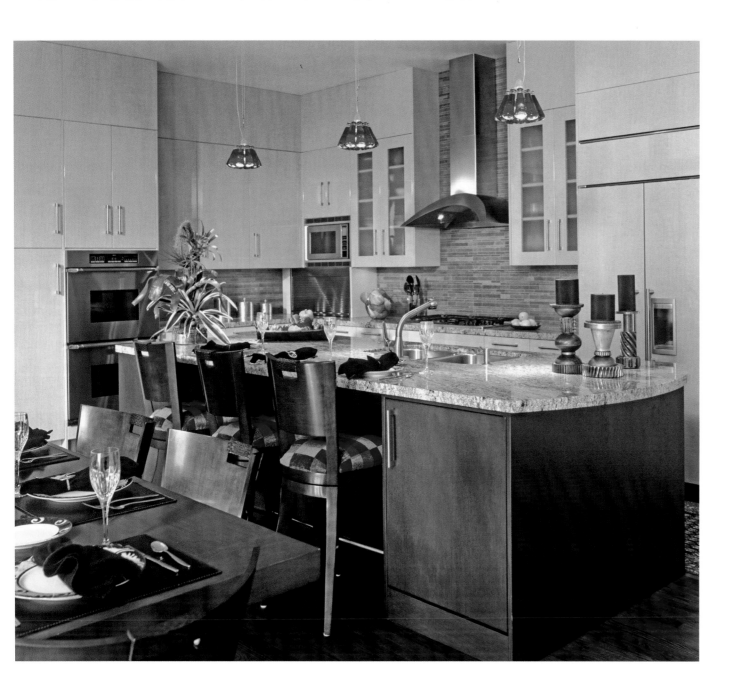

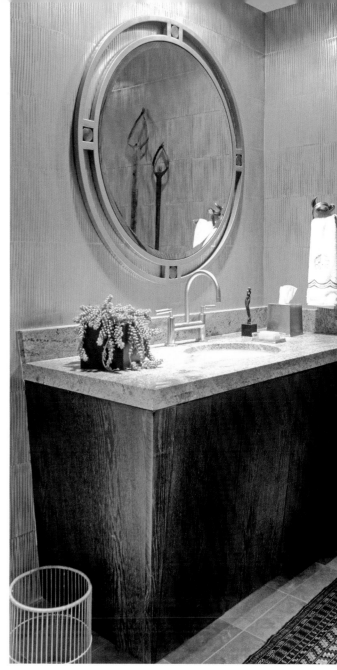

Through her company, Marilyn delivers stunning solutions to sophisticated clients across Texas and the United States, including Los Angeles, La Jolla, New York and Santa Fe. Recognized for her responsiveness and attention to detail, Marilyn and her talented associate Richard A. Gordon approach each project with the firm's guiding principles: quality of product and integrity of design. This proven philosophy has led to top honors by industry organizations and recognition in numerous national magazines. But more importantly, it has secured the valued relationships upon which Marilyn's trusted firm is solidly built. ■

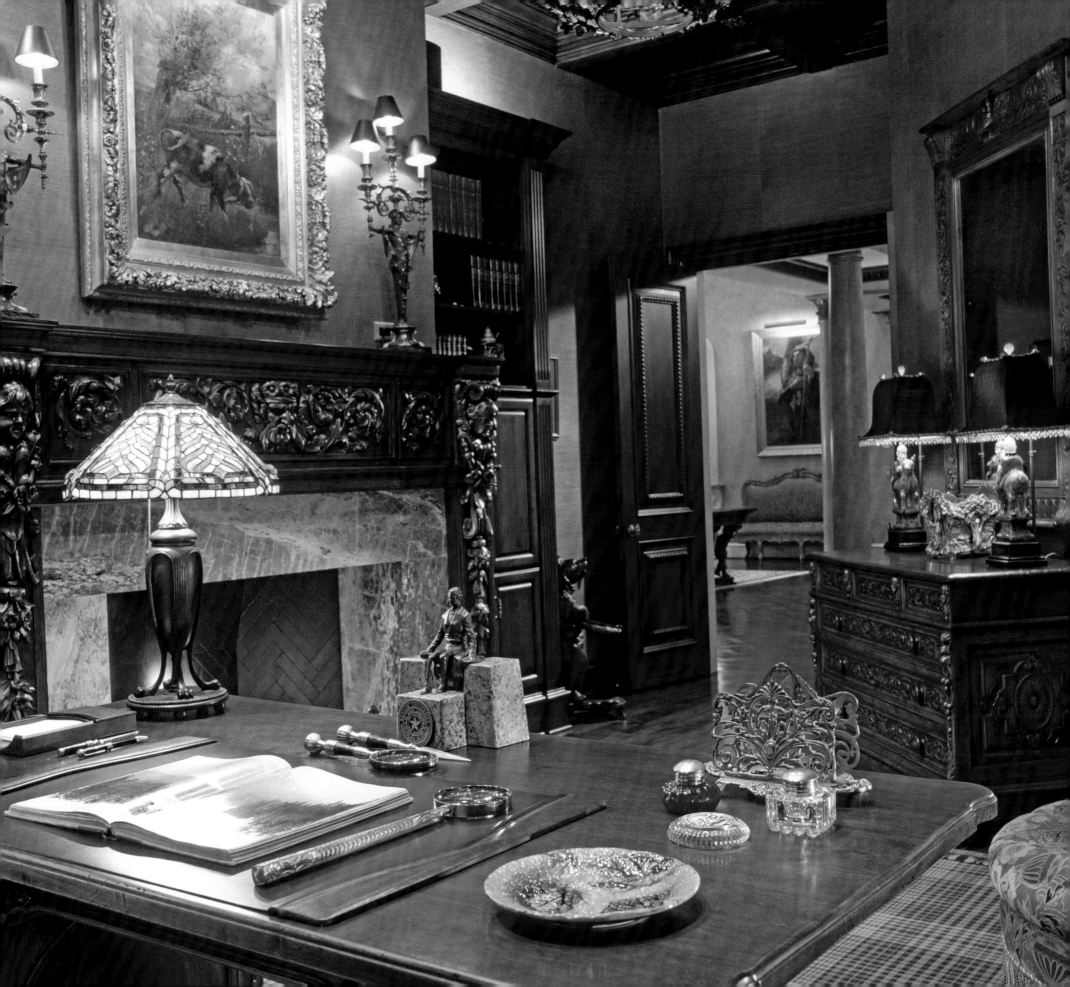

David Salem, ASID
Lolly Lupton, Allied ASID

SALEM AND ASSOCIATES

An abundance of work brought designers David Salem and Lolly Lupton together. But mutual respect, complementary design styles and a growing family of clientele has kept this charismatic team with more than 50 years' experience together.

David, one of four creative siblings whose talents range from screen writing to television image consulting, opened David Salem Interiors in 1986 after arriving in the world of interior design by way of art school. An artist who was drawn to all elements of design, David couldn't decide on one specific medium in which to specialize. Then he discovered interior design. "It combines all the things I love in art—color, form and composition."

In 1991, David enlisted the help of designer Lolly Lupton to assist with his growing number of projects. She and David had crossed paths for years, meeting first at a furniture showroom owned by Lolly. David, her customer, enjoyed a business association with Lolly until she closed her company in 1990 and returned to her first love, interior design.

David's business began to soar, prompting his plea for help from the gregarious designer. The talented team with similar tastes and views rolled up their sleeves and began tackling a myriad of projects from Texas to Arizona, Colorado to Florida. In 1996, the two designers officially became partners, prompting a change in the firm's name to Salem and Associates.

Today, David primarily handles clients from their base in Dallas, while Lolly splits her time between the Dallas and Waco offices—which is fine with her since she began her career in the central Texas town. "I grew up in Waco, where all through high school I worked at Braswell-Davis, an interior design studio," she explained. "Upon graduation, I trained at

ABOVE: The Cat's Meow. The sleek curves of the contemporary Donghia chair contrast the straight edgy lines of a downtown view that makes cats purr.

LEFT: A carved European mantel, coffered oak ceiling and 19th century paintings complete the luxury of doing business.

DAVID SALEM, ASID
LOLLY LUPTON, ALLIED ASID
SALEM AND ASSOCIATES
4600 SOUTHERN AVENUE
DALLAS, TEXAS 75209

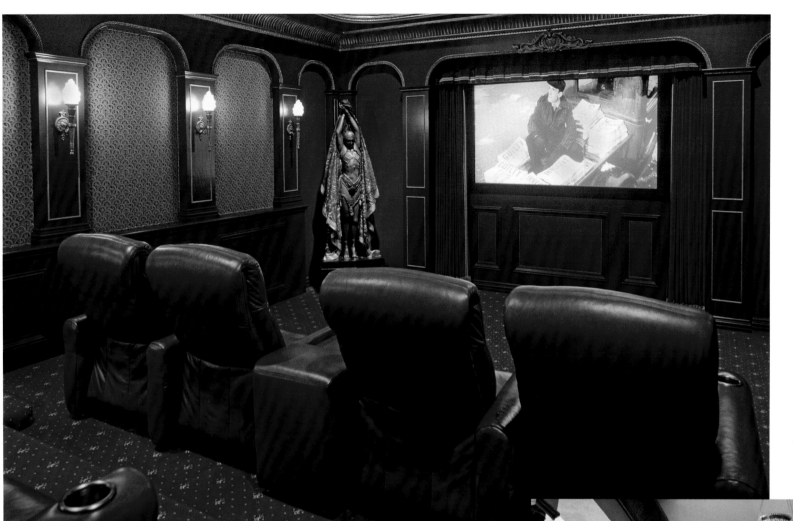

LEFT: An Old-World theatre reflects a time from Hollywood's golden years with elegant materials and art deco elements like the Erte statue.

BELOW: Ladies lounge with a view. A spectacular view from this upper gallery also doubles as the perfect venue for musicians.

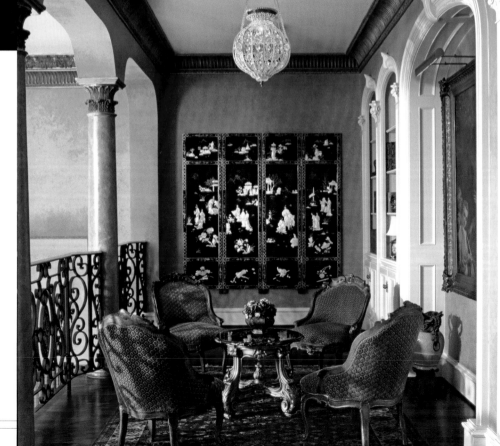

the New York School of Interior Design, and later I studied art at the Instituto Allende in San Miguel de Allende, Mexico." Although Lolly never thought she'd return home to work, she's glad she did. "I'm truly happy to help the central Texas clients who seek our services."

The pages of the firm's impressive portfolio are brimming with diverse designs: a Spanish colonial hacienda with 20 tons of custom-designed Mexican tile; the corporate offices of a private aircraft company housed in a round building; a Turtle Creek penthouse; an authentic 100-year-old, Texas rock-house ranch. Regardless of the project, David and Lolly fashion interiors reflective of the people who live or work in them.

"We enjoy learning how our clients live and uncovering what's important to them," Lolly explained. Then the dynamic duo creates a unique setting that complements the client's personality and lifestyle. "We balance creativity and function to design a space that appeals to the owner's senses and is a joy to live in," exclaimed David.

BELOW: Windows to the garden allow natural light to flood the white-washed walls, vaulted ceilings and floors made from long-leaf pine salvaged from a cotton compress.

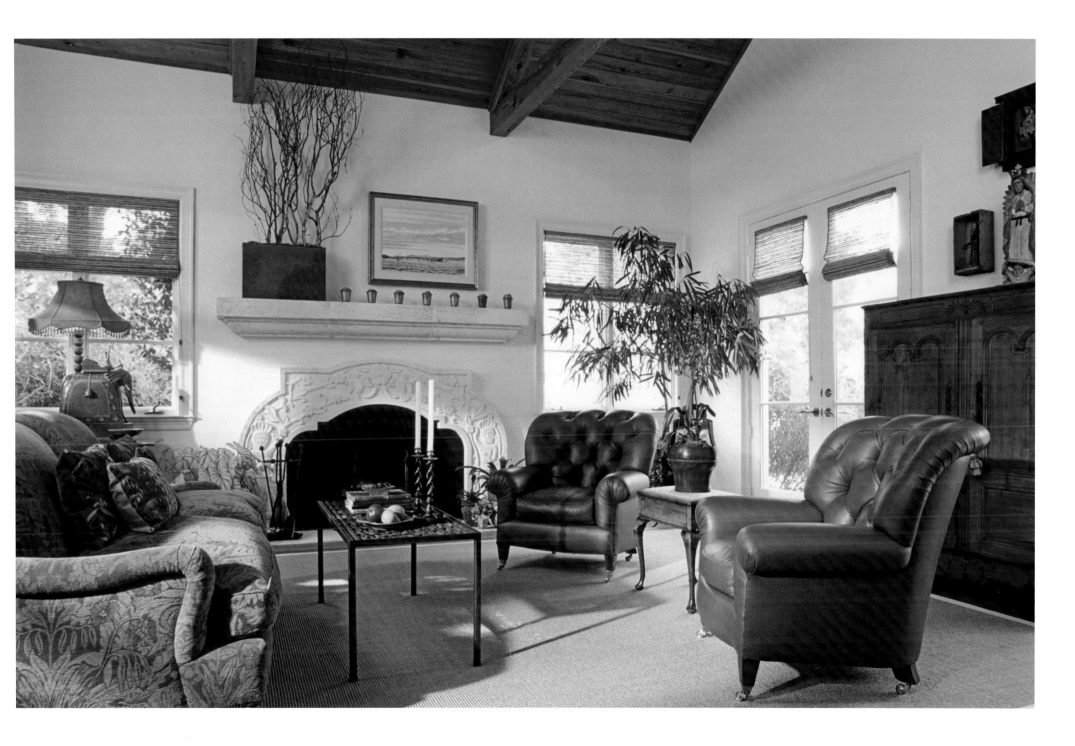

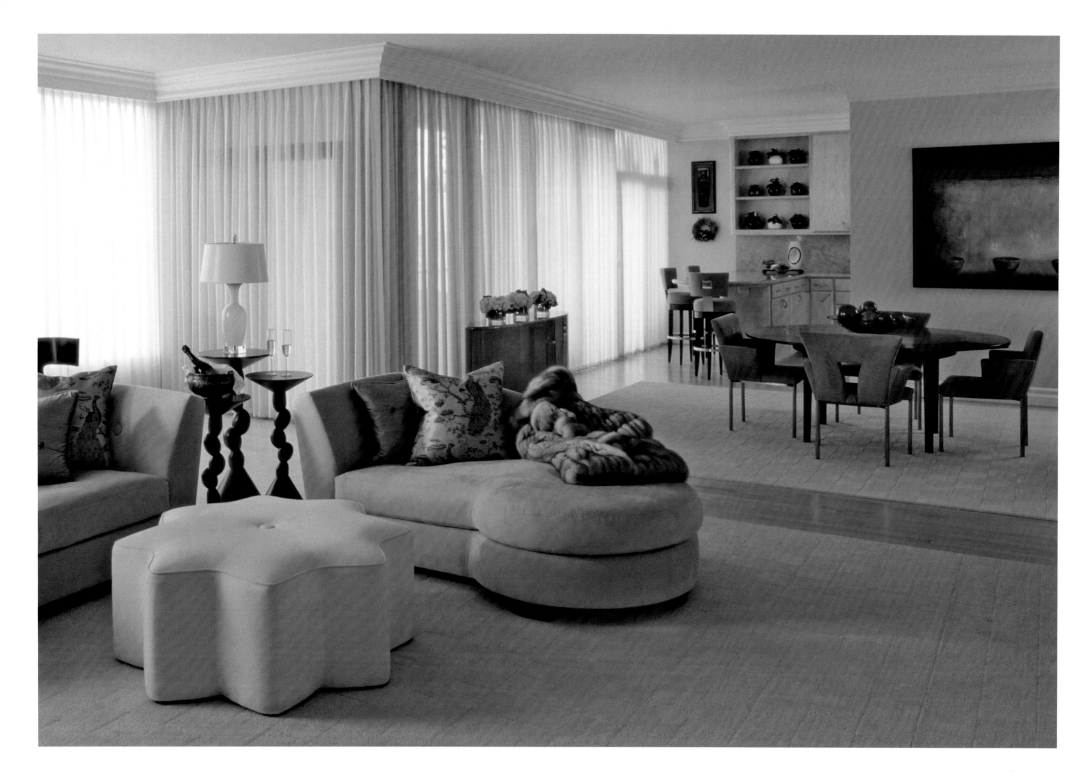

ABOVE: Sun, moon and stars? Curves, stars, circles and squares are the mandate in this home. The sensual shapes and lines play off each other, creating an easy living universe.

To assemble their inviting interiors, the experienced designers encourage clients to invest in fine architecture and quality furnishings that will last. They also urge them to mix things up. "A space comes alive when traditional designs are given a contemporary flair or a surprising twist of color," explained Lolly. "David and I know how to give a fresh face to a timeless setting, regardless of the style."

Where do the noted designers find inspiration for their memorable designs? From their travels. Both are known to roam the roads in search of the simple and the extraordinary. From Texas courthouses to European hotels, they study every architectural style, finishing appointment and color combination. "I'm fascinated by every design, whether a 30-year-old post office in my neighborhood or a 300-year-old cathedral in France," David said.

The distinctive designs for which they are sought are the designers' signature trademark. Whether it's an African game room, a European-style estate or a treasured lake house, every interior is unique—like the acclaimed design team of David Salem and Lolly Lupton. ∎

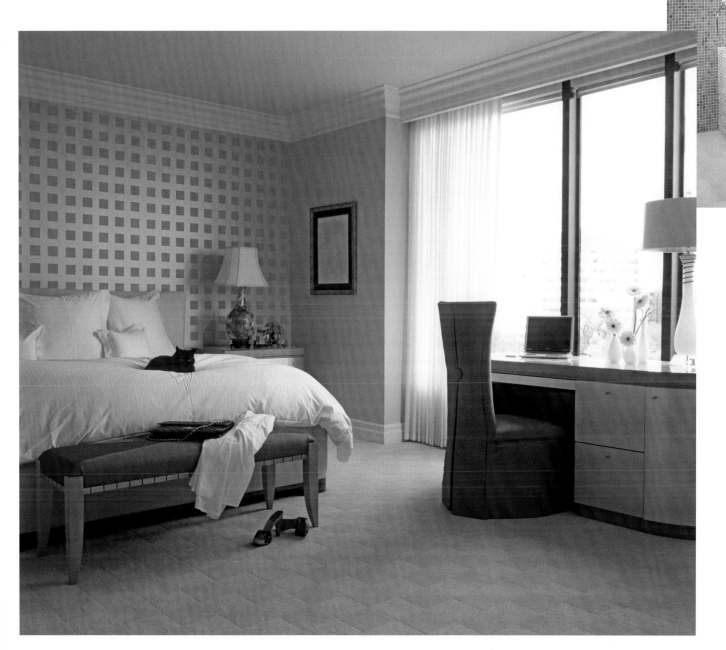

ABOVE: Water, water, water...is the dominant element considered for this bottle-green, glass-tile bathroom.

LEFT: Slumber comes easy in this balanced respite with Radius corners, loads of filtered sunlight and a touch of sparkle on the walls, which completes the restful magic.

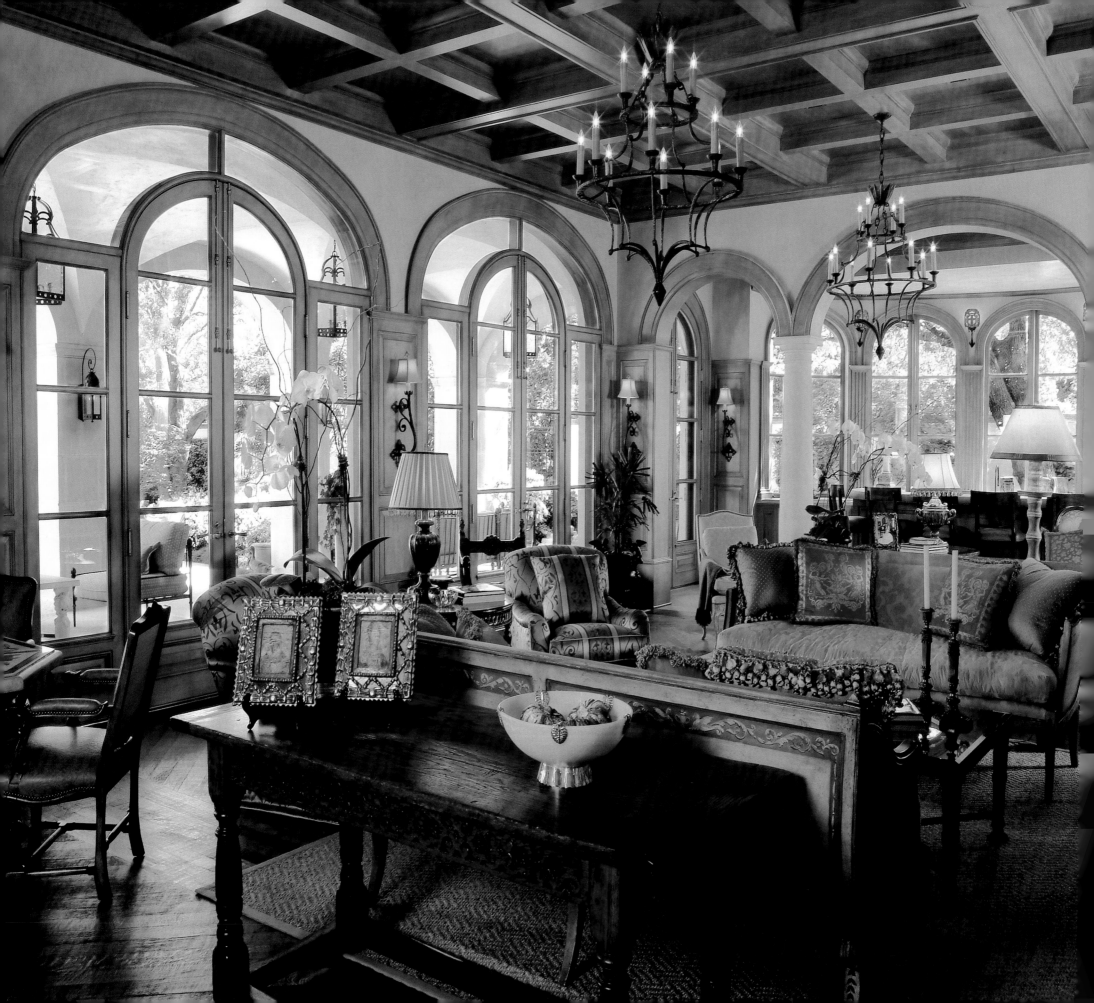

Lynn Sears, ASID

LYNN S. SEARS INTERIORS, INC.

*D*allas designer Lynn Sears' vocation and avocation are the same. "I love to create and draw," she said. "I have traveled around the world, soaking up new ideas from the places that I've visited. Everything inspires me!"

The award-winning designer with 34 years' experience and a degree in interior design from the University of Texas often turns her ideas into innovation. "If I can't find the right piece for a project, I create it," Lynn declared. Her inventiveness has led to more than 150 copyrights for everything from light fixtures to door hinges. And while Lynn's crazy about creating, she's equally passionate about interior design.

"I love every aspect of the design process," Lynn explained. "From conception to completion, I'm there every step of the way ensuring that no detail is left undone."

Her devotion to her profession has resulted in numerous accolades for her nationally recognized firm, Lynn S. Sears Interiors. The ASID bestowed them several DesignOvation awards, and *D Magazine* declared one of the firm's projects "Home of the Year." Several publications have featured the boutique design firm's "timeless, not trendy" interiors, including *Southern Living, Veranda* and the *Dallas-Fort Worth Design Guide.*

While the acknowledgment is appreciated, Lynn gains greater reward from her work. "I enjoy creatively solving clients' problems and addressing their needs while producing original and quality designs," she said. She personalizes every project—whether a luxurious residence or a professional office—often exceeding her clients' expectations. "I actively listen to my clients and work seamlessly with architects and contractors. Doing so guarantees satisfied clients, which," Lynn said proudly, "is how I measure true success." ∎

LEFT: The challenge was to create the feel of an old Italian villa in this Mediterranean home with Venetian plaster walls, sconces, chandeliers and Italian-influenced furniture.

ABOVE TOP: Natural light washes the warm tones of this Country French kitchen with custom strap hinges, hammered copper vent-a-hood, limestone counter tops and a glass backsplash.

ABOVE BOTTOM: Trompe l'oeil creates the fantasy of columns while the reclaimed wood ceiling and stenciled Venetian walls makes this bedroom—with its peach and taupe color palette—charming, quaint and inviting.

LYNN SEARS, ASID
LYNN S. SEARS INTERIORS, INC.
4324 WINDSOR PARKWAY
DALLAS, TEXAS 75205
214.521.9717
WWW.LYNNSEARSINTERIORS.COM

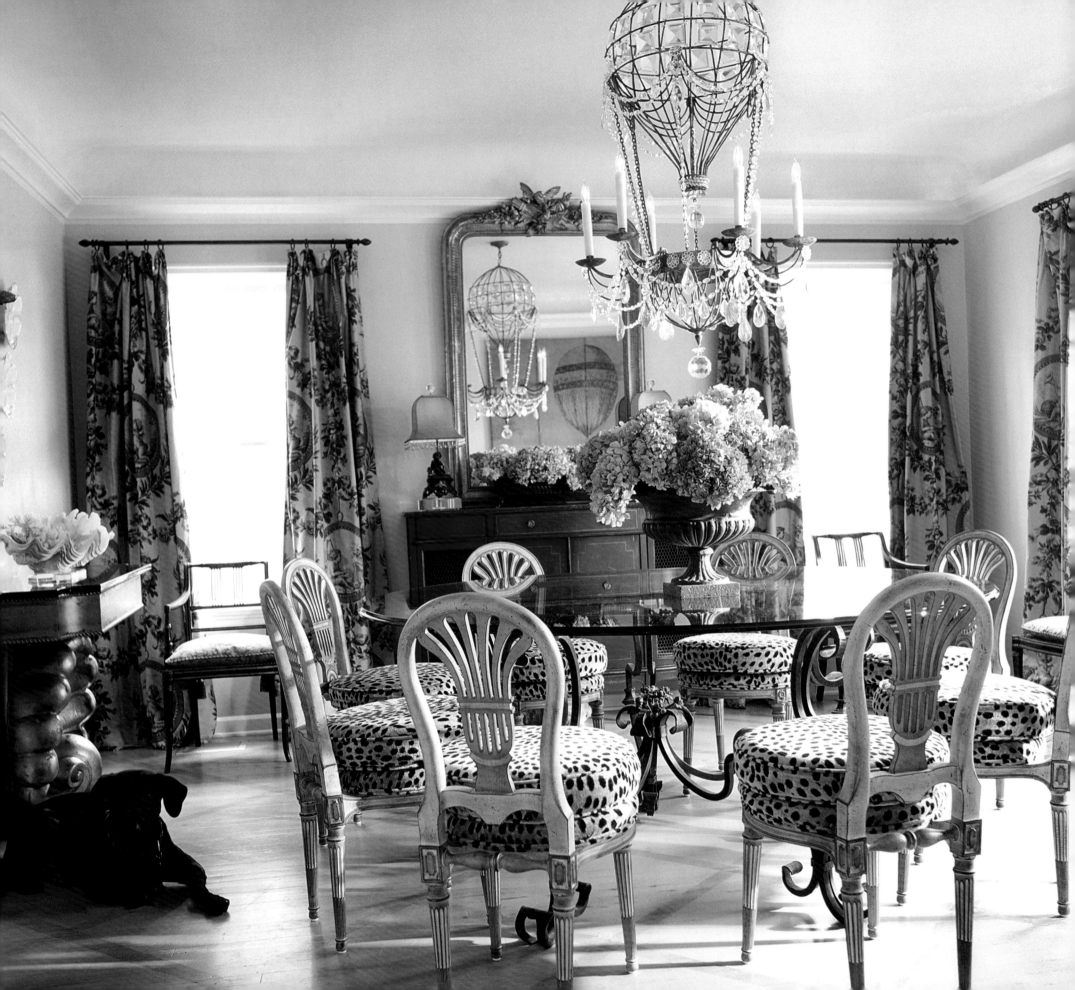

Mary Anne Smiley, ASID

MARY ANNE SMILEY INTERIORS

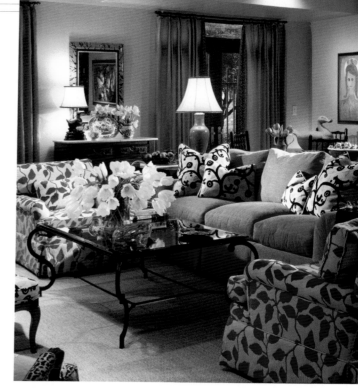

ABOVE: Scrumptious fabrics layered in pattern, texture and color contrast with collections of antique metals and porcelain to create a warm sitting area for entertaining.

LEFT: This dining room—jewel hot with pearl, smooth walls and painted floor with diamond pattern—is dramatic and dog friendly. Sparkling balloon chandelier repeats the balloon motif of an antique screen.

A kaleidoscope of ideas and a palette of visions inspire the award-winning projects of Dallas designer Mary Anne Smiley. "I love mixing it up, layering unexpected patterns, colors and design elements to create fresh, distinctive spaces," Mary Anne said of her approach to design. "Embracing the client's personal taste and lifestyle is always the launching point of the design process."

Sometimes her designs translate into contemporary homes with incredible light and original art. Other times they result in traditional residences with bold colors and custom chandeliers. Regardless of the style, every one of Mary Anne's design projects adhere to the design principles of balance, rhythm and proportion. "Creating clean, functional design is the foundation of every successful project," she said. "A truly beautiful house is a livable home."

Mary Anne's career began inadvertently in the '60s when she was denied admission into architectural school because of her gender. After pursuing a degree in art for one year, she discovered the school of interior design. "It has been a great adventure ever since."

And a notable one. Mary Anne has received top honors from industry organizations, and she has been published in prominent design magazines. Add to that her outfitting of President George W. and Laura Bush's East Texas lake house during their pre-governor days and you've got one impressive career.

While the accolades are appreciated, Mary Anne admits that the real reward comes when clients proclaim their gratitude for her custom creations by saying, "I just love it! It's so me!" ∎

MARY ANNE SMILEY, ASID
MARY ANNE SMILEY INTERIORS
3617 FAIRMOUNT STREET, SUITE 105
DALLAS, TEXAS 75219
214.522.0705
WWW.MARYANNESMILEY.COM

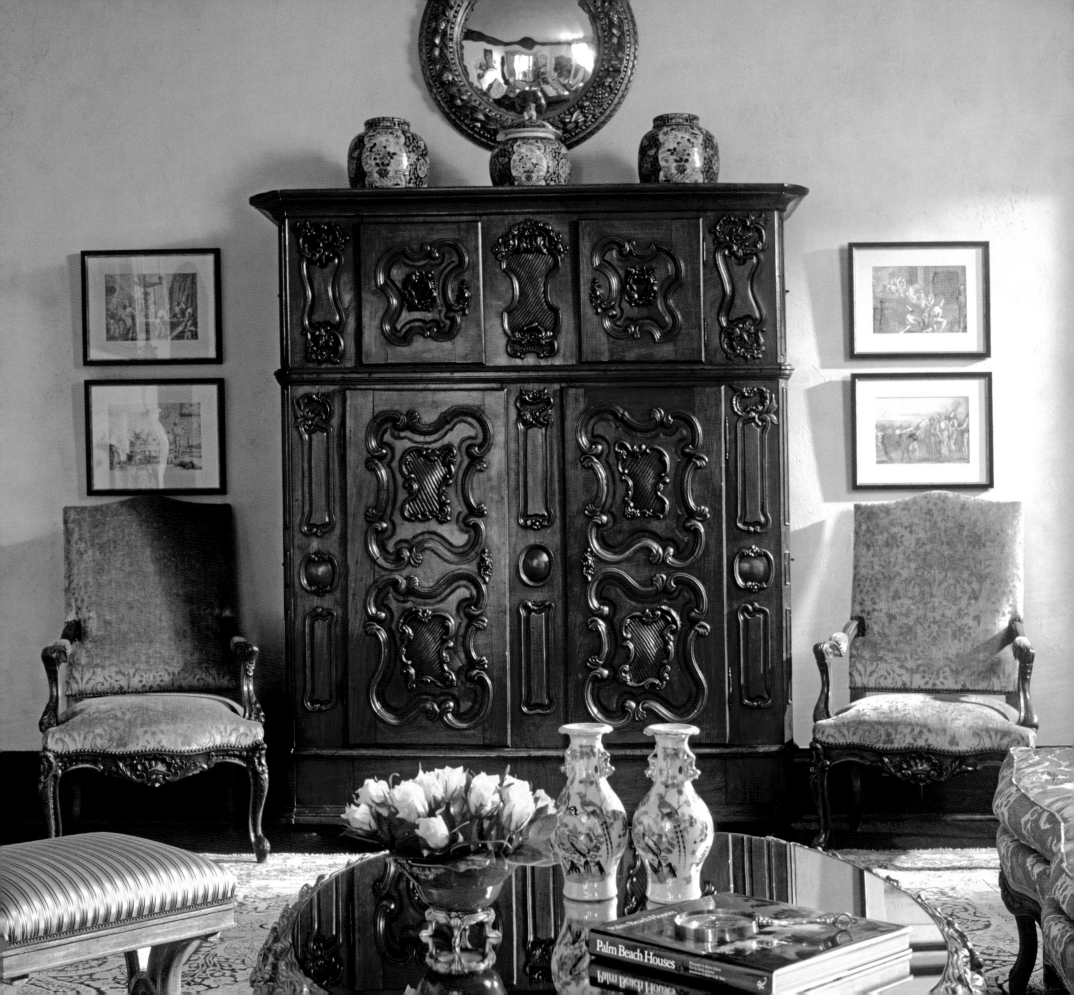

Richard Trimble, ASID, IIDA

RICHARD TRIMBLE AND ASSOCIATES, INC.

Dallas designer Richard Trimble is legendary for his finely appointed interiors and classic designs. With a polished eye, he composes elegantly understated settings that seamlessly meld period antiques with modern furnishings. The result is warm, welcoming rooms with clean lines and timeless style.

Residences are the primary beneficiary of Richard's award-winning designs, though commercial installations share space with estates, second homes and ranches in his impressive portfolio that expands across 11 states and three countries. To ensure that each interior is unique in its final dressing, Richard paints the personality of each occupant within its walls. Using calming colors, innovative ideas and custom details discovered during his extensive travels across the globe, he creates livable environments that conform to his clients' lifestyles while meeting their requirements for function. This approach has won the acclaimed designer loyal clients during his nearly 30-year career.

He founded his firm, Richard Trimble and Associates, Inc., in 1976 after earning degrees in marketing, psychology and interior design. His education in these areas, along with his innate creative ability and astute business skills, has enabled him to grow his company into one of the nation's finest design firms. Earning top accolades like several ASID DesignOvation and Silver Style Awards, the company's stellar designs have been featured in numerous periodicals including *Southern Living, D Home* and *Traditional Homes* and design books like *Decorating With Southern Living, Showcase of Interior Design, Provencal Interiors: French Country Style in America* and *French by Design*. Richard, an ardent supporter of the arts, was listed in *Who's Who in American Interior Design*, and in 2004 and 2005, he was deemed one of the best designers in Dallas.

Recognition for his body of work is appreciated by the affable designer, who is quick to credit his success to mentor Arlis Ede, whom he met through ASID, the industry organization that Richard has served both regionally and nationally. "Arlis encouraged me to open my firm, even subleasing me space in his office," he said. "I am grateful for his early encouragement and thankful for his ongoing support."

So are his valued clients, in whose lives Richard Trimble has left an indelible mark. ■

LEFT: The focal point of the formal living space is the antique European cabinet with elaborately carved panels. The warm wood tones are a pleasing counterpoint for antique Imari jars and a bulls-eye mirror.

TOP: Luxurious, but durable, fabrics in blue tones are family friendly and provide a comfortable area for lounging and entertaining for this young family. A wall of windows with remote-controlled drapes overlooks the landscaped pool.

ABOVE: The warm terra-cotta color scheme of this bedroom serves as a backdrop for antique furniture and accessories. An antique "carona" holds the bed draping above an upholstered headboard.

RICHARD TRIMBLE, ASID, IIDA
RICHARD TRIMBLE AND ASSOCIATES, INC.
3617 FAIRMOUNT STREET, SUITE 121
DALLAS, TEXAS 75219
214.526.5200

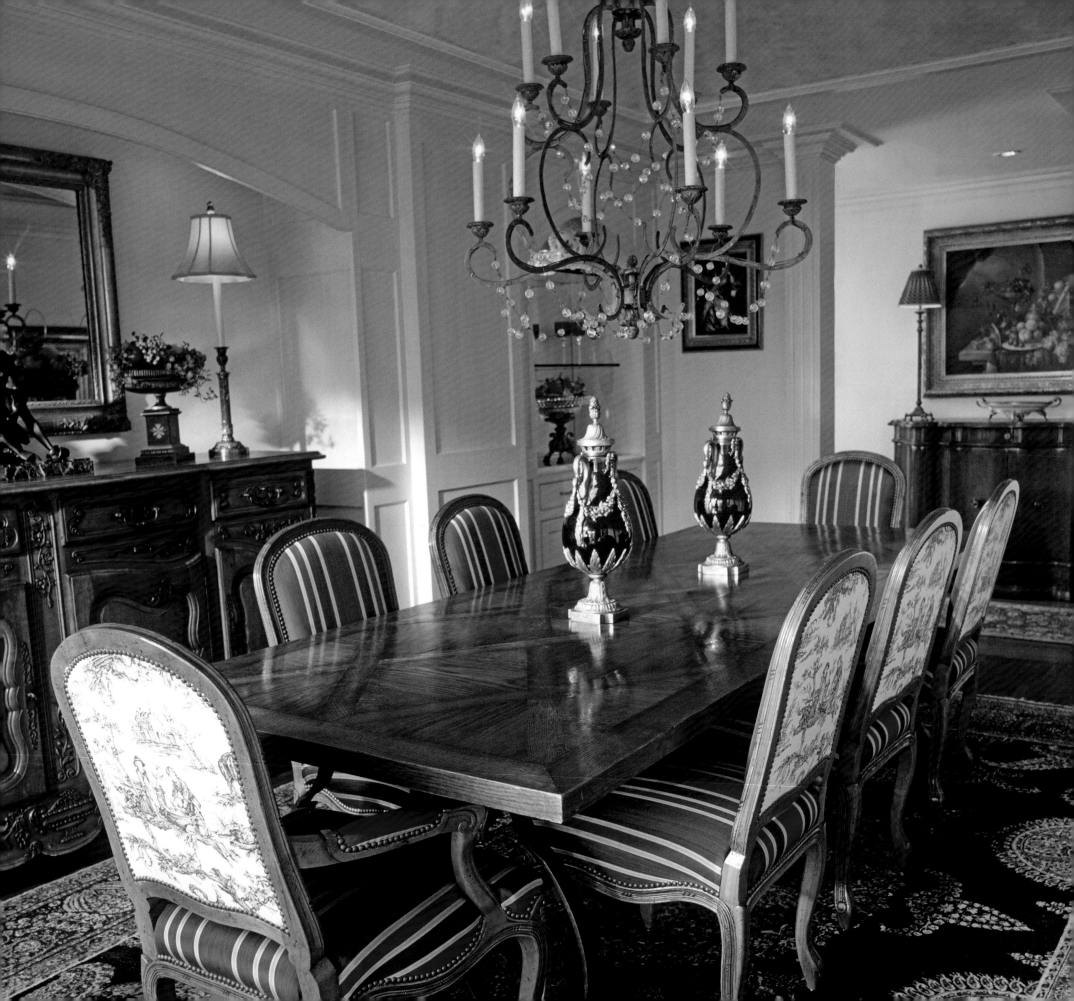

Cheryl A. Van Duyne, ASID

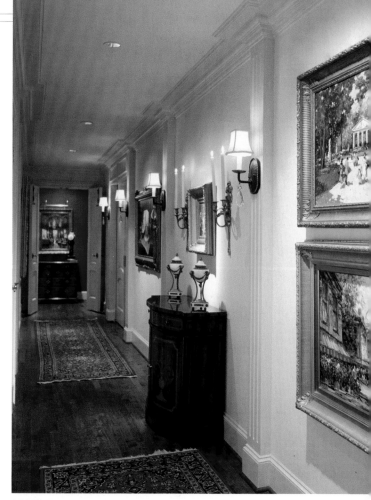

Dallas designer Cheryl Van Duyne says that lighting can make or break a project. That's why lighting design is a top priority on every job. "Lighting is important for many reasons," she explained. "Take color, for example. You spend time selecting the right color for the walls, yet if the lighting isn't correct, the color won't look the same in the finished interior."

Proper lighting isn't the only element essential to Cheryl's award-winning designs. Well-planned spaces, the correct use of materials, custom-designed cabinetry and clutter-free interiors are signature to her expansive portfolio that's rooted primarily in residences. "I love working on projects like the Turtle Creek penthouse I've just completed," said Cheryl. "But I also enjoy the challenge of taking any space and turning it into a homeowner's dream."

Though the majority of Cheryl's projects are traditional, she has designed every style of interior. From Spanish Colonial to formal French and English, Cheryl has left her mark not only in Dallas, but in residences in Maryland, Arizona, Vermont and Hawaii. Each of her designs is signature simple, reflecting Cheryl's belief that clutter detracts from good architecture. "Regardless of the style or location, I enjoy working in the minimalist venue," she stated.

Cheryl's love of clean designs was born from her friendship with Japanese interior designer Takashi Aso, whom she met while studying to become a designer. His influence in uncluttered concepts is often seen in Cheryl's designs. "I like to keep confusion out of my projects so the lines of architecture remain important in the design," she explained. Also contributing to the simplicity of her work are neutral backgrounds, which she says many clients prefer.

ABOVE: The homeowner's art collection lines the walls of this beautiful gallery where custom sconces, pilasters and lighting add personality and interest.

LEFT: This dining room was bare before incorporating beautiful architectural details that enhanced the homeowner's existing furnishings and provided needed storage.

CHERYL A. VAN DUYNE, ASID
14902 PRESTON ROAD,
PMB 404-775
DALLAS, TEXAS 75254
972.387.3070

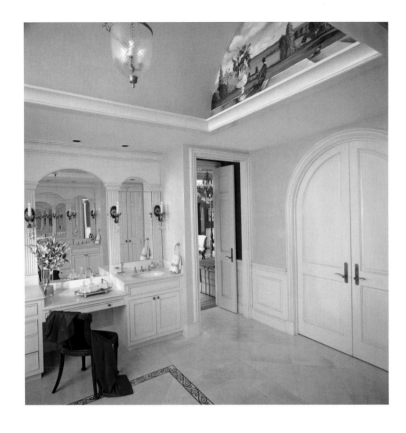

Designing personalized interiors reflective of the individual tastes of the people who live there is the goal of the noted designer with more than 20 years' experience. "My main focus is to listen to the desires and concerns of my clients and integrate their ideas into good interior design." Often her finished interiors include custom-made elements. "It's difficult to find the right item for certain areas, so I often have lighting fixtures, cabinetry, doors, furniture and rugs made," Cheryl explained. "Then each space truly is unique."

Her innovative designs have led to an impressive list of awards from industry organizations, including several ASID DesignOvation and Texas Legacy of Design awards. Named one of the "Best Designers in Dallas" by *D Home* magazine, along with publication in numerous national books and periodicals, landed Cheryl a segment on a Home & Garden Television feature. They'd heard about a master bathroom she remodeled and wanted to feature it on one of their programs.

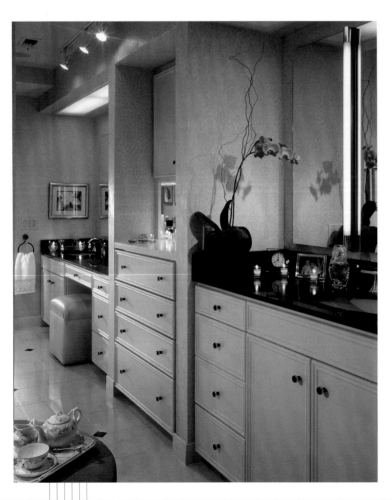

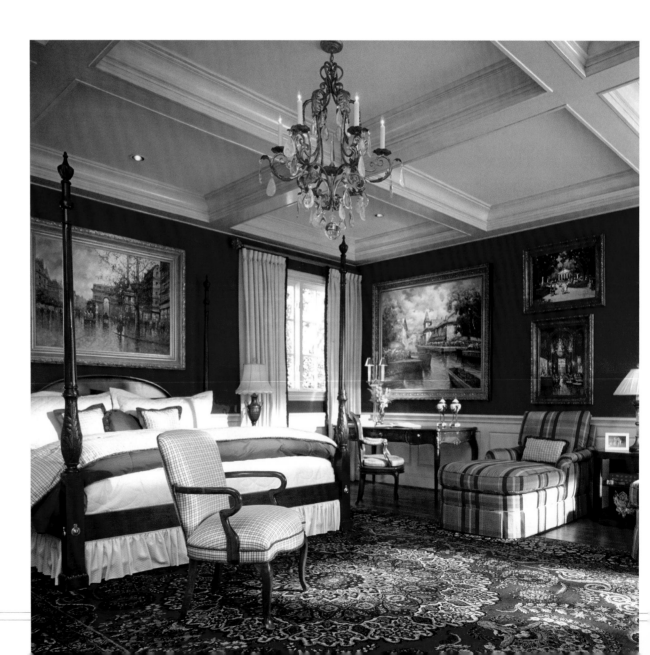

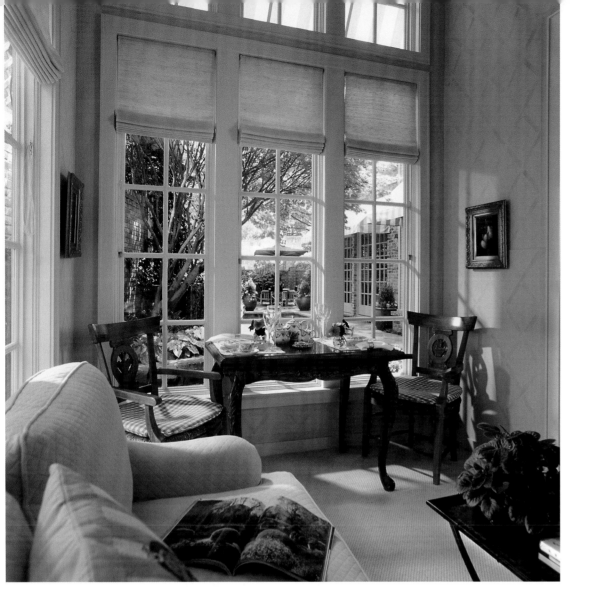

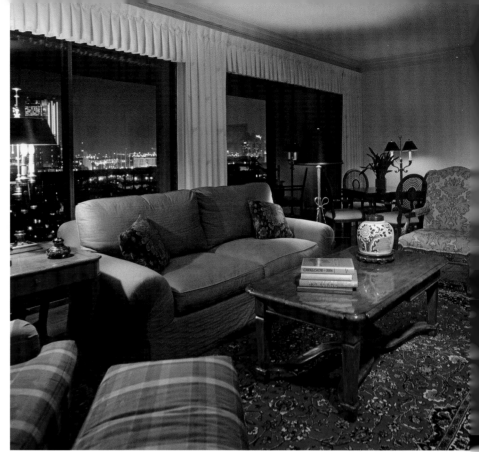

Her recurring studies in England and France also contribute to her acclaimed designs, but it's a personal characteristic that gives her interiors a distinguishing edge. "I'm shorter than most interior designers," Cheryl confessed, "which gives me a different view of the world. I tend to be more aware of size as it relates to convenience and the use of space. This makes for good interior design." ∎

ABOVE: This small conservatory proved to be a very worthwhile addition for the homeowners who spend many hours enjoying breakfast in the sun-filled room overlooking their back yard, pool and outdoor living area.

ABOVE RIGHT: The downtown skyline makes a beautiful backdrop for this casually elegant living room in a Dallas high-rise.

OPPOSITE PAGE:

TOP LEFT: This custom-designed bath features interesting architectural features, beautiful cabinetry, luxurious flooring and an original mural.

BOTTOM LEFT: The simple color scheme, good lighting and added storage give this remodeled, narrow bath an updated look and more useable space.

BOTTOM RIGHT: The classical architectural elements, great lighting and rich colors make a beautiful background for the elegant rug, fine furnishings and treasured art collection in this master bedroom.

Awards
- Several Dallas ASID DesignOvation awards
- Several Texas ASID Legacy of Design awards

Publications
- *D Magazine*
- *Dallas Design Book*
- *Dallas Fort Worth Design Guide*
- *The Dallas Morning News*
- *Park Cities People*
- *Southern Living*
- *Spectacular Homes of Texas*
- *Remodeled Kitchens and Baths*
- *Porches and Other Outdoor Spaces*
- *Southern Room*

Professional accomplishments
- *D Home* Magazine, "Best Designers in Dallas"
- Home & Garden Television feature
- Served on several professional boards

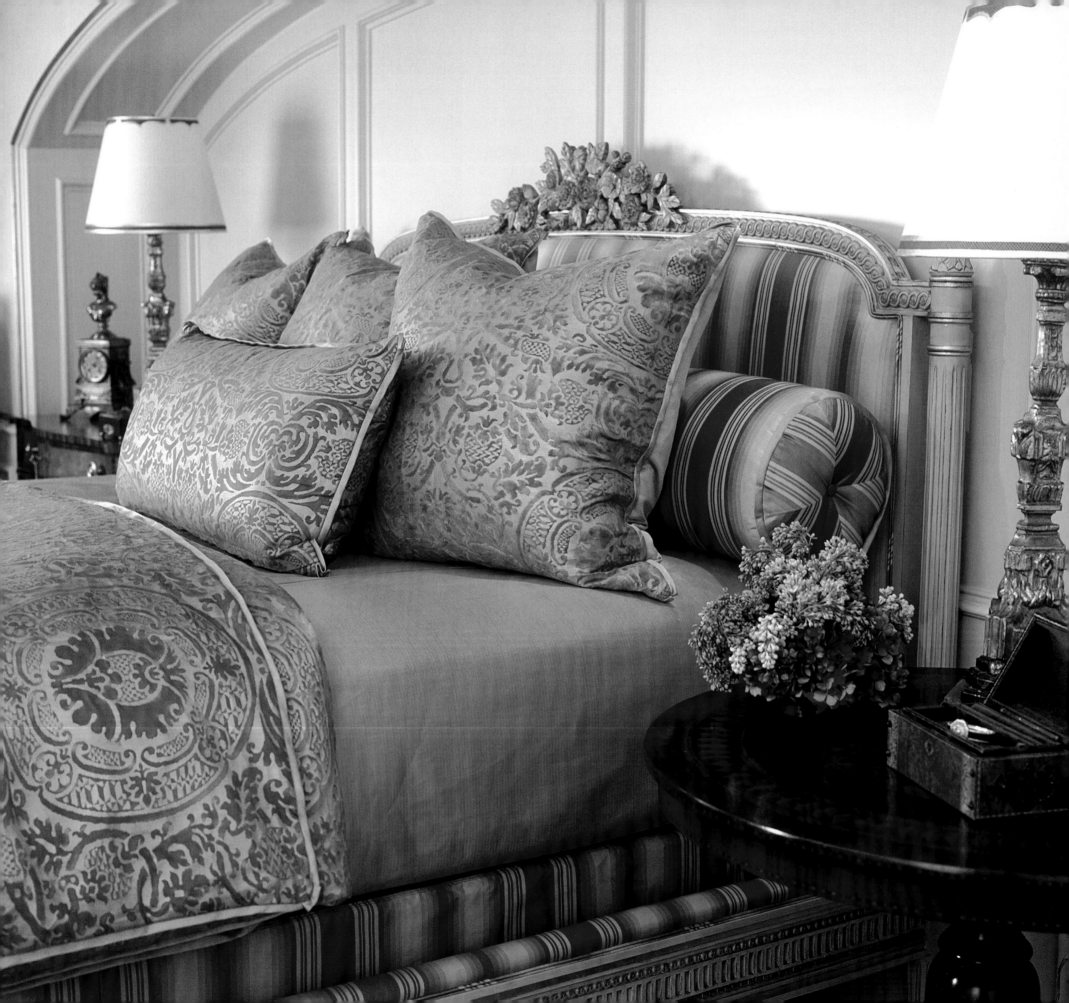

Deborah Walker, ASID

DEBORAH WALKER AND ASSOCIATES

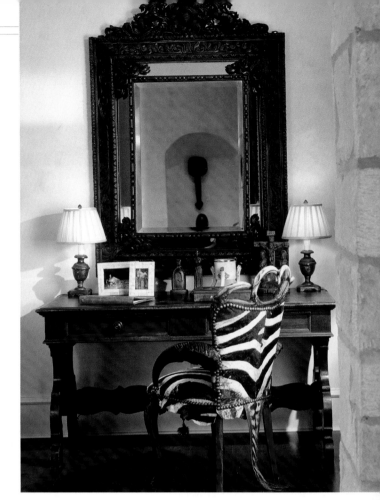

ABOVE: 18th century Spanish desk comes alive when paired with a 19th century zebra chair.

LEFT: A custom-designed bed with carved details and vintage Fortuny fabric complements the Brunshwig & Fil stripe.

Her innate eye for design and an extensive library allow Deborah Walker, owner of Deborah Walker and Associates, to design classic interiors that comfortably fit each client. "I research all projects to ensure that every detail—from the architectural elements to the custom-built furniture—is accurate," Deborah said. Doing so enables her to create livable designs that age beautifully. "I am respectful of my clients' needs. Therefore, I compose timeless, not trendy, interiors that are attractive as well as functional."

With a discerning mix of traditional and contemporary furnishings, Deborah layers impeccable tastes with signature style to create sophisticated rooms for high-end residences. Clients across the nation seek the new construction and remodeling design services of the Dallas designer with 25 years' experience. They trust her to deliver the personalized settings for which she is known.

Deborah has developed her skill of editing so that her rooms are perfectly appointed. Evidence of her ability to create warm, welcoming interiors is found among the pages of some of the nation's finest publications including *Traditional Home, Home Décor* and *Dallas Home Design.* Several of the Betty Lou Phillips' books—*French by Design, Villa Décor* and *French Influences*—have featured Deborah's body of work. And in 2005, Deborah was deemed one of the top 50 designers in Dallas.

Acknowledgement of her contributions is appreciated, but the ASID professional finds real reward from a job well done. "My staff and I are blessed with wonderful clients who depend on us to deliver designs that work," Deborah said. "There is no greater satisfaction than having clients declare that their spaces will happily fit them for years to come." ■

DEBORAH WALKER, ASID
DEBORAH WALKER AND ASSOCIATES
1925 CEDAR SPRINGS ROAD, SUITE 103
DALLAS, TEXAS 75201
214.521.9637

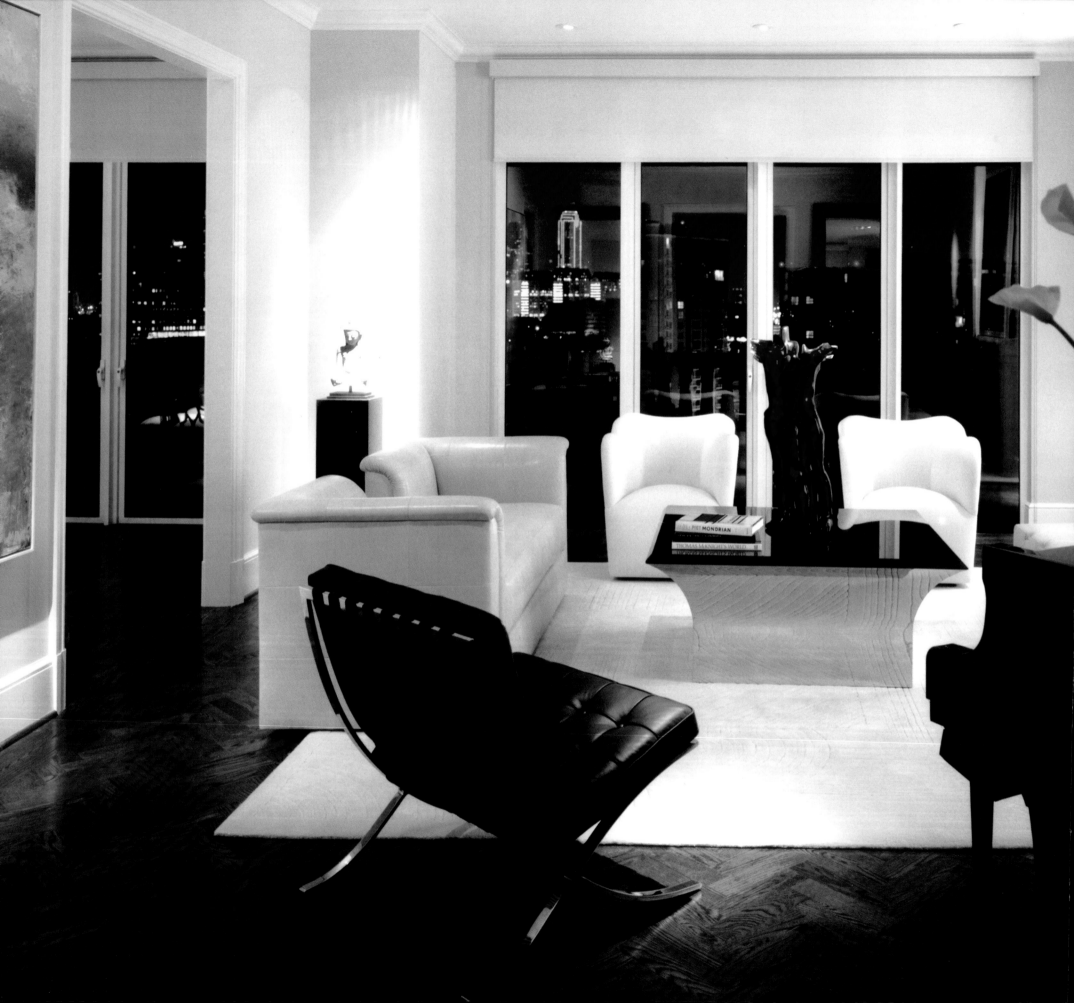

Rodney Woods, Allied ASID
Julie Butler, Allied ASID

WOODS BUTLER, INC.

ABOVE: Rodney Woods and Julie Butler of Woods Bulter.

LEFT: Featured Barcelona chair by Knoll, art titled "Tangerine" by Mark Dickson, 19th century Buddha, sofa and chairs by J. Robert Scott, glass sculpture by Daum, custom cocktail table by J. Robert Scott and custom rug by Edward Fields.

Woods Butler is the award-winning interior design firm of principal partners, Rodney Woods and Julie Butler. Located in the heart of Dallas' Design District, the firm's balanced perspective in creating stylish environments has resulted in an impressive portfolio of interior projects that speaks volumes for this young agency's talents.

In a partnership that was formed in 2002, Woods Butler brings a strong sense of purpose and a fresh attitude to interior design with a sensibility that stems from the creative, hands-on approach of contrasting personalities. With combined experience of over 27 years, two bachelor degrees—one in interior design, another in art history—and a graduate degree, both partners share an appreciation for sophisticated elegance, yet each draws their own creative inspiration from widely different perspectives.

Rodney, a self-proclaimed introvert and perfectionist, adopts a studied, contemplative methodology to design, while Julie draws on her European cultural experiences, art history background and strong visual energy. The combination is one that is dynamic and fresh.

RODNEY WOODS, ALLIED ASID
JULIE BUTLER, ALLIED ASID
WOODS BUTLER, INC.
1501 DRAGON STREET, SUITE 106
DALLAS, TEXAS 75207
214.522.3310

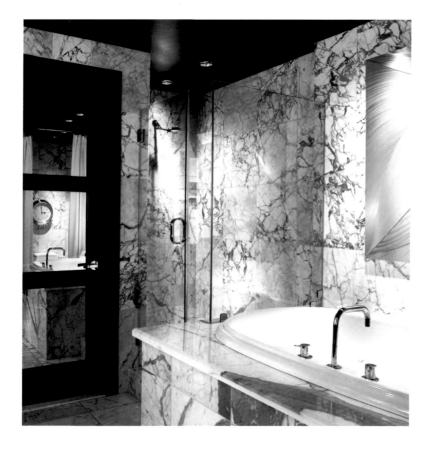

LEFT TOP: Bathroom is decorated with statuary marble, a stainless steel sculpture by Laddie John Dill, fixtures by Vollia and drapery fabric by Glant.

LEFT BOTTOM: Dining room showcases art by Elizabeth Braden, a Saarinen dining table by Knoll, silk slipcovers and draperies by J. Robert Scott, a paper woven rug, polished Venetian plaster walls and ceilings and natural maple hardwood floors.

RIGHT: Living room lithograph is by Rauschenburg, with Klismos chair by Donghia covered in white leather by Contemporary Hides, sofas by Interior Craft covered in J. Robert Scott fabric and a custom cocktail table by Woods Butler.

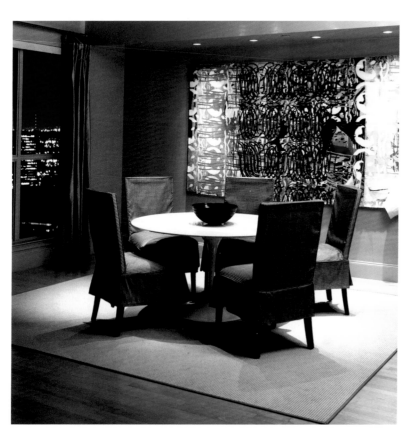

The refined awareness by which the firm approaches a project lies in the partner's abilities to analyze, translate and examine a client's lifestyle and taste. Often exceeding expectations, Woods Butler explains that creating striking environments requires knowledge of science and art, where the artistic influences transform functional space into effortless elegance.

Access to global resources enhances the creative process. Continually exploring new sources, Rodney and Julie search for unexpected and exceptional finds from around the world. The two partners immerse themselves in the study of international trends and styles. Frequent buying trips include France, Italy and England, as well as the major domestic markets of New York, Los Angeles, Chicago, Miami and New Orleans.

The forward thinking, modernist point of view and a lighthearted sense of being distinguishes Woods Butler as an interior design firm that is in tune with the 21st century– you see it in the stimulating, personable and livable environments they create. ■

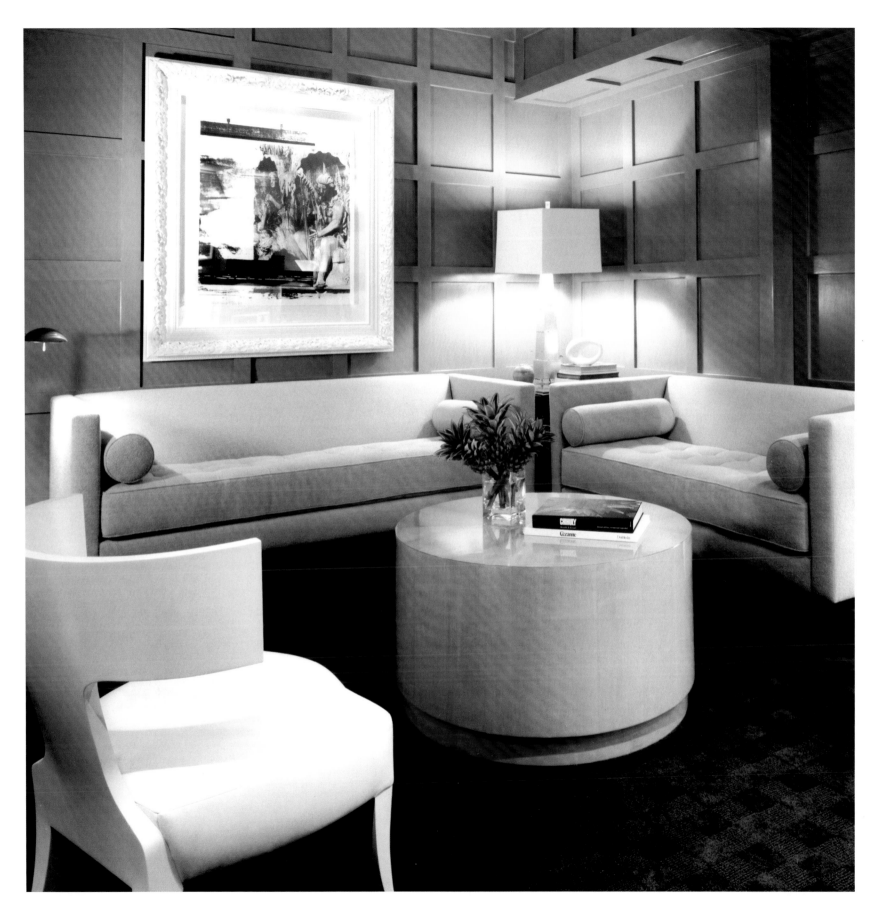

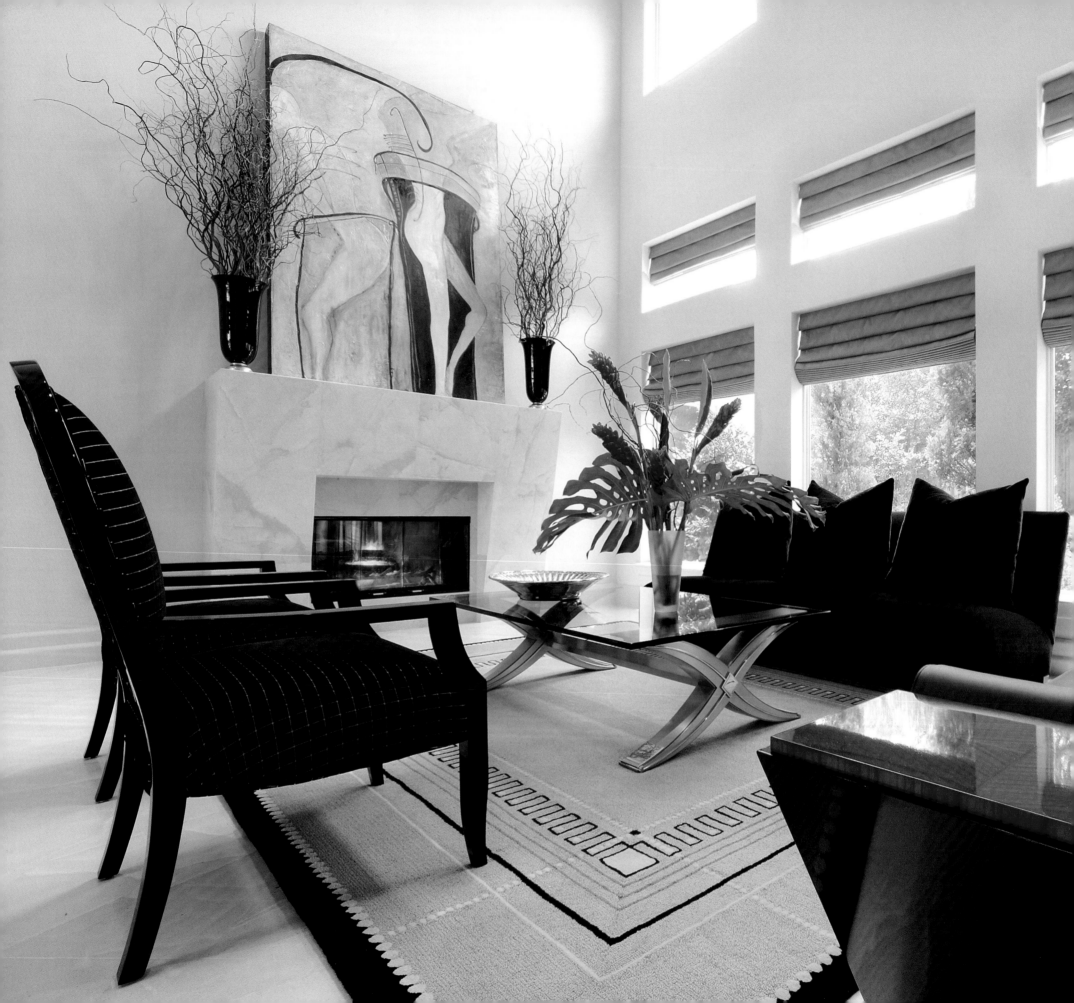

Joanie Wyll, ASID

JOANIE WYLL & ASSOCIATES, INC.

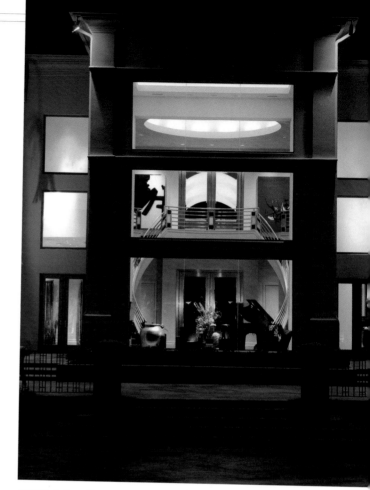

ABOVE: A dramatic exterior view shows an entry and living room with circular stairs and a clerestory enclosed with a glass dome.

LEFT: This French modern living room has a selection of textures—the fabrics, the area rug and the hard surfaces—to complete this clean-lined, sophisticated design.

*D*allas designer Joanie Wyll has a flair for the bold and the beautiful. "I like to step outside of the ordinary, incorporating unusual and unexpected features that hat complement my clients' lifestyles," Joanie explained. The results are stunningly elegant interiors that are not only cutting-edge, but inviting. "I love to create dramatic, sophisticated spaces that welcome my clients home," she declared.

The innovative designer, who through her noted firm Joanie Wyll & Associates, Inc. has customized settings for Dallas' most discerning homeowners—including several media personalities and professional athletes—works in both contemporary and traditional genres. Signature to her clutter-free designs is the classic elements of scale and proportion, which ground each setting providing a fresh palette from which to customize with quality details. Using rich color, textured fabrics and outstanding artwork, Joanie expertly dresses each interior to perfectly fit her clients' individual tastes. The result? A loyal following. Lasting designs. And numerous accolades.

Joanie's memorable designs have graced the covers of noted publications like the *Robb Report, Estates West* and *Dallas Home Design.* The professional member of the ASID and current chair of the Dallas association has also won numerous awards both on the local and state levels.

JOANIE WYLL, ASID
JOANIE WYLL & ASSOCIATES, INC.
12740 HILLCREST ROAD, SUITE 160
DALLAS, TEXAS 75230
972.380.8770
WWW.WYLLINTERIORDESIGN.COM

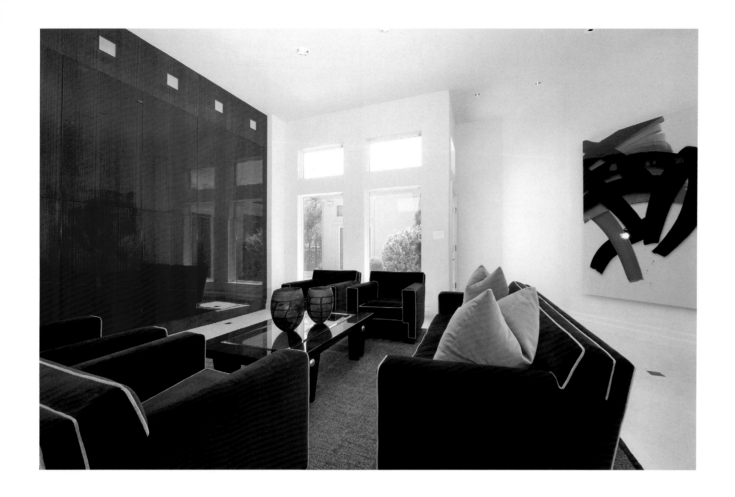

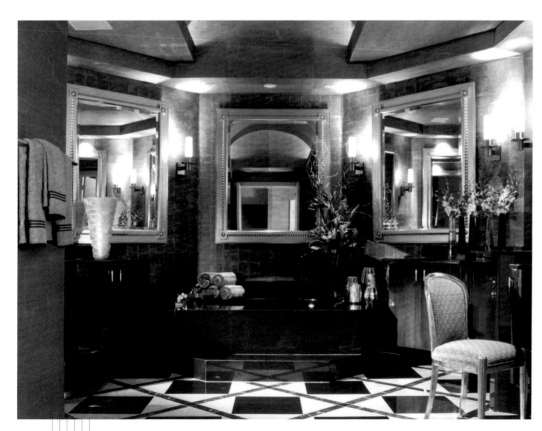

Applause for her body of work is appreciated by the energetic designer who began her career more than 20 years ago designing hospitals and medical facilities. After honing her skills in the medical field, Joanie turned to the more creative residential and commercial design world, where today she adds high-end drama to everything from homes to restaurants to designer show houses. Regardless of the project, Joanie's passion for quality furnishings, art and design is evident.

"I encourage my clients to leave a space blank rather than filling it with items of inferior quality," she explained. "My goal is to create classic settings that will last them for years to come." Joanie also strives for simple designs that enable clients to relax. "Because our lives are often dictated by our busy schedules, we want our homes to be clean and uncluttered," the acclaimed designer explained. "My desire is to give each client an escape from the hectic, outside world."

OPPOSITE PAGE:

TOP LEFT: A ribbon Sapelli mahogany built-in was designed floor to ceiling to create drama for this family room.

TOP RIGHT: This formal entry has contrasting linear lines in art and furniture, which complement its circular floor plan.

BOTTOM LEFT: This spectacular master bath features a barrel vault and silver leaf wallcovering.

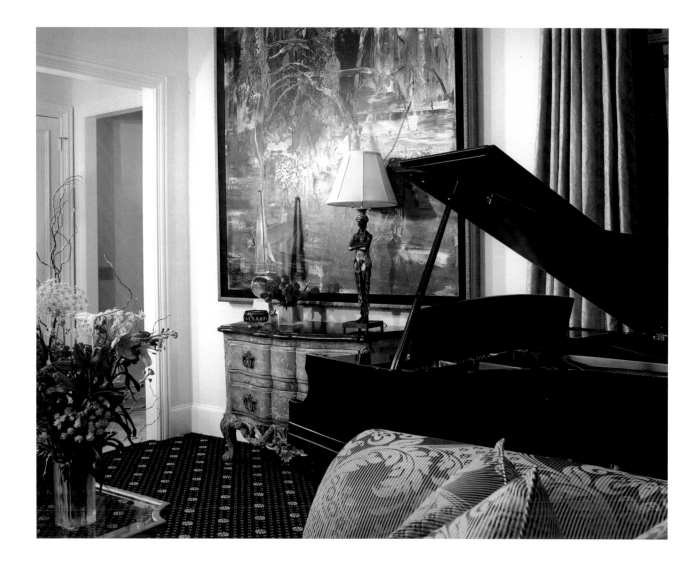

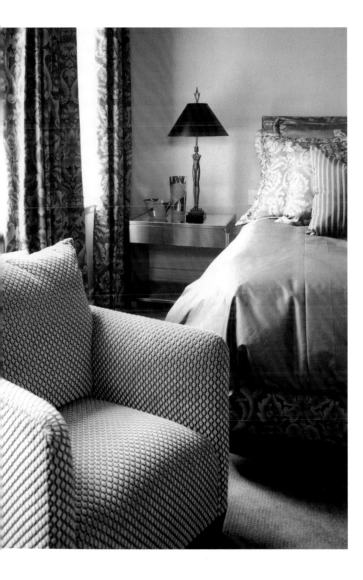

Her minimalist styling has proven positive for her clients, who are scattered across Texas and the U.S. in places like the California wine country and West Palm Beach, Florida. They seek Joanie's modern approach to solving today's needs. "I spend time with my clients, learning about how they live and how they want their spaces to function," she explained. "Then I turn their visions into reality so that the final designs simply reflect their personalities, not mine." The reward comes when at the end of the sometimes lengthy process, a client sports an approving smile and declares the space a perfect fit. "Then I've realized true success," Joanie said. ■

ABOVE: This traditional living room was completed with dramatic contemporary art and accessories.

LEFT: The right scale and proportion with bedding and drapery in this guest bedroom enhance the smooth textural color palette.

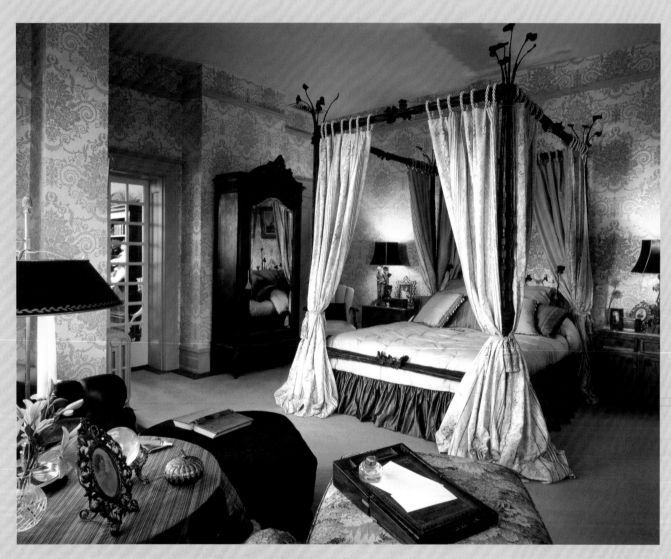

KENNETH JORNS, ASID

Fort Worth

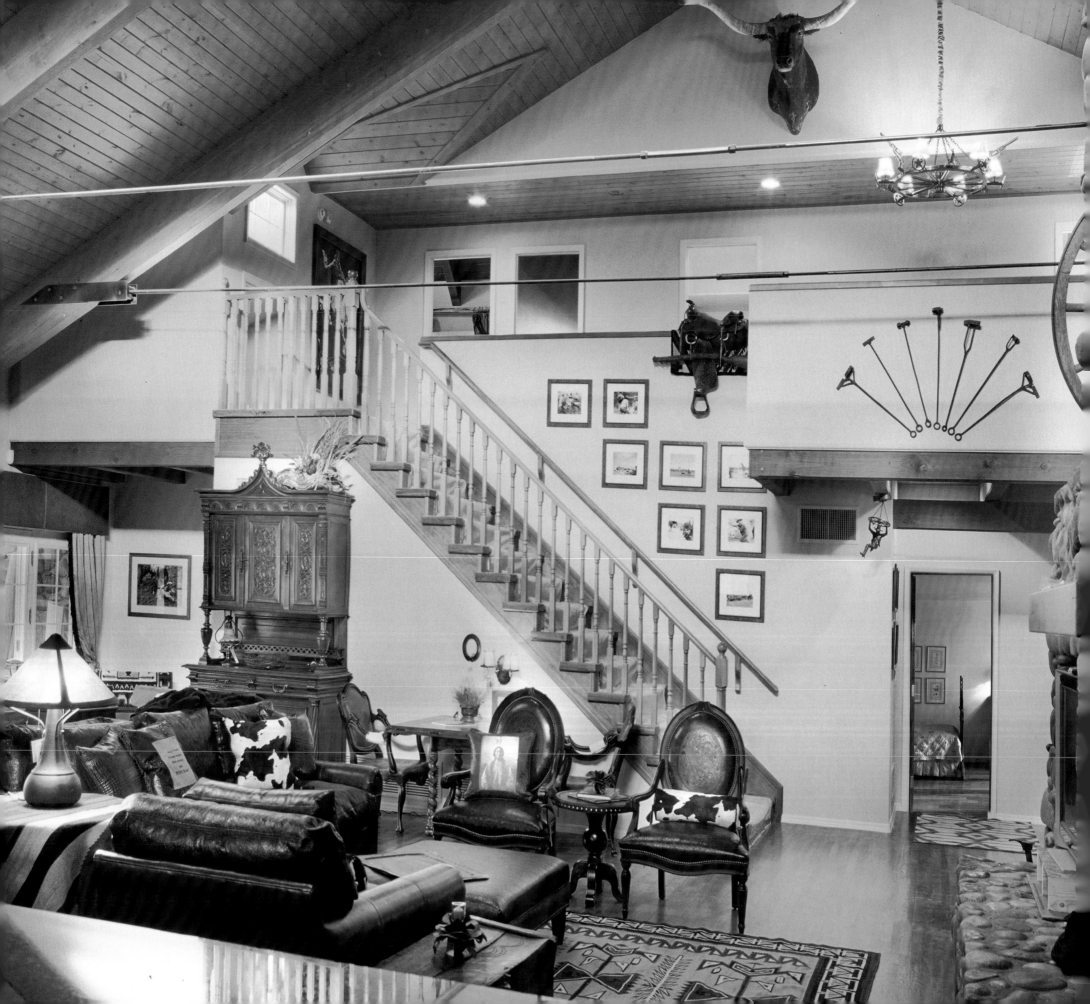

Juan Antonio Castro, Jr., ASID

RANCH HOUSE TRADING CO.

*J*uan Antonio Castro's signature brand began when he was a child. "I wanted to be John Wayne after watching him in movies," confessed Castro. "Opening Ranch House Trading Co., which specializes in fine western interiors, is as close as I can get to fulfilling that dream."

Though John Wayne spawned Castro's fascination with the "Wild West," it was his mother who introduced him to the world of color. "My mother was an artist who colored black and white photographs. In the summers, she would let me paint on duplicates for fun." Soon Juan began to paint his bedroom, changing colors and designs to suit his whims. So it's no surprise that after attending Texas Christian University in his hometown of Fort Worth, Juan launched a career in interior design. By the age of 24, he had already completed two large jobs in New York.

Today, Juan's designs grace residential, vacation and commercial properties from Tucson to Austin. With an emphasis on "elegant western," his carefully crafted spaces provide a perfect juxtaposition between rustic and traditional styles. "My designs incorporate the best of both worlds, resulting in an understated elegance that today's sophisticated client desires."

Every project is important to Juan. After listening to a client's needs, he pulls from his more than 25 years' experience to create a colorful vision of the proposed design. Then he works to personally ensure that every detail—from specialized wall finishes to custom window treatments—is exact before accessorizing with unique pieces from his store, located in the heart of Cowtown.

The result? Chic, irresistible interiors with an elegant western flair—perfect for every cowboy—and girl—at heart. ■

LEFT: In this Tucson, Arizona residence, western chic warms this inviting great room.

TOP: This picture-perfect setting greets clients of the Ranch House Trading Co. in the Fort Worth Stockyards.

ABOVE: This formal setting in a private residence in Dallas reflects the homeowner's colorful personality.

JUAN ANTONIO CASTRO, JR., ASID
RANCH HOUSE TRADING CO.
200 W. EXCHANGE AVE.
FORT WORTH, TEXAS 76106
817.625.2341
WWW.JACASTRO.COM • WWW.RANCHHOUSETRADINGCO.COM

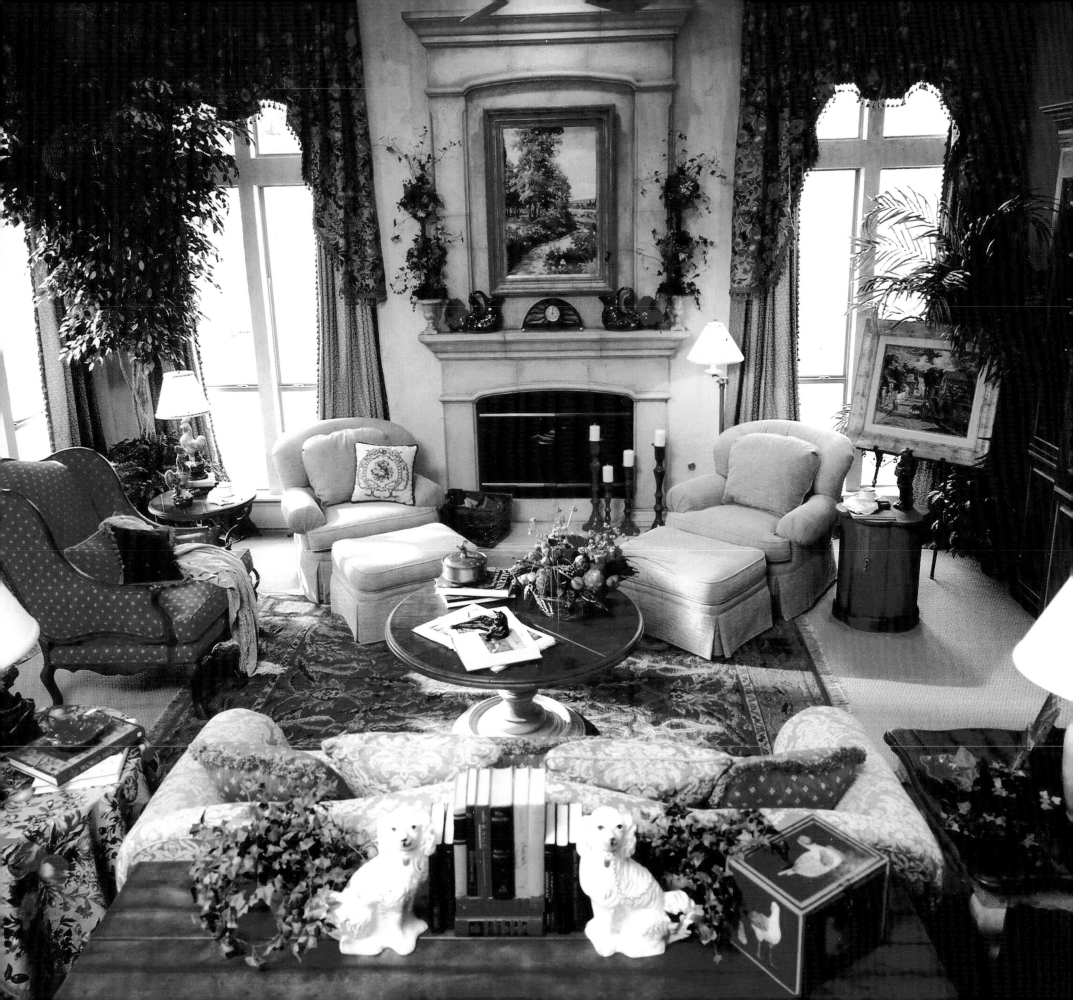

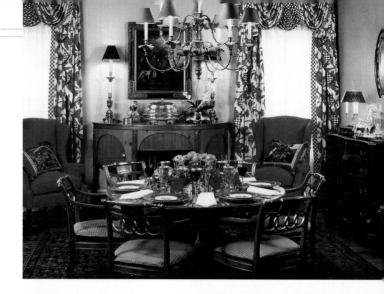

Carole Smith Harston, ASID

CAROLE HARSTON INTERIORS

Carole Harston views the world through an artist's eye. A landscape painter and designer, she relies on her innate abilities and professional training to compose colorful designs. "I approach an interior the same way I do a painting," Carole explained. "I give a lot of thought to the composition, focal points, color scheme, patterns and textures while incorporating my client's personality."

With a focus on residential design, Carole serves many couples and families whose tastes run from the more traditional styles of Country French, Tuscan and Southwestern to the contemporary lines of Asian. Whatever the style, she strives to make her designs representative of the people who live in them. "I spend quality time learning as much as possible about each client," she said. "It's essential to know what they do, how they live and what they desire." Then she weaves the homeowner's dreams into warm, beautiful interiors filled with finishing details. A well-placed antique. A modern sculpture. An added trim. Throughout the Southwest, her artful flair is evident in her "relaxed-elegance" designs.

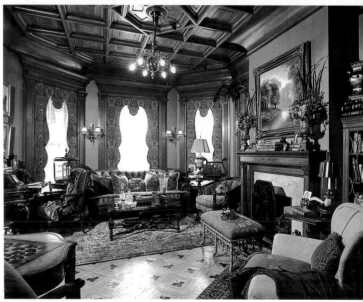

The skillful designer who received her degree in interior design from the University of North Texas has actively engaged in the profession for the past 28 years. Former senior designer at The Design Studio of Gabberts in Fort Worth, Carole now owns her own business. She's twice served as the chair of the Fort Worth ASID Association, and she's been a regular contributor to area showhouses, earning the Best Interior Design award at the Tarrant County 1998 Kaleidoscope of Homes. Carole's work has also been published in the book *Showhouses, Signature Designer Styles,* which featured her dining room from the 1997 Tarrant County Historic Preservation Designer Showhouse.

She appreciates the acknowledgement of her talents. But the real reward, Carole says, comes from creating inviting interiors for her valued clients. "I want their chair, their room, their home to say, 'Welcome Home.'" ■

TOP RIGHT: The refined, yet cozy, dining room of the 1997 Tarrant County Historic Preservation Designer Showhouse tempts guests to come in and stay awhile. The exciting color scheme of vibrant reds and soft greens, contrasted with the mellow gold-pine furnishings, creates an inviting dining experience.

RIGHT: Architectural details original to the 1899 McFarland House in Fort Worth, Texas, provide a dramatic backdrop for the family parlor. Warm colors, vintage-style fabrics and trims, unique furnishings and Victorian-inspired lambrequins and lace sheers evoke a sense of period style that is still comfortable and welcoming for today.

LEFT: Variety of color, pattern and texture establishes a rhythmic balance in this charming and comfortable Country French family room. Centered on the fireplace, the seating group creates a perfect location for conversation with family and friends.

CAROLE SMITH HARSTON, ASID
CAROLE HARSTON INTERIORS
1409 PORTO BELLO COURT
ARLINGTON, TEXAS 76012
817.860.7748 • 817.657.8738
WWW.CAROLEHARSTONINTERIORS.COM

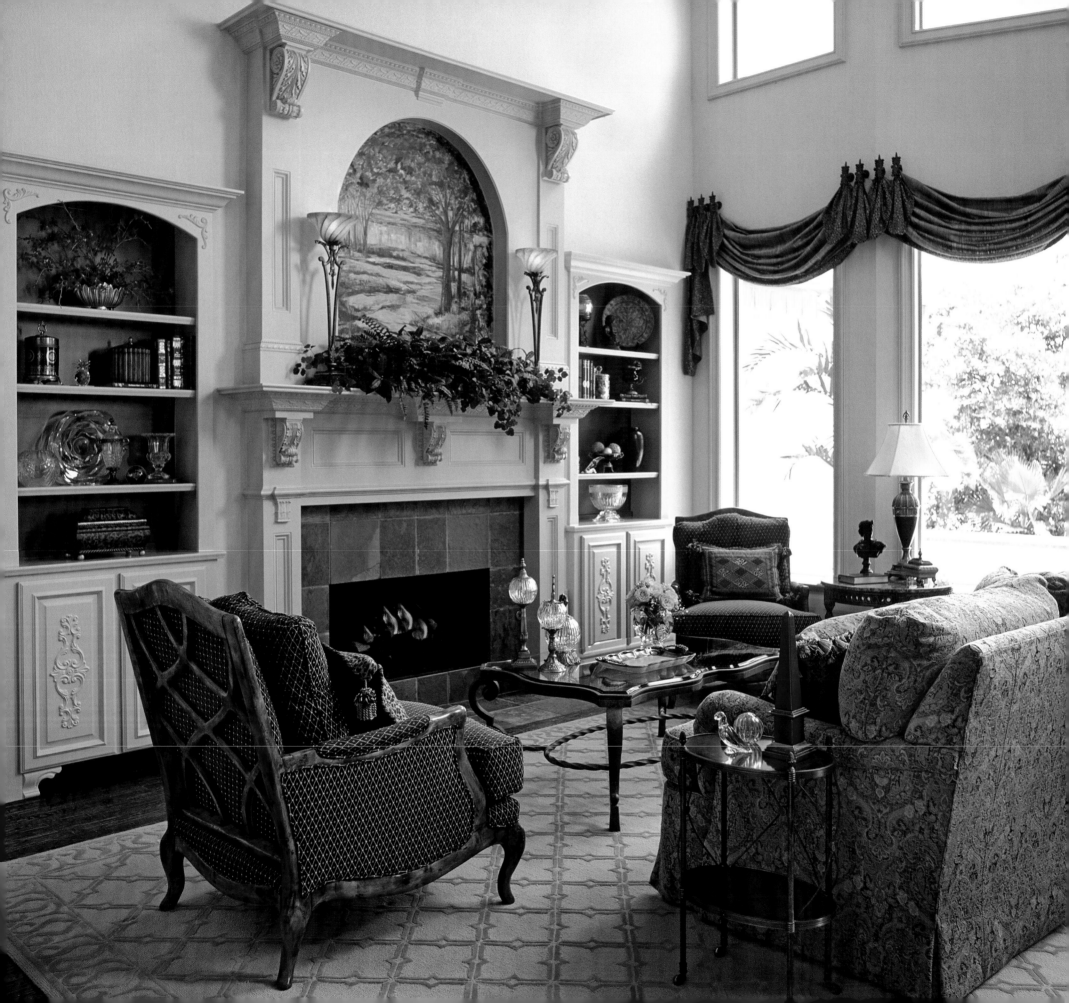

Lisa A. Henderson, Allied ASID

ENTIRELY INTERIORS

ABOVE: The woodwork in this room makes it very impressive and masculine. Appointed with an unusual wall hanging, the warm texture of the fabrics and light from outside, this is a relaxing place to work.

LEFT: In this beautiful home on Lake Lewisville, the formal living room provides a wonderful place to relax and converse while absorbing the views of the pool and lake.

BELOW: Lisa with her American Saddlebred horse "Annie" at her Dad's ranch.

When she's not working, Arlington designer Lisa Henderson is outdoors. She loves to ride horses, water ski and fly fish. She finds the beauty of nature peaceful and relaxing.

So it's not surprising that when designing spaces, Lisa looks for ways to incorporate the exterior view within interior rooms. "So many times what is outside the window is a beautiful backdrop to complete a room," she said. "I consider the outside color to create fluid, harmonious designs."

In her soothing rooms are specific details gleaned from Lisa's travels to Europe, where she's photographed everything from flowers to doorways, gardens to windows. "I'm always searching for something intriguing to weave into my designs," she said. "For example, I once framed brass rubbings and used them in a room. They fit perfectly with the client's tastes."

Knowing a client's style and personality is essential to Lisa's work, which primarily consists of residences in the Dallas-Fort Worth area, though she's completed several professional offices and theological seminaries in both New Orleans and Fort Worth during her nearly 30-year career. She enjoys commercial design, but her heart lies in the homes of the clients she and her staff at Entirely Interiors serve. "I become very close to my clients, which isn't surprising given that I invest time getting to know them." That, she says, is the secret to designing the beautiful, classic interiors for which she's known.

"I take great pride in listening to my clients, learning about their interests and hobbies," Lisa explained. "Doing so enables me to design a functioning home or office reflective of their personalities." And even though the clients provide the backdrop of architecture, collections and nature, it's Lisa who brings the professional experience and creativity that marries all the elements. "It's my job—and joy—to create a respite from the outside world where a client's needs and desires are met within a beautiful, relaxing setting." ■

LISA A. HENDERSON, ALLIED ASID
ENTIRELY INTERIORS
3605 B WEST PIONEER PARKWAY
ARLINGTON, TEXAS 76013
817.265.4561

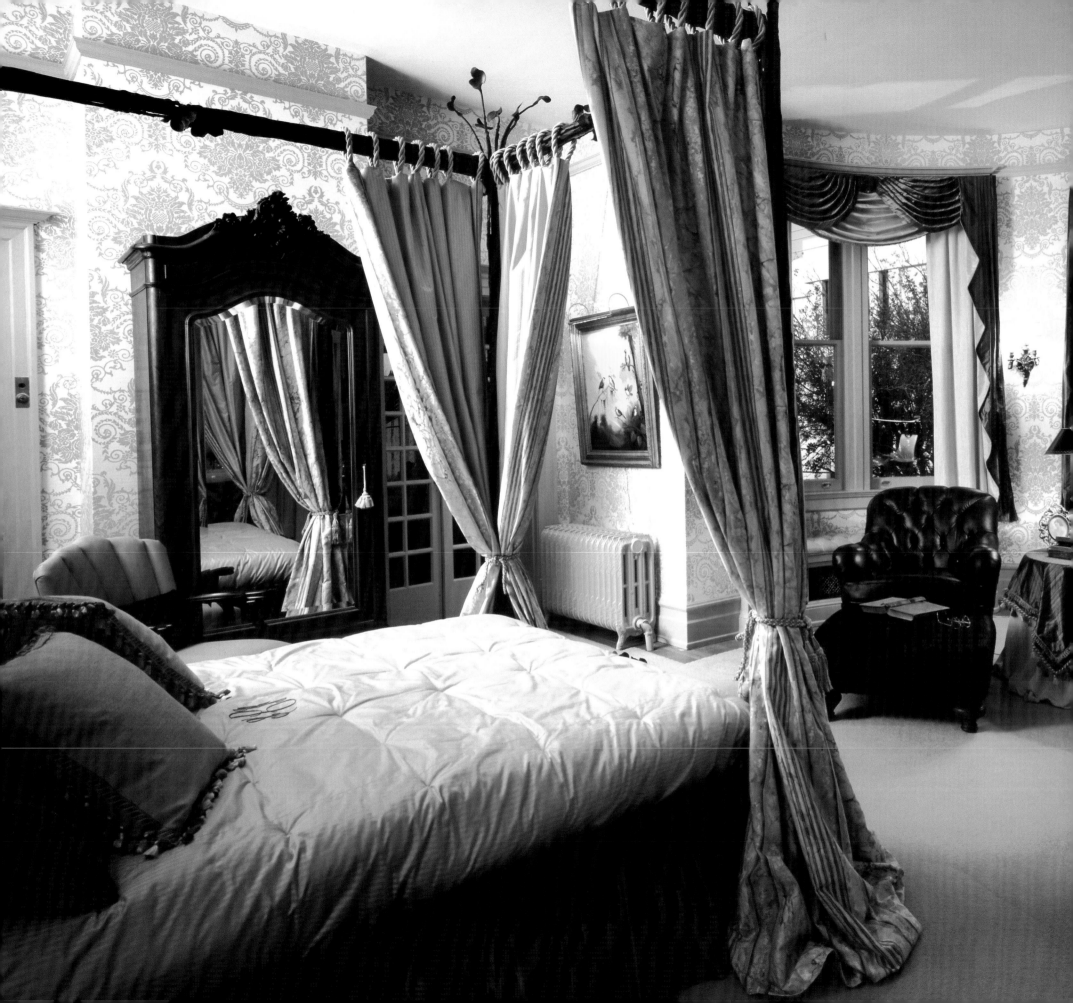

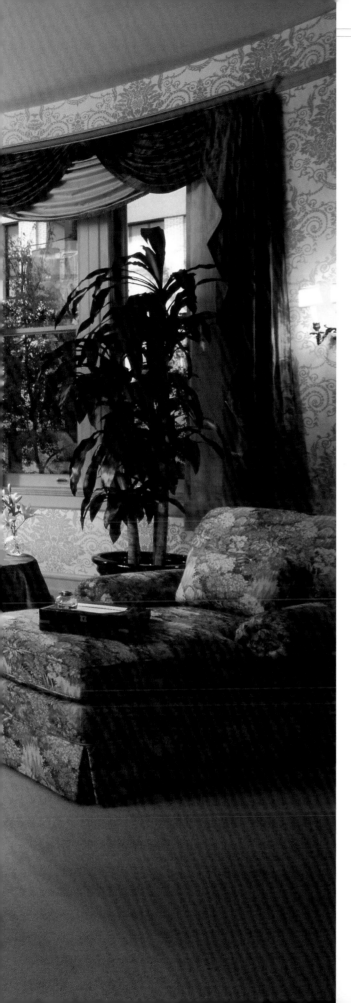

Kenneth Jorns, ASID

KENNETH JORNS & ASSOCIATES

The resume of interior designer Kenneth Jorns is impressive. The noted designer and former officer in the American Society of Interior Designers (ASID) has a bevy of accolades, including several nods in the *Who's Who in Interior Design International* publications, recognition as one of the 10 Outstanding Young Designers by *Dallas/Fort Worth Home and Garden* and numerous features in noted publications. While the acknowledgement of Ken's 30-year achievements says volumes about his talents, they don't begin to tell the story of the man behind the winning designs.

At age seven, Ken was already showing signs of a promising career in interior design when he began rearranging the furniture in his parent's new home, the first built in Fort Worth's prestigious Tanglewood neighborhood near Colonial Country Club. So it's not surprising that he earned a degree in interior design from Texas Christian University, where he was a popular cheerleader who led U.S. clinics for the National Cheerleaders Association after being hand-picked by icon Lawrence "Herkie" Herkimer.

The energetic Ken quickly put his training to work, opening Kenneth Jorns & Associates. For 30 years, he not only has enjoyed national and international projects, Ken has valued clients in Fort Worth, Dallas and Austin, where his participation in the 1983 Parade of Homes earned him national and international recognition. Though he has designed some of the state's finest residences, Ken made his mark in the healthcare, financial, education, hospitality and corporate industries. Designing everything from dormitories and restaurants to hospitals and boardrooms—including the Fort Worth mayoral office—he applied the principles of balance and scale to compose inviting interiors. "Regardless of the project, I create warmth and welcome by properly planning the space and applying crisp details while adhering to my clients' requirements for budget and need," the talented designer explained.

KENNETH JORNS, ASID
KENNETH JORNS & ASSOCIATES
3909 MOCKINGBIRD LANE
FORT WORTH, TEXAS 76109
METRO - 972.445.5151

LEFT: A historic Texas home reflects furnishings and backgrounds of the early 1900s. The custom-designed, four-poster iron bed is the focal point of this master bedroom.

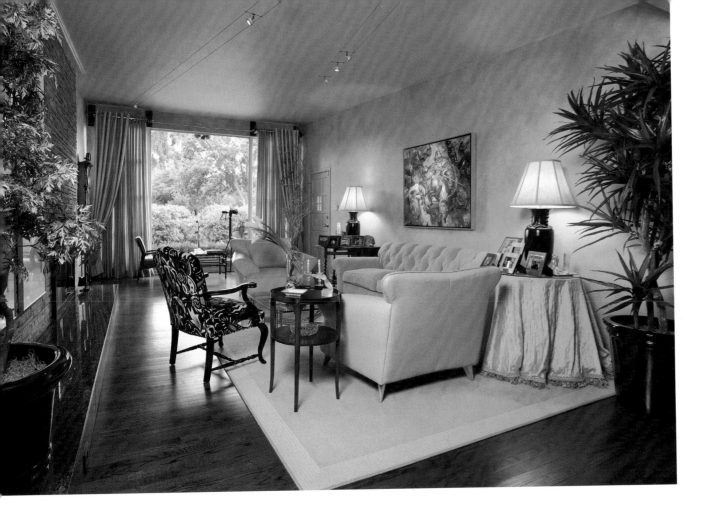

For a short period, Ken took a brief sabbatical and invested time in a personal cause. "I decided to use my cheerleading talents to start an area cheer squad called Cheer Dallas," he said. Though originally formed as a performing cheerleading squad to lend support for Team Dallas athletes, it wasn't long before the non-profit group started raising funds and awareness on a national level. "We were asked to participate in local, state and national events, programs, conferences and numerous fund-raisers for well-known organizations such as the Juvenile Diabetes Research Foundation, the Susan G. Komen Breast Cancer Foundation and various AIDS organizations," Ken said. "In fact, Cheer Dallas developed its own platform called Cheer for the Cure, which caught on with other organizations working to benefit incurable diseases." Before long, major cities like New York and San Francisco—who in 1997 awarded the pioneering Dallas squad with its coveted Cable Car Award—started their own "Cheer" groups, many of which are still in operation today.

ABOVE: A retro, contemporary '50s home with an eclectic combination of furnishings finds antiques from family members paired with a custom, tufted sofa and commissioned painting.

RIGHT: This dining room features a buffet and a table custom-designed by Ken, who partners with a library of gifted craftsmen and artisans.

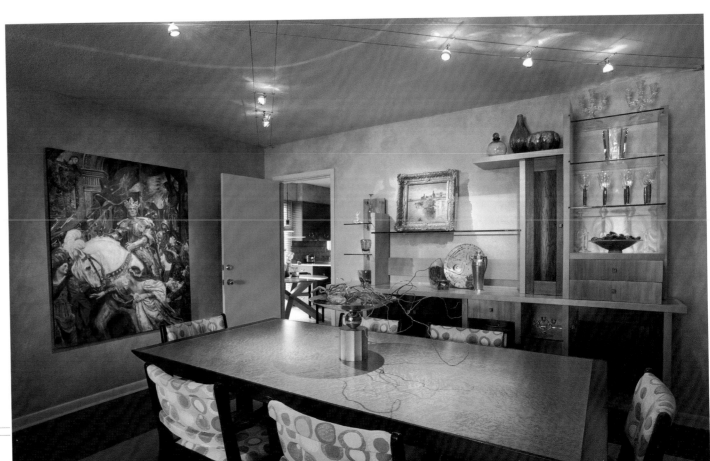

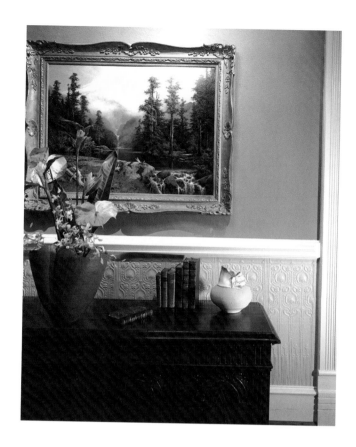

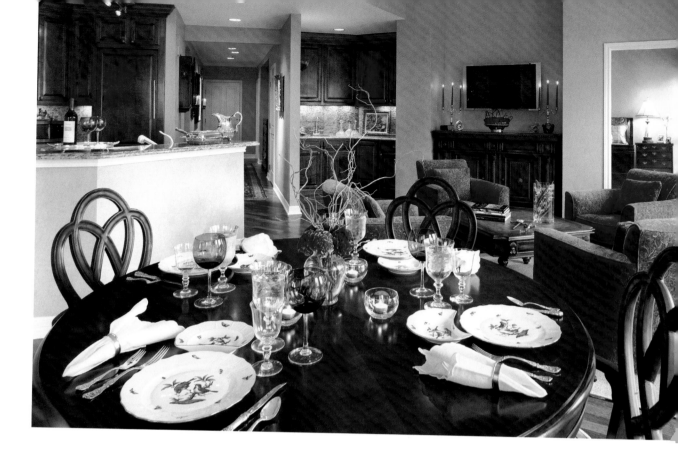

TOP LEFT: In this entry, a facsimile of "patterned tin" panels of wallcovering is the focal point. The antique chest is home to contemporary ceramics.

TOP RIGHT: The owner's traditional furnishings, which incorporate contemporary Donghia lounge chairs, aid in making the living room, dining room and kitchen work together in this high-rise condominium.

RIGHT: In this family room, tasteful accessories and primitive-style antiques complete the living space.

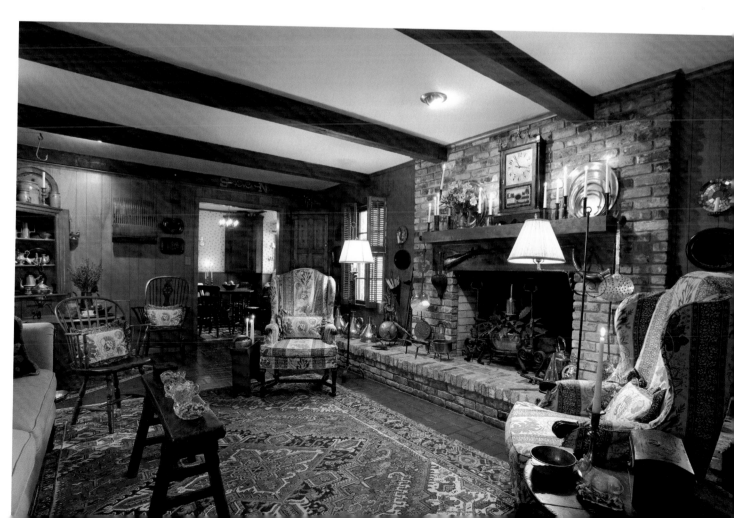

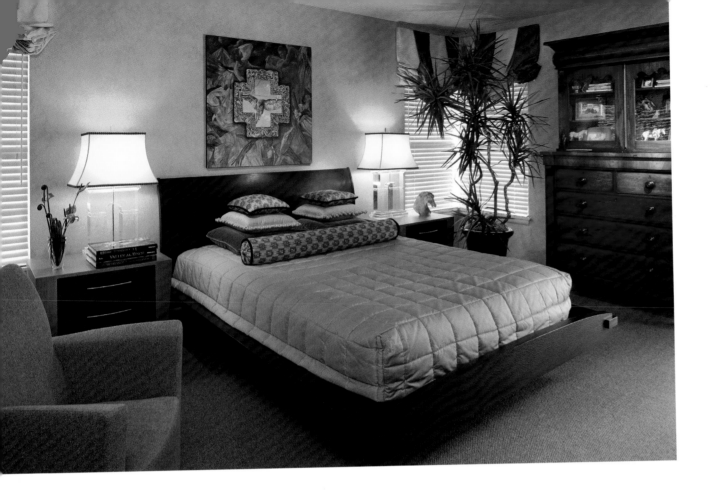

TOP LEFT: Creative design is evident in this successful mix of clean, contemporary lines punctuated with a touch of antiques.

BOTTOM LEFT: At first glance, this room looks contemporary. But a closer look reveals traditional pieces like the classic Kllamos lounge chair and chaise, circa 1600 B.C.

OPPOSITE PAGE:

TOP LEFT: The private office of this bank presents simplicity in a tasteful way. The antique skirt, framed under Plexiglas and topped with clay accents, adds texture.

TOP RIGHT: The historic entry warmly welcomes all who enter this tasteful, classically elegant environment.

BOTTOM LEFT: A view of the beautiful skyline makes this work space more enjoyable. Soft colors in the interior complement the exterior's colorful views.

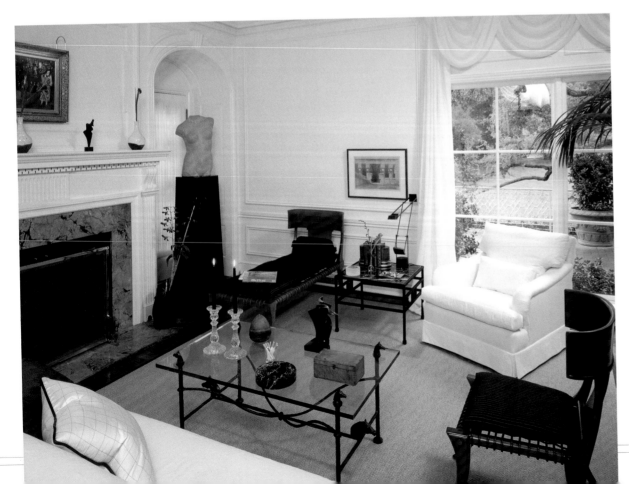

Ken dug back into his design business with renewed enthusiasm and focused fervor in 1998. Drawing from his extensive network of resources, Ken laid the business foundation that now enables him to provide a complete assortment of interior design consulting services. Today, he offers turnkey procurement of furnishings, fixtures, equipment and accessories for projects of every variety and scale.

With a continued focus in many industries, the respected designer is proudly serving corporate clients across the nation like Bell Helicopter, for whom he's designed everything from their world-class Customer Care Center in Texas and visible headquarters in the states of Maryland, Alabama and Texas to their noted Training Academy and entertaining Texas Motor Speedway hospitality suite near Fort Worth. Cook Children's Health Care System and other area medical facilities routinely benefit from his creative talents, as do hotels, restaurants and corporate executives, whose offices and boardrooms bear Ken's handsome signature.

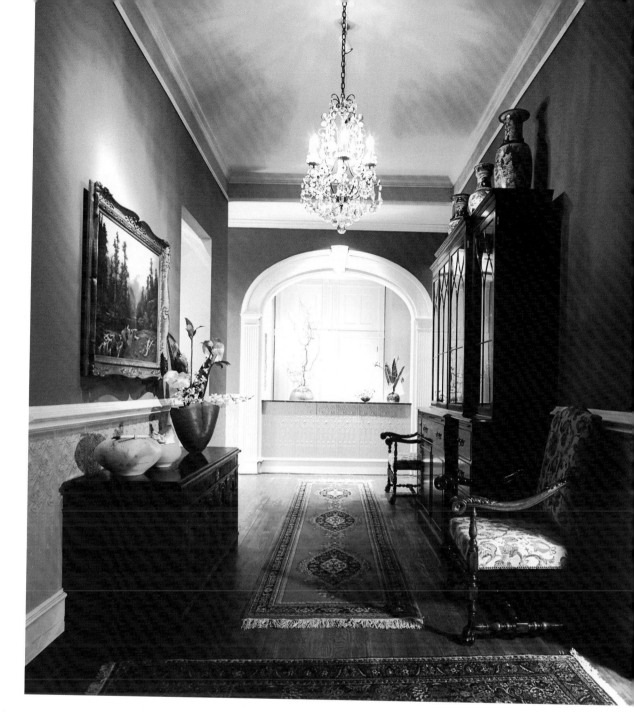

Traditional houses, luxury high-rises and vacation homes also fill the pages of the busy designer's expansive portfolio, which now includes the children of some of his early clients. "I'm honored that these families trust me to design homes that are representative of their lifestyles and personalities," Ken said. "Designing residences is very personal. To achieve a warm, welcoming room, I incorporate treasured belongings into a properly planned space; add a dose of color and the finishing details." Of course, what's inviting to some isn't necessarily appealing to others. "Every client is different. Some prefer contemporary, others traditional, and often there's a mix, which adds more interest and character."

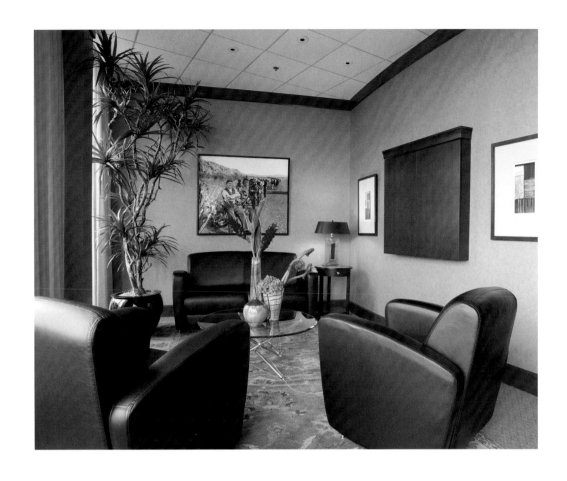
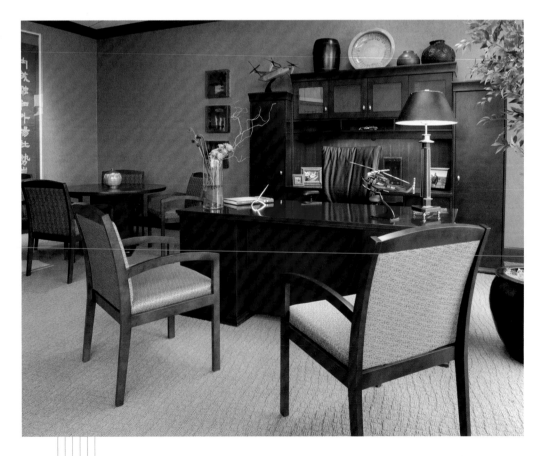

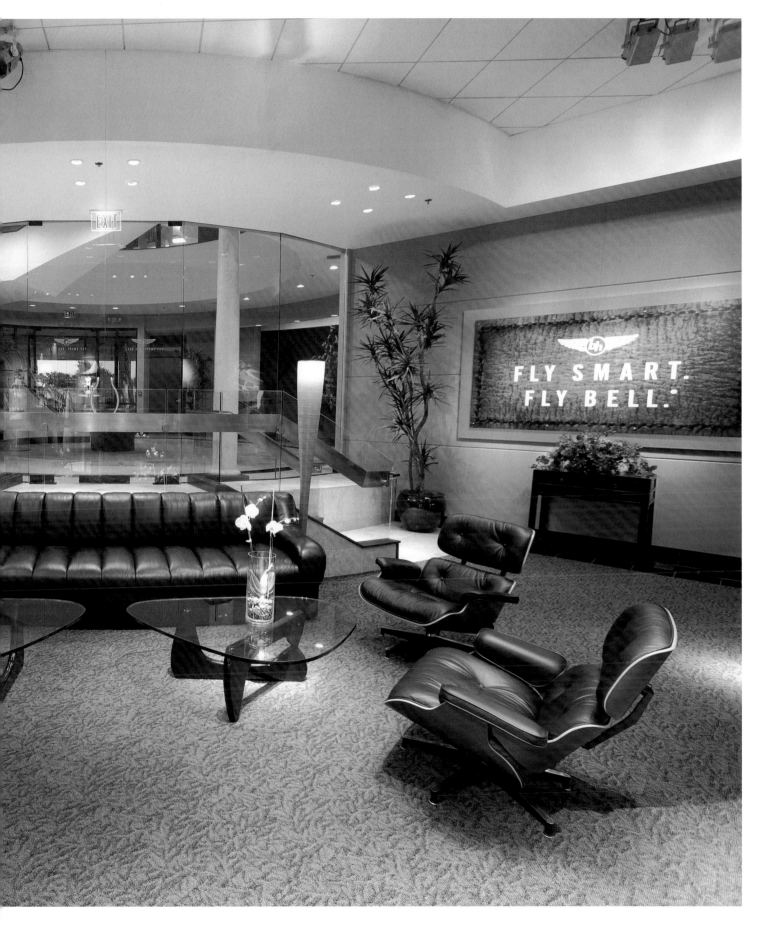

TOP FAR LEFT: The office of this Chief Executive Officer was personalized with a commissioned painting of him on his prized Harley Davidson.

FAR LEFT: Transitional-style furnishings are always a welcome touch. The rich mahogany tones and softly colored fabrics and background helps set off the accessories and art.

LEFT: Classic Eames lounge chairs, a custom channel-back leather sofa and floor lamps resembling helicopter rotor blades help make Bell Helicopter's Customer Care Center a state-of-the-art facility.

Regardless whether the project is residential or commercial, eclectic or traditional, Ken's goal is to understand the client's voice. "I work for my clients. I have to hear their voices. If the finished designs don't fit them perfectly, then I haven't done my job," he explained.

To creatively craft the harmonious interiors for which he's sought, the affable Ken partners with his clients, gently guiding them through the process that can sometimes be daunting. He builds consensus with the client, architect and contractor, and while being responsive to the needs of each, he gets the job done—on time and within budget. The result? An enjoyable experience…and designs that work!

When people step into these spaces, I want them to immediately experience a sense of delight," Ken confessed. "For me, there's no better reward." ∎

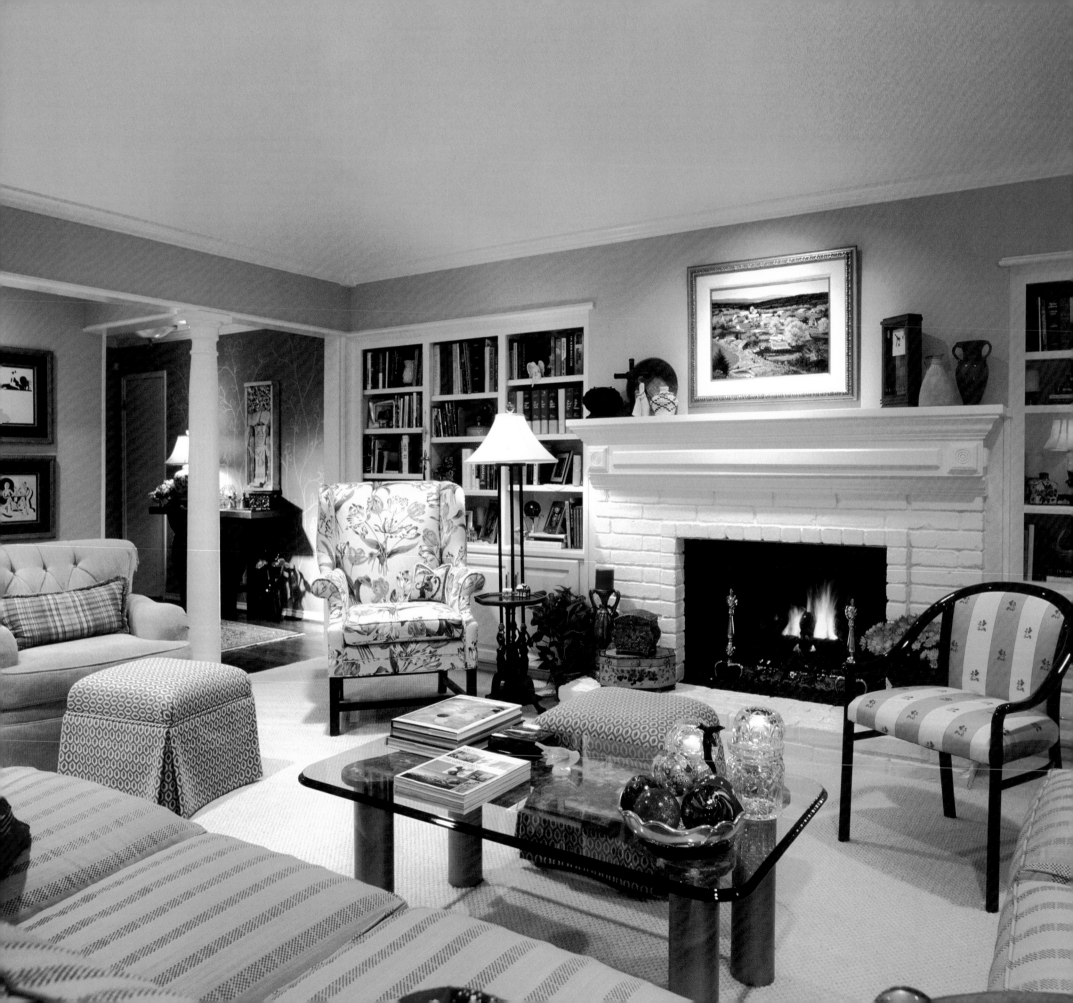

Judith Marsee, ASID

MARSEE DESIGN, INC.

ABOVE & LEFT: A residence built in 1968 was transformed and updated. Dark-paneled walls were removed to create an open living area and a large dining room.

ABOVE: In the family since 1929, this Highland Park home was renovated blending the owner's contemporary furnishings with the home's distinctive original woods and antique pieces.

Arlington-based designer Judith Marsee believes that homes should be a welcoming haven in which to relax and refresh. "To achieve this goal, I create designs that are elegant and comfortable, stylish and intimate," she said.

A graduate of the University of Texas at Arlington with a degree in architecture and a concentration on interior design, the founder and principal of Marsee Design, Inc. began her career creating commercial interiors. For more than 16 years, she focused on corporate design for noted companies like Johnson & Johnson Medical, Inc., The Bombay Company, Inc. and the American Paint Horse Association's corporate headquarters.

In 1995, Judith began designing houses after being drawn to the more intimate elements of residential design. Believing strongly that the home is the core of any person or family, she designs residences that reflect the distinct personalities of their owners while emphasizing function and comfort.

Judith's success in residential design comes from her ability to listen to her clients, assess their needs and propose unique creative solutions to a variety of design challenges. With a gift for organization and scheduling, she oversees every project from conception to completion, marrying existing furnishings and antiques with contemporary acquisitions to create seamless, inviting interiors.

Her stellar designs and her warm approach have rewarded Judith with an endless following of satisfied clients who remain dear and valued friends. ■

JUDITH MARSEE, ASID
MARSEE DESIGN, INC.
P.O. BOX 13190
ARLINGTON, TEXAS 76094
817.469.6101

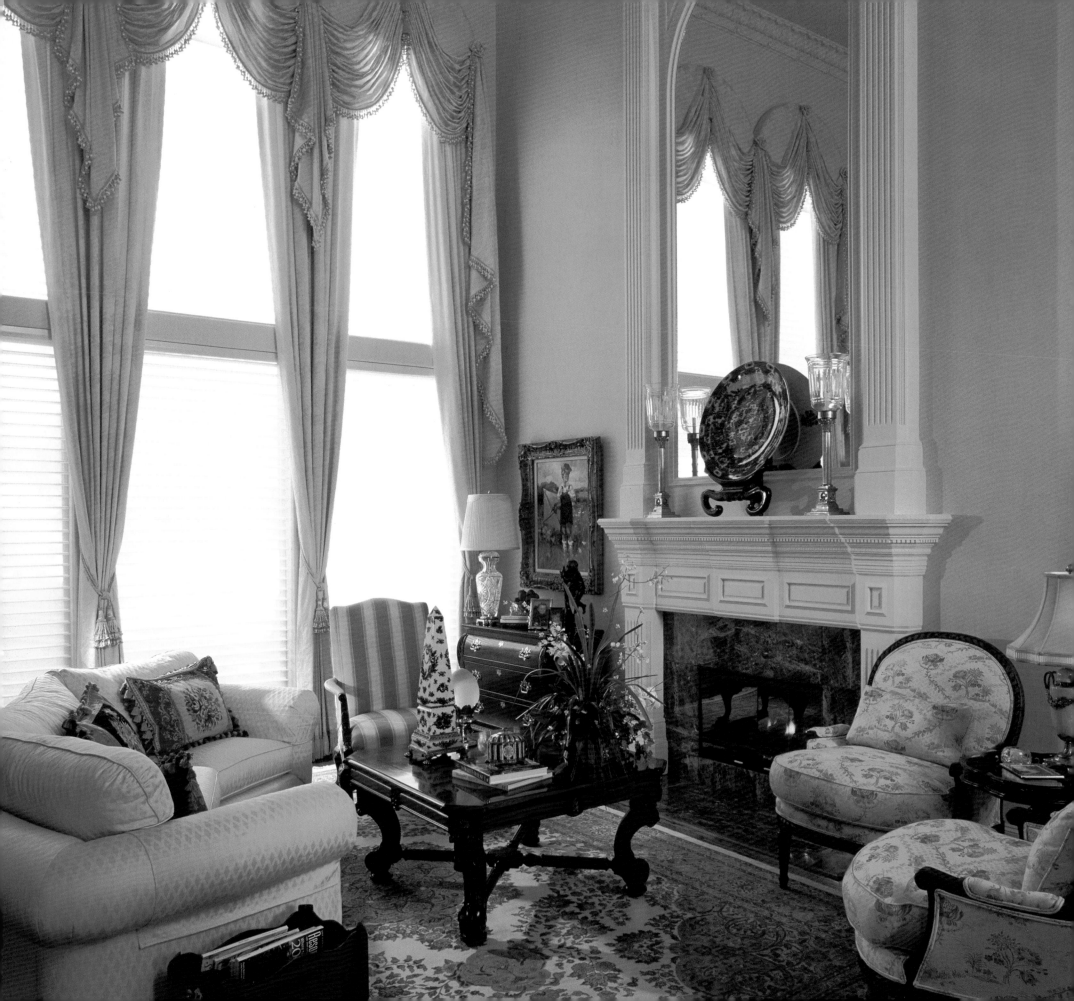

Jeffrey McAllister, ASID

THE DESIGN STUDIO OF GABBERTS

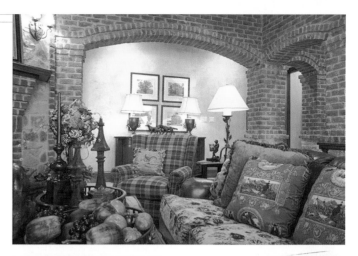

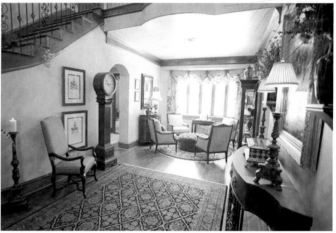

TOP: Colorful combinations of plaids, florals and leather, along with the brick architecture, generate a place to gather.

ABOVE: The warm and inviting colors in this spacious entry lead to an intimate seating area around an oversized, tufted ottoman, bidding guests to come in and visit.

Planning usable spaces is essential to Jeffrey McAllister's success. "Interior design is much more than decorating. It is the process of discovering clients' preferences while getting to know them and their lifestyles." As a senior designer for The Design Studio of Gabberts in Fort Worth, Jeffrey has tackled the most challenging design issues with prized solutions. Whether it's first-time buyers, savvy business owners or empty nesters, Jeffrey devises a plan to fit every client's needs—and budget.

"While some clients ask for my assistance on new construction, many seek my help with remodeling, which I also enjoy, explained Jeffrey. "Some of my projects are done in several stages and devising a master plan is helpful to clients because they can call me when they're ready to pursue the next phase."

Jeffrey's access to some of the country's finest furniture and accessories through Gabberts enables her to quickly respond to every client's request, resulting in award-winning interiors for every lifestyle. "Every client is unique. That's why I spend time understanding their needs before designing spaces for them."

Casually elegant bedrooms with a French flavor. High-rise homes that meld the old and the new. Commercial offices with functional style. Ranch houses reminiscent of the Old West. These are signature designs in Jeffrey's portfolio of satisfied clients. They are also interiors that are rich with colors and textures that provide a welcoming ambience. "Rooms should be inviting places to live, work or play," Jeffrey said while insisting that surroundings should also be comfortable. "Even the most formal settings should make one feel at ease."

LEFT: Lavish details, silk fabrics, trims and antique needlepoint pillows create this elegant and inviting living room.

JEFFREY MCALLISTER, ASID
P.O. Box 100925
FORT WORTH, TEXAS 76185
817.360.2353
WWW.JEFFREYMCALLISTERINTERIORS.COM

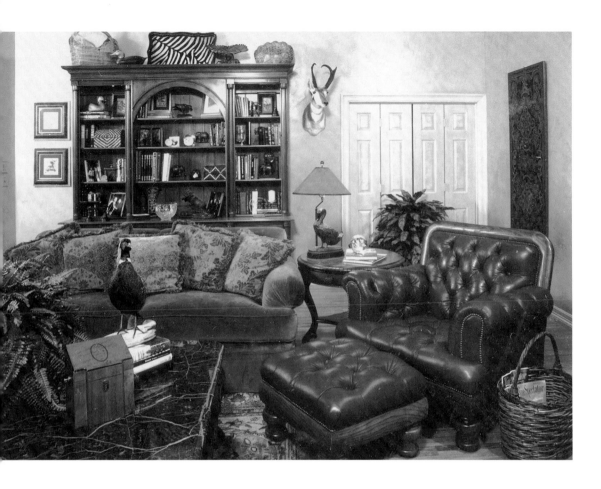

LEFT: This masculine retreat uses memorabilia and trophies from big game hunting excursions to create a cozy and inviting room.

BELOW: French architectural details inspired the mood for this soft aqua and cream bedroom. Silk draperies and bedcovers create an ambiance of formality.

OPPOSITE PAGE:

RIGHT: A soft, silky flowing valance and embroidered sheers make a dramatic backdrop for this elegantly traditional dining space—perfect for formal entertaining.

Jeffrey calls on her more than 20 years' experience to compose her attractive interiors. Initially a silk floral designer, she wanted to be involved with more of the project. So she enrolled in Texas Christian University, where she received a bachelor of science degree in interior design. Her career journey began with her ownership of a business, followed by hands-on training at another design company. She arrived at Gabberts, where she joined The Design Studio in 1997.

Throughout her interior design career, Jeffrey has remained true to one important mantra: provide the highest level of care and concern to each project. Doing so enables her to open the lines of communication so she can fulfill her clients' needs and create notable interiors like the bedroom she designed for a Colleyville showhouse that earned her the "Best Master Suite" award.

Earning recognition for her work is appreciated, but Jeffrey derives satisfaction from knowing that her clients are pleased with the final project. "My greatest sense of accomplishment comes from being able to help clients create an environment that reflects their personalities and tastes." Whether that means widening a doorway to accommodate a wheelchair, topping a table with family heirlooms or dressing a window with brightly colored fabrics, Jeffrey puts her personal preferences aside so she can create interior designs that perfectly fit each client. ∎

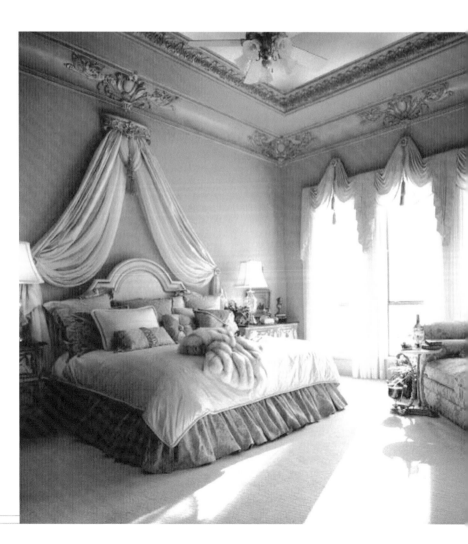

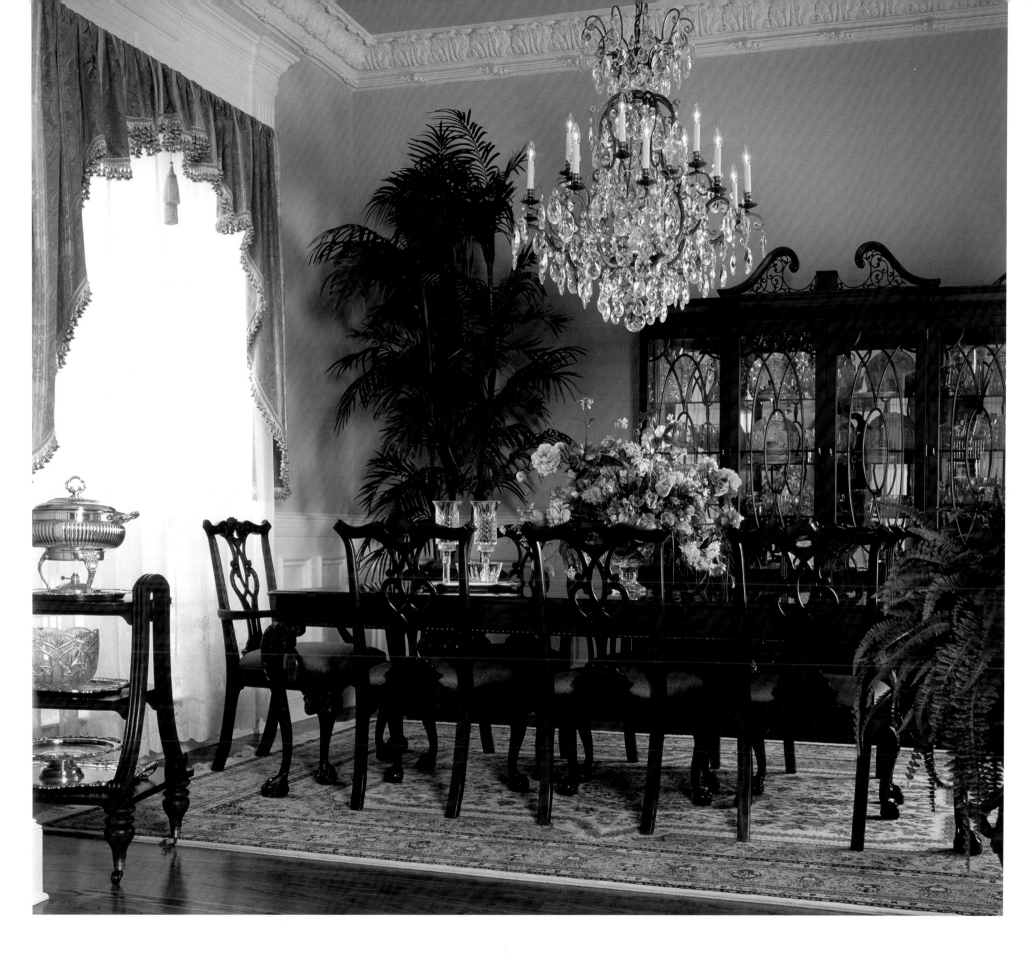

Dianne Rose, ASID

DIANNE ROSE INTERIORS

With a major in interior design and a minor in art, Dianne Rose set out on her more than 30-year career as an interior designer. Her first stop was at an architectural firm that specialized in commercial design. While outfitting offices and country clubs, she was approached about designing residences.

Dianne landed on the doorsteps of some of the area's finest homes in Fort Worth, where she answered the call to design interiors fitting for every lifestyle. With quality on her mind, she personalized designs for functional, yet beautiful, homes with finishing touches like custom fabric treatments and fashionable accessories. Her desire for easy access to outstanding products with which to her complete her designs led to the 1997 opening of her retail store, Dianne Rose Interiors.

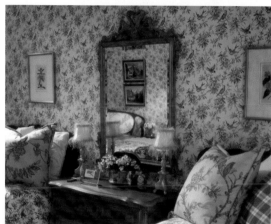

Dianne attracts new design clients who enter her inviting Camp Bowie shop looking for a special piece of antique furniture, fine porcelain or original art from the five artists whom she represents. While they may leave with a Majolica platter or an English dresser, they soon return to join the loyal following of clients who depend on Dianne to transform their spaces into the "sophisticated elegant" interiors for which she's known.

Dianne's signature style can be seen throughout the new homes and remodels that grace the neighborhoods of Fort Worth. Her classic, clean lines are timeless and her attention to detail unrivaled. Every element is part of a well-constructed plan that begins with freehand drawings and ends with livable spaces.

Perhaps that explains the satisfied clients who consistently trust Dianne to deliver designs that work. ■

TOP RIGHT: The chest is at home with the antique books, an original oil painting of the Netherlands and an antique Rose Medallion.

RIGHT: This blue-and-white room is accented with yellow-and-blue toile, which dresses the French-style settee. French cane twin beds–with antique botanical prints hanging overhead–provide the focal point. Reflected in the Italian gold-leaf mirror are two original oils of the Swiss countryside. The chest-of-drawers is a French reproduction in a white, crackled finish. A pair of small lamps with "eye-lash" trim add a whimsical touch to the setting that has a floral arrangement in a cricket cage.

LEFT: This dining room is dressed with blue-and-white antique Chinese porcelains and an antique mirror, which reflects an original oil purchased for cartons of cigarettes in Germany just after World War II.

DIANNE ROSE, ASID
DIANNE ROSE INTERIORS
4630 CAMP BOWIE BLVD.
FORT WORTH, TEXAS 76107
817.732.7666
WWW.DIANNEROSEINTERIORS.COM

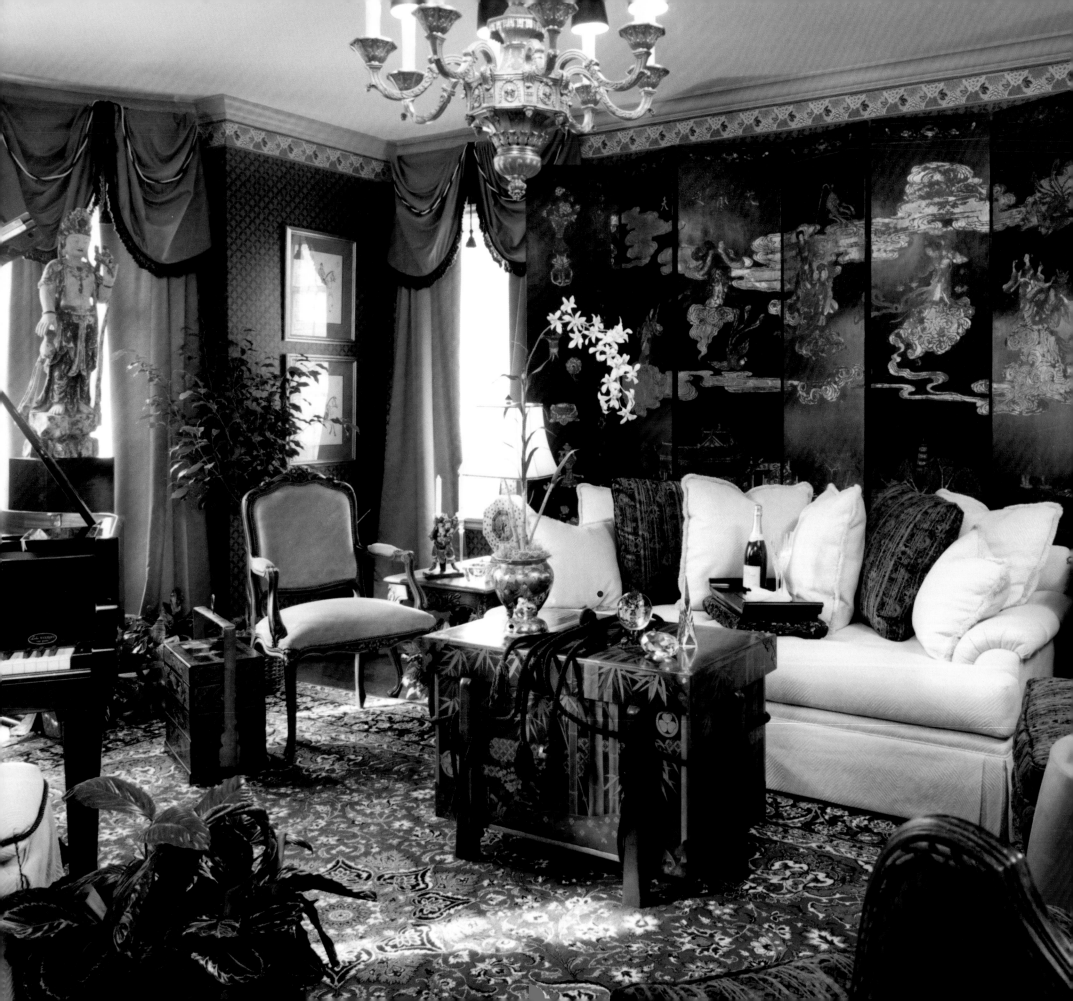

Mary Stelter, ASID

PARK HILL DESIGNS

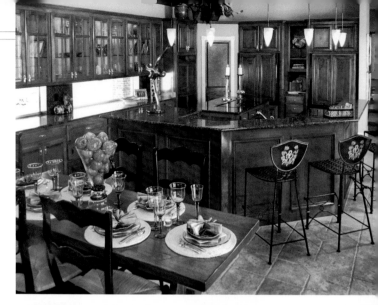

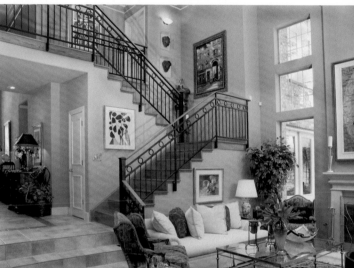

TOP: This eclectic kitchen features French and contemporary accents.

ABOVE: This transitional living room was built around the homeowner's art collection.

Fort Worth designer Mary Stelter remains open to the possibilities in life. Whether it's traveling to Mexico with friends or collecting modern art—two of her many passions—Mary adopts a sunny, "can-do" attitude that's reflected in her designs.

"I try to incorporate something different and fresh into each design," Mary explained. "I love it when clients trust me to explore the possibilities." Though she strives for the unique, Mary's creations are not trendy. "I listen to what my clients want and build them classic designs that last."

During her 34-year career that included a stop at The Design Studio of Gabberts before opening Park Hill Designs in 1983, Mary has left her timeless mark in homes and offices in the Dallas-Fort Worth Metroplex, though she has also helped clients in Minnesota and Iowa. From new construction to extensive remodels—and everything in between—Mary prides herself on delivering common-sense solutions that fit a client's needs. "The clients are the most important part of my business," she said. "I do what's needed to make them happy."

That may explain why Mary, a former president of the Texas ASID, is now designing for the children of valued clients. "It's true that I'm helping the second generation of certain families," she said. "What fun!"

It's that refreshing attitude—along with her total honesty and accurate instincts—that keeps Mary in demand. Whether designing a million-dollar house, adding a home office or helping a neighbor with an elaborate party, Mary jumps in head first with creative energy and invaluable experience. The result? Personalized, one-of-a-kind designs reflective of the people who live or work there. "I get great joy out of clients who profess their love for their interiors," Mary declared. "There's nothing more rewarding that hearing the words, 'It's wonderful!'" ■

LEFT: This traditional living/music room was inspired by the owner's collection of oriental artifacts.

MARY STELTER, ASID
PARK HILL DESIGNS
3533 CLUBGATE DRIVE
FORT WORTH, TEXAS 76137
817.232.5952A

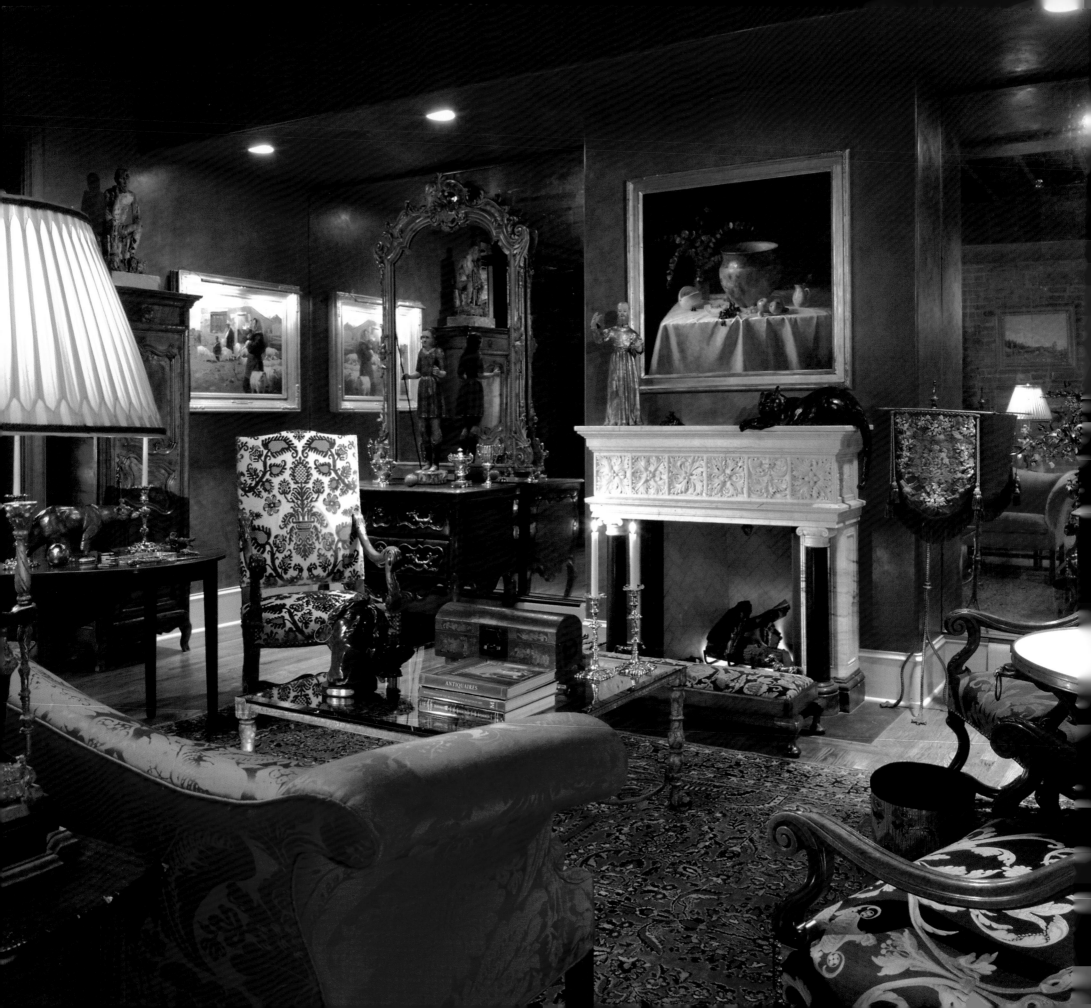

Amy Walton, ASID

WALTON AND WALTON

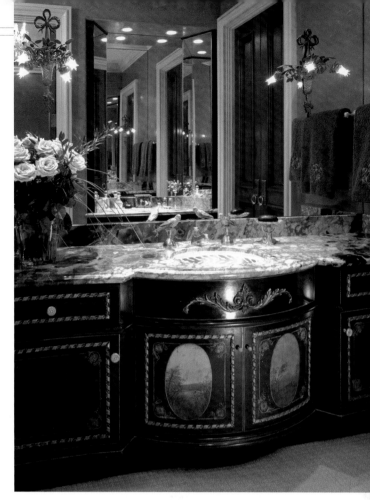

ABOVE: A master bathroom uses rare Breccia Vendome marble on a hand-painted custom vanity to impart a look of antique furniture.

LEFT: Amy transformed a century-old commercial building into an elegant residential loft that is sophisticated enough to accommodate a worldly couple and their fine possessions.

The advice of a teacher led Amy Walton to a career in interior design. "Recognizing my talents, a professional designer who was teaching an undergraduate course urged my parents to enroll me in Pratt Institute in New York," she said. The move proved to be life changing. "While there I not only gained invaluable training in my chosen field of interior design, I met my future husband, architect Randall Walton."

The husband and wife team now own Walton and Walton, an integrated architectural and interior design firm located in Fort Worth. Through this rare collaboration of disciplines, the firm works cohesively, meeting their clients' needs and expectations from the outside in and the inside out.

With input from each client regarding function, style and taste, Amy creates hand-drawn sketches to visually guide clients through the process as she weaves their extraordinary interiors. From stately residences steeped in tradition to colorful adobes akin to their geographical digs, each detailed design reflects the characteristics of the people who live or work there. "Designers are illusionists who incorporate the principles of balance and scale to create imaginative interiors," Amy explained. "I immerse myself into my clients' worlds so that when I emerge, their designs capture the visions they desire."

Often that means incorporating custom-made furniture built by caring craftsmen. Other times it means adding hand-forged ironwork, carved marble mantels or intricate fabric trimmings. Always it results in clean, classical designs that age gracefully and beautifully, regardless of the style.

The award-winning designs for which Walton and Walton is known has led to publication in numerous magazines. And while the recognition is welcomed, Amy acknowledges that true satisfaction comes from the loyal clientele who seek the services of the acclaimed firm. "Our clients become our friends. They trust us to deliver designs that perfectly fit them." ■

AMY WALTON, ASID
WALTON AND WALTON
1407 TEXAS STREET, SUITE 104
FORT WORTH, TEXAS 76109
817.732.1536
WWW.WALTONWALTON.COM

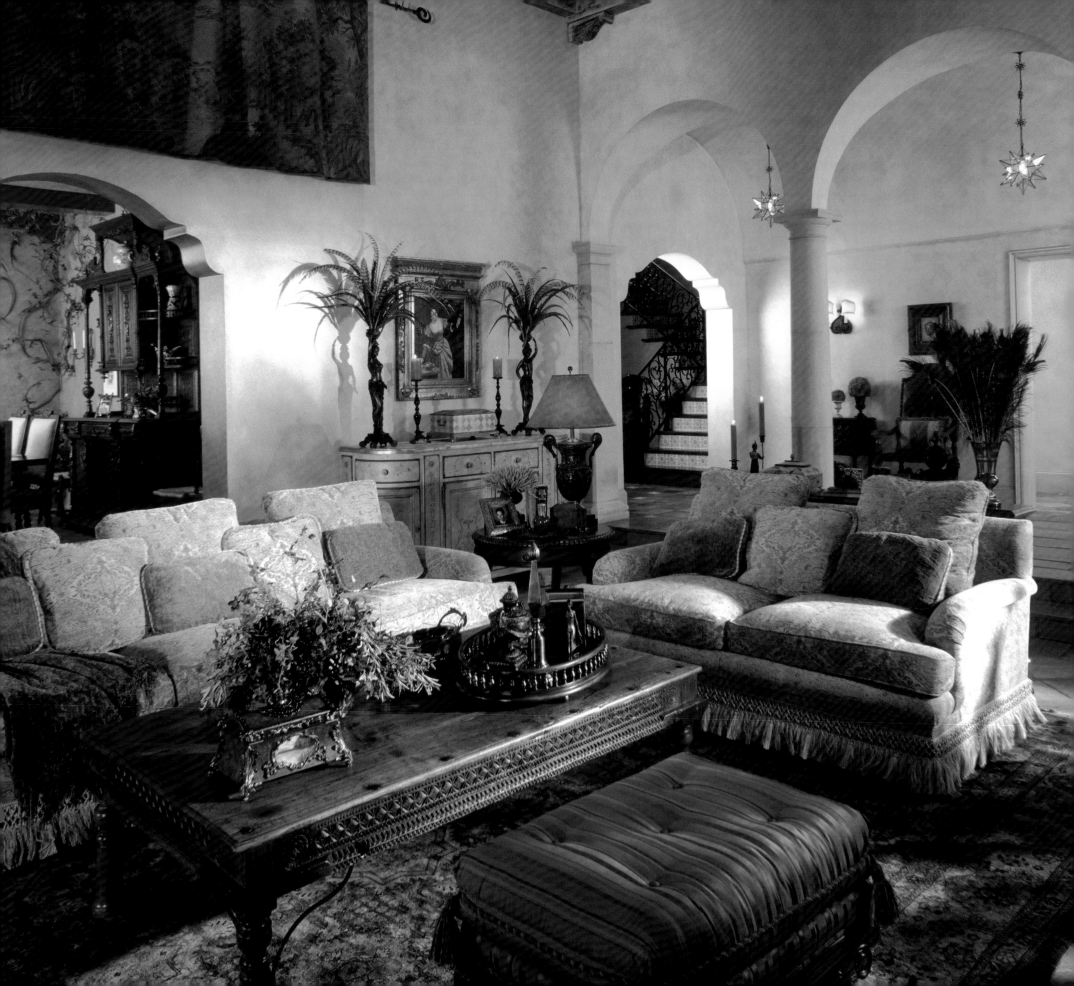

Dennis Waters, ASID

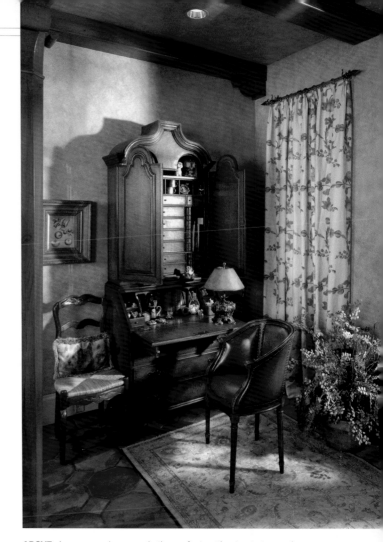

A raging snow storm in Chicago prompted Dennis Waters' move to Texas. "I was tired of the freezing temperatures, so I packed my belongings and headed south of the Mason-Dixon line." A warmer climate and a promising career in interior design greeted the North Carolina native when he landed in Dallas nearly 30 years ago.

"I arrived with S&A Restaurant Corp., where I was on a design team for the company concepts before I was promoted to heading the Steak and Ale concept," said Dennis. "As design director, I created everything from prototypes and interiors to uniforms…the complete ambiance of the concept." Armed with this hospitality experience—and that from his early days with Karl Steinhauser Associates, Childs-Dreyfus and Grignon Studios, where he learned about turnkey installations, designing showrooms, photography and film set design and model homes—he opened his own company, Dennis Waters Designs, Inc.

Through his company in Southlake and his affiliation with The Design Studio of Gabbert's in Fort Worth, Dennis applies his valuable knowledge to create award-winning interiors. Primarily residential, his projects are rooted in Texas. But his designs cross state lines into places like Jackson Hole, Wyoming; Denver, Colorado; Scottsdale, Arizona; New York, New York; and Washington, D.C. Add to that a restaurant in Monterrey, Mexico and you've got a body of work that's as expansive as Dennis' creative styles.

"From traditional to contemporary, I excel in themes that capture the essence of a region," explained Dennis. "I am not shy about using drama and glamour if the project invites those elements. At the end of the day, however, the design should stand the test of time, evolving with a client's needs and interests."

DENNIS WATERS, ASID
475 BENTWOOD LANE
SOUTHLAKE, TEXAS 76092
817.481.7984
WWW.DENNISWATERSDESIGN.COM

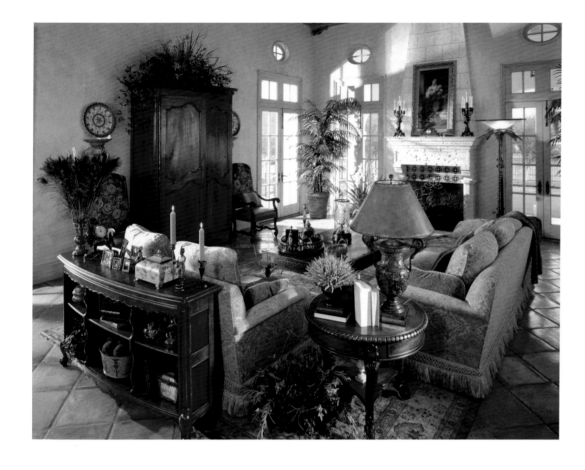

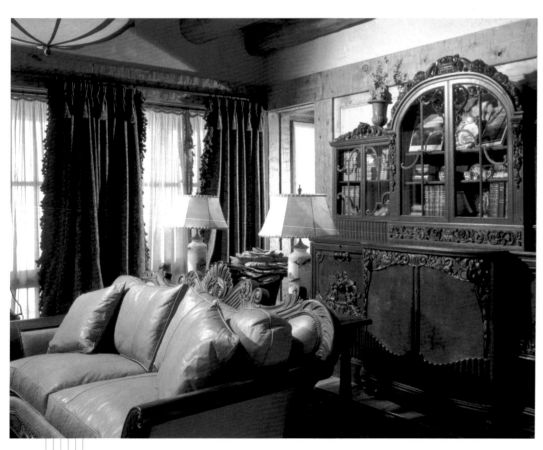

Where does Dennis find inspiration for his lasting designs? From his journeys around the world to places like Europe, Southeast Asia, North Africa, Central America and the Ukraine. "The genesis for my architectural designs comes from my travels, where I absorb as much as possible the essence of a country." This translates into elements like roof tiles similar to those found in Dubrovnik or mosaics patterned after a cathedral inlay in Venice.

At the core of Dennis' worldly visions are the basics of sound design. "I subscribe to the philosophy that form should follow function," he said. To arrive at that destination, Dennis listens to, learns from and observes each client. By engulfing himself in his client's world, he establishes trust and opens lines of communication. Doing so enables him to accomplish his client's stated goals and develop the livable interiors for which he's known. "I create living designs that incorporate the important attributes of style and taste."

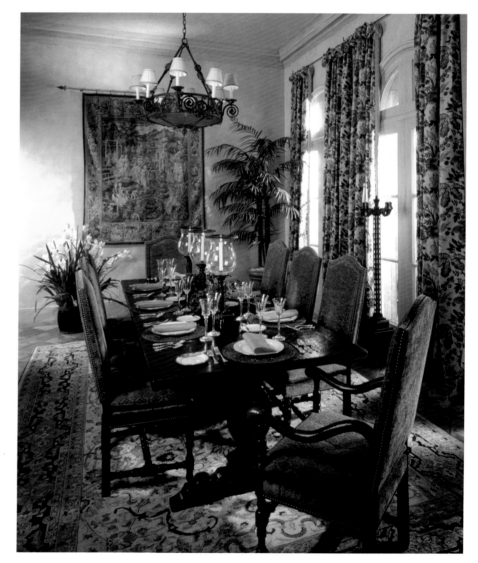

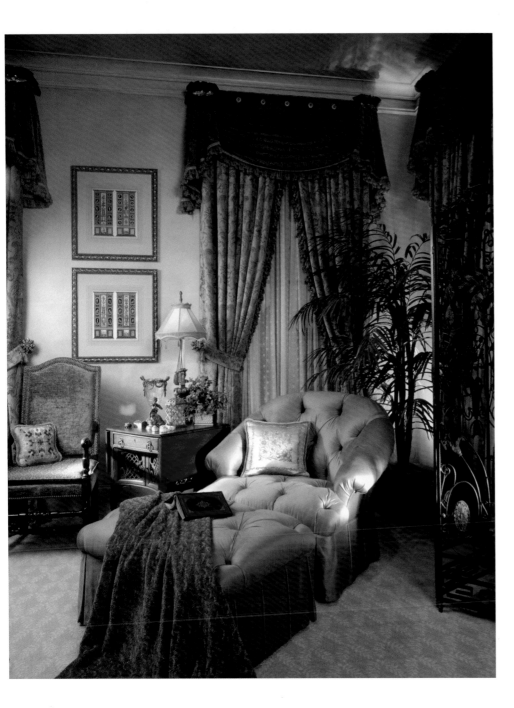

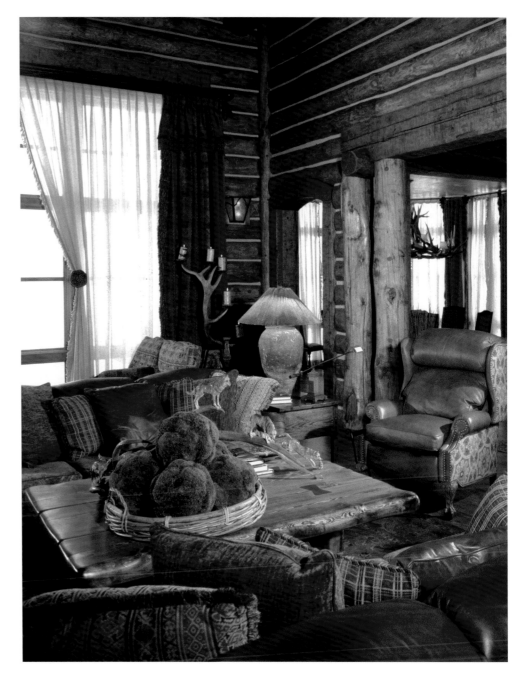

Testament to his design approach is Dennis' own residence. A showcase of his work and talent, the Italian, contemporary, western rustic and gothic styles merge to create a pleasing and interesting mix of moods and motifs. Dennis considers it one of his finest accomplishments. "The harmonious blend of styles pay homage to many of my favorite projects," he said. "And the knowledge I gained from designing, specifying, building, decorating and installing my own home has been invaluable."

Solid experience. Broad visions. Lasting interiors. These destinations are the mark of Dennis Waters, ASID. ■

ABOVE LEFT: This is an elegant and intimate reading area designed for a master bedroom suite. Custom decorative hardware and exquisite passementeries provide the backdrop for these luxurious furnishings.

ABOVE: This great room of grand proportions, nestled at the base of the Grand Tetons in Jackson Hole, Wyoming, lives up to its name.

OPPOSITE PAGE:

TOP LEFT: Relaxed elegance was the theme for this room. Besides being designed for entertaining, the goal was to incorporate the pristine views of the outdoors.

LEFT: A handsome library for a private retreat in Jackson Hole, Wyoming, captures the rustic charm of the region.

RIGHT: This Tuscany inspired formal dining room is inviting and richly appointed in every detail.

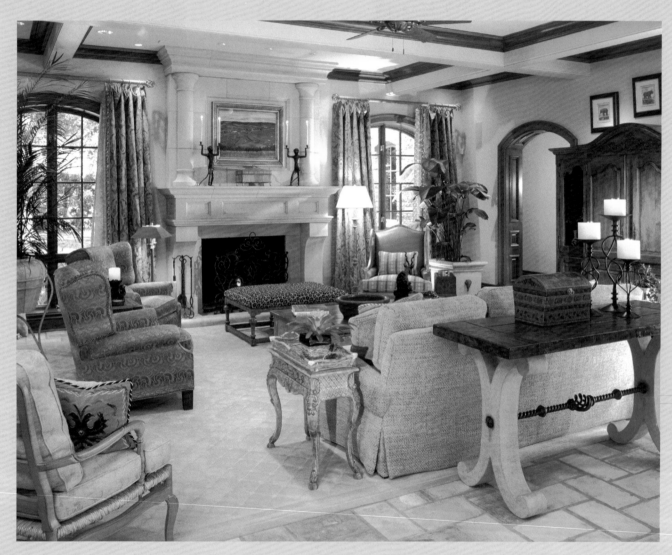

JANE PAGE CRUMP, ASID

Houston

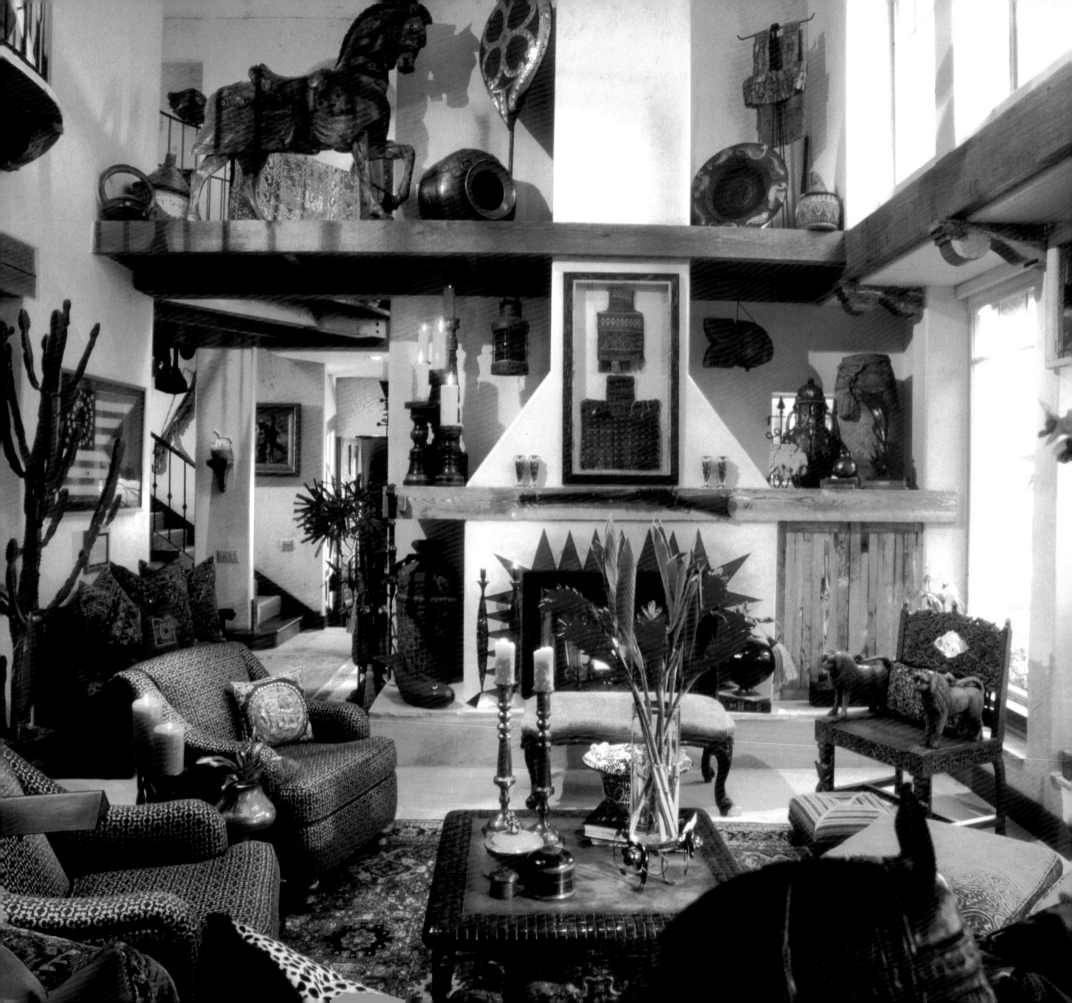

Peggy Lee Baker, ASID

PEGGY LEE BAKER INTERIORS

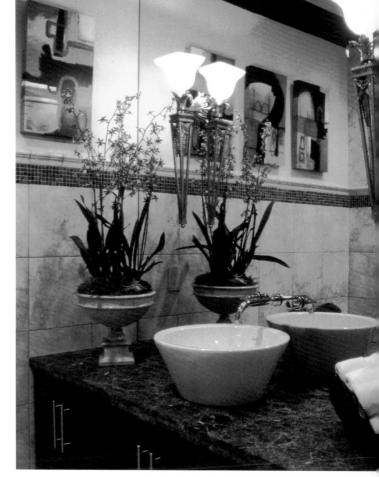

Peggy Lee Baker is a passionate interior designer who believes that each home should reflect the owner's personality. To achieve this goal, she takes the time to visit with each of her clients, learning as much as she can about their preferred styles, their personalities and their likes and dislikes. "Individual attention is the key," Peggy stated. "I openly communicate with each client to educate them through the design process and to meet their specific requirements."

Her Houston design firm, Peggy Lee Baker Interiors, has earned a reputation for consistently providing magnificent residential spaces. With 20 years of interior design experience, Peggy strives to make her clients' homes special by meticulously picking each object in an interior. "I only select items that mean something to my clients," she explained. "I search high and low for items that I know my clients will treasure and talk about with their friends." Often she personalizes her quality designs by incorporating her clients' collectibles or other significant belongings.

Finding a unique style for each of her clients is important to Peggy, who travels the world searching for inspiration. Many of her eclectic design ideas are a result of her journeys to other countries, where she pays close attention to architectural and design details. "I have found that the interiors in Europe, Mexico and the Caribbean reflect a much more casual attitude," she said. "You see some of the wildest combinations."

LEFT: Strong architectural details, such as those in this living room, provide an interesting foundation for displaying this couple's collection of art, treasures and antiques. Peggy took extra care in creating balance in the space.

PEGGY LEE BAKER, ASID
PEGGY LEE BAKER INTERIORS
15 WATERFORD OAKS LANE
KEMAH, TEXAS 77565
713.991.2029

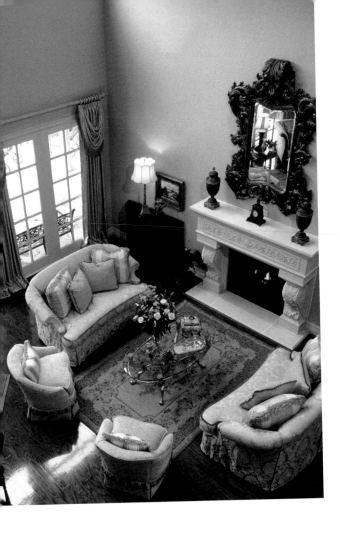

TOP LEFT: Peggy's clients requested an elegant, traditional–but updated–living room design. The traditional elements are repeated through out the space where hardwood floors, a French limestone fireplace, and a French aubusson-style rug are paired with richly upholstered furniture in silks, damasks and velvets. The oversized gold-leaf mirror balances the scale of the fireplace and provides a strong focal point for the two-story space.

LEFT: Peggy specified diamond shaped "pillow" travertine tile for the walls and vanity of this exotic powder room. The vanity vessel is made of chiseled red travertine to complement the red alabaster Italian sconces. The walls have layers of texture and bronze metallic paints.

RIGHT: This round master bedroom features a custom-carved antiqued bed crown draped in yards of iridescent silks. The antique rug blends fabulously with the hand-painted moiré velvet bed coverings. The accent pillows are Fortuny fabric handmade in Italy. The "four seasons" antique walnut carved side table is English, and the hand-carved stone Saint Francis statue is from Central Mexico. The tufted chaise is covered in woven raw silk.

Peggy is comfortable mixing international styles. "As long as you adhere to the basic design principles and the room is balanced," she said, "these designs look great." Her masterful blend of contrasting styles results in a much more interesting look. "I love to take Spanish colonial and throw in some French provincial or add a contemporary feel to a classic Mexican hacienda," she exclaimed.

Learning the basics of quality design at the University of Houston, Peggy graduated with a degree in interior design. She is NCIDQ-certified and takes pride in her professional memberships in the TAID and the ASID, whose Texas Gulf Coast Chapter issued her a prestigious 2004 Presidential Citation for distinguished service in honor of Peggy's commitment to her profession.

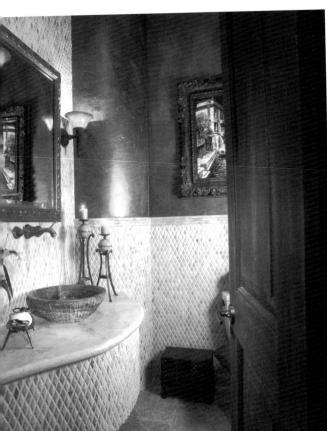

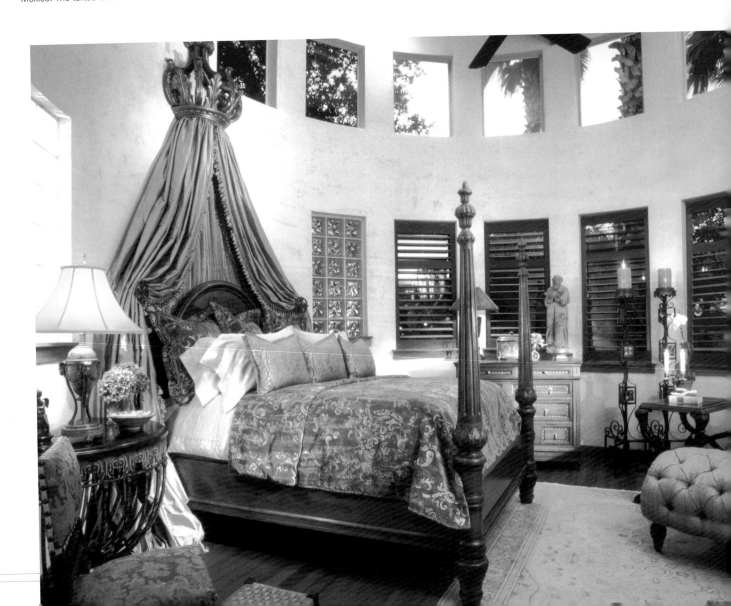

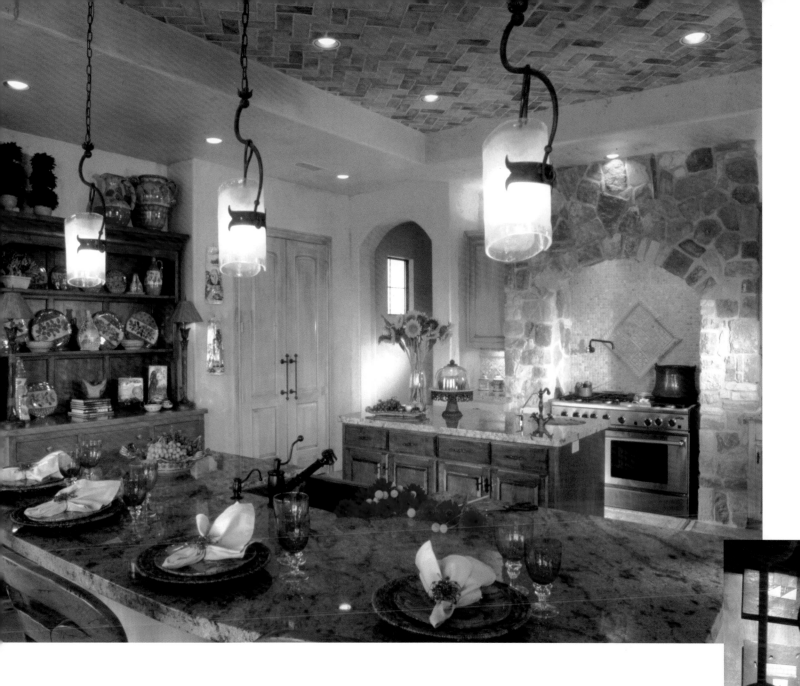

LEFT: This open "'eat-in'" style kitchen features double island and sink areas, which provide for the shared cooking duties of the residents. Peggy selected bold and richly layered textured finishes, such as brick ceiling, stone cooktop surround, travertine mosaic backsplash and glazed cabinets, to complement the Mediterranean style of the home. The pendant lamps are handmade from Italy.

BELOW: The original art collection and Italian glass tile counter tops can be see through the custom iron doors, designed by Baker. The round glass roundels were incorporated in the wine room door design to imitate the bottoms of wine bottles. The vibrant colors add a touch of whimsey to the small space.

Dedication to her craft extends to her vision of the future. "I see designs in the United States heading in a more casual and comfortable direction," Peggy said. But she is quick to add that her clients still want to emulate luxury in their homes. "The trend is toward natural colors and materials that look and feel luxurious, but translate into comfort," the respected designer said.

No matter the trend, Peggy's ultimate goal is to please her clients. "If my clients are happy at the end of the design process, then I feel I have been successful in enhancing their homes to be as pleasing as possible." ■

Ginger Barber, ASID

GINGER BARBER INC., INTERIOR DESIGN

"Keep it simple" is Ginger Barber's motto. Her love of an uncomplicated look, paired with natural, textured materials provides the cornerstone of her delightfully harmonious designs for her residential clients and retail store, The Sitting Room. "The key to creating a peaceful balance is to not have too many wonderful things together," she explained. "A room should not look decorated. I find one strong item and work around it, letting one piece dominate the group."

Ginger's signature design style arose from the early influences of growing up in an old cottage on a small island off the coast of Florida with a decorator mother and an artist grandmother. She was surrounded daily by the constant creativity of her family and the relaxed, rhythmic beauty of island life. "I grew up with sisal mats on the floor," she said. "I love to mix formal with informal styles and toss in something with texture. Anything woven is best–clay with wicker, stone with wicker–then I'll throw in a great silver piece that just feeds the eye."

After training in design at Sarasota's Ringling School of Art and Design in Florida, Ginger moved to Houston 30 years ago and launched her own interior designer firm. She has an extensive background in both contemporary and traditional interiors, which is evident in her design work where she skillfully combines the classic elements of style, both past and present. In 1993, she decided to expand her business by opening The Sitting Room, which is located in West University Village on Edloe. That move proved to be an exciting success.

"I want to be more accessible to customers," said Ginger. "I feel it's important to give them the opportunity to meet me and get a tangible feel for my work." A tour through her 2,000-square-foot shop offers real room settings filled with new and vintage garden-style furniture and accessories, dried topiaries, beautiful wicker baskets, unusual lamps mixed with natural fiber upholstery and European antiques. "Mixing styles and textures is a wonderful way to add interest in a design," she explained. "It makes interiors feel relaxed and simple. My clients love the look, often saying that I 'Ginger-ized' their homes!" ■

GINGER BARBER, ASID
GINGER BARBER INC., INTERIOR DESIGN
THE SITTING ROOM
6231 EDLOE
HOUSTON, TEXAS 77005
713.523.1925 WWW.THESITTINGROOM.NET

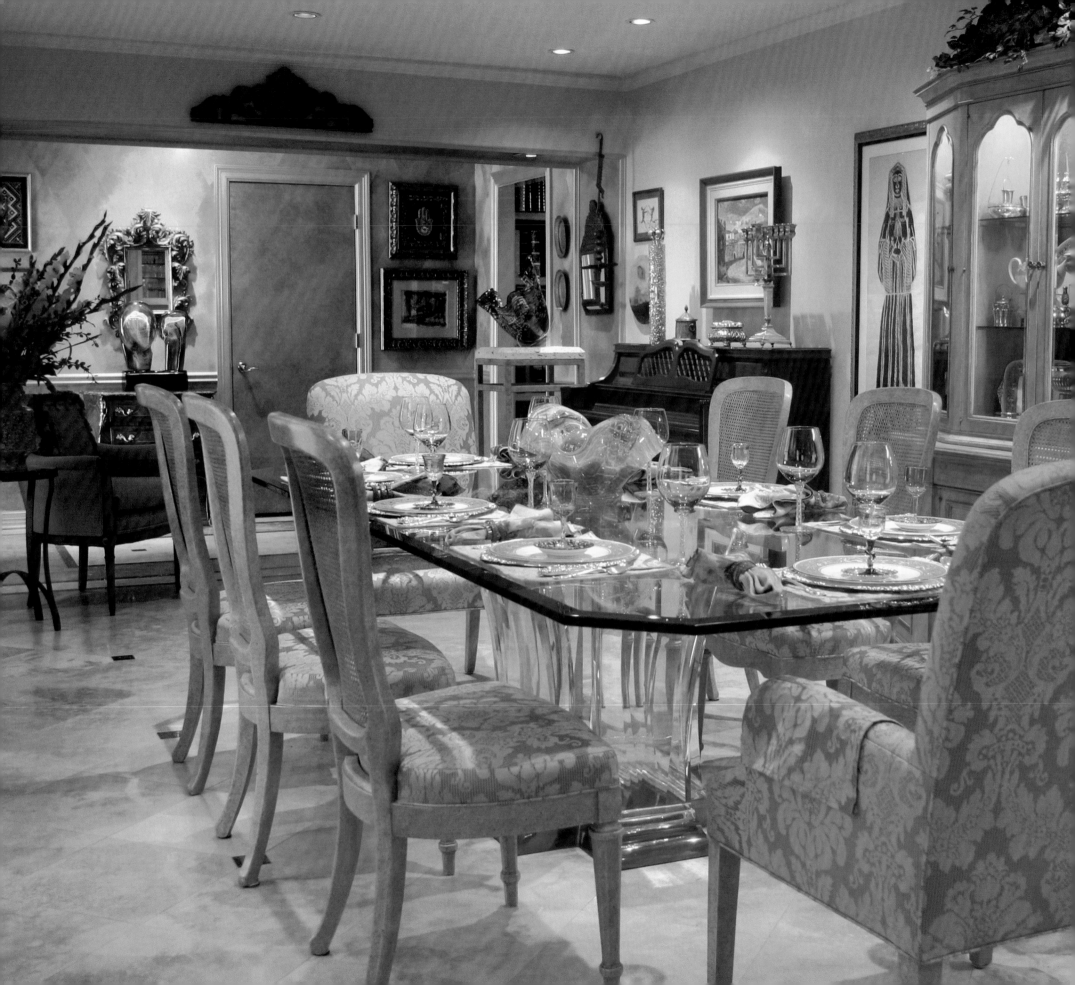

Dena Brody, ASID

DENA BRODY INTERIORS

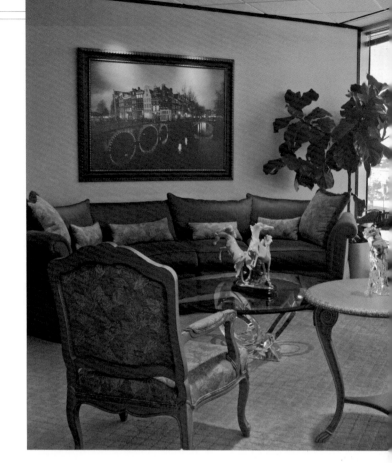

ABOVE: This real estate executive wanted a luxurious residential feel for his private office. Comfortable seating, art and accessories are well lit and complete the look.

LEFT: Low-voltage ceiling accents bathe the owner's eclectic art and furniture in crisp and sparkling light. The reflection of the table on the floor adds an extra dimension to the spectacular floor design using Turkish and gold travertine and blue pearl granite.

*E*very project Dena Brody designs reflects the individuality of her clients. "I meet with all family members or employees of an office to fully garner their expectations so I can develop an integrated design program specific to their needs," the award-winning designer said. Through her full-service Houston design firm, Dena Brody Interiors, Dena has successfully created unique interiors for a vast array of residential and commercial clients for over 33 years.

On commercial projects like offices, healthcare facilities and educational and religious institutions, Dena studies her clients' operations and interviews their workers before she uses computer-aided software to draft her designs, which provide her clients with several options and enable them to participate in the design process. Although commercial projects are often viewed as stark and uninviting, Dena's designs are warm and welcoming.

"I strive to give character to the workplace by dividing the commercial environment into two distinctly different categories—private spaces and public places," she explained. "Private offices allow the individuality of the employee to come out in the objects or pictures that fill their spaces. They should be comfortable for the employee, yet compatible with the overall look of the office. Public places should convey the purpose and intent of the company," Dena says. "Through the proper use of color, materials, lighting and decorative items, public spaces should speak of their company's image."

DENA BRODY, ASID
DENA BRODY INTERIORS
4315 BREAKWOOD
HOUSTON, TX 77096
713.721.0577
WWW.DENABRODYINTERIORS.COM

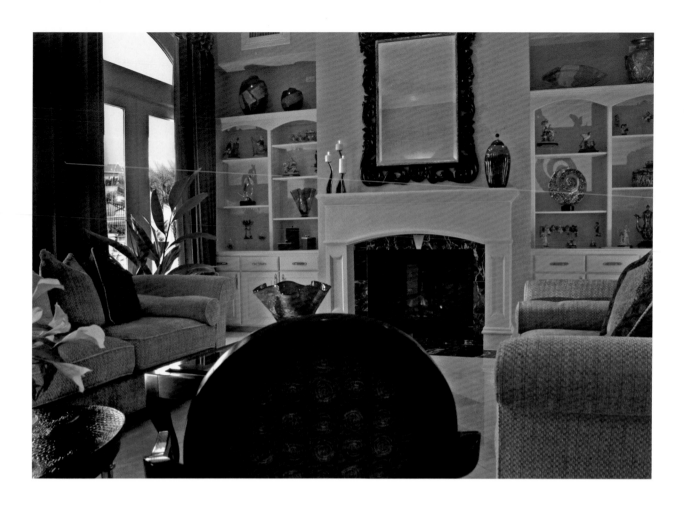

For her residential designs, which include everything from starter homes to large estates, Dena works closely with her clients, reviewing their lifestyles and listening to their likes and dislikes. Doing so enables her to provide them with personalized options for space planning or furniture layouts.

To craft both the residential and commercial designs for which she is sought, Dena closely collaborates with innovative architects, reliable contractors and talented craftsmen using the latest technology to stretch the boundaries of what can be done and what works for the client. From concept through completion, she manages every

TOP LEFT: The soft, contemporary lines of the furniture and the rich browns and lush creams of the Michelangelo marble fireplace surround repeated in the fabrics distinguish this award-winning home.

LEFT: The intricate tapestry, with its delicate colors, is the focal point for the small accents of color in this room. The rich tones and inlays of the wood secretary assure that the piece will not go unnoticed. The xenon-lit art glass cabinet was originally an unused gun cabinet!

RIGHT: A typical 1960s kitchen with eight-foot ceilings was transformed by the designer into this striking contemporary kitchen with new windows, cathedral ceiling and cabinets in two contrasting maple stains with varied depths and heights.

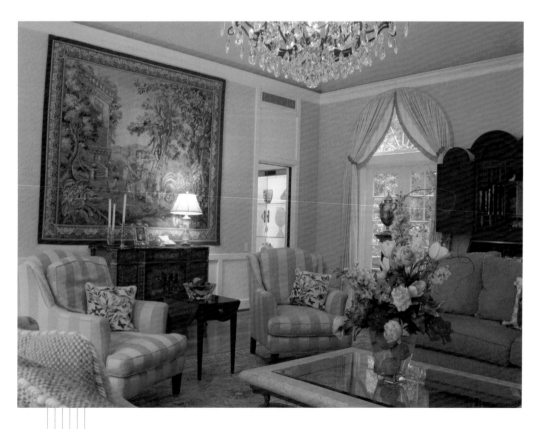

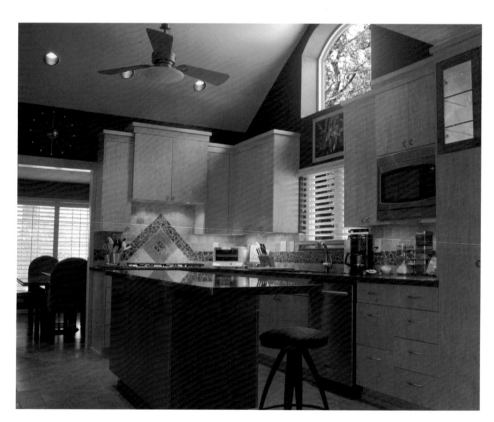

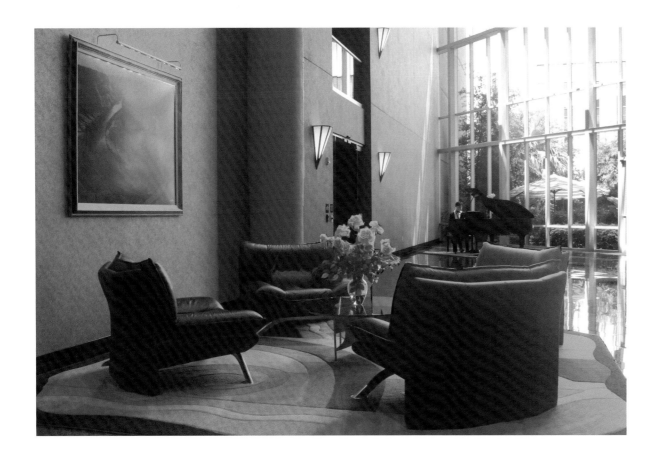

LEFT: Custom area rugs, sconces, baby grand player piano with a dummy dressed in tails, lighting, wallcoverings and granite floor patterns are details specified and executed by the designer to give this office building atrium the hotel-lobby appearance the client requested.

BELOW: Sharp colors, nickel finishes, low-voltage lighting and sleek maple furniture and seating, as well as A/V ports on the table, give this conference room a cutting-edge look.

step of the project, ensuring that the client's requirements for budget and delivery are efficiently met. Then, using her keen eye for detail and applying her years of vast experience, she expertly dresses each interior with quality furnishings, custom window coverings and accessories.

In 2004, Dena won first place in the Residential Design Over 5,000 sq. ft. category in the ASID Texas Gulf Coast Chapter design competition. This is only one of many accolades bestowed on this dedicated designer with a degree in psychology from Barnard College, Columbia University in New York and a degree in interior design from Mt. Ida College in Boston. A consummate professional, Dena has also served the ASID by sitting on its board of directors and co-chairing the newsletter, the referral service and the CEU committees.

The respected designer is happy to contribute to her industry and is appreciative of these acknowledgements. But she says that true success lies in her relationships with her clients. "I am very proud of the cadre of clients I've assembled over the years. I consider my loyal clients part of my extended family." ■

Mary Ann Bryan, FASID

MARY ANN BRYAN DESIGNS

ABOVE: Details make the difference. A hand-painted band above the windows and entry doors brings the two-story rooms into human scale.

LEFT: Electric blinds at the base of the windows provided the option for a creative window treatment that met the client's request for an open space.

"Beauty and order are essential to a fully rational life," said Mary Ann Bryan, an interior design icon with over 45 years of experience. "A well-designed environment is comfortable, well-ordered and rewarding," she said of the design philosophy that has benefited her clients through the years.

Mary Ann's long and distinguished career began in 1946 when, at the young age of 16, she left Houston for the University of Texas in Austin, where she studied architecture and interior design. After graduating in 1950, she returned to Houston and joined Foley's Department Store's management training program, which provided her with merchandising and home-furnishings buying experience.

In 1961, she married Frank Bryan, a Rice architecture graduate, and she left Foley's to form her own small residential design business. It expanded into The Bryan Design Associates, a large, highly respected firm that for a number of years employed numerous interior designers, many of whom are prominent and respected designers today.

During her illustrious career, Mary Ann has earned copious awards and her interiors have appeared in a host of publications. She's also served the ASID in various leadership capacities—she was the first president of the Texas Gulf Coast Chapter, and in 1997, she was honored as an ASID Fellow. Mary Ann also left her mark in her profession by being the first interior designer to serve on the Texas Board of Architectural Examiners. For her many contributions, the UT Department of Ecology designated her a Distinguished Alumna.

Mary Ann decided to close the doors on her large corporation in 2005. She now serves clients in the Houston area through her smaller design firm, Mary Ann Bryan Designs. Although she's scaled back, the acclaimed designer vows never to retire. "I still like working very much," she said. "I enjoy creating environments that my clients love and are proud of." ■

MARY ANN BRYAN, FASID
MARY ANN BRYAN DESIGNS
6628 BAYOU GLEN
HOUSTON, TEXAS 77057
713.907.4033

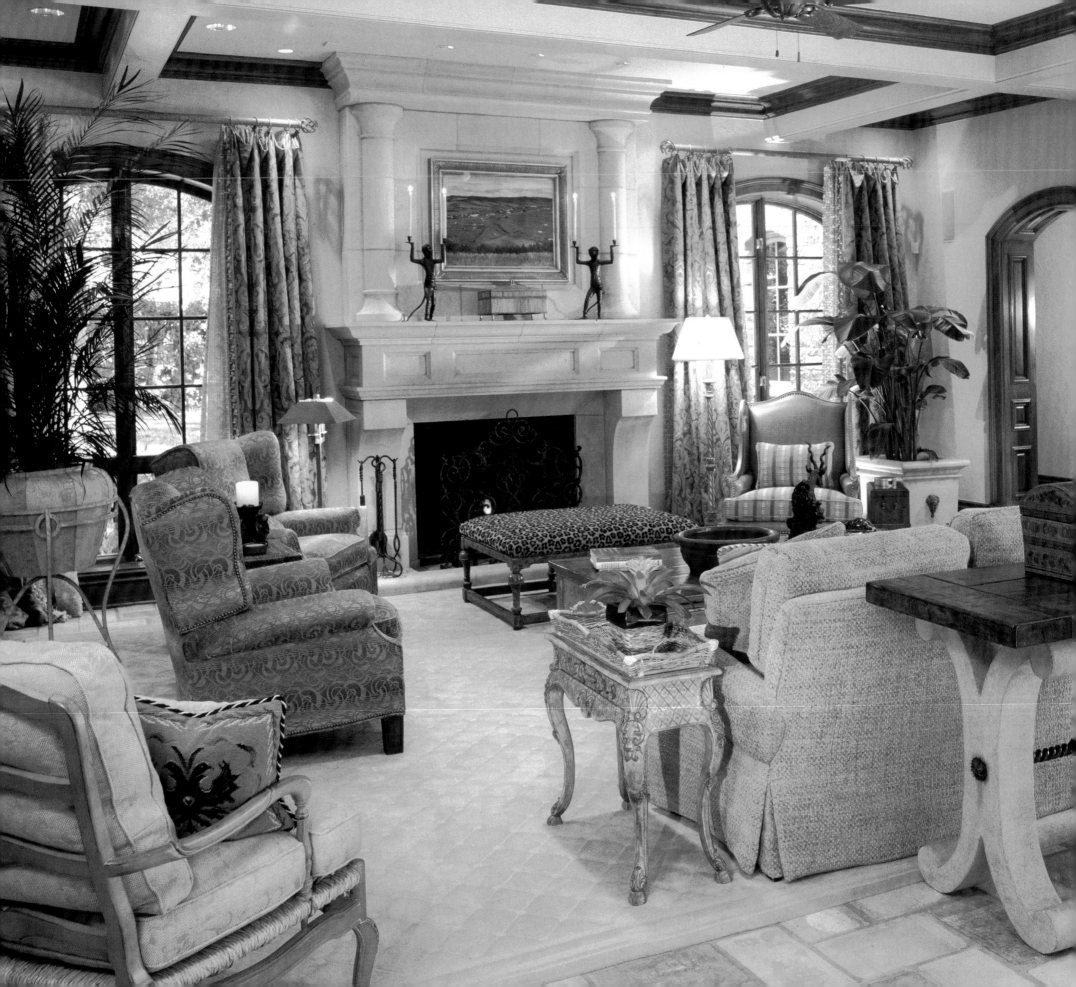

Jane Page Crump, ASID

JANE PAGE DESIGN GROUP

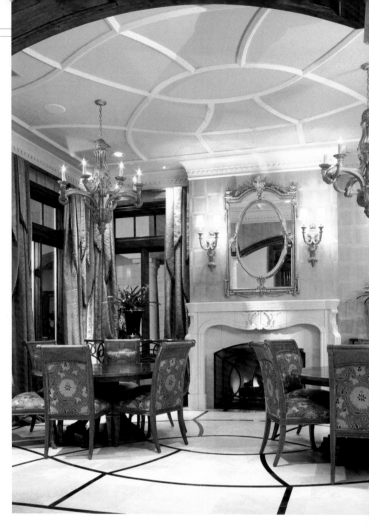

ABOVE: This dining room features a custom plaster ceiling treatment, which is mirrored in the intricate stone floor. Other details include Pawlonia wood-paneled wallcovering, custom furnishings and layered window treatments.

BELOW: Left to right: Laura Timanus, Allied ASID; Amanda Crump, Marketing Director; Jane Page Crump, ASID; Kristen Carlson, ASID; Lisa Vaccaro, Allied ASID; Sarah Willson, ASID; Courtney Williams, Allied ASID.

JANE PAGE CRUMP, ASID
JANE PAGE DESIGN GROUP
500 DURHAM DRIVE
HOUSTON, TX 77007
713.803.4999

In 1977, Houston designer Jane Page Crump founded her full-service design firm, Jane Page Design Group, which has grown to become one of the most well-respected interior design companies in the industry. Besides her close circle of family and friends, Jane Page counts her esteemed business as one of her greatest accomplishments. "I'm very fortunate," she remarked. "I have always been blessed with wonderful, talented employees and great, appreciative clients."

Known for its elegant and distinctive interiors, Jane Page Design Group works primarily with new construction design and remodeling of high-end residential properties. They have also designed commercial properties like boutiques, restaurants, bars, coffee shops and executive offices. To effectively serve their impressive client list of Fortune 500 executives, celebrities and political nobles, the firm follows a team approach—they work closely with the finest contractors and architects to ensure that their clients' requirements for budget and custom design are met.

"Time is money, and when two or more designers are assigned to a project, someone is always available to make timely decisions," Jane Page explained. Having a team of designers also helps when defining the project style. "I believe that collaboration by multiple designers leads to more sophisticated and detailed designs," she added.

LEFT: Warm color and textural interest give this family room its relaxing and inviting understated elegance. Comfortable upholstered seating with a mixture of woven fabrics, leather, stained chair frames and nail-head trim are combined to create the richness of this interior.

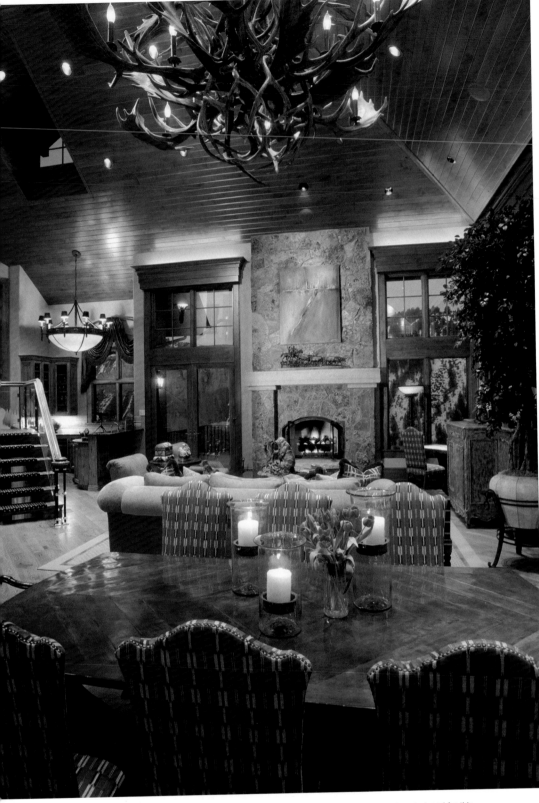

Custom cabinetry, design detailing, lighting design and rich finishes are signature to the firm's award-winning designs that center around each client's personality and lifestyle. With an affinity for richness in form and finishes, Jane Page's trusted staff artistically balances color, textures and patterns to compose timeless, inviting designs.

"In general, function should precede design." Jane Page said. "A setting's demand for function should challenge the designer to achieve excellence in the final finishing of the space." This approach has led to acclaimed success, which Jane Page contributes, in part, to her diverse education. "My business background has proven to be an invaluable asset," said the designer who earned a degree in business and an MBA in finance from the University of Texas.

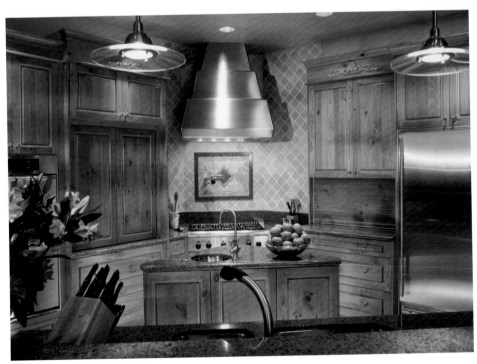

ABOVE: Custom-designed cabinets, wood ceiling beams and a unique, three-tiered stainless hood are just a few of the special details in this Colorado kitchen. Lighting was added on top of the "floating" beams for dramatic effect.

ABOVE: All decorative lighting fixtures in the staircase, great room, dining room and bar were custom designed for this Colorado vacation home. The designers were also responsible for all cabinet and trim design, finishes and furnishings throughout the house.

Upon graduation, Jane Page was a tax accountant for a major accounting firm in Houston, but her passion for design was beckoning. In the evenings she began designing clothing, but ultimately found the fashion world too illusive. So, she decided to pursue an artistic career with lasting value and reward. "I began studying interior design and later became NCIDQ certified." She opened what has now become one of Houston's largest, independently owned residential design firms.

To achieve the exceptional designs for which her firm is sought, Jane Page encourages continued studies. "To be a good interior designer, you must build on your passion for design by continually studying and educating yourself," she said. "In addition to learning about new products and installation options from vendors, our staff frequently takes field trips. I have taken my designers to France and Italy, where we focused on ancient architecture and we gathered new ideas."

ABOVE: Art Deco elements were incorporated in the renovation of this 1930s theater. Shaped ceiling details and pilasters topped with custom-designed, iron-and-acrylic light fixtures give interest to the large theater.

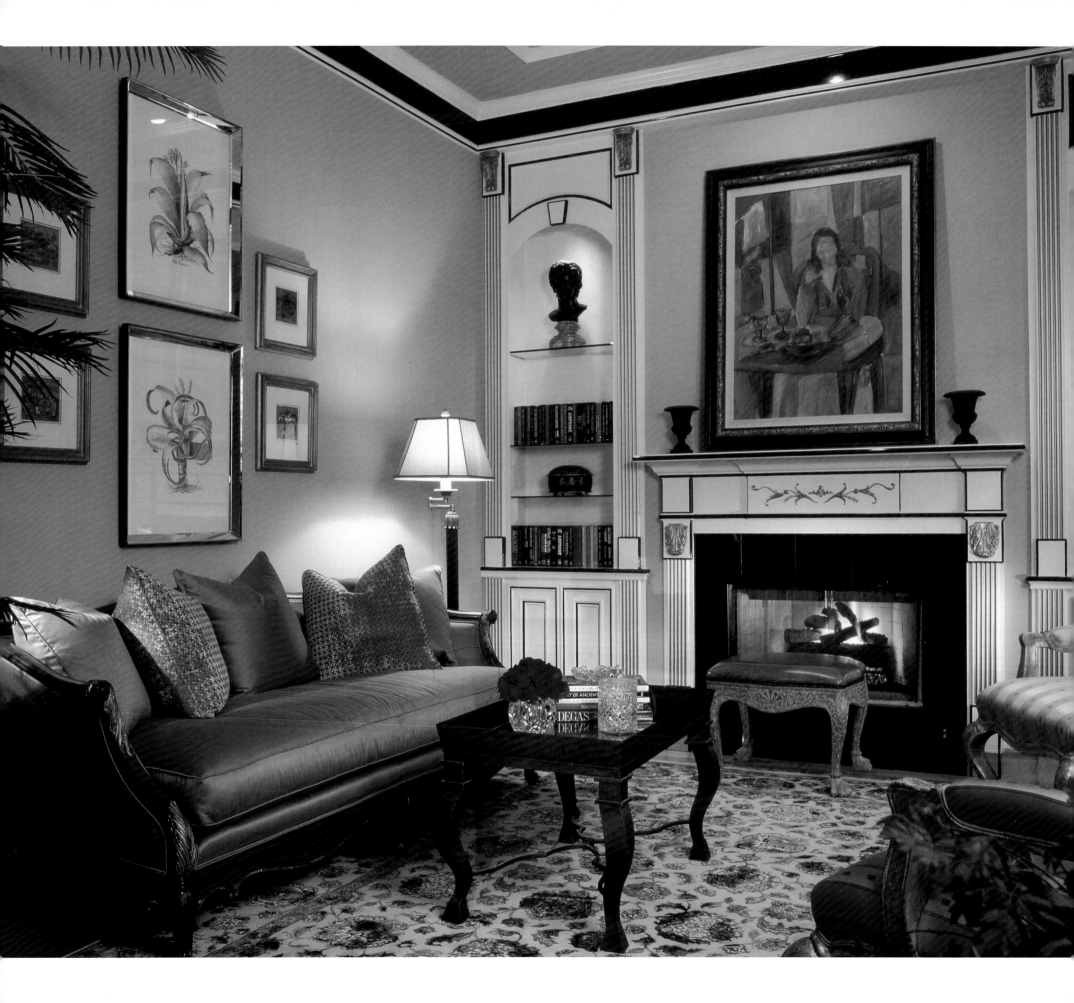

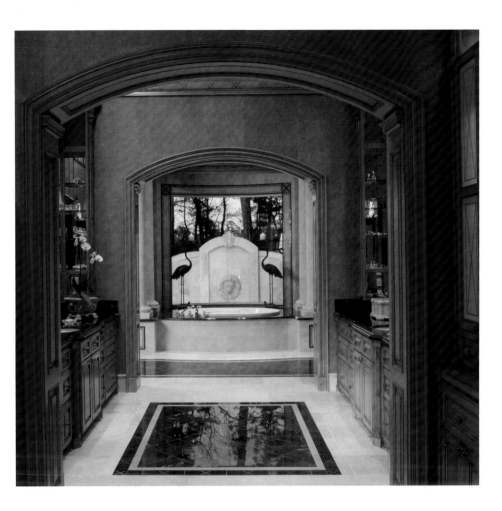

With renewed inspiration and education, the team expertly crafts designs that have won numerous accolades from national and international organizations. They have also been published in several hardcopy publications including *Southern Rooms; Spectacular Homes of Texas; Showcase of Interior Design, Southern Edition; Casa & Estilo, Design 2005; Great Designers of the World, Third Edition; Great Designers of the World, Fourth Edition; Houston by Design; Designed in Texas* and *Dream Homes of Texas*.

In addition to her body of work, Jane Page is also known for her professional service. A member of the ASID, she is a former president of the Texas Gulf Coast Chapter. She is also a former president of the TAID, on whose board she currently serves. Jane Page is a frequent speaker at design seminars, where she willingly shares her knowledge of and admiration for the profession. "Interior design brings together my love of people and their appreciation for beautiful interiors," she said. "To be of value to your client, design cannot be a part-time job. I immerse myself into every project, melding architecture, beautiful fabrics, art and the psychology of the space to create breathtaking interiors that perfectly fit each client." ■

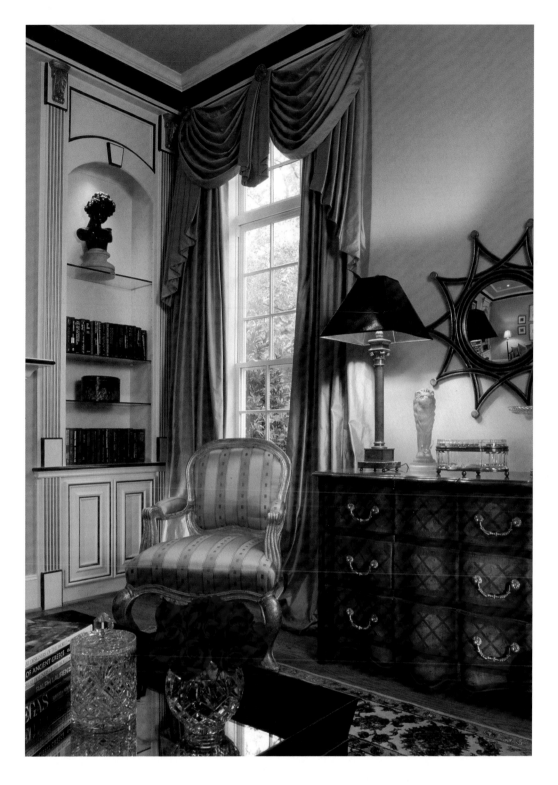

ABOVE LEFT: This luxurious bath features custom alder wood vanity cabinets with mirror-and-glass storage areas surrounded by reed-and-ribbon trim details. Other features include etched details in the marble floor and walls, a towel warming drawer and accent lighting in the cabinets, ceiling, niches and toe kicks.

ABOVE & FAR LEFT: Elegant furnishings, such as the custom iron-and-mirror cocktail table and carved frame seating, were selected for this elegant living room. Neoclassic details and dramatic black accents were incorporated into the custom cabinets and trim.

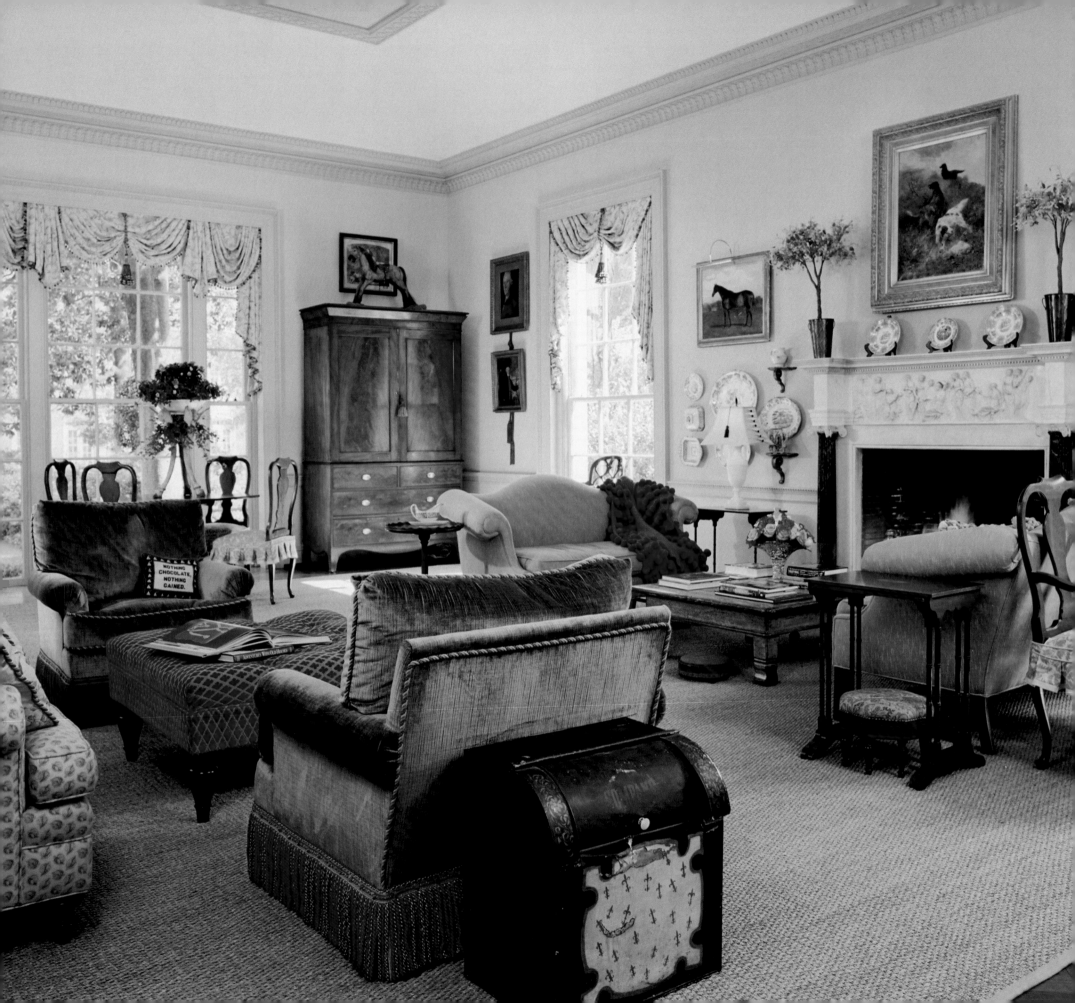

Suzanne Duin, ASID

GB DESIGN, INC.

ABOVE: When architectural details are this rich, the interiors need only to enhance the overall design.

LEFT: This John Stub home provides a perfect backdrop for antiques, rich textiles and period paintings, thus a "classic" English country manor.

Trained from an early age in the realm of interior design, Suzanne Duin grew up surrounded by the business. Her mother, Virginia Beilharz, was as an established interior designer who founded her own firm, GB Design, Inc., in 1974. "I worked closely with my mother for many years and learned a great deal about the entire design process," said Suzanne.

To further hone the initial design skills she learned from her mother, Suzanne earned a fine arts degree from the University of Texas at Austin in 1981. Upon graduation, she decided to try the sales side of the interior design business and worked for five years representing New York-based Maharam Fabrics in the Gulf Coast region. Suzanne then returned to work with her mother at GB Design, which was a natural next step given Suzanne's real desire was to design interiors.

While under her mother's lead, the firm's wide-reaching client base included many commercial projects such as healthcare facilities, executive offices and restaurants. But Suzanne chose to concentrate primarily on residential designs. "I truly enjoy bringing warmth and comfort to the family home, and I love working directly with my clients to personalize each space," she said. "I finally took over the reigns of my mother's entire business in 1997 and integrated it into the opening of my own store, Maison Maison."

Located in the heart of River Oaks, Maison Maison specializes in French antiques and home accessories. Everything from fine furnishings and period reproductions to exclusive fabrics and one-of-kind works of art is offered in this attractive storefront. Noted for its beautiful lamps and antique pillows, the shop overflows with furniture and accessories. "This is where you come for the finishing touches to any project," said Suzanne. "I love to make lamps out of anything. My staff jokes that if you stand still long enough I'll make a lamp out of you."

SUZANNE DUIN, ASID
GB DESIGN, INC.
MAISON MAISON ANTIQUES
2709 SACKETT STREET
HOUSTON, TEXAS 77098
WWW.MAISONMAISONANTIQUES.COM

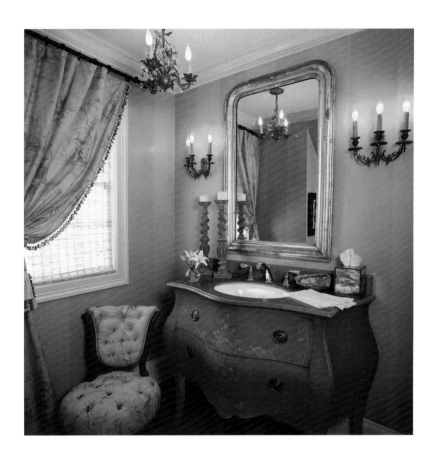

Lamps are not the only accessory that Suzanne invents. Her clever use of unusual treasures as accessories is a skill of which she is proud. "Drums become ottomans, a window frame will morph into bathroom mirror and old signs will get a new life as a headboard," she explained. "I strive to uniquely personalize each room of my clients' homes." Besides one-of-a-kind accessories, Suzanne loves to work with her clients' collections and believes their homes should be a reflection of their interests and travels.

TOP LEFT: This custom powder room features a hand-painted chest and etched-glass sink.

LEFT: This room, dominated by the pair of French mirrors, is truly continental in design with influences from England, Sweden and Italy.

RIGHT: By adding the long custom-built console, a narrow space became an intimate dining space that provides a service area for entertaining.

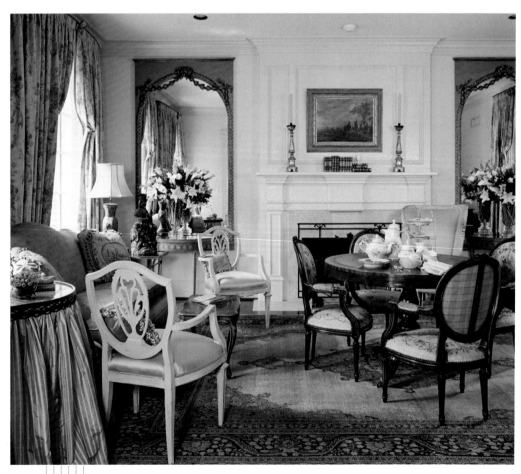

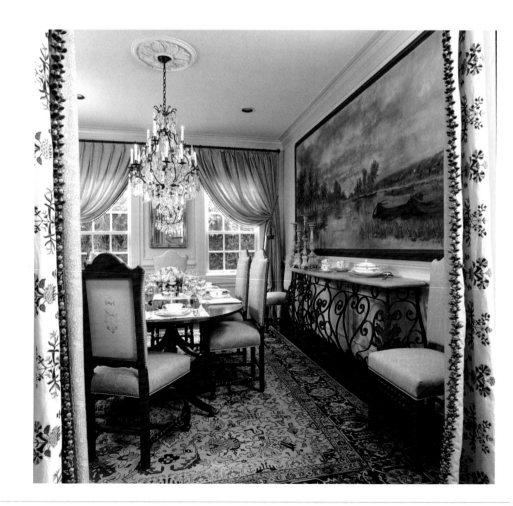

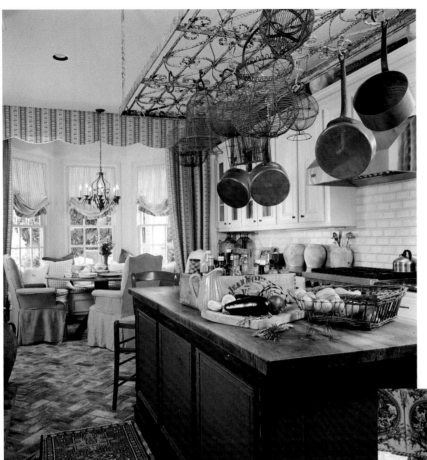

Often traveling herself, she visits Europe and Asia several times a year to personally select classic pieces and unusual treasures. "I'm always buying things for my clients," Suzanne said. "My store is representative of many cultures, a conglomeration of what I uncover on trips." She feels the pieces she finds abroad help create warmth and instill a sense of age in her projects here at home. "The worn edges of antiques tell interesting stories of a past steeped in history," she remarked.

Suzanne's eclectic and distinctive designs are a proven winner with her clients. "It's always fun to start a new project and even more rewarding to see my clients' delight with the finished results," she said. "I love my work, and the ability to create each day is such a joy!" ■

LEFT: The owners wanted a living area added to their kitchen. The built-in bench and comfortable, slip-covered chairs accomplished this goal.

RIGHT: The inspiration for this master bedroom came from a pharmacy sign, now a headboard, found in South France.

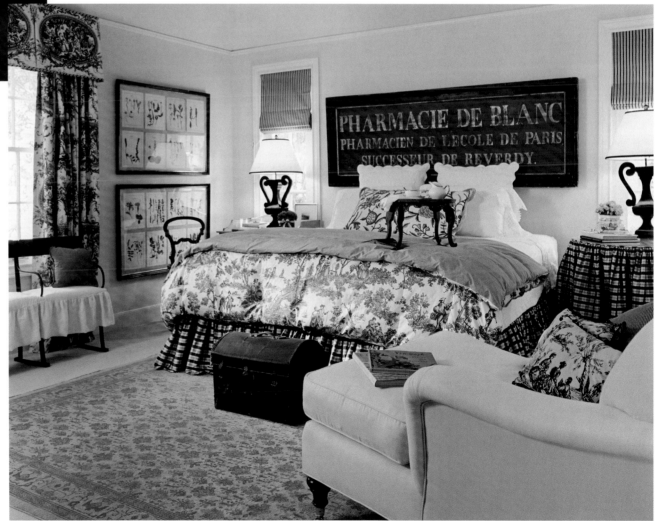

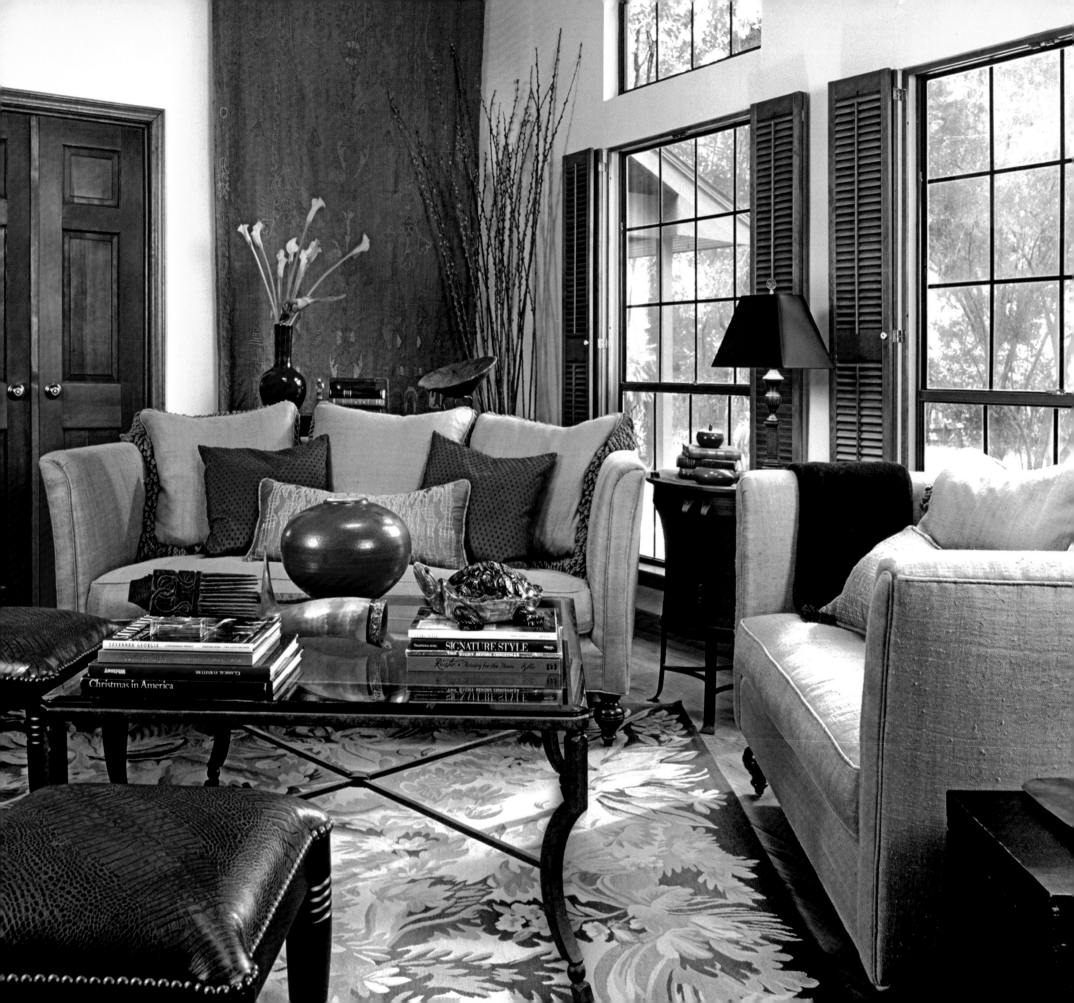

Andrea S. Garrity, ASID

THE GARRITY DESIGN GROUP

For more than 25 years, Andrea Garrity has combined her exceptional interior design skills with a steadfast commitment to her clients and created stunning residential spaces all over Texas. This award-winning designer, originally from New York, relocated to Houston, where she established her residential design firm, The Garrity Design Group. Today, the respected firm has a reputation for excellence and continues to successfully meet the specific needs of each client.

"My objective with each client is to establish a close rapport built on trust. I listen closely and consult with each client to ensure that my designs reflect their unique lifestyles and personalities," she explained. Translating her clients' objectives into successful realities, Andrea enjoys a reputation for understanding. "I treat each individual client as I would want to be treated," she said. "I attribute my success to this belief." Also contributing to her longevity is Andrea's strong business skills, which enable her to handle all aspects of every project.

Whether it's new construction or remodeling, Andrea manages each project from inception to completion. "I work with the architect and the builder to ensure that the house flows properly," she explained. "I consider traffic patterns and measure everything so that each piece of furniture and art will perfectly fit in its new home." Then Andrea expertly dresses each setting, adeptly grouping and placing her clients' collections in a transitional mix of styles.

"My signature is neither formal nor casual. Rather, it's a satisfying blend of fabrics, textures, wall finishes and accessories that creates overall warmth," she declared. "For example, I'll place a piece of ethnic pottery on a wonderful antique chest and then finish the setting with a piece of contemporary art."

ABOVE: Combining textures in the woven hanging, pussy willows, raw-silk sofa and pillows add warmth to this expansive setting.

LEFT: This inviting living room, designed around an antique wall hanging and custom-designed sofa, mixes the old with the new. An antique rain drum, oxblood vase, antique box and books and an old wooden bowl add to the overall comfort.

ANDREA S. GARRITY, ASID
THE GARRITY DESIGN GROUP
5402 MOUNT ROYAL CIRCLE
HOUSTON, TEXAS 77069
281.440.5098

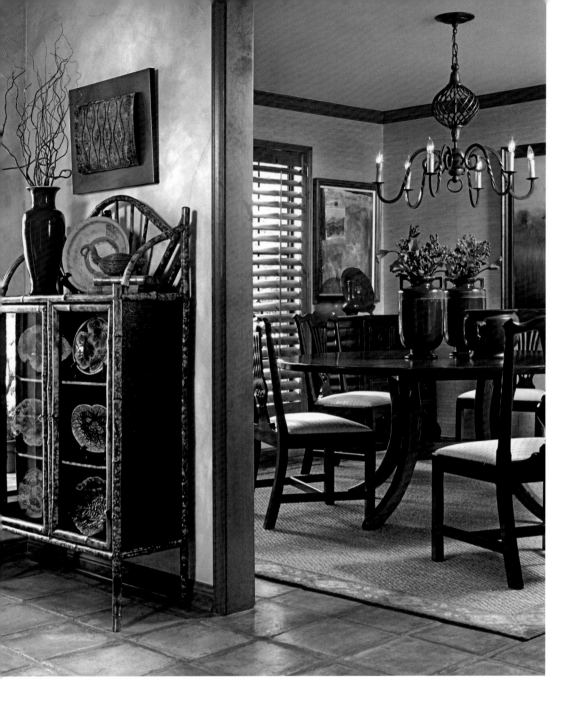

Her approach to design has won the energetic designer a *Houston Chronicle*/ASID design award and frequent invitations to participate in area showhouses. An active ASID member, Andrea is the current president of the Texas Gulf Coast Chapter, and she has twice chaired its annual Fantasy Gala fund-raiser.

Andrea's commitment to her profession—coupled with her full-service attitude, attention to detail and regard for her clients—has earned the popular designer loyal clients. "I respect my clients and work to ensure that the design process is enjoyable for them," she said. "From selecting the brick on the outside of the house to placing the final book on the shelves inside, I guide my clients to an enjoyable outcome where warm interiors welcome them home." ■

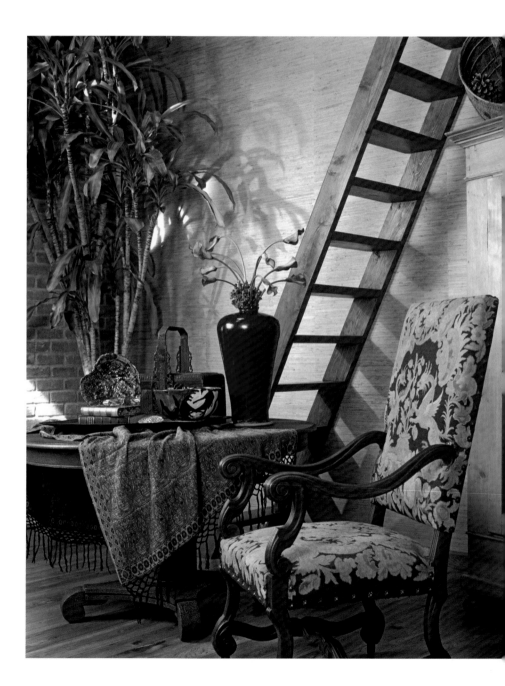

ABOVE: The antique bamboo cabinet in this entryway complements the round table in the warm, inviting dining room wrapped in antiques and an Art Deco chandelier from France.

RIGHT: In this living room, an oversized chair carved full of rich detail and tapestry commands an audience near the entrance to the loft. An oxblood vase, antique basket, burnished metal tray and old table distressed with a faux finish quietly complete the setting.

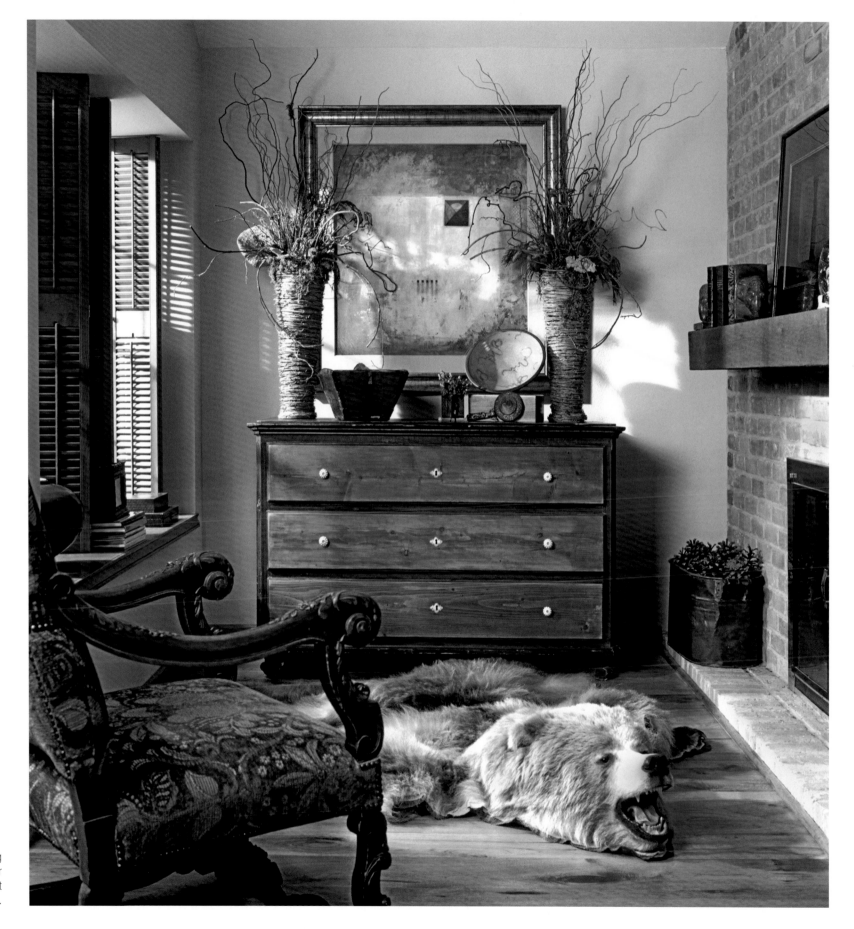

RIGHT: The contemporary art and twig urns complement an antique chair and chest in this inviting space that creates a wonderful eclectic feel.

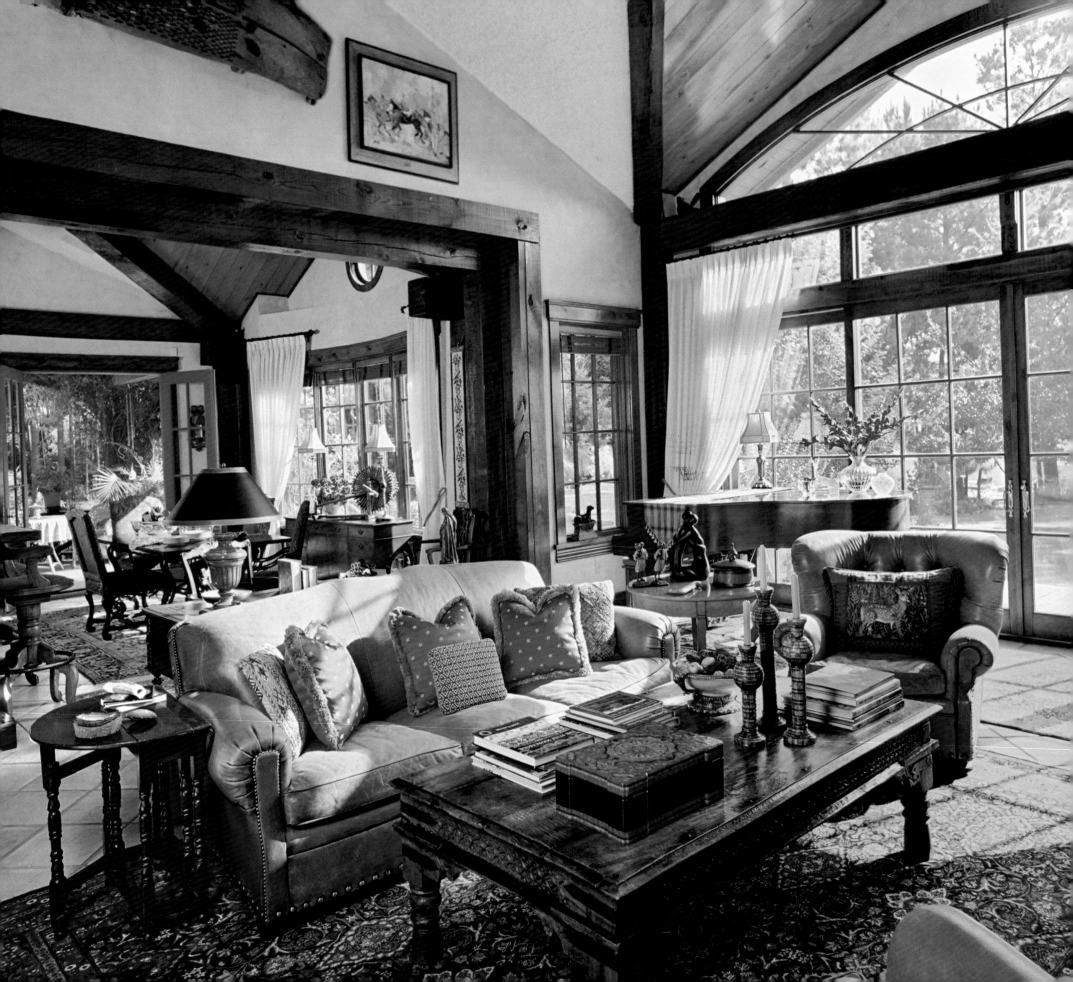

Louise Girard, ASID

GIRARD INTERIOR DESIGN, INC.

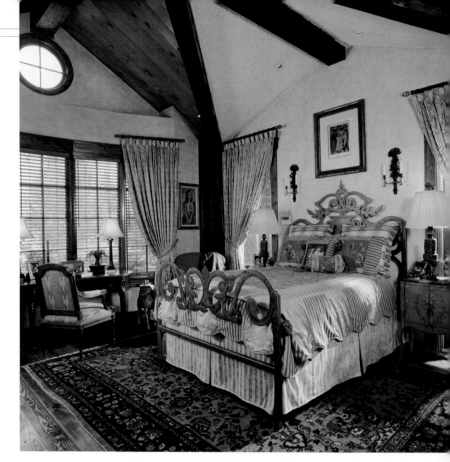

After a decade of owning a flourishing architectural design firm, Louise Girard tried to retire in 1998 to live in the scenic countryside northwest of Houston with her husband, Dr. Louis Girard, former professor and chairman of the Department of Ophthalmology at Baylor College of Medicine. However, her retirement was short-lived. "When we moved to Magnolia, I had every intention of enjoying retirement sailing on our lake, planting my garden and cooking for friends and family," Louise said. "But I sorely missed my clients and the interior design business." It wasn't long before the award-winning designer was back to creating fabulous interiors for her clients through her new company, Girard Interior Design, Inc.

The full-service design firm brings considerable creativity and experience to an array of projects in the greater Houston area. Their expansive portfolio of residential designs includes ranches, country homes, urban townhouses and a host of custom, single-family residences of varying sizes and complexities. Commercially, Louise and team have designed, constructed and furnished numerous executive offices, corporate headquarters, restaurants, clubs and special events for business leaders and entrepreneurs.

Louise expertly manages each project from concept through construction, providing a broad range of services that includes everything from space planning, to lighting and custom cabinetry design, as well as selecting finishes, furnishings and artwork. Wherever possible, she reuses her clients' furniture and collectibles in new and different ways, helping them keep their favorite possessions around them.

ABOVE: Massive architectural beams, bow-front mullioned windows, hand-sponged glazed walls and antique pine flooring create a unique and striking bedroom made luscious with rich textiles, hand-painted furniture, iron bed and sconces, stone fireplace, Picasso lithograph and antique Persian Sultanabad rug from Abraham Oriental Rugs.

LOUISE GIRARD, ASID
GIRARD INTERIOR DESIGN, INC.
20126 INDIGO LAKES DRIVE
MAGNOLIA, TEXAS 77355
281.798.2631
WWW.GIRARDINTERIORDESIGN.COM

LEFT: Girard Interior Design is known for its comfortable, traditional style mixed with European and Middle Eastern formal or country-toned atmospheres, finished with extraordinary detailing. An East Indian carved "day bed" holds books and collections from travels abroad anchored by a rich Iranian Moud carpet.

LEFT: Girard's design of a massive "Texas Gold" stone fireplace, hand-carved pine cabinetry, Italian tagina glazed tile flooring create a rustic yet elegant "envelope" holding antique oriental rugs, imported furnishing and artwork from around the world. The Canadian moose head is a bit of humor for the Texas longhorn enthusiasts!

RIGHT: A Baker distressed pine-and-iron table and Panache dining chairs sit comfortably on a fine antique Persian Serape rug. A rustic Dutch yarn winder lends textural interest in front of the bowed windows. The open French doors reflect the red trim on the house exterior and invite one outside to enjoy the lake front view on the covered porch.

Center to her personalized interiors is ethnic art, for which she gained a deep appreciation after traveling extensively around the globe. "Ethnic crafts are made by hand from knowledge passed down through generations," she explained. "They exude the feelings of human touch and provide a sense of individual creativity, which enriches any setting."

How does Louise create these welcoming interiors? "Whether it's a single room or an entire house, I develop each project with the clients' goals, budgets and time frames in mind." She begins the process by creating a furnishings plan. "I introduce colors, patterns, textures and artwork before designing the lighting to reflect on those objects," she said. "I strive for excellence in craftsmanship and details, and ultimately the creation of rooms that are warm, inviting and interesting to experience."

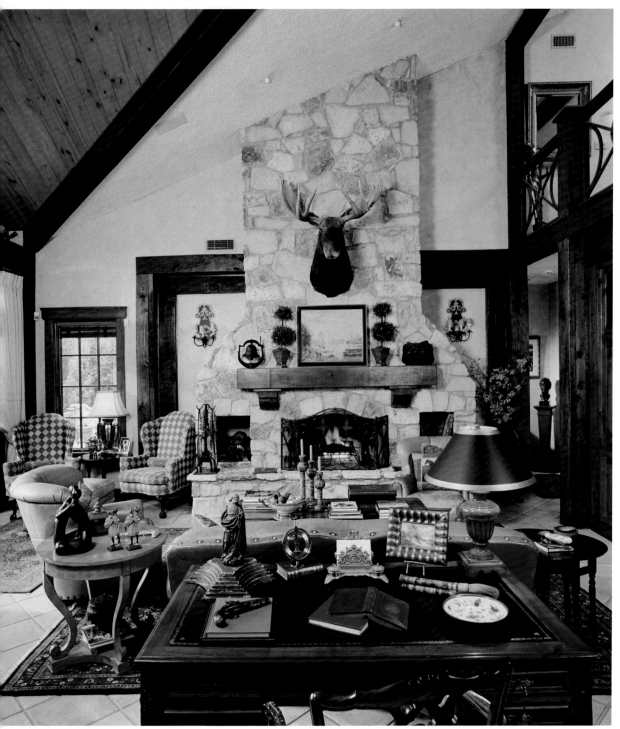

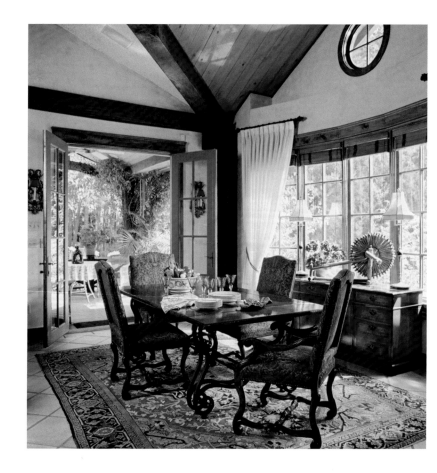

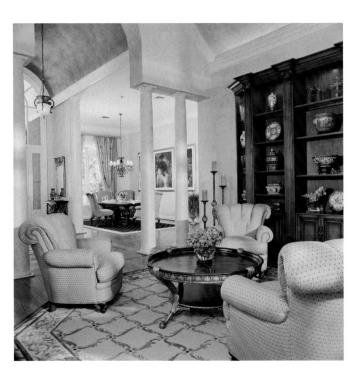

Her success is evident, as many of her award-winning projects have been featured both locally and nationally in publications like *Restaurants & Institutions, Travel & Leisure* and the *Houston Chronicle*. Internationally, Italian periodicals *Ville e Casali* and *Chi* published her design of a "country living" estate. Louise's work is featured in home tours sponsored by the Rice Design Alliance and the 2004 Bellaire Fall New Home Showcase.

Louise earned her bachelor of arts degree from Rice University, where she graduated with honors after majoring in Spanish with minors in French and Portuguese. She pursued her passion for interior design by studying at the Art Institute of Houston, earning an associate's degree in interior design and graduating with the highest honors. She became the first graduate inducted in the institute's prestigious Hall of Fame.

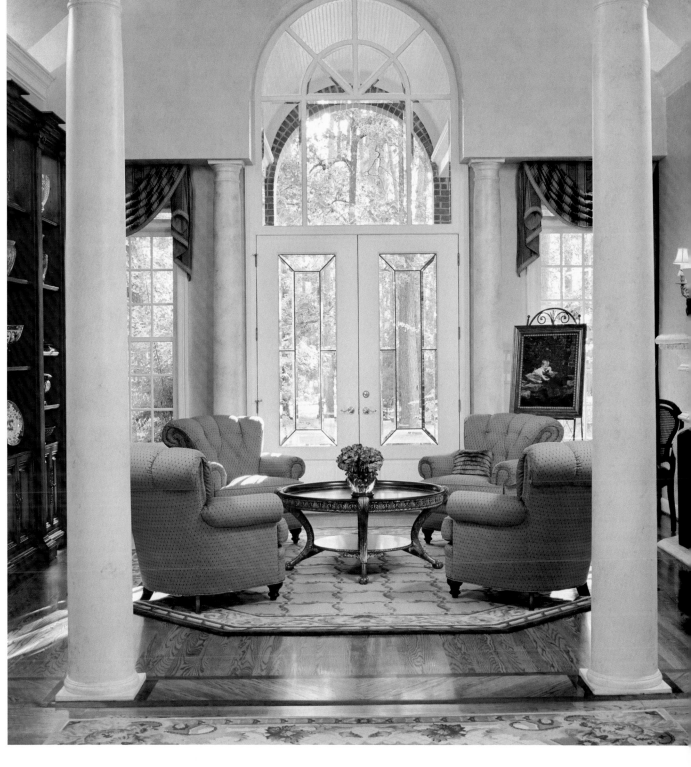

LEFT: A custom-designed octagonal wool and silk Hokanson rug anchors the circular sitting area that features four Jessica Charles lounge chairs surrounding a Maitland Smith mahogany and gold leaf cocktail table. An 11-foot high walnut display cabinet balances the opposing limestone fireplace and features the owners' collection of French porcelain, cut crystal and oriental pottery.

RIGHT: Limestone faux finished columns frame the elegant, yet comfortable, formal living room. Wall-to-wall carpeting was replaced with oak and walnut flooring by Schenck & Co. Scalamandre silk draperies and tie backs add strong color and soft outline of the tall windows facing the backyard. Zenon cove lighting illuminates the vaulted ceiling finished in golden metallic glazes.

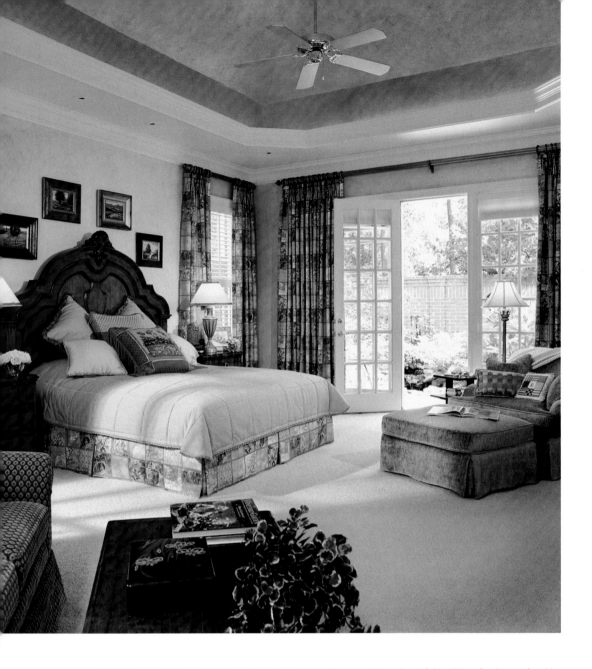

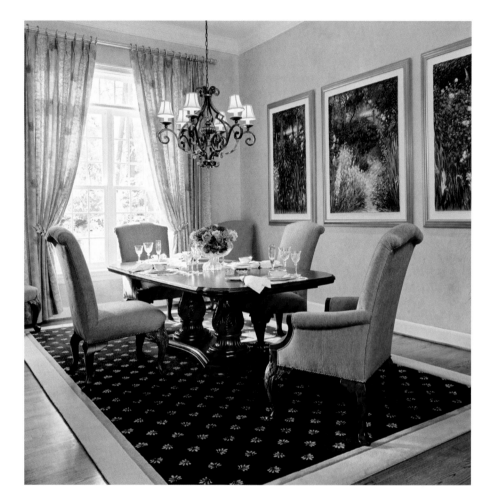

LEFT: Osborne & Little painted linen draperies and bed skirt set a rich and colorful backdrop for the comfortable master bedroom/sitting area. Zenon cove lighting reflects pewter metallic faux-finished ceiling. Turin gold leaf lamps with hand painted shades illuminate miniature original oil paintings over Century headboard. Brunschwig & Fils chenille covers lounge chair and ottoman.

RIGHT: The brilliantly colored framed triptych by Singly sets the color and tone to the formal dining room. Osborne & Little painted linen draperies hang softly from metallic painted carved rod and brackets. Fine Arts pewter/gold finished iron chandelier hangs over pedestal table and oversized dining chairs covered in Osborne & Little ottoman silk fabric.

In fall 1991, Louise partnered with architect Sharon Perry to create Perry & Girard, Inc. With the support of six employees, the firm received numerous accolades, including a 1994 *Houston Chronicle*/ASID award for a large hospitality project. In 1995, Louise formed another successful company, Girard Builders Custom Homes, where she was a general contractor until her "retirement" in 1998.

Today, Louise puts her vast experience and valued education to good use in her current firm, Girard Interior Design, Inc. Her fluency in languages enables her to communicate with foreign-speaking clients and manage multi-cultural subcontracting crews. Her commitment to her profession through long-standing memberships in the ASID and TAID allows her to stay abreast of industry issues. And her passion for design fuels her desire to create timeless interiors that perfectly fit each client. "I receive the greatest satisfaction when my clients feel comfortable, proud and increasingly pleased with their environments as a result of my efforts on their behalf," the noted designer proclaimed. ■

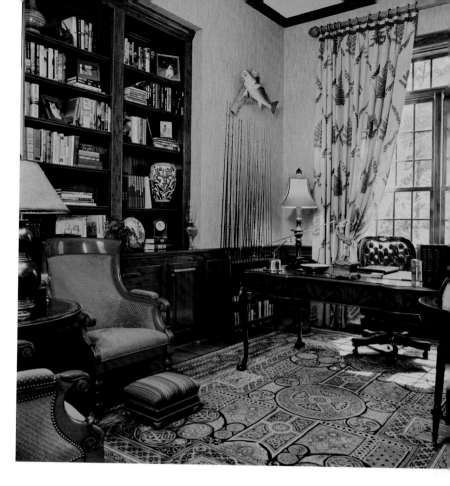

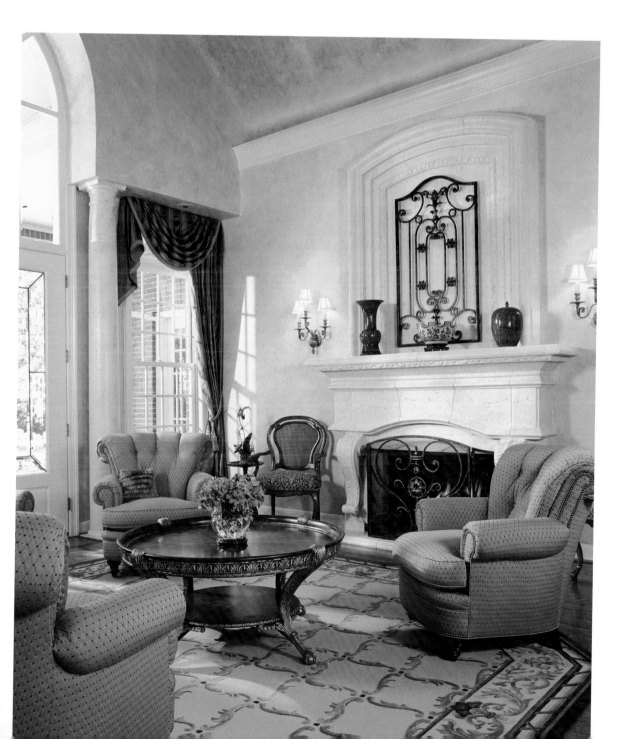

ABOVE: Schumacher textured reed woven wall coverings sets a warm, interesting backdrop for the owner's collections of sporting gear and trophies. Nina Campbell woven linen draperies frame large windows to the countryside beyond. Nancy Corzine chairs and Brunschwig & Fils ebonized table and foot stool create a cozy conversation corner for the study.

LEFT: Gustav Carroll cane side chairs covered in Scalamandre velvet flank a custom carved limestone fireplace surround and back wall. Girard's designs for the iron fireplace screen and upper wall bracket were manufactured by Peck & Co. Fine Arts tortoise finished wall sconces and silk shanting shades highlight brightly colored imported pottery.

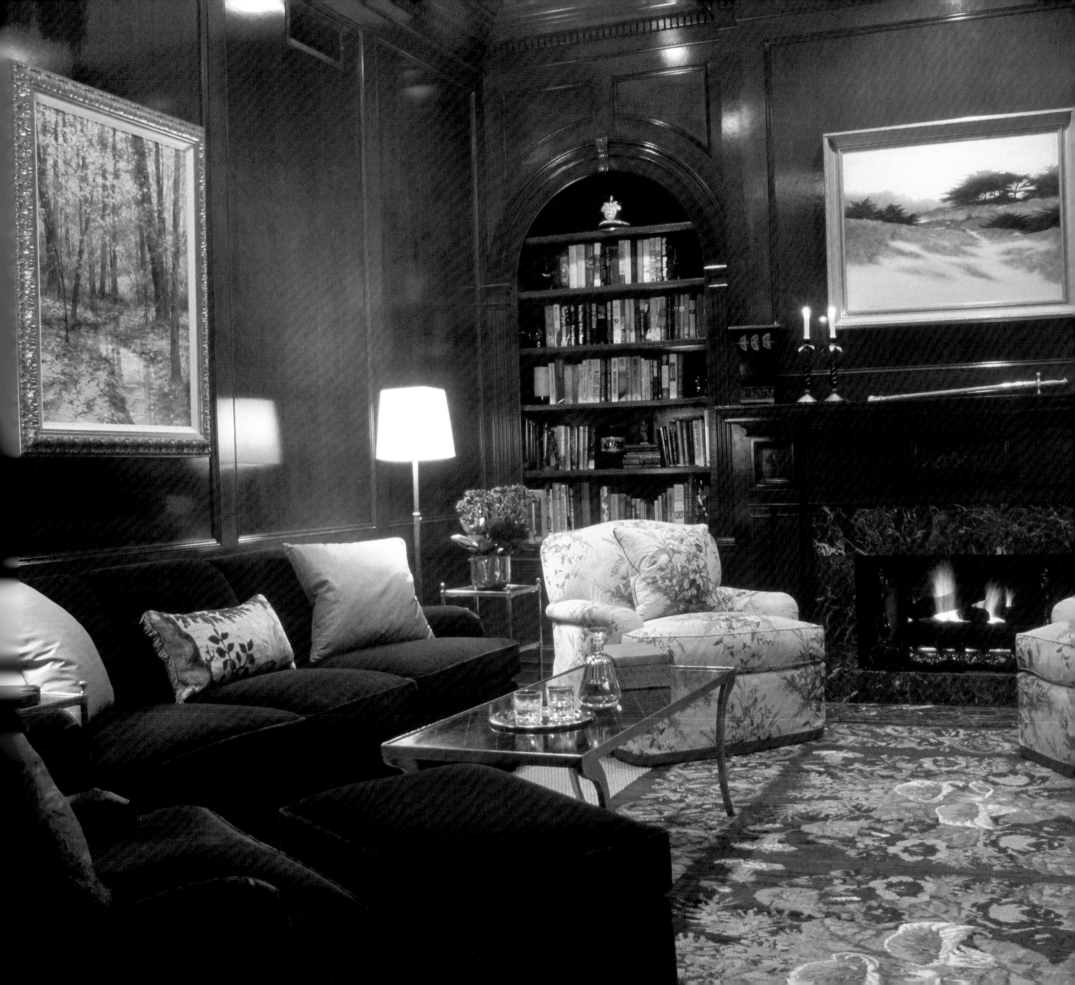

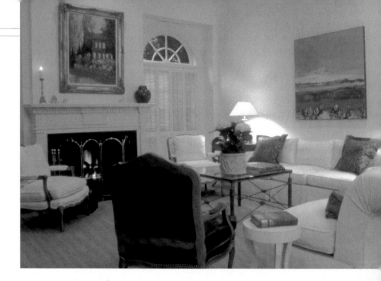

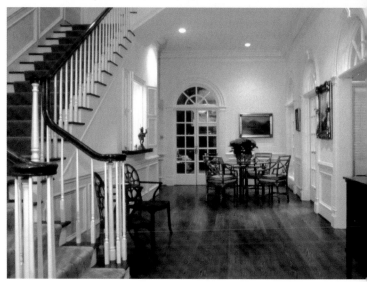

Annette Graf, ASID

ANNETTE GRAF INTERIOR DESIGN

*A*nnette Graf believes that understated décor and mingling of styles reflects true confidence in design. "With respect to architecture, I prefer that rooms breathe and allow the surrounding environment to influence design," she explained. "The most rewarding aspect of my work is when I have achieved a harmony and balance between aesthetics and comfort for my clients."

A native of upstate New York and a Houstonian for more than 25 years, Annette effortlessly marries East Coast sophistication with a well-traveled knowledge of styles and a bit of Southern charm. "I favor the 'less-is-more' approach and enjoy combining the old with the new to create welcoming comfort with unexpected contrast," she said.

She founded her company, Annette Graf Interior Design, in Houston in 1982 and has since worked on residential and corporate projects throughout the country. Her designs have graced urban lofts, private residences, offices for CEOs and corporate condos in San Francisco, Chicago, Washington, D.C. and New York, as well as vacation homes in California, Hawaii and Florida.

Annette attended Syracuse University, graduated from the University of Houston and holds a certificate from the New York School of Interior Design. As a member of the ASID, she has enjoyed serving as a past board member, a judge for the Design Excellence awards and a member on various committees. In addition, her design work has been featured in national and local publications.

Her clients appreciate Annette's style, which can be described as classic, timeless and casually elegant. ∎

ABOVE, LEFT, FAR LEFT: This private residence achieves perfect harmony with respect for the Georgian architecture.

ANNETTE GRAF, ASID
ANNETTE GRAF INTERIOR DESIGN
627 SHADYWOOD
HOUSTON, TEXAS 77057
713.783.6609

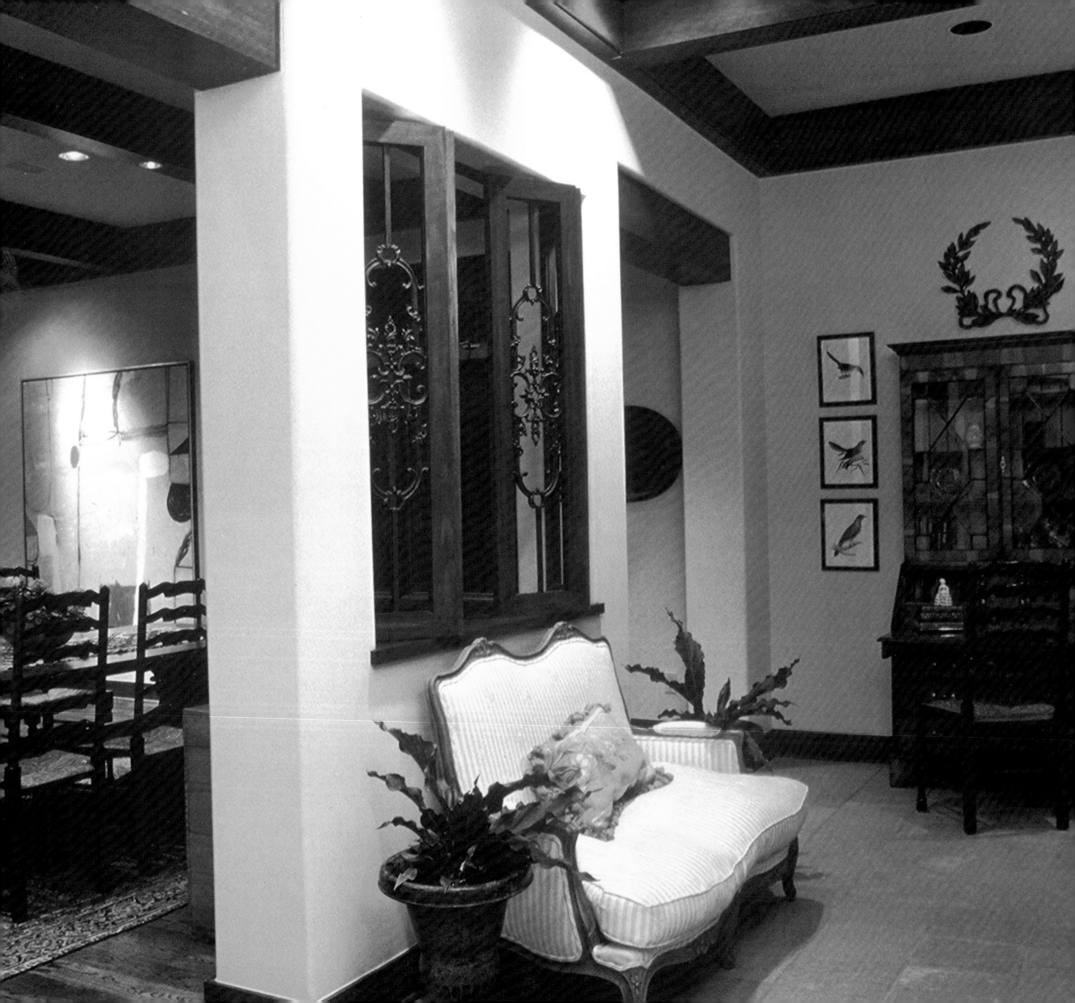

Karen Graul, ASID

KAREN GRAUL DESIGN

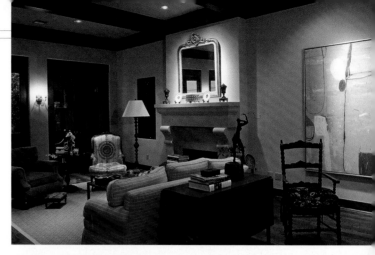

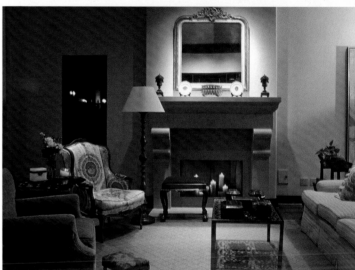

TOP: Furnishings in this great room range from a Louis Phillipe mirror to an abstract painting by Gary Komarin. Architecture by Tom Wilson and Associates.

ABOVE: Seating around the fireplace is one of two sitting areas in the great room, which also includes a large dining area.

Award-winning Houston designer Karen Graul has experienced the interior design business from all angles. She began her career as an award-winning design writer, then she became a columnist before launching her career as an interior designer. Her wide variety of jobs and full range of expertise has given Karen an excellent background and a wealth of knowledge from which to compose her many residential projects.

A graduate of the University of Oklahoma with a degree in journalism, one of Karen's first jobs was fashion writer for the *Houston Post*. "I covered all the New York fashion shows, which was exciting," said Karen. "However, I had a lifelong fascination with interior design and was led in another direction." She switched positions within the organization and became the home furnishings editor. In that role, Karen initiated a syndicated budget design column.

Later, Karen became a contributing editor and columnist with *Houston Home & Garden* and a regional editor for the national publication *Home*. She also assisted Jeffrey Weiss, a New York publisher of interior design books. During this time, Karen began accepting residential and commercial design commissions and remodeled several homes for sale. These engagements fueled Karen's desire to open her own interior design firm.

In 1984, she launched her company, Karen Graul Design, which specializes in new home building and residential remodels. Today, her business is vibrant and highly successful in the residential design world. With a strong commitment to excellence, Karen oversees every detail in the design process from conception to completion.

Her visually sophisticated projects have earned her an impressive six *Houston Chronicle*/ASID Design Awards and a cache of loyal clients who enjoy her sophisticated, yet inviting interiors. "I like to avoid trends," Karen explained of her approach to design. "My clients prefer a natural, undecorated look that isn't dated." ■

LEFT: Shutters with iron grills are part of the openness between the entry and great room in this Houston home.

KAREN GRAUL, ASID
KAREN GRAUL DESIGN
3125 WROXTON DRIVE
HOUSTON, TEXAS 77005
713.667.3494

Peggy Hull, ASID

CREATIVE TOUCH INTERIORS

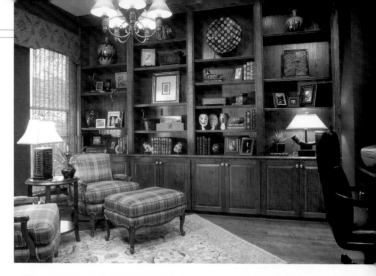

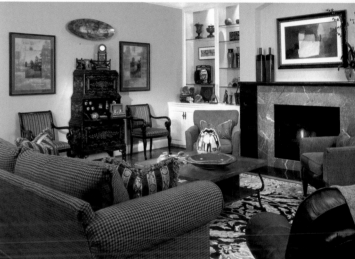

Successful Houston designer Peggy Hull started her career as an educator, which may explain why she often assigns her clients homework. "I do a complete house analysis to define each client's needs," she explained. "Then I ask every client to write down their goals, time frames and budgets." Using her teaching skills, Peggy educates her clients about the design process and seamlessly guides them to completion. This approach has served the established designer well during her 17-year career.

This third-generation Texan graduated from the University of Texas with a degree in education and an MBA from the University of Houston. Peggy taught school for six years before pursuing her passion for design. "I dropped off my youngest at kindergarten and immediately enrolled in design school," she recalled. Then in 1988, Peggy opened her own firm, Creative Touch Interiors, which currently specializes in residential design.

Peggy strives to make clients comfortable in their own homes by molding her style of design to fit her clients' needs. "Every room should have a touch of whimsy that's reflective of the clients who live there," she said. "The second ingredient to creating ambience is color. It is not unusual for one of my designs to incorporate 20 colors of paint. While that may seem extreme, every room seamlessly flows into the next."

Her colorful designs have been featured in local publications, and she is a frequent participant in area showhouses. Peggy understands the importance of supporting her profession and is an active member of the ASID, where she devotes her time chairing various committees.

The real reward comes from seeing the smile on her clients' faces when thanking her for a job well done. "My mission is to create warm, relaxing environments. I want my clients to walk into their homes after a busy day and exclaim, 'This is my haven, my respite.' Improving my clients' quality of life is what motivates and inspires me." ∎

TOP: In this study, rich mahogany is the backdrop for displaying treasured mementos from the clients' travels. Texture is provided by the tapestry window cornice, grass shades and hand woven rug. The deep red color on the walls accents the soft gold and green in the fabrics.

ABOVE: Texture comes in to play in this transitional family room that provides ample seating for entertaining. Collectibles are displayed on glass shelves against a grass-cloth wall covering. Dramatic colors are reflected in the marble-and-granite fireplace surround and they are repeated in the rug.

PEGGY HULL, ASID
CREATIVE TOUCH INTERIORS
2222 BISSONNET STREET
HOUSTON, TEXAS 77005
713.529.7681

LEFT: In this 14 x 16-foot living room designed for entertaining and music, rectangular spaces are softened with the curved sofa, metal-and-glass cocktail table, chair and hand-blown vase. A Ghazni rug is angled, providing pattern and texture, while silk window treatments on iron rods provide strong vertical lines. The theme of music is carried through with a serigraph by Yunessi. Not shown are Gregorian chants circa 1450, which are framed on the wall next to the piano.

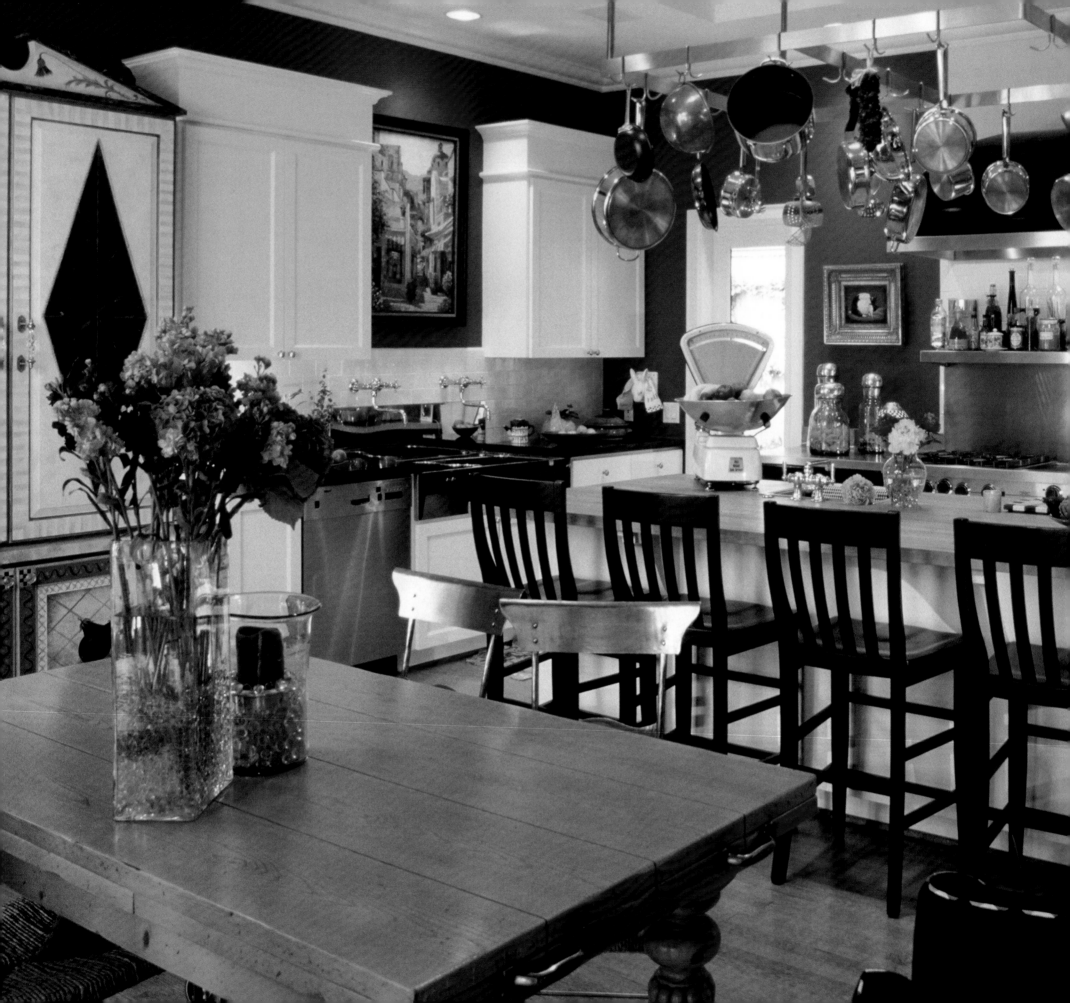

Cindy Hunter, ASID

SUGAR CREEK INTERIORS

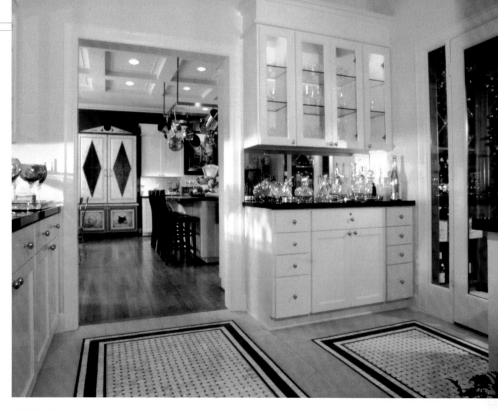

Talented interior designer Cindy Hunter began her career in Monticello, Illinois, in 1980, when she opened an accessory and furniture store catering to the design trade. Five years later, she moved to Texas and launched Sugar Creek Interiors in Sugar Land. The popular business flourished, prompting a January 2005 move to Houston.

Today, Cindy's stunning 4,800-square-foot storefront happily sits in the heart of the design district, where an atrium fountain and spacious skylight welcomes her clients to the establishment that specializes in distinctive furnishings, fabulous fabrics and inspiring accessories. With sections devoted to both contemporary and traditional décor, along with a special section for design work, the store provides Cindy's clients the opportunity to see first-hand the expansive inventory that is meticulously handpicked by the noted designer. "The ability to visit a retail location helps my clients through the design process," Cindy explained. "My store is the heartbeat of my business."

Cindy, an Illinois native who grew up on a grain farm, received her degree in interior design from the Illinois State University. She gained excellent business skills growing up in the family business. "At an early age, my mother let me pay all the bills," said Cindy. "This experience helps me immensely when running and overseeing my design firm."

When working with her clients, the successful businesswoman and respected designer prides herself on having excellent listening skills. Once she's heard her clients' desires and learned of their requirements, she extensively researches each project to ensure a unique fit. "I like to layer a project by gaining input

CINDY HUNTER, ASID
SUGAR CREEK INTERIORS
3461 WEST ALABAMA STREET
HOUSTON, TEXAS 77027
713.212.0000

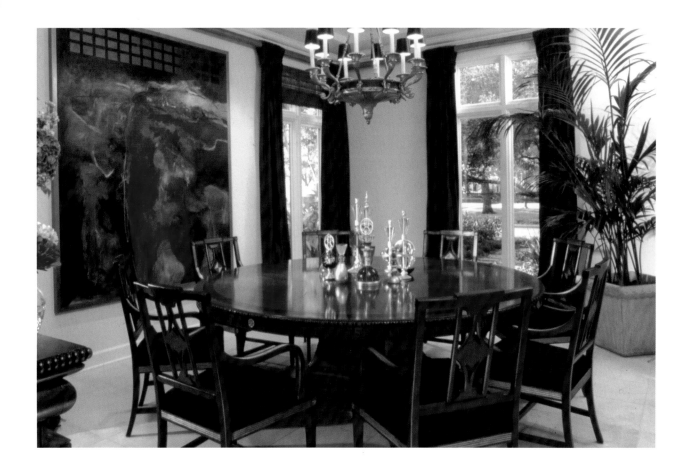

TOP LEFT: This seven-foot walnut table under the Chapman chandelier is surrounded by Directroire style chairs. The sideboard is 19th century English in flame walnut. The Harold Larsen oil is flanked by Schumacher magenta silk panels hung on a gold-leafed rod system.

LEFT: A pair of Marge Carson silk "Gallery Chairs" divides the living room from the foyer. The wing chair is outfitted in Brunschwig & Fils silk damask. Opposite is a brown chenille chair and ottoman from TRS and a John Widdicomb reproduction black-and-gold cabinetry on Kerman carpet. The painting sits over the black-and-gold mantel by Ken Muezenmayer.

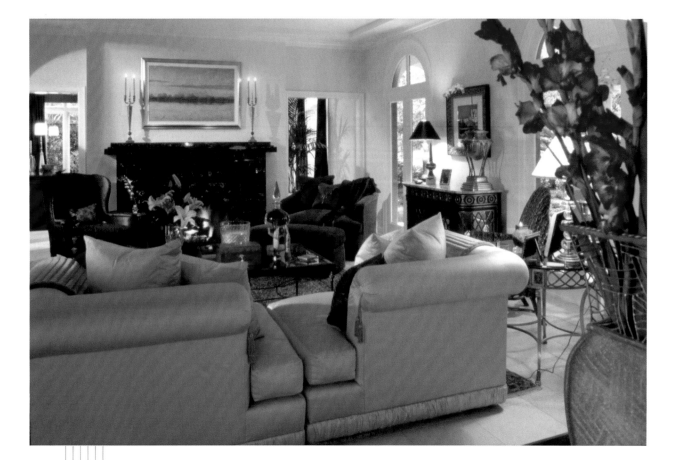

from the client on every level," she said. "After our initial meeting, I present my clients with an in-depth presentation, complete with trim and fabric samples specific to their homes," Cindy said. "This approach establishes trust as we move forward together through the design project."

Cindy loves creating and is especially adept at thinking outside the box. "Designing is a fun job that I thoroughly enjoy," exclaimed Cindy. "I love to solve challenging design issues." For example, she once helped a client by creating a space where the extended family of 12 could dine together.

For her innovative designs in states like California, Maine and Minnesota, Sugar Creek Interiors has received numerous accolades like the 2004 Prism Award for Interior Design. Her body of work has been featured in several publications,

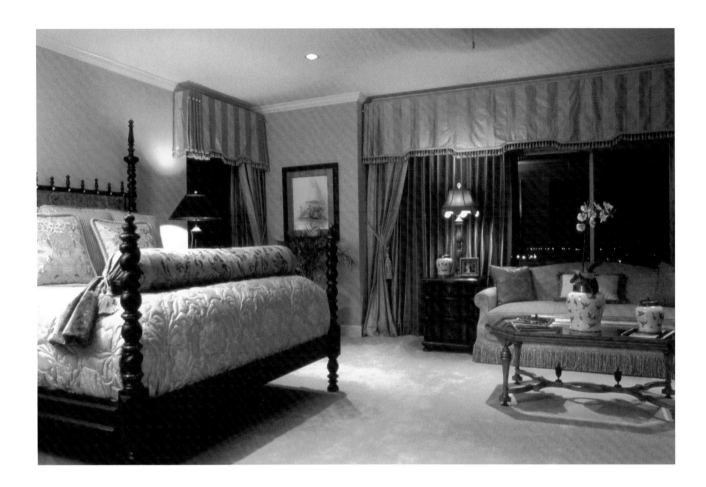

LEFT: The Portuguese-influenced bed is a focal point to this master suite on the 28th floor of a Houston high-rise. The suite is dressed in rich silks and velvets in colors of golds, corals, yellows and greens.

BELOW: A David Goldberg hand-painted wall covering surrounds you when you enter this high-rise. The furniture and design details make this not only an entrance space, but a place to stop and enjoy the view.

including the *Houston Lifestyles & Homes* spread that featured her own home. Testimony to her exquisite style, Cindy designed a light-filled home with generous spaces for entertaining and intimate settings for two people to comfortably live. "My husband and I wanted to be able to casually entertain in the kitchen and to host more formal events in our living room," she said. "We accomplished this goal."

As in her own home, Cindy has a gift for designing inviting interiors that reflect the personalities of the people who live in them. "I embrace each client's needs to create beautiful interiors unique to their tastes," she said. "When I leave a completed project, I know I've met my goal and successfully served my clients when they declare their home a perfect fit." ∎

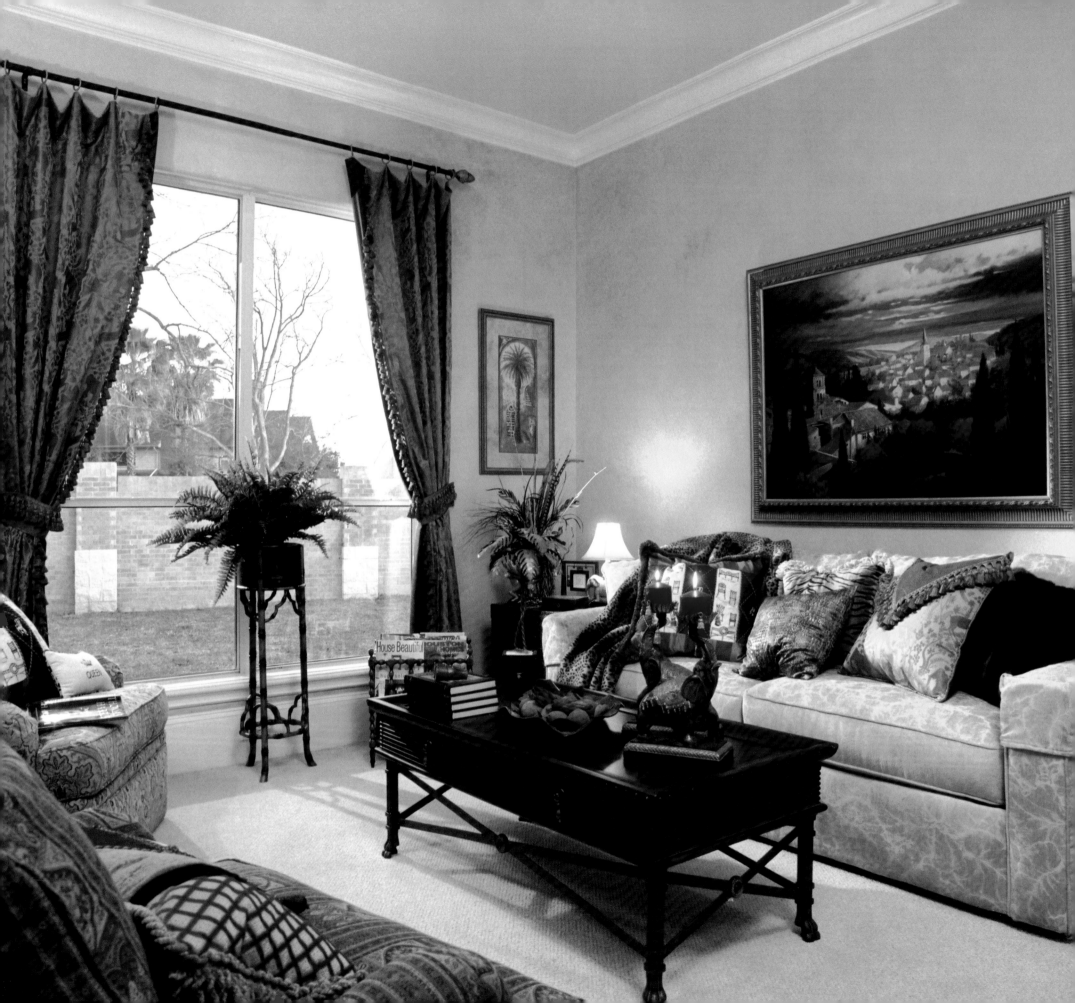

Donna M. Jarnigan, ASID

LACY-BOONE INTERIORS

ABOVE: Cool limestone, ivory gold granite, brushed satin nickel and "watermark parquet" wallcovering give this guest bath its luxe look and soothing, spa-like feel.

LEFT: This sumptuous guest retreat creates private quarters that can easily morph from a sitting room by day to a bedroom at night.

As the need for more soothing and eco-friendly environments grows, interior designers are expanding their horizons and answering the call. Donna Jarnigan, owner of Houston firm Lacy-Boone Interiors, has over 30 years of design experience to draw from to create beautifully unique spaces that often incorporate the principles of Universal Design, Aging-in-Place and Green Design.

"With the hectic, fast-paced lives we lead, now—more than ever before—there is a greater need for beautiful and restful places to call home," Donna said of her design beliefs. "My firm focuses on creating sophisticated interiors that reflect our clients' personalities, lifestyles, tastes and preferences. We also offer designs for special needs."

Lacy-Boone Interiors recently added a remodeling and general contracting division to its successful operations. With this addition, the firm truly is a full-service interior design company that serves a variety of residential and commercial clients. From private residences and model homes to hospital interiors and retail stores, they work to pleasantly serve each client, giving the utmost attention to detail while meeting their individual requirements for budget.

Donna's firm is widely recognized for its warm, inviting environments that have been featured in newspapers and magazines and on television and radio programs. Donna has also been extensively involved in the ASID, where she will serve as president of the Texas Gulf Coast Chapter in 2005 – 2006.

The noted designer who has invested time in her profession, leading organizations and growing to accommodate her clients' needs, says that success doesn't come from accolades, but from a job well done. "The greatest compliment comes when, after working with clients to create beautiful, soothing environments, they excitedly declare, 'I just love my home!'" ■

DONNA M. JARNIGAN, ASID
LACY-BOONE INTERIORS
1622 MAUX DRIVE
HOUSTON, TEXAS 77043
713.647.0647
WWW.LACYBOONE.COM

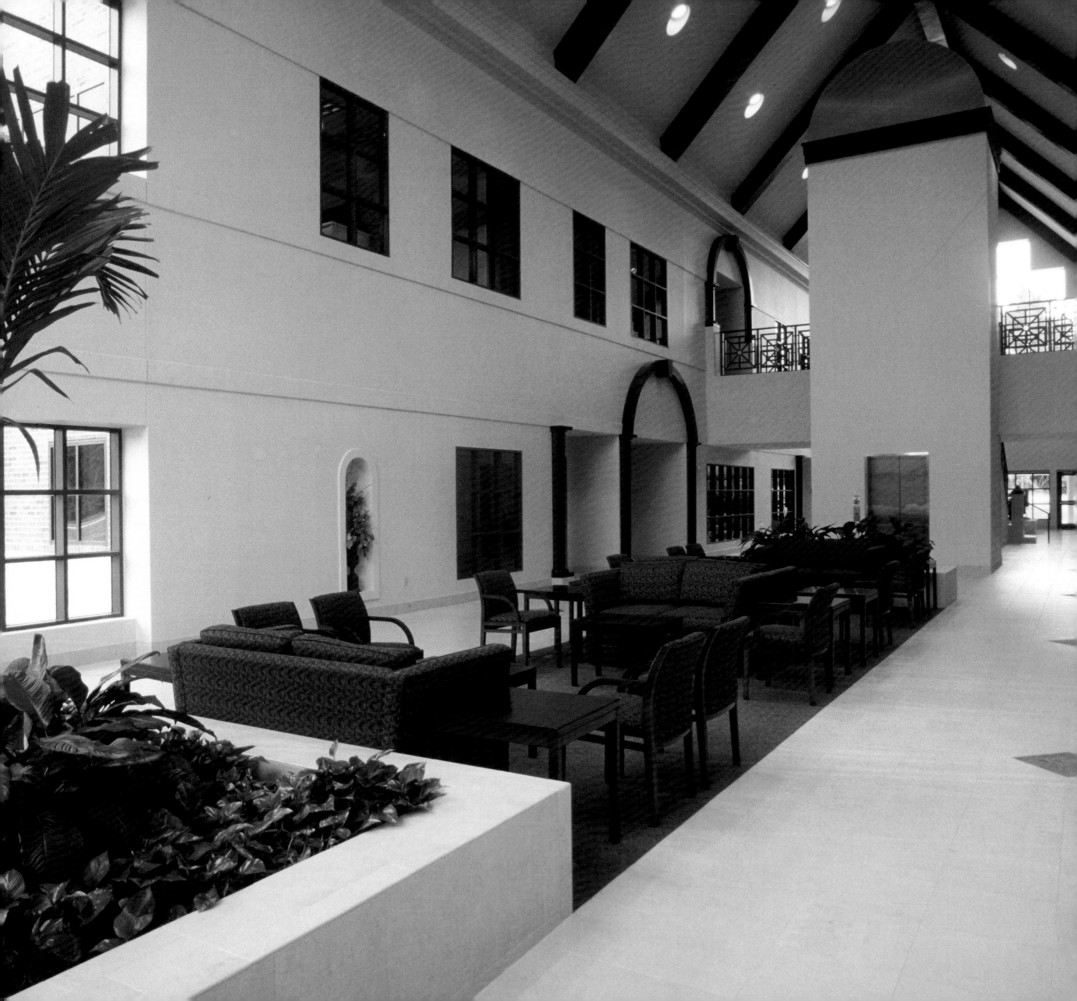

Colene Joiner, ASID, IIDA

JOINER PARTNERSHIP, INC.

ABOVE: This dramatic canopy is used for student drop-off at the entrance of the Humble Elementary School.

LEFT: This area is designed with furnishings to accommodate the Kingwood College community waiting for theater events and student gatherings.

Joiner Partnership, Inc. (JPI) is a true family business. Colene, a registered interior designer, has worked alongside her architect husband Carl since opening their firm in Louisiana nearly 28 years ago. A 1984 move returned the successful team back to the Houston area, where they've built an impressive portfolio of large-scale commercial projects. "The majority of our current work is educational facilities and municipal buildings," explained Colene. "However, over the years I've worked on many hospitality and medical projects."

With a staff of 10 and over 900 completed projects, JPI is committed to excellence in the built environment. "Our clients require more than just architecture and interior design," said Colene. "We make it our business to know what it takes to build good investments, and we design accordingly." The firm has an excellent track record for repeat business and offers quality service from the design phase through the completion of construction.

"Our motto is, 'Whatever it takes' and we display that saying on our construction hard hats," said Colene. "We do whatever it takes to please our clients." For Carl, that means a wide range of architectural planning services, such as site analysis, project development scheduling and construction phase services. On the interior design side, Colene oversees space planning, finish specifications, color selection, furniture selection, bidding and procurement.

The firm's list of awards is impressive. JPI has won five *Houston Chronicle*/ASID design awards—the most recent in 2004—and a 2002 IIDA Design Excellence Award. In 2000, they received top honors from the Texas Association of School Administrators and the Texas Association of School Boards for their work on the Kingwood College Student Center and the Fine Arts facility. In 2005, the Decorative Center of Houston gave them a Design Excellence Award.

COLENE JOINER, ASID, IIDA
JOINER PARTNERSHIP, INC.
TWO KINGWOOD PLACE
700 ROCKMEAD, SUITE 265
KINGWOOD, TEXAS 77339
281.359.6401
WWW.JOINERPARTNERSHIP.COM

National and local publications that have featured their award-winning design work include *Southern Living, Paper City, Designer's West Magazine,* and the *Houston Chronicle*.

This husband and wife team consistently supports their professional affiliations. Colene holds an interior design degree from the University of Houston and has proudly served as president of the ASID Texas Gulf Coast Chapter as well as president of the TAID. Currently, she sits on the NCIDQ committee that is producing the practicum portion

of the licensing test for new interior designers. Carl, a licensed architect and graduate of the University of Kansas, is an active member of the AIA, where he has served on various boards and committees in both Texas and Louisiana.

The combination of quality architect and skilled interior designer has proven to be a winning solution. The addition of son Chad as director of construction three years ago strengthened what is a solid team. "Clients come to us for good design," stated Colene. "We have the expertise to take them through the entire process of creating a built environment." ■

ABOVE: This dramatic entrance is featured in many of Kingwood College's publications. It was programmed for easy student access to admissions, the bookstore and other functions of this multi-purpose, award-winning building.

LEFT: Programmed for a dual role for both the local community and the college, this award-winning space serves to offer fine art enrichment for all.

OPPOSITE PAGE:

TOP LEFT: The bold color palette reflects the corporate identity of taupe and burgundy, which is blended with rich cherrywood finishes for an award-winning space.

LEFT: Company projects displayed on a conference room wall accented with lighting are features that enhance the custom verde marble and cherrywood conference table.

RIGHT: This new school replaced the oldest elementary in the school district and continued with the original school color of green to maintain the community history.

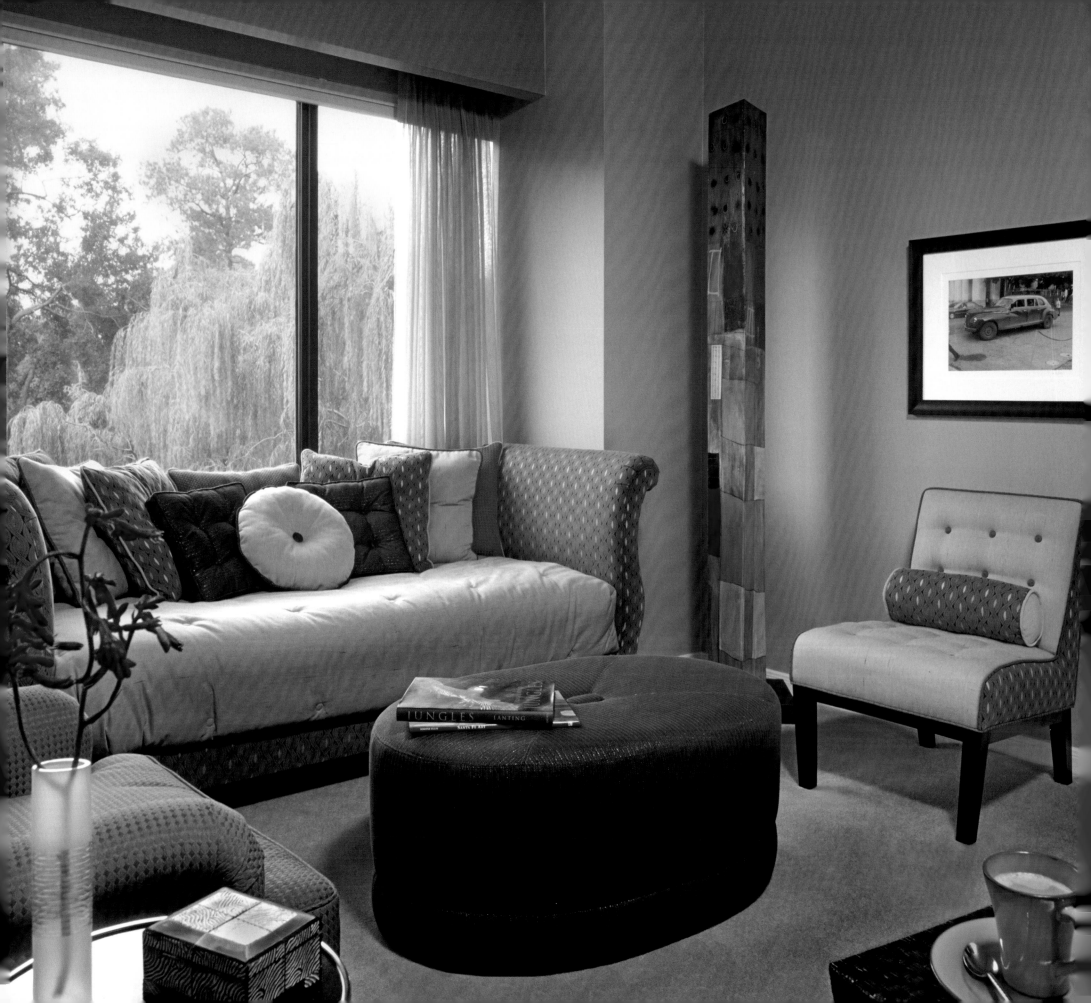

Lynne T. Jones, ASID

LYNNE T. JONES INTERIOR DESIGN

ABOVE: The mirrored console and original 'four-squared' artwork makes a dramatic first impression in this Houston high-rise foyer.

LEFT: The all-upholstered, custom daybed allows the art-filled 'Sassy Green' den to double as a cheerful guest room.

Growing up outside a small town in the panhandle of Texas, Lynne Jones rarely saw artistically decorated homes. But from the day she had her first look at one, she was hooked. "I went to visit the home where my two great aunts lived and could not believe my eyes," she explained. "They were artists who would spend half the year in New York City buying incredible sculptures and art work. Their house was so beautiful and different; I had never seen grass-cloth wallpaper before and the window treatments were gorgeous. I was fascinated."

The image of that house started Lynne on her journey to become an independent designer and to create beautiful homes for people to enjoy. She graduated from Texas Tech University with a degree in interior design and headed southeast to Houston. Now, 27 years later, her residential design firm, Lynne T. Jones Interior Design, has a devoted following of clients.

"I really enjoy working with people in their homes, helping them define their own design styles," Lynne said. "Traditional, Art Deco, country, transitional, ranch-style or contemporary–whatever their favorite may be–I help guide them through every step of the creative process so they truly enjoy it. The journey is half the fun!"

Lynne encourages her clients to grow and expand their design visions by trying new things usually involving patterns and color. She often combines florals, stripes and small prints with traditional furniture and contemporary art. "Mixing elements can be a challenge," she admits. "But when it works, it is so much more interesting than seeing a space where everything coordinates and matches perfectly."

LYNNE T. JONES, ASID
LYNNE T. JONES INTERIOR DESIGN
3506 HIGHWAY 6 SOUTH, SUITE 365
SUGAR LAND, TEXAS 77478
281.437.3307
WWW.LYNNETJONES.COM

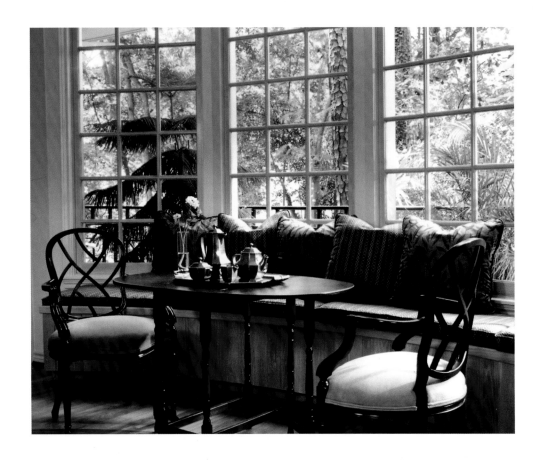

The eclectic twist that comes from the combining old and the new is a favorite of Lynne's, who is drawn to antiques. Frequently, she includes great older pieces in her design projects. "I think older things have so much character and charm, and they have a story to tell," she said. Color is also an important element in her designs. "I incorporate color into rooms using newer touches like bright, cheery fabrics and sunny wall glazes. They create a warm and inviting feel."

The results are impressive. Her rendition of an Adirondack-style log cabin won the *Houston Chronicle*/ASID Design Award, and many of her design projects have been featured in such publications like *Better Homes & Gardens Bedroom & Bath Ideas, Better Homes & Gardens Decorating Ideas,*

TOP LEFT: Cozy, built-in banquette seating provides an ideal place to enjoy a spot of tea or to curl up with a good book.

LEFT: Art Deco-inspired custom lounge chairs set the tone for this high-rise living room.

BELOW: This Adirondack-style, log-cabin guest room is a fusion of colors and textures, complete with Twig beds, colorful blankets and kid-friendly, built-in bunks.

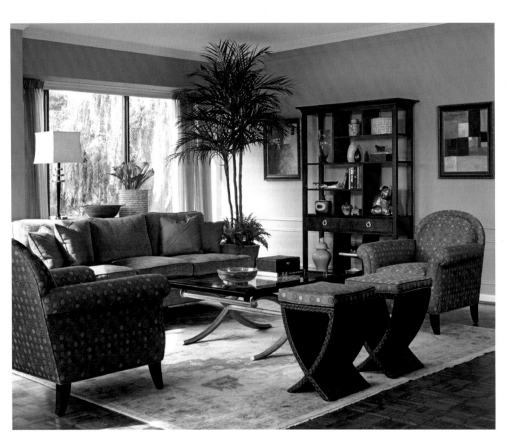

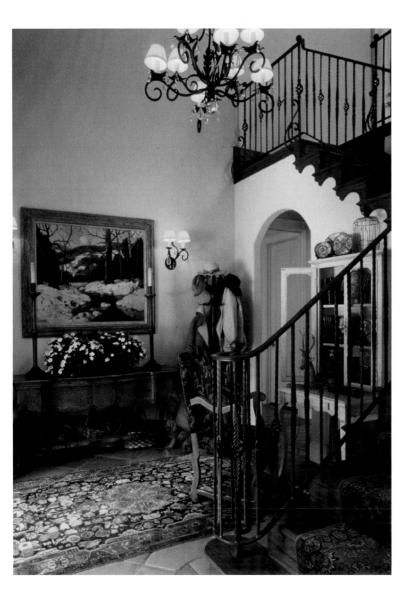

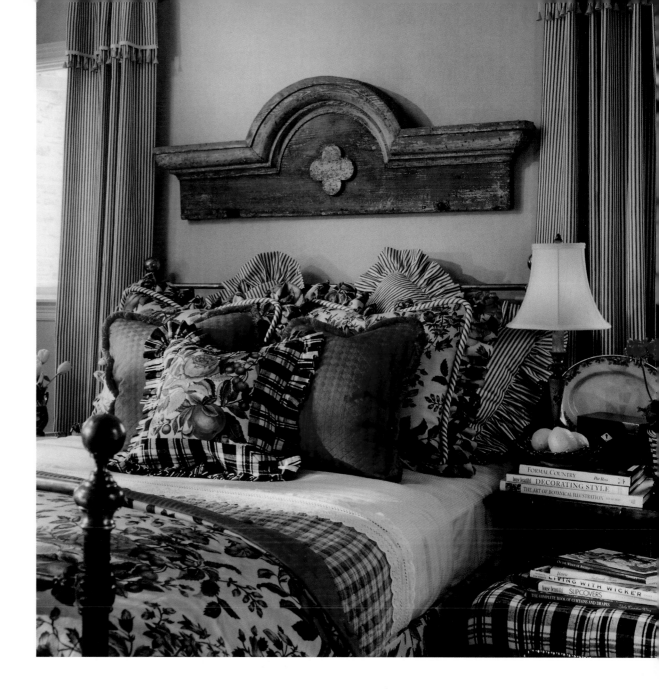

Southern Living, First for Women, Houston Home & Living, Houston & Fortbend Lifestyles and Houston House & Home. Lynne continues to design rooms for ASID showhouses, and she regularly contributes "Designer Tips" to Home and Garden Television.

Lynne is also active in the ASID, where she has served the organization for many years by working on and chairing various committees. Currently, she is gearing up for a two-year commitment as financial director of her local chapter. "I'm honored that my colleagues have that faith in me," she said.

From a small-town girl from West Texas to a distinguished, big-city interior designer, Lynne's imaginative mix of designs–complete with bold colors, fabulous patterns and an assortment of styles–continues to please and thrill her clients. ■

LEFT: The jewel tones in the rug and the custom iron railing, along with the carved wooden console, add to the warmth of this entryway.

RIGHT: Glazed yellow walls, multiple fabric patterns and one strong vintage architectural element come together in a happy combination.

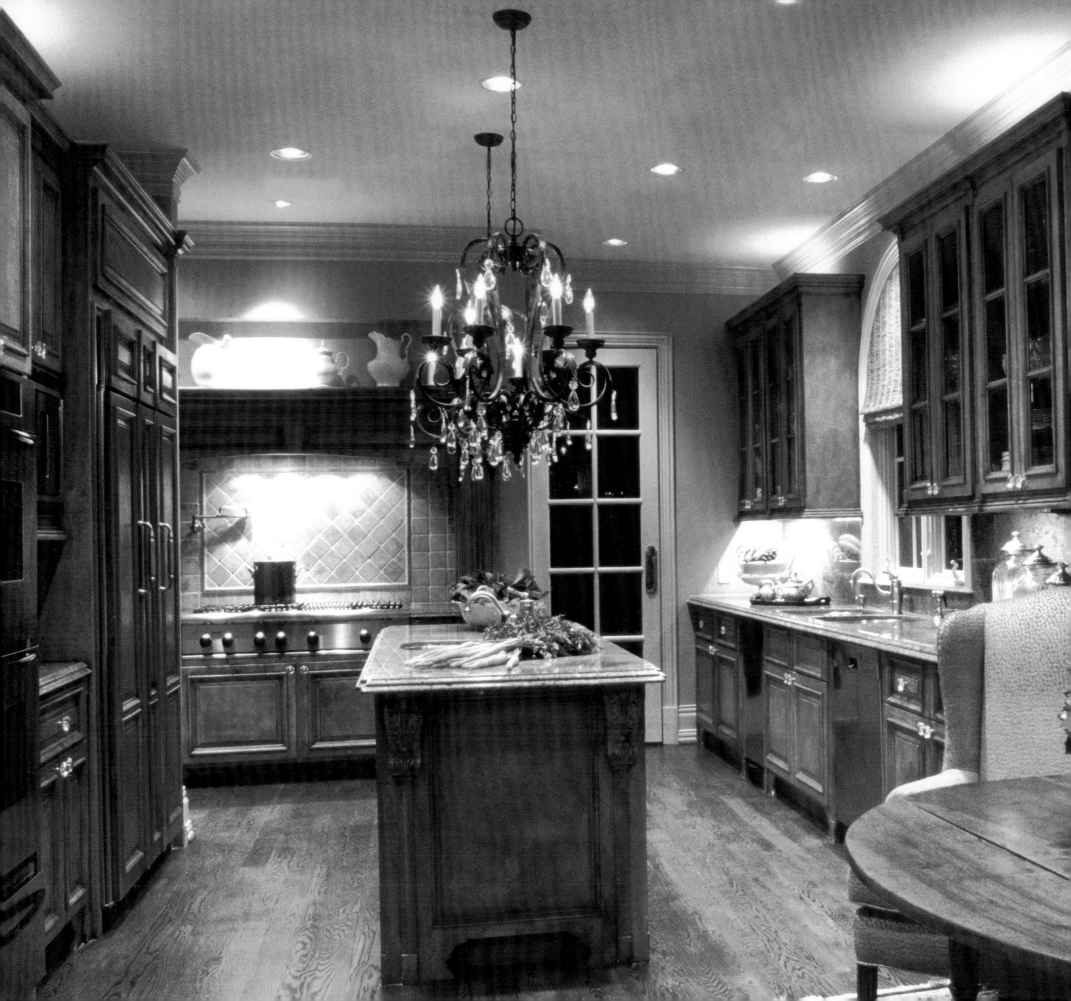

Connie LeFevre, ASID

DESIGN HOUSE, INC.

ABOVE: Peace and quiet are yours on this bench with a view of the living room, library and entry. The atrium was created with serenity in mind.

LEFT: Comfort with stylish distinction is abundant in this city residence featuring custom faux finished cabinets and a slightly rustic chandelier with crystal drop accents.

Noted designer Connie LeFevre has a passion for the unique and the exceptional. "I search the globe for one-of-a-kind items for my Houston showroom, Design House, Inc.," she said. Among her finds are European antiques, art, accessories, lighting and custom pieces, which she uses to expertly dress spaces for discerning clients. "One unusual piece can complete an entire setting, giving it personality and flair," she said.

Design House's clients—who are primarily residential and based in Houston, though several are scattered across the nation—rely on Connie and her staff to compose creations reflective of their tastes. "Design House is a full-service design firm with experience in new construction, remodeling and space planning," Connie explained. "Regardless of the style—traditional, contemporary or transitional—our team listens carefully to clients' needs during conception, and we partner with them throughout the entire process to ensure that their visions are realized."

Combining three existing warehouses into one spacious showroom nearly four years ago has enabled the respected firm to centralize its products and services, which benefits the clients. "Trying out a chair or seeing a piece of art before purchasing helps establish trust and it also prevents errors," Connie said. She's quick to note that other designers also benefit from her expansive inventory. "They shop our showroom when looking for an exceptional piece to anchor their designs. Because my worldwide selections are unique, designers and clients are guaranteed something fresh and exciting," she said.

CONNIE LeFevre, ASID
DESIGN HOUSE, INC.
7026 OLD KATY ROAD, SUITE 115
HOUSTON, TEXAS 77024
713.803.4949

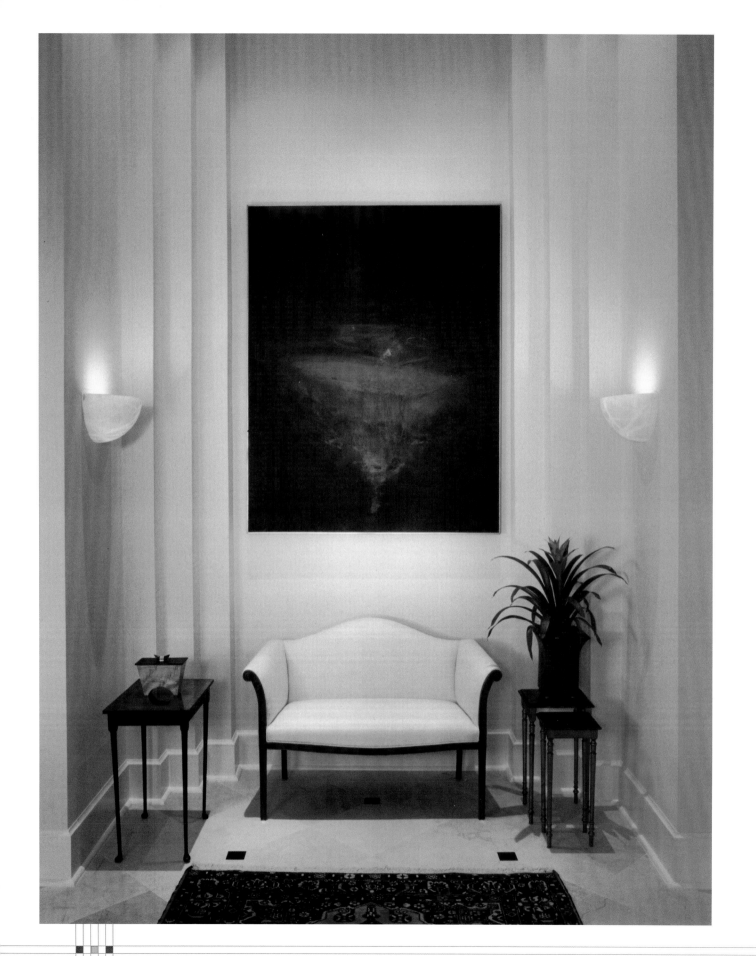

LEFT: This home was done in whites, creams and beiges to accent the art and antique collection of the homeowner. The colors of the art vibrate against their minimalist settings.

Leading the charge at the award-winning firm is founder and owner Connie LeFevre. A seasoned professional interior designer with 30 years' experience, Connie began her trek toward her career as a student at Louisiana State University. After her husband's transfer to Houston, she enrolled at the University of Houston and earned a fine arts degree in interior design. "I'm an artist at heart," the now savvy and successful businesswoman said.

Shortly after graduation, Connie was off to Philadelphia on her first big job. There, she converted a multi-storied plant into a corporate headquarters. The significant endeavor was a huge success, and her interior design career was born.

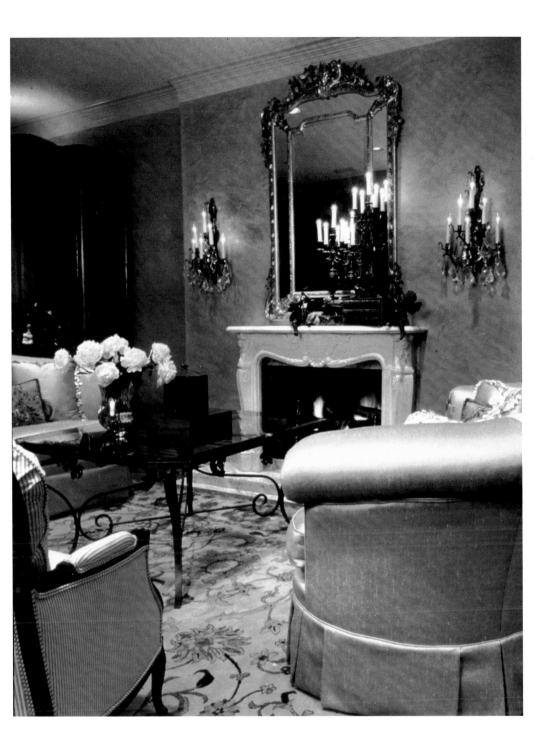

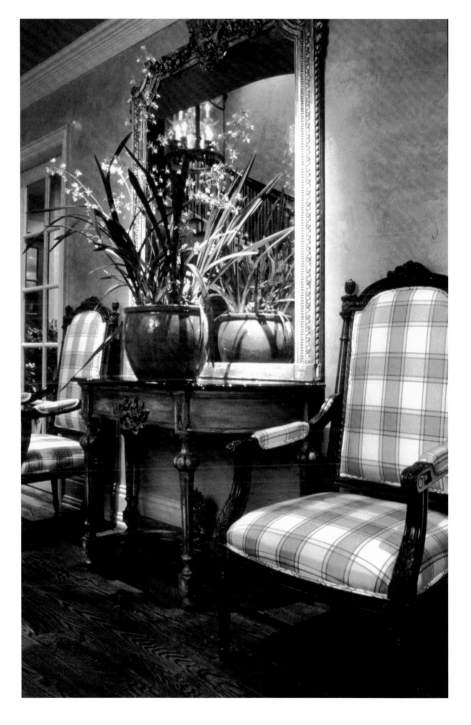

LEFT: This living room features Venetian plaster walls with custom and antique furniture. The rug is Egyptian.

BELOW: The 20' ceiling in the entry is slightly diminished by oversized chairs, the large mirror and jardiniere. One chair is an antique and the other was custom made to match it. The antique console and mirror were custom finished to match. The mirror has a carved M on top of the frame that personalizes it for the clients.

Today, Connie and her team of five full-time and several part-time employees—including a rotation of interns from the neighboring universities—tackle projects of all sizes. In addition to incorporating unique elements to create individual designs, they rely on the latest technology to get the job done. "The advances in technology have proven extremely useful," Connie said. "For example, I can snap a shot of a piece of furniture in Europe and send it directly to my client in the states, who can immediately make a purchase decision." She also uses technology to complete her sought-after designs.

TOP LEFT: Minimalist bathroom designed to showcase the clients' contemporary taste.

LEFT: Traditional powder room designed with silver leaf walls, custom finished cabinets and a magnificent antique French chandelier.

RIGHT: These stairs were designed to have a minimal look on a limited budget. Instead of metal, LeFevre used ebonized maple for treads and the handrail. The balustrade is made of wooden dowels that were sprayed with car bumper paint to look like stainless steel.

"Once we outfitted the ceiling of a seaside home with fiber optics to recreate an astronomically correct star chart," Connie explained. "By dotting the inside of the domed ceiling with "stars" made from bundles of fibers that poked through holes punched in the ceiling, we simulated the night sky."

Innovations like this one contributed to the *Design Times'* declaration that Connie is one of the "10 Designers to Watch." Appreciative of that nod, Connie is quick to give credit to her supportive staff. "We are a team that works together to efficiently and effectively serve our clients." This approach has led to numerous accolades by industry organizations and features in national and local publications.

ABOVE: This section of the library emphasizes the mix of textures used in the space. The antique settee is upholstered in mohair and the windows have woven natural grass shades that compliment the sisal rug. Antique Louis XIII chairs upholstered with needlepoint rugs sit beside an antique library table.

Connie willingly gives back to the industry that's supported her. She is a former president of the ASID Texas Gulf Coast Chapter and the former vice president and board member of the TAID. Her active involvement in these groups has contributed to her achievements, which, in turn, have led to a loyal following. "My staff and I are blessed with extraordinary clients who trust us to deliver personalized designs that are functional and aesthetically pleasing," Connie said. "We consider a project successful when our clients declare that we provided the right solutions to their unique environments. That," she continued, "is how we measure true success." ∎

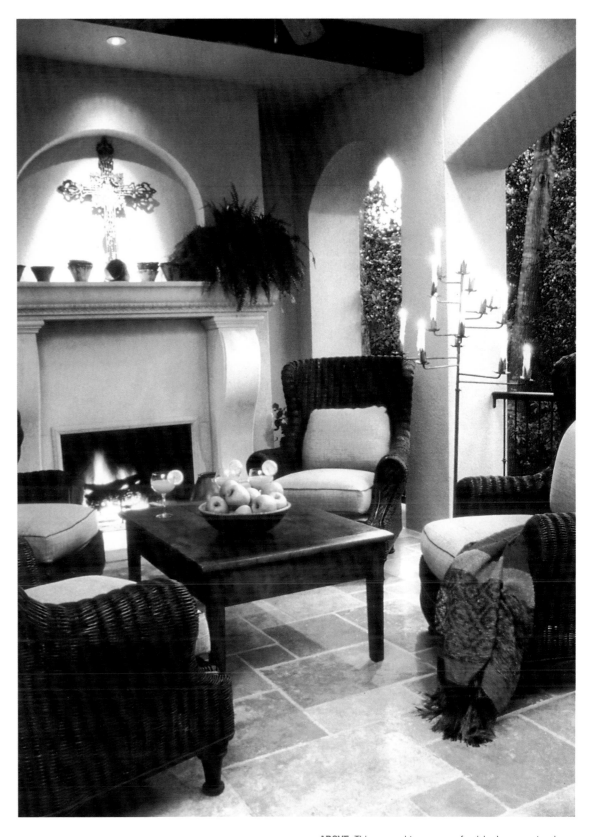

ABOVE: This covered terrace was furnished as an extension of the living room. With a mix of wicker, wood and iron, the terrace has a cozy, relaxing feel overlooking the bayou.

Sandra Lucas, ASID
Sarah Eilers, ASID

LUCAS/EILERS DESIGN ASSOCIATES, LLP

ABOVE: An eclectic mix of European antique furniture and accessories reflect the home's old-world charm.

LEFT: An antique, French hand-painted screen sets the tone for this warm and comfortable living area.

Two native Houstonians, who met in college at the University of Texas at Austin, traveled their separate ways after graduation. The pair reunited when they worked together at the same design firm and later struck out on their own to start an interior design business together. The two designers whose paths kept crossing are Sandy Lucas and Sarah Eilers, owners and partners of Lucas/Eilers Design Associates, LLP. The firm opened its doors in 1995 and has grown into one of Houston's premier design firms.

"It is unusual to know someone at the beginning of college and to run into them again in a new job a few years later," said Sarah, who graduated in 1980 with an interior design degree. "That's right," agreed Sandy. "We both started working at The Bryan Design Associates in 1980, where we honed our skills for the next 15 years under owner and mentor Mary Ann Bryan." Sandy, a 1978 interior design grad, first worked at an architectural firm specializing in hospitality design before signing on with The Bryan Design Associates. "Over a two-year period," Sandy said, "I was involved in the design of over 20 hotels and restaurants, which was an exhausting, but invaluable, experience."

Today, the noted designers serve residential clients across North America in locations like Houston, New York, Colorado, California, Tennessee, Wisconsin, South Carolina, Massachusetts and New Mexico. Their expertly designed interiors do not adhere to one style; traditional homes line the pages of their portfolio next to contemporary and eclectic ones. And while their styles may vary from project to project, their approach to design remains constant. Both Sandy and Sarah agree that each interior should be elegantly classic with clean, timeless lines that will function well for years to come.

SANDRA LUCAS, ASID
SARAH EILERS, ASID
LUCAS/EILERS DESIGN ASSOCIATES, LLP
1502 AUGUSTA, SUITE 220
HOUSTON, TEXAS 77057
713.784.9423
WWW.LUCASEILERS.COM

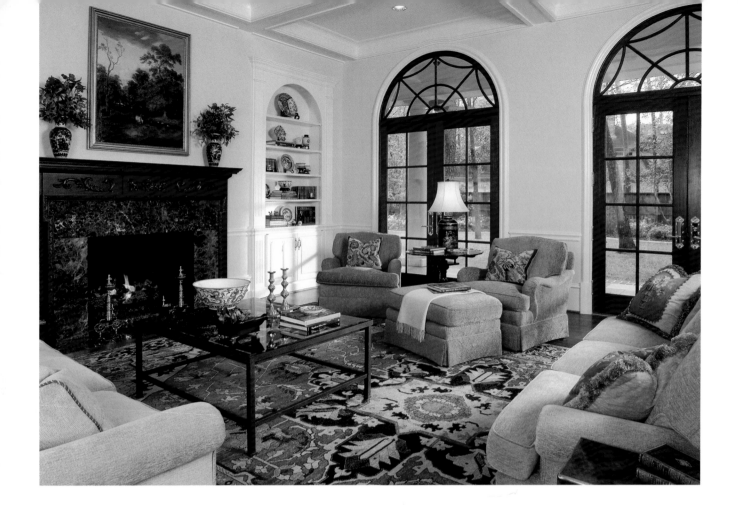

LEFT: A traditional Georgian home provides the perfect environment to showcase warm textural fabrics, antiques and oriental rugs.

BELOW: A collection of folk art paintings and antique tole ware completes the composition in this casual family room.

"A house is the single most important investment a person usually makes," said Sarah. "Our job is to implement the principles and elements of quality design into our projects while incorporating color and texture with exceptional attention to detail. We want each interior to look great the day we finish and still be impressive 10 years later." Sandy agrees. "A home is commonly understood to be the embodiment of its owner's soul. Therefore, it is very important that each setting reflects the personalities, tastes and desires of the people who live in it."

To achieve this goal, the designers must first understand their clients' lifestyles. "We thoughtfully consider how each client uses their spaces before creating environments that uniquely fit them," Sandy explained.

The acclaimed firm employs a staff of seven, which works cohesively as a team when partnering with architects, contractors and consultants. Sarah and Sandy believe this cooperative approach is best. "The relationship and communication between the design team and the clients are integral to a successful project," Sarah said. "We also have the added advantage of offering custom design elements." Having long-standing relations with vendors and intricate knowledge of residential products enables the firm to expertly embellish each interior with custom details. By selecting and installing furnishings, fabrics, art, accessories, lighting and window treatments, they confidently create beautiful, functional homes that are aesthetically exciting.

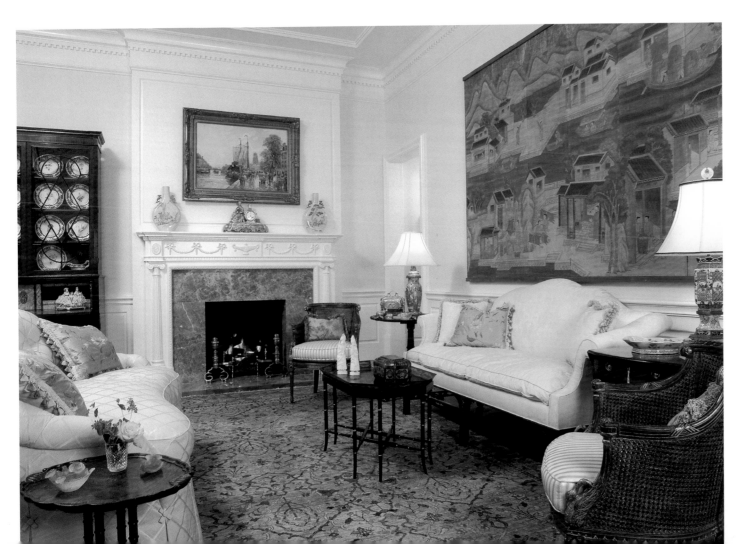

ABOVE: The design of this cheerful breakfast room centers on the client's colorful artwork.

LEFT: The formal living room was inspired by an oriental screen, fine art and a porcelain collection.

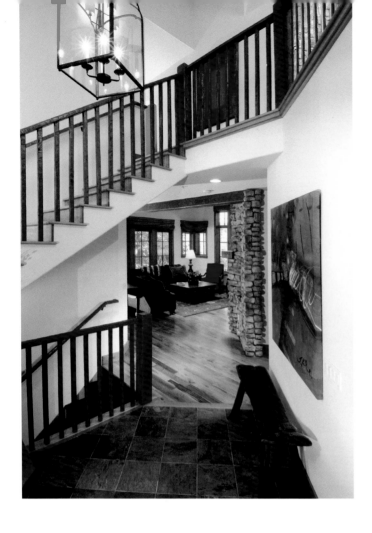

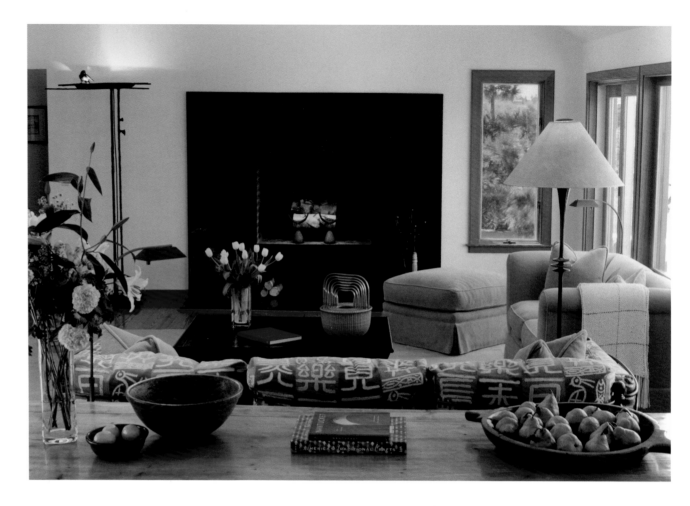

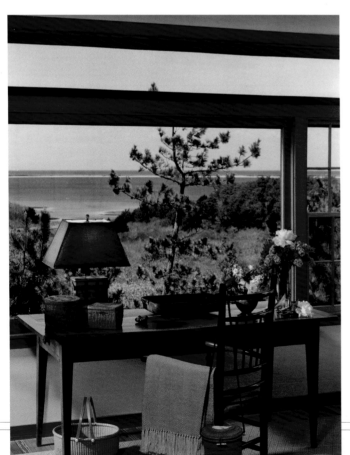

TOP LEFT: Textural finishes makes this an inviting entrance to a vacation home in Colorado.

TOP RIGHT: A versatile floor plan allows for both summer and winter furniture arrangements to take advantage of the warmth of the fireplace and the spectacular views.

LEFT: A personal writing area is designed to take advantage of the breathtaking views.

This dynamic pair does not solely attribute their firm's success to the quality of their designs; they believe their attention to the business side of owning a company is a definite differentiator. "We believe that professionalism in business practices is as important as the creative aspect of our designs," explained Sandy. "We pride ourselves on using the latest technology to manage our projects so we can meet our clients' requirements for budget and need."

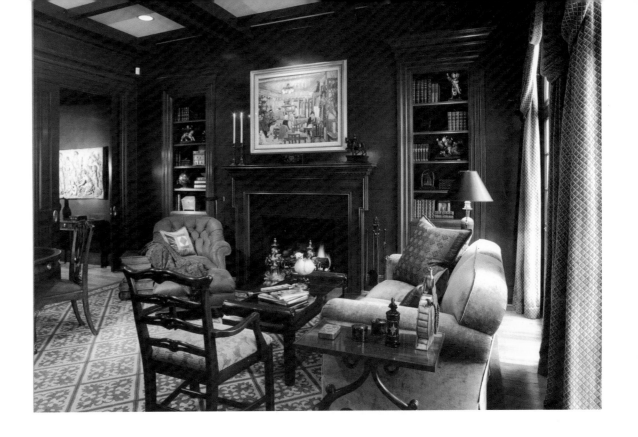

TOP RIGHT: The lacquered green walls of this library creates a dramatic backdrop for the client's eclectic art collection.

RIGHT: An elegant combination of pattern and texture completes the design of this delightful breakfast room.

Evidence of their success is apparent. They have been the recipients of numerous ASID design awards, and many of their outstanding projects have been featured in local and national publications. Both Sarah and Sandy are active in their local ASID chapter–Sarah has been both treasurer and secretary and she has served on several boards; Sandy's contributions include terms as bazaar and consignment chairs. Sandy has also served the NCIDQ as juror and proctor. Both designers willingly invest time in the profession they have called home for over 25 years.

"We love what we do," said Sarah. "Whether it's creating beautiful environments for our clients or giving back to our profession, every project brings something new and exciting." ■

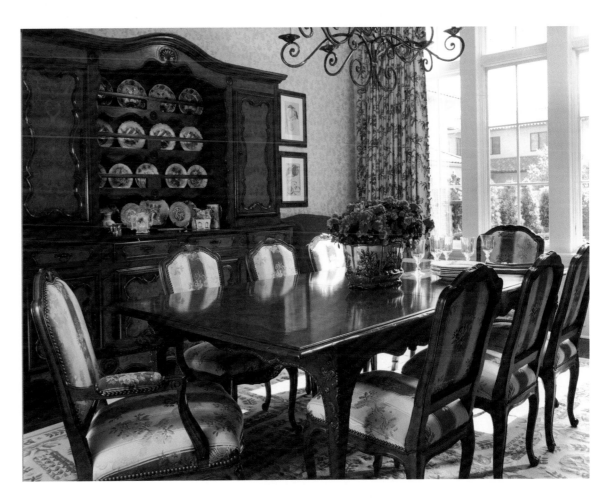

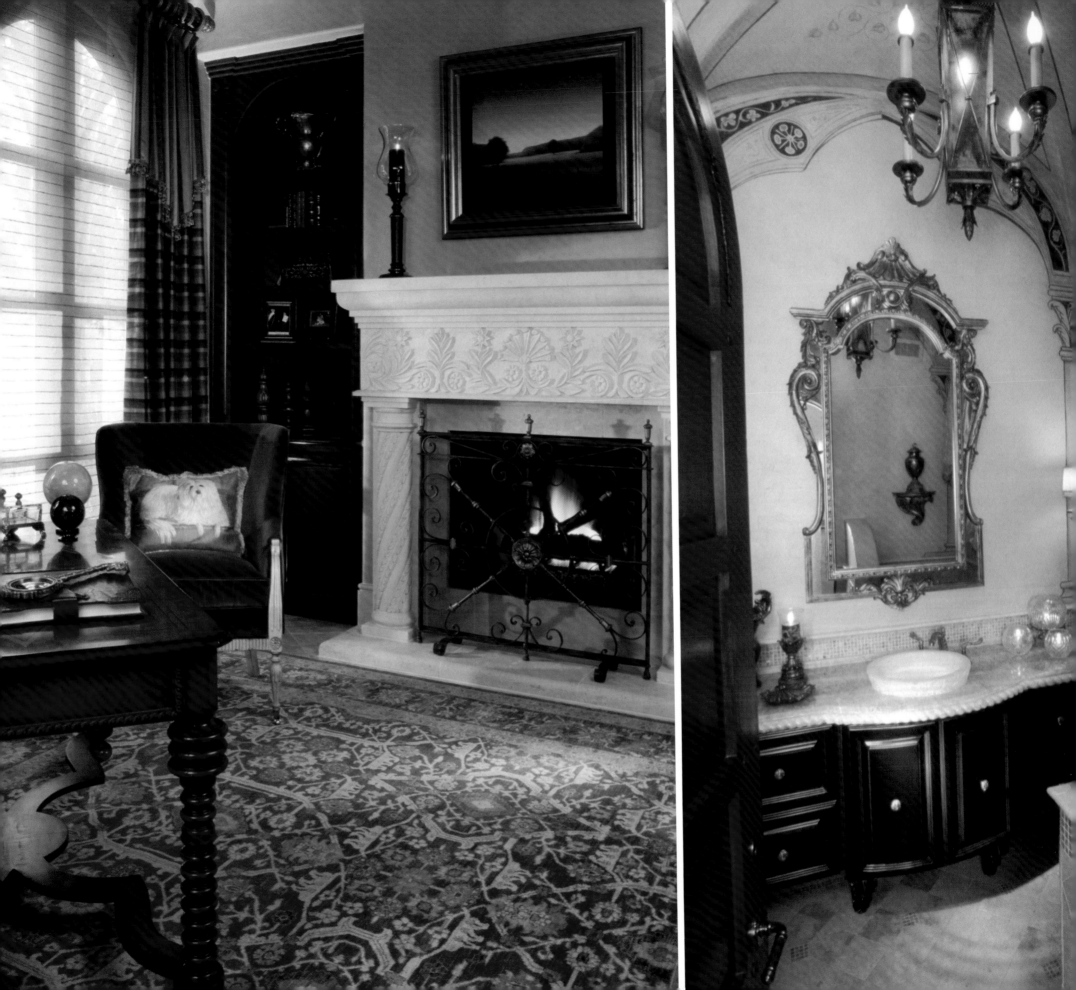

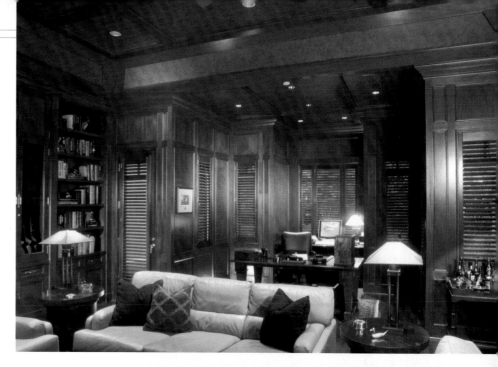

Shelia Lyon, ASID

SHELIA LYON INTERIORS, INC.

Shelia Lyon began her successful interior design career in 1979, three years after opening her own window-covering retail shop. "It all started at that store," she recalled. "I wanted to start my own small business and window treatments seemed like a good fit." Soon the store was flourishing, so Shelia added carpet and furniture reupholstering to the bustling business. "As the store grew, so did my desire to venture further into the world of interior design," she said. "It was a natural progression for me to open my own firm."

Shelia Lyon Interiors, Inc. is full-service Houston design firm with a solid reputation for superior work and a long list of delighted clients. "I have a high-energy, creative design team who specializes in turnkey, high-end residential design," Shelia said. "Together we handle a high volume of new construction, remodeling and furnishings." Her firm, which employs a staff of two full-time assistant designers, one office manager and one part-time accountant, strives to make a conscious effort to design around each client's individual tastes.

Shelia accomplishes personalized service by ensuring that a good chemistry exists between client and designer. "It's important that I listen carefully to my clients so I can develop a relationship in which my clients feel comfortable expressing their needs and concerns," she said. "Having sound relationships is vital to my success."

The firm's accomplishments are evident, as many of their exceptional projects have been published in the *Houston Chronicle, Houston Lifestyles* and *Homes* and *Houston Home*. Shelia also recognizes that supporting her professional organizations is important; she is proud to be a long-time member of both the ASID and the TAID.

From a small window-treatment shop to a thriving interior design firm, Shelia is pleased to continue offering beautiful spaces to her clientele. "I feel gratified when I see the delight in my clients' faces," she proclaimed. "That's the best part of my business!" ∎

ABOVE TOP: This multi-functional space, fashioned with extensive wood paneling and custom architectural details, serves as both a gentleman's library and a media room.

ABOVE BOTTOM: This Art Deco-inspired home theater captures all the magic of yesteryear with its life-like usher, refreshment stand and seating for eight.

FAR LEFT: Both business associates and guests feel welcome in this cozy study with its imported carved stone fireplace and custom-made screen, which complement the furniture and the art collection.

LEFT: This powder room "jewel"–with its lighted onyx sink, opulent fixtures and superb artistry–was fashioned in Old-World grandeur.

Left to right: Lauren Michelle Hansen, Allied ASID, Sheila Lyon, ASID, and Lauren Grumbles, Allied ASID.

SHELIA LYON, ASID
SHELIA LYON INTERIORS, INC.
5120 WOODWAY, SUITE 9018
HOUSTON, TEXAS 77036
713.993.9001

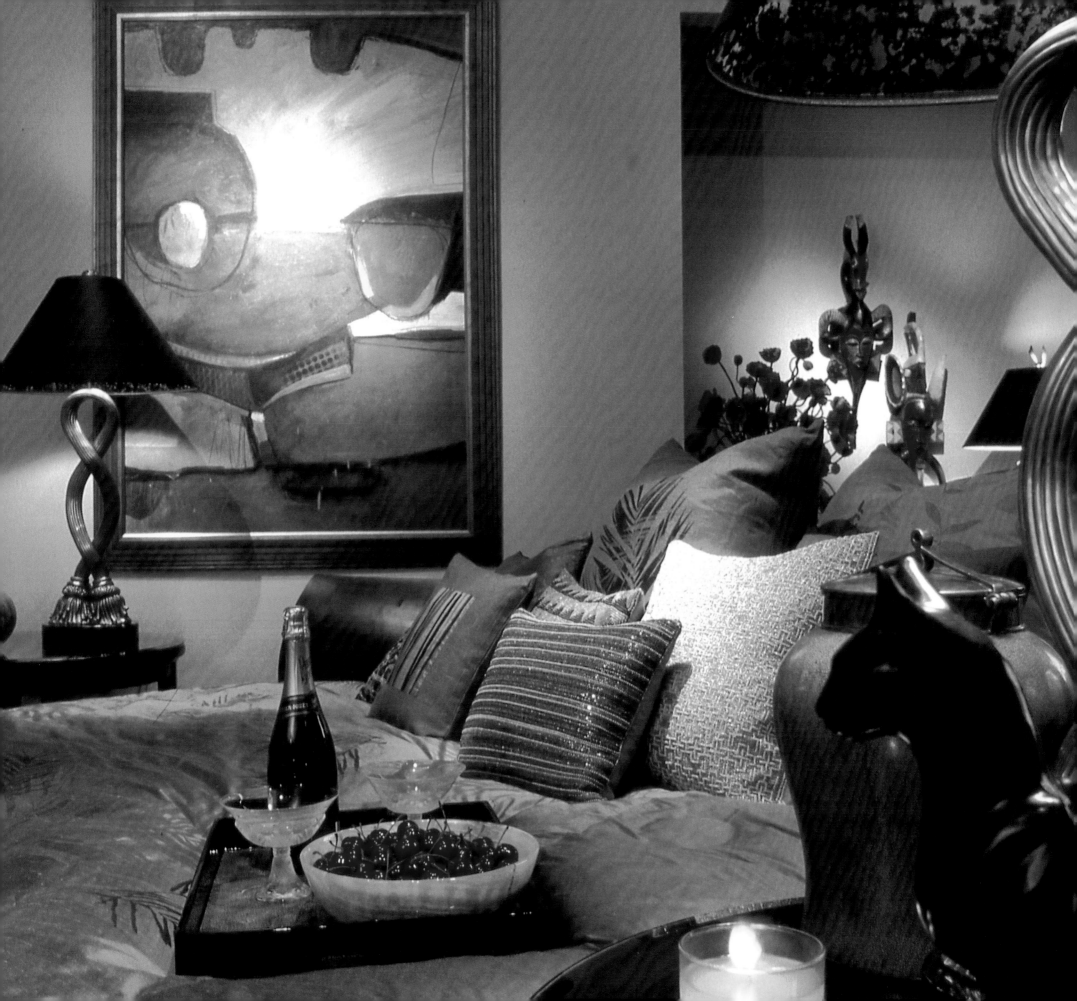

Perry Mavrelis, ASID

PERRY MAVRELIS

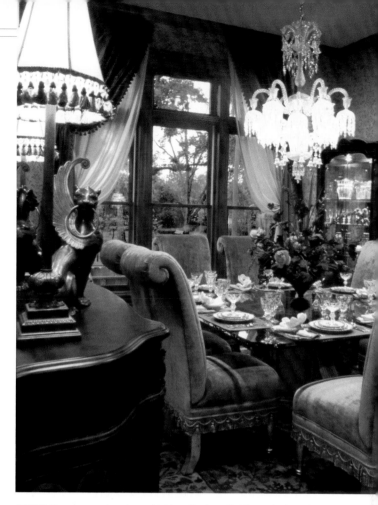

By surveying a client's closet, Houston designer Perry Mavrelis can immediately determine the perfect colors for the project at hand. "It never fails," he said. "You can tell so much about people by the predominate colors of their clothing." Knowing whether they prefer neutrals instead of brights or dark colors instead of light ones enables the noted residential designer to personalize interiors for his clients.

With a background in architecture and a wealth of over 37 years' experience, Perry begins each project with a pre-planning phase. "A good designer needs to be part psychologist and part listener," he explained. "It's important that I form close bonds with my clients so I can help them devise handsome settings specific to their individual needs."

For every project, Perry develops a long-term design plan, which enables his clients to prepare for the future and to effectively use furnishings they already own. "I do not push my tastes on my clients," he said. "Rather, I work with what they have so that the finished product reflects their distinct personalities." Perry also advises his clients to purchase quality furniture over time. "I urge my clients to purchase quality, not quantity," he added. "I'd prefer that they have a more sparse setting with a few select pieces rather than a space filled with inferior ones." This approach is especially beneficial for new couples, for whom budgets are important.

Raised in Massachusetts, Perry headed south after his tour of duty in the U.S. Navy to attend the University of Florida's School of Architecture. He returned home and began working in an architectural firm, where he soon became bored sitting at a drafting table all day. In college his minor was interior design, so in 1970, he decided to pursue the more creative career, opening his own design firm in Agawam, Massachusetts.

Perry moved to Florida in 1977 and set up shop in Venice and then Sarasota, where he successfully served clients for many years. In addition, he was very involved in the Florida chapter of the ASID, serving two terms as vice president of Association IV. In 1997, he decided to give Texas a try, so he packed up and moved to the Houston area, where today he offers a full range of design services to a variety of clients.

To ensure that his interiors perfectly fit each client, Perry supervises every step of the design process. From concept to completion, he puts the clients' needs first—supervising construction, designing furniture and even stocking the refrigerator. This approach results in seamless projects…and satisfied clients. ■

ABOVE: The square, glass-topped table with elegantly trimmed velvet chairs reflects a magnificent Baccarat chandelier that evokes a feeling of Victorian elegance.

LEFT: A classic sleigh bed in a rich, red mahogany sits at a 45-degree angle, giving the bedroom a feeling of retreat.

PERRY MAVRELIS, ASID
PERRY MAVRELIS
5139 CYPRESS SPRING DRIVE
MISSOURI CITY, TEXAS 77459
281.208.2360

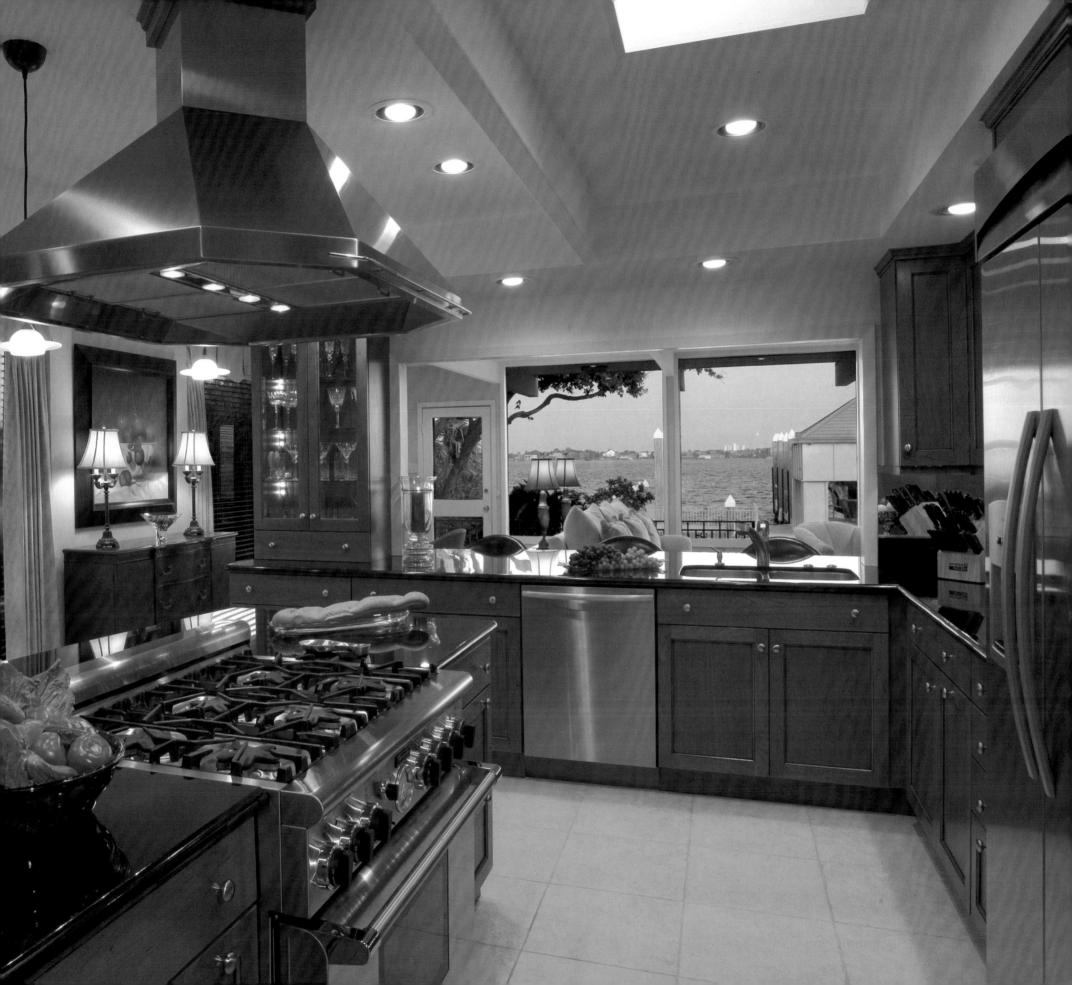

Peggy McGowen, ASID, CMKBD

"THE KITCHEN QUEEN" KITCHEN & BATH CONCEPTS

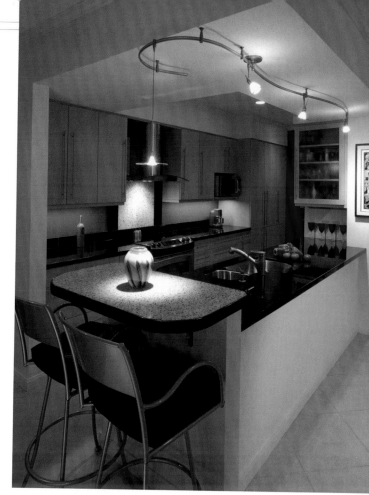

ABOVE: This sophisticated condo kitchen features dramatic lighting and vibrant color.

LEFT: A perfect blend of casual and elegance, this waterfront home's dream kitchen features cherry cabinetry by Brookhaven and stainless professional appliances.

Peggy McGowen is the "Kitchen Queen," and it's not because of her zest for cooking, which she loves. Peggy has a passion for designing fabulous kitchens that enhance her clients' quality of life. "Redoing or building a kitchen can be life-changing," she said. "People spend huge amounts of time in their kitchens, so why not make them as beautiful and functional as possible?"

To satisfy her passion for designing kitchens, Peggy founded Kitchen & Bath Concepts in 1986. The company specializes in the consultation and design of new and remodeled luxury kitchens and baths. "We are a family-run business and do all things kitchen," she explained. "We help our clients improve their quality of life and set themselves apart from the ordinary with distinctive designs and unmatched quality." Her firm offers complete design and installation services using fine custom cabinetry, state-of-the-art appliances, plumbing fixtures, lighting and convenience accessories to create the perfect kitchens for their clients.

The firm has an outstanding reputation among professionals in the kitchen and bath industry, where Peggy is a Certified Master Kitchen and Bath Designer (CMKBD). She earned this distinctive certification after undergoing 100 hours of training in professional development courses. She and her staff of residential kitchen specialists work closely with their clients and collaborate with the architects, designers and contractors to achieve the best possible results.

Peggy evolved into the self-proclaimed "Kitchen Queen" designation–a crown she wears proudly. Her series of presentations for consumer, professional and trade association groups led to frequent speaking engagements at home shows and trade conferences, which she continues today. A recipient of numerous design awards, Peggy uses her knowledge to judge the work of others, participating in a variety of contests including the National Kitchen & Bath Association (NKBA) Design Competition. Peggy's award-winning work has been featured in many local and national publications and she has appeared on Home & Garden Television several times.

From cabinetry, countertops and appliances to cutlery, condiments and pots and pans, Peggy and her team of professionals see to every detail and provide life-changing results for their valued clients. ■

PEGGY McGOWEN, ASID, CMKBD
"THE KITCHEN QUEEN" • KITCHEN & BATH CONCEPTS
4702 MT. VERNON
HOUSTON, TEXAS 77006
713.528.5575
WWW.KITCHEN-CONCEPTS.COM

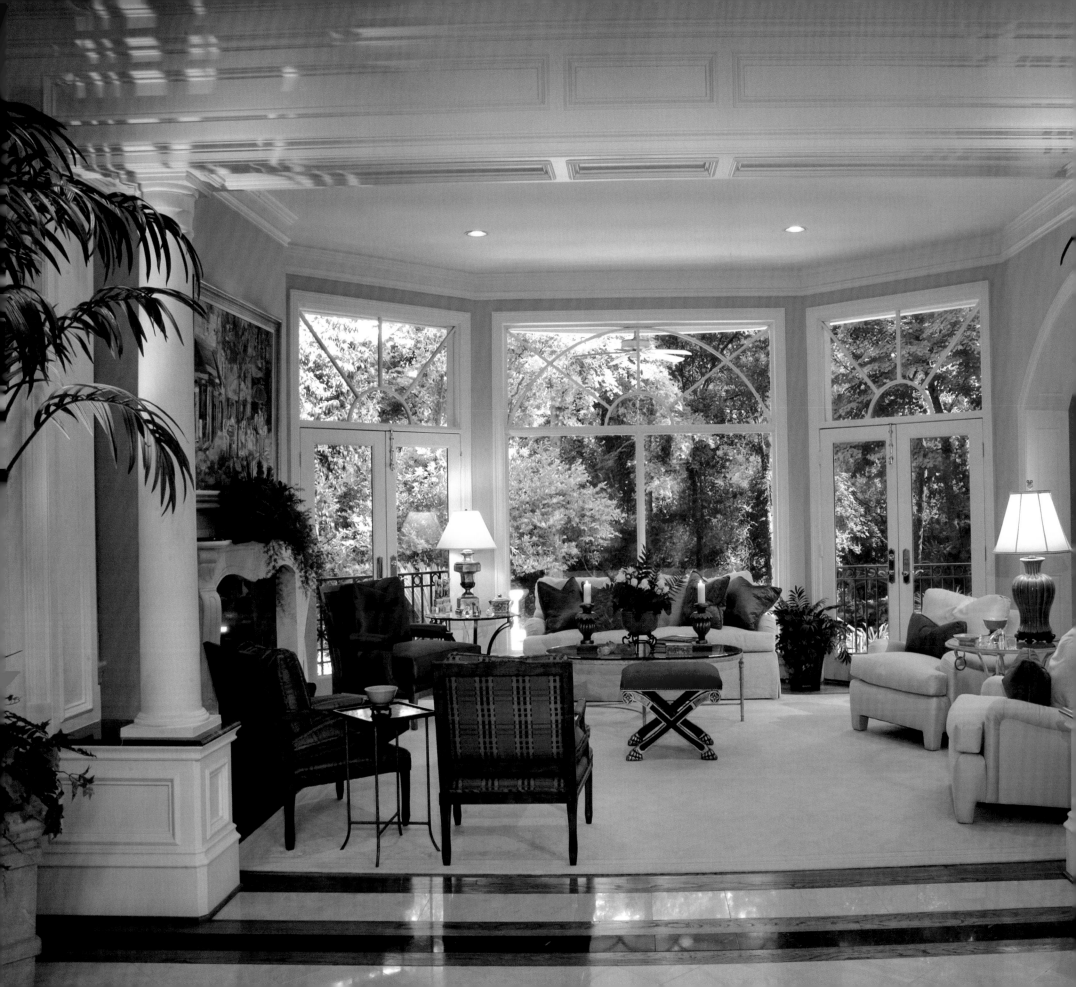

Carl Mitchell, ASID

CARL B. MITCHELL INTERIORS

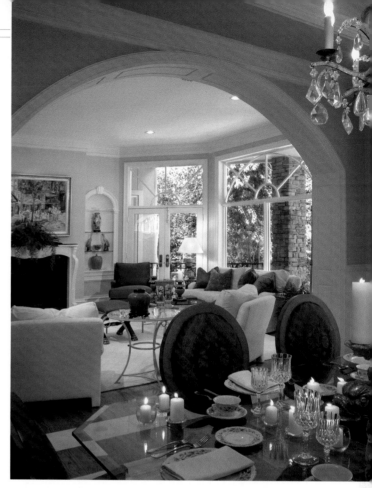

ABOVE: This living area features a painting from the Nowlin-Rankin Gallery; dining chairs by A. Rudin, which are upholstered in Rodolph silk; a rock crystal chandelier by Dennis & Leen; and a custom rug by M&M Carpet.

LEFT: Accents of celedon, mulberry and bronze give punch to a neutral background of restrained elegance without overwhelming the lush, evergreen view in the Houston Memorial area.

Carl Mitchell loves color. Rich reds. Elegant greens. Sophisticated neutrals. He uses them all. "A room comes to life with the right colors," he said. "Unexpected color is my favorite. I chose a turquoise-blue tile for the floor of a client's home in the Bahamas and it was riveting. The floor seemed to flow right out the door and into the ocean." By masterfully picking the perfect colors for his projects–often utilizing his clients' art collections, antique furnishings or nature itself–he successfully composes beautiful interiors around the world.

Carl's distinguished career as a designer began 35 years ago when he was employed for many years at Wilds & Canon Design, an illustrious design firm. "I had just graduated from the University of Texas and was fortunate to be hired by a great firm," he explained. "The terrific training I received provided me with an excellent background in design." He soon became a partner in Wilds, Canon & Mitchell Design, where he stayed for 22 years. Today, he operates his own company, where he has a loyal following of satisfied clients.

Specializing in high-end residential and executive commercial office interiors, Mitchell provides turnkey services. "From design to purchase to installation, I see to every detail," he stated. By working closely with his clients, he garners their needs. In fact, he often develops strong personal relationships with his clients–even third-generation ones.

CARL MITCHELL, ASID
CARL B. MITCHELL INTERIORS
1610 BIG LAKE DRIVE
HOUSTON, TEXAS 77077
281.293.7700

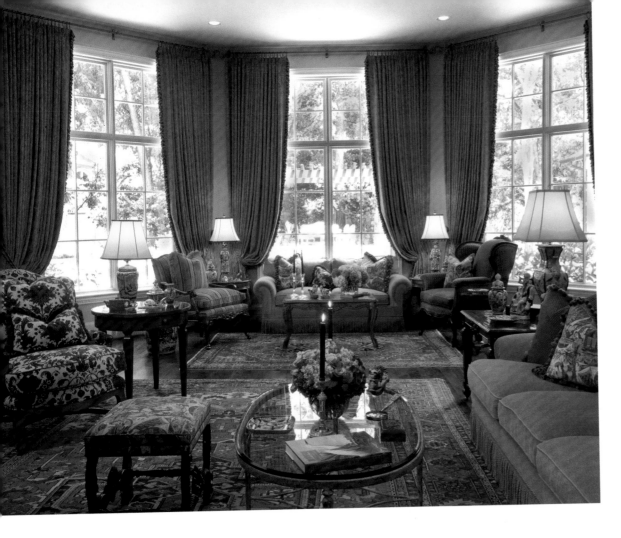

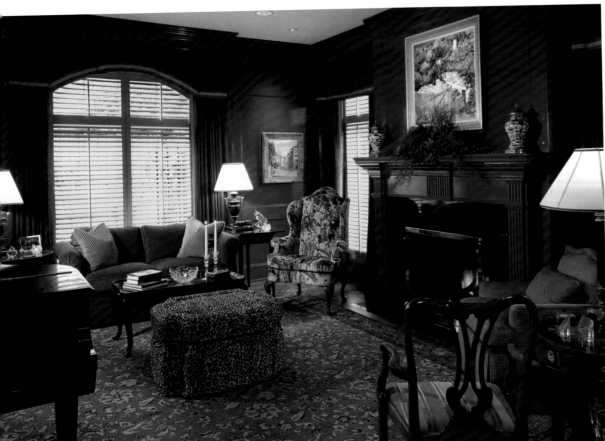

TOP LEFT: Beautiful antique Serapi and Heriz rugs, along with the client's antique Imari porcelain collection, suggested the color palette for this Houston Memorial-area family room.

RIGHT: This welcoming setting features a custom onion fringe on pillows of Pierre Frey fabric and a Minton-Spidell cocktail and Country French chair upholstered in cut-velvet stripe by Zimmer and Rhode.

LEFT: Emerald green paneling, a custom Stark rug and jewel tone colors make for a cozy library. Painting through Nowlin-Rankin. Chinoiserie velvet on wing chair by Mauel Canovas.

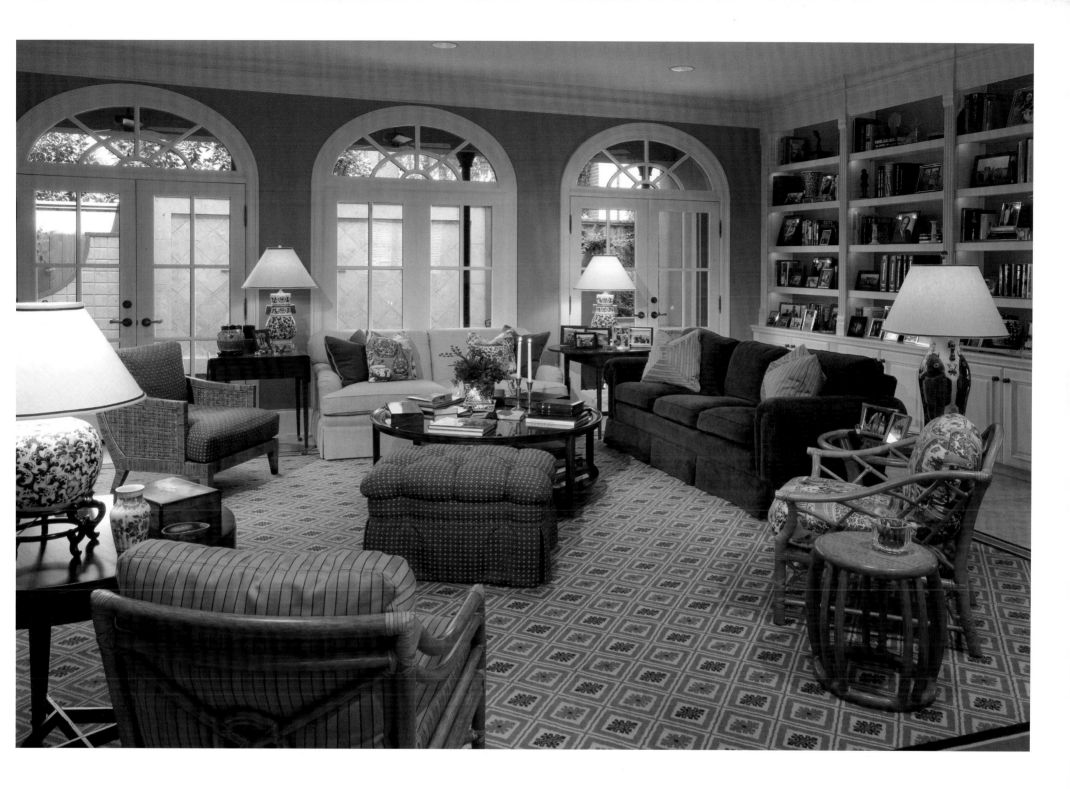

Mitchell has a well-earned reputation for quality in his work, which is evident in his use of superior materials such as Venetian plaster and gold-leaf wallpaper. His many refined projects cover the globe. Besides homes in the Bahamas, he has created exquisite interiors for a townhouse in London's Belgravia area, a fabulous villa in the mountains on the coast of Mexico and homes in Aspen, Beaver Creek and Lake Tahoe, as well as the greater Houston area.

ABOVE: A custom Stark rug, McGuire seating and blue-and-white porcelain are key elements of this family room in the Houston River Oaks area.

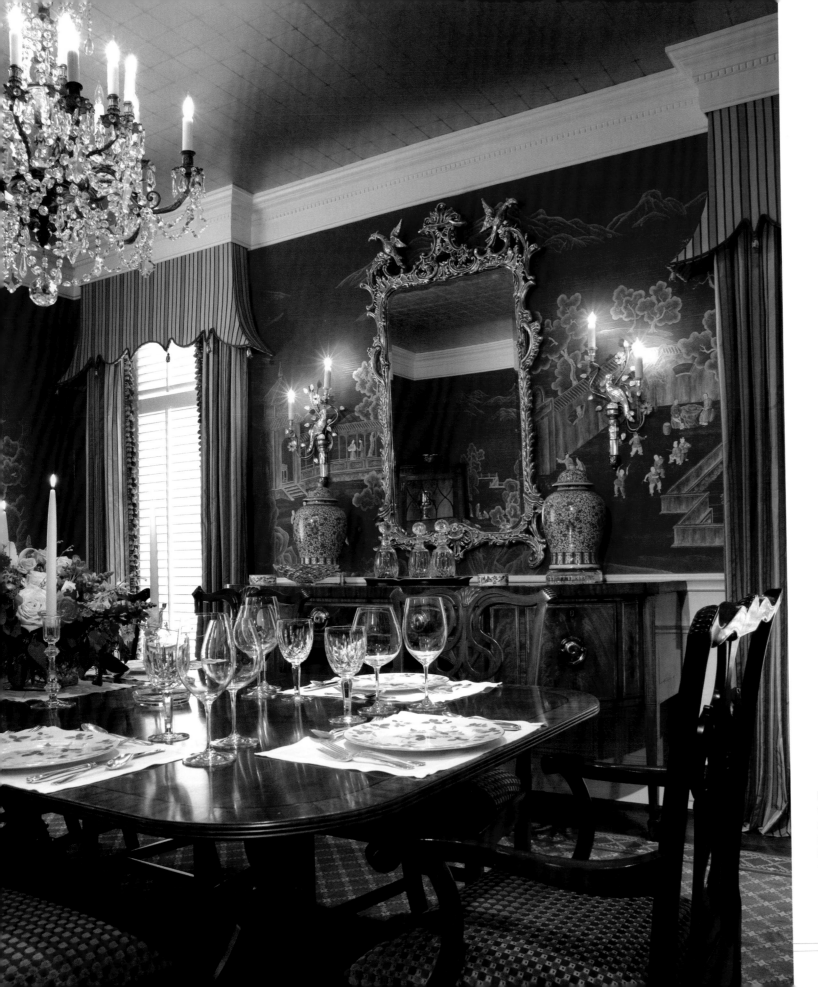

LEFT: Custom, handpainted Gracie wallcovering, gold leaf squares on the ceiling and antique furnishings make for a dramatic dining room where red and gold Scalamandré draperies reside peacefully under Pagoda-shaped cornices.

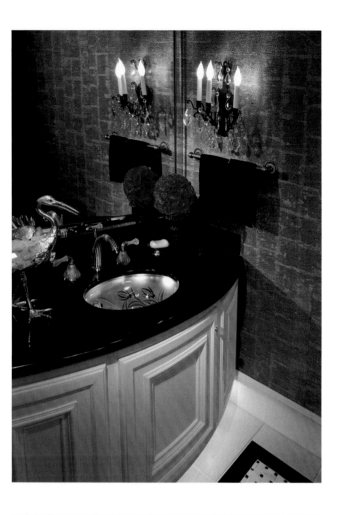

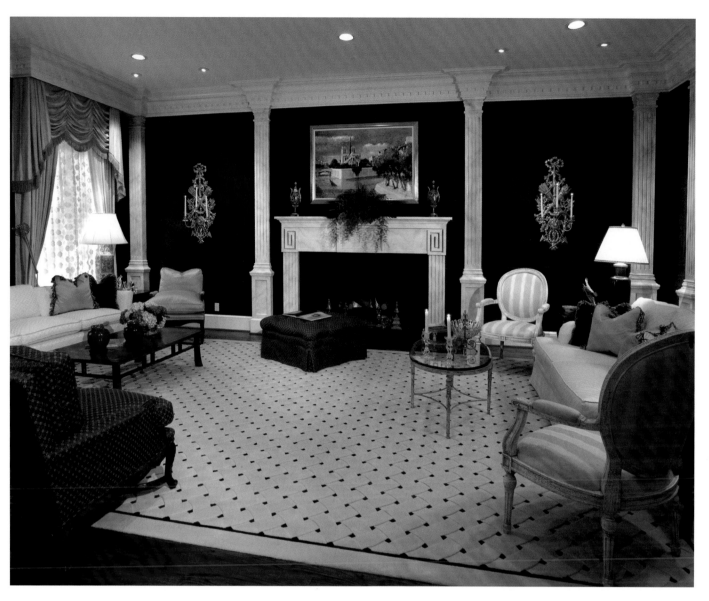

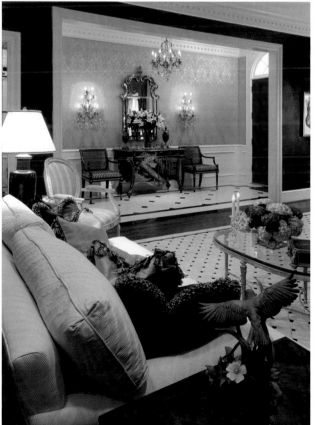

Whether he is extracting the perfect wall color from a magnificent antique Serapi rug or deciding on the perfect hue of red for the hand-painted Chinese wallpaper, Mitchell masterfully expresses his clients' tastes and styles with sophisticated elegance that results in designs with a timeless quality. ■

ABOVE: Yellow and white are crisp contrasts for Lapis-blue Venitian plaster walls that serve as a backdrop for the painting (through Nowlin-Rankin) and custom-textured, basket-weave rug (through M&M Carpet).

TOP LEFT: This cut-crystal lavatory lights from beneath. A frosted, crystal/pewter lavatory set, black-and-white mosaic tile insets and corrugated, silver-leafed wallcovering glazed in black greets guests.

LEFT: Yellow silk Damask wall fabric echoes the living room of this Houston townhome, as does the black granite l insets in the floor.

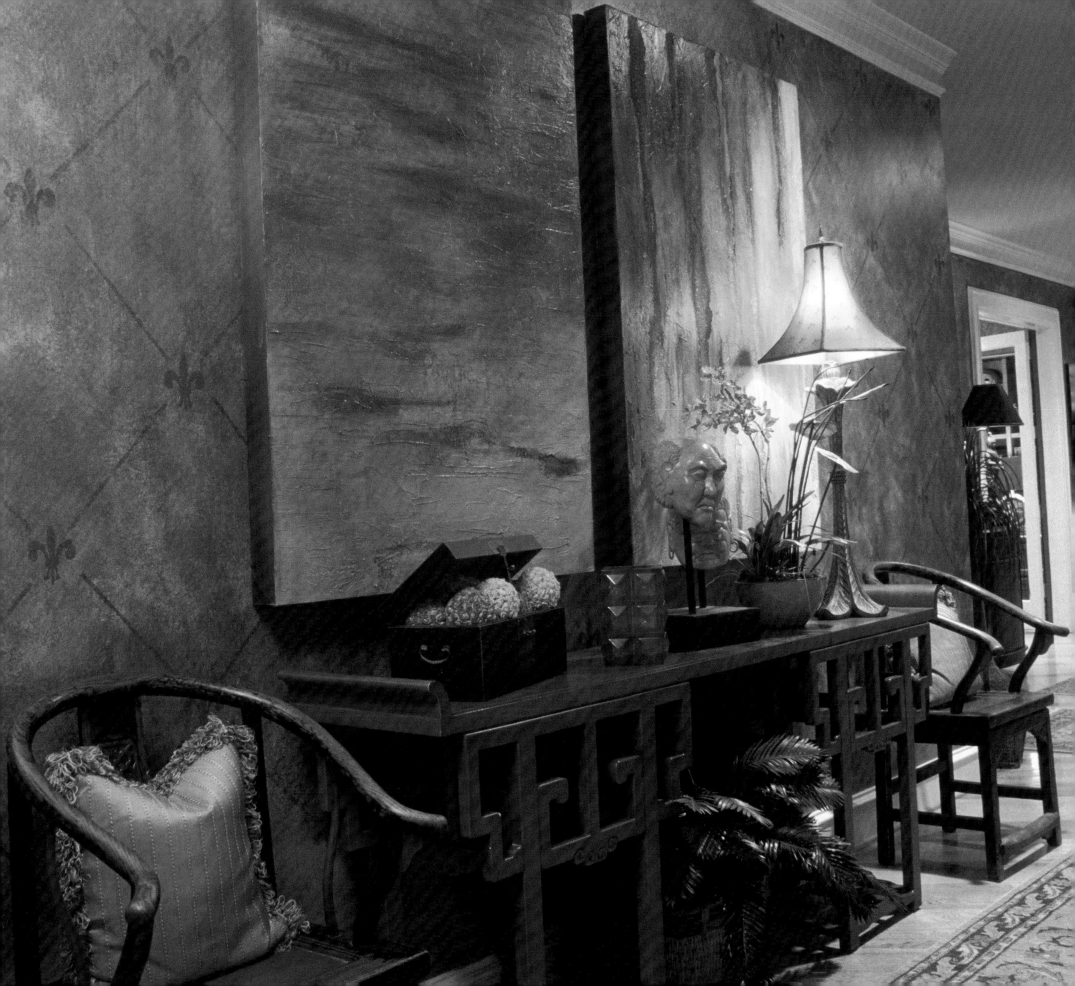

Karen Moore, ASID

MOORE INTERIORS, INC.

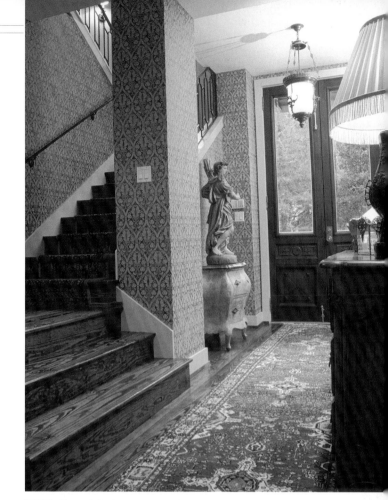

ABOVE: Elevated finishes expressed through simple, yet elegant, furnishings and accessories create a memorable introduction to this home.

LEFT: Eastern furnishings combine with Western finishes to create a sophisticated, and lasting, first impression.

Commercial real estate is not the usual catalyst for a residential interior design career, but that's exactly how Karen Moore got her start. "I went from managing office space to designing office space," she explained. "Then, after years of working on large-scale commercial design projects in the corporate world, I decided to try my hand at residential design and I loved it."

Karen's transition from overseeing construction, tenant management and the build-out of up to 80,000 square feet of office space to designing refined residential homes and high-rises was surprisingly easy and successful. "The business skills I learned–managing costs and negotiating and meeting deadlines–help me every day. in my residential design work," she said. "My clients often call me 'Ms. Fixit' because when a problem pops up, I solve it. I get things done."

This high-energy dynamo grew up in Pennsylvania, but headed south for warmer weather and friendlier people to study real estate at the University of Houston, where she earned a business degree while majoring in real estate and working full time. Karen then completed Rice University's executive business management program, and later she attended the Art Institute of Houston, graduating magna cum laude with a degree in interior design. Karen maintains a real estate broker's license, which she uses to help clients make design-related investment decisions.

Today, Karen has over 20 years of design experience, which she uses to run her own Houston design firm, Moore Interiors, Inc. The shift in her design work from commercial to residential came gradually as Karen increasingly felt the need to better express her creative talents. She also realized the enjoyment that comes from a more personal connection found with residential projects. "I love working with homeowners," she said. "Turning clients' hopes, wishes and dreams into physical and functional realities is wonderful. I strive to create environments that reflect their unique and personal tastes, while helping them to discover their own styles."

By harnessing her creative energy and embracing her clients' styles with sound business sense, Karen skillfully enhances homes, efficiently creating casual, functional elegance. ∎

KAREN MOORE, ASID
MOORE INTERIORS, INC.
510 BERING DRIVE, SUITE 302
HOUSTON, TEXAS 77057
713.974.9320
WWW.KMOOREINT.COM

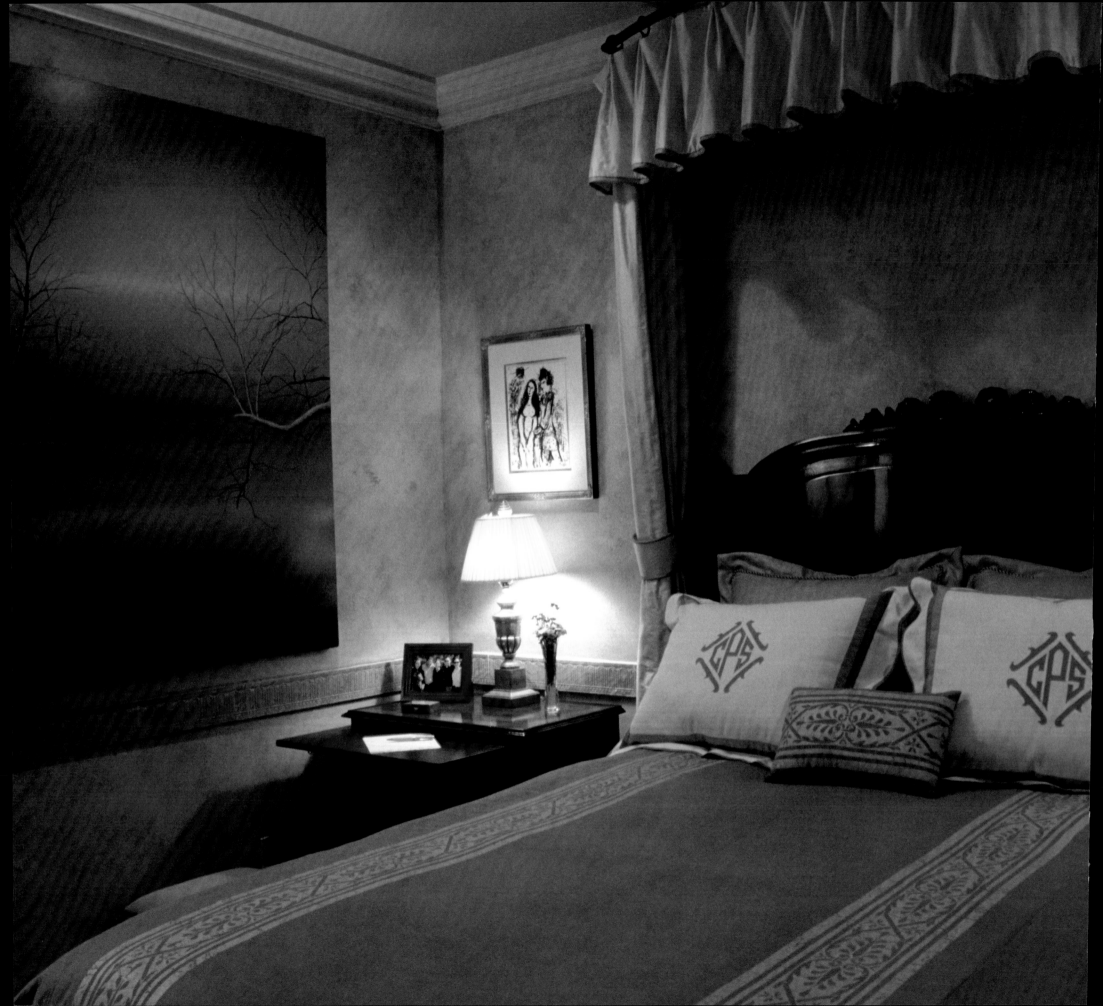

Cecilia Pacheco, ASID

STYLE USA INTERIOR DESIGN

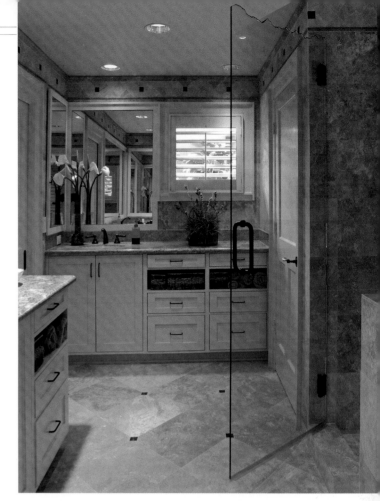

The love of exquisite art and the thrill of world travel stimulated Cecilia Pacheco's desire to become a professional interior designer. "I have been very fortunate to have lived and traveled throughout North and South America and Europe," she said. Her visits to celebrated art museums and lush ornamental gardens provide daily inspiration for her designs. "Every place has something beautiful to offer, and I like to share this beauty with my clients."

Originally from Columbia, Cecilia moved to the Houston area 19 years ago and began her interior design career after earning degrees in both art and design. She runs her own firm, Style USA Interior Design, in Kingwood and Houston where she has a strong following of satisfied clients. "I focus on meeting all of my customers' needs," she explained. "I spend a lot of time with new clients simply listening to their expectations. I let them talk, and then we choose a style that suits their lifestyles. My clients really care about their homes; my job is to create their dream designs."

A key element to Cecilia's success is her sophisticated use of space planning. She prefers that spaces not be too crowed or busy. One quality piece of furniture or art is superior to three medium ones. "In my designs, I strive to incorporate tailored, elegant items that also function well for my clients. Scale and proportion are important factors in creating a balanced room that has rhythm and unity."

Equally important is her enthusiasm for her work. "I have a deep passion for design and decorating and truly love working with my clients. I believe they feel this passion and energy. When they say, 'Oh, it's so beautiful,' I know I have done a good job."

By combining the knowledge gained from her world travels, her study of design and her passion for her clients, Cecilia has achieved the perfect balance of beauty and style in her interiors. ■

CECILIA PACHECO, ASID
STYLE USA INTERIOR DESIGN
5502 BEAVER LODGE DRIVE
KINGWOOD, TEXAS 77345
281.360.8761

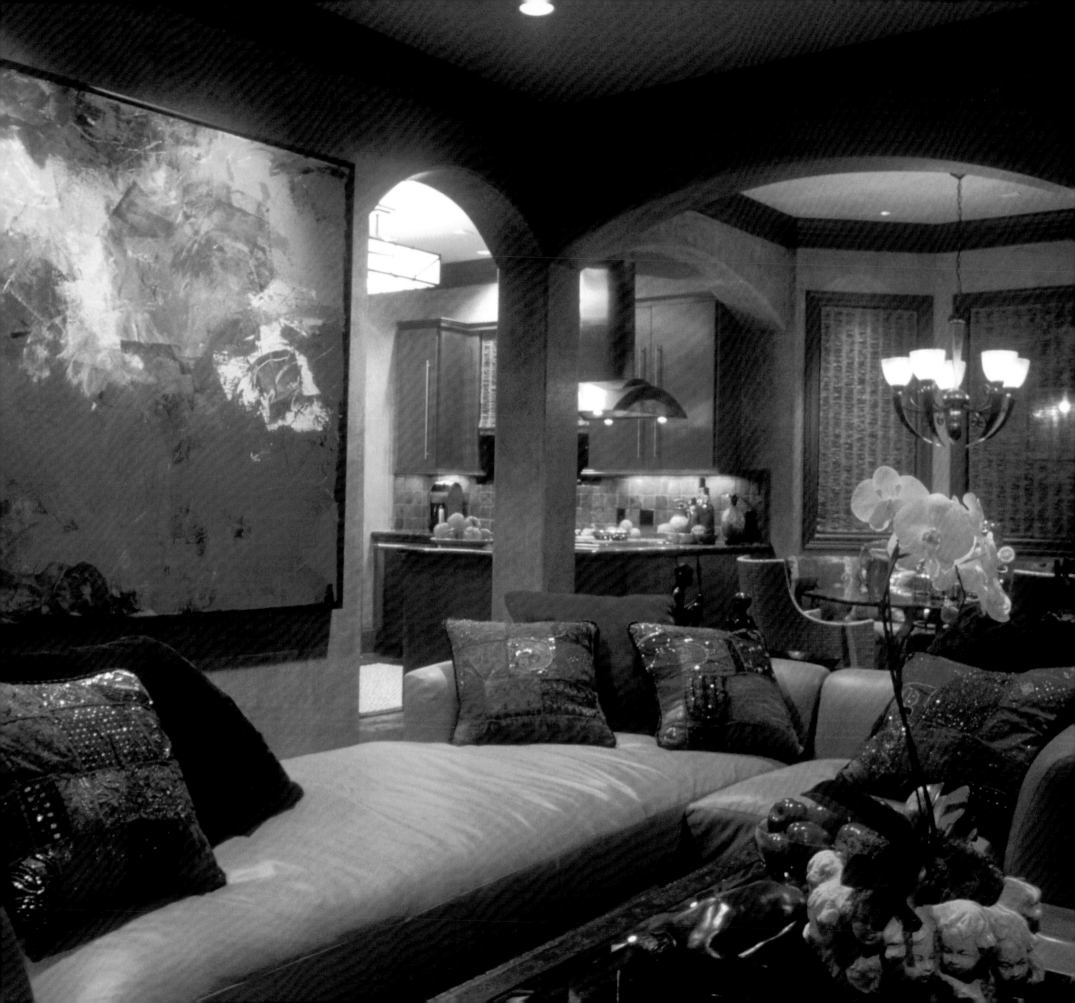

John Tryon Robinson, FASID

ROBINSON & ASSOCIATES

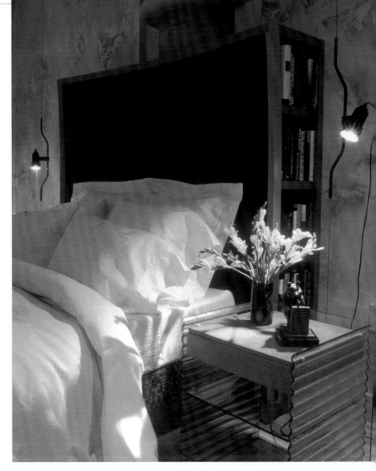

ABOVE: By incorporating a structural column, the custom-designed concave headboard with its mahogany hardwoods and tightly stretched chenille inset became the focal of this master bedroom. Each side has its own bookcase and floating directional lighting.

LEFT: The warmth of this open-plan entertainment space was accomplished using complementary textures, bold colors and subtle lighting.

The interior design industry would have suffered a crushing loss if John Tryon Robinson had pursued his original goal of becoming a doctor. "My first degree was premed, and I was accepted to Tulane Medical School," he recalled. "I was visiting New Orleans before starting classes and kept thinking about all the wonderful architecture, not about medicine." His father and grandfather were both doctors and John had wanted to continue the legacy, but instead he decided to earn a second degree in interior design from the University of Houston. "I have always appreciated good architecture, balance, scale and texture. It was a natural choice."

This esteemed designer and third-generation Houstonian has now practiced in his chosen field for over 32 years. The owner of Robinson & Associates, the design firm he founded in 1987, John is a full-phase designer who collaborates with other professionals through all facets of his projects, which include residential, commercial, hospitality and healthcare facilities. "My projects range from single spaces to corporate offices," he said. "No job is too small."

Throughout his remarkable career, John has honed his craft while partnering with various firms. His extensive portfolio of award-winning work is evidence of his success, as are the six *Houston Chronicle*/ASID design awards that line the walls of his noted firm. Numerous publications have also featured his acclaimed designs.

JOHN TRYON ROBINSON, FASID
ROBINSON & ASSOCIATES
1700 MAIN STREET, SUITE 2A
HOUSTON, TEXAS 77702
713.659.4849
WWW.ROBINSONASSOC.COM

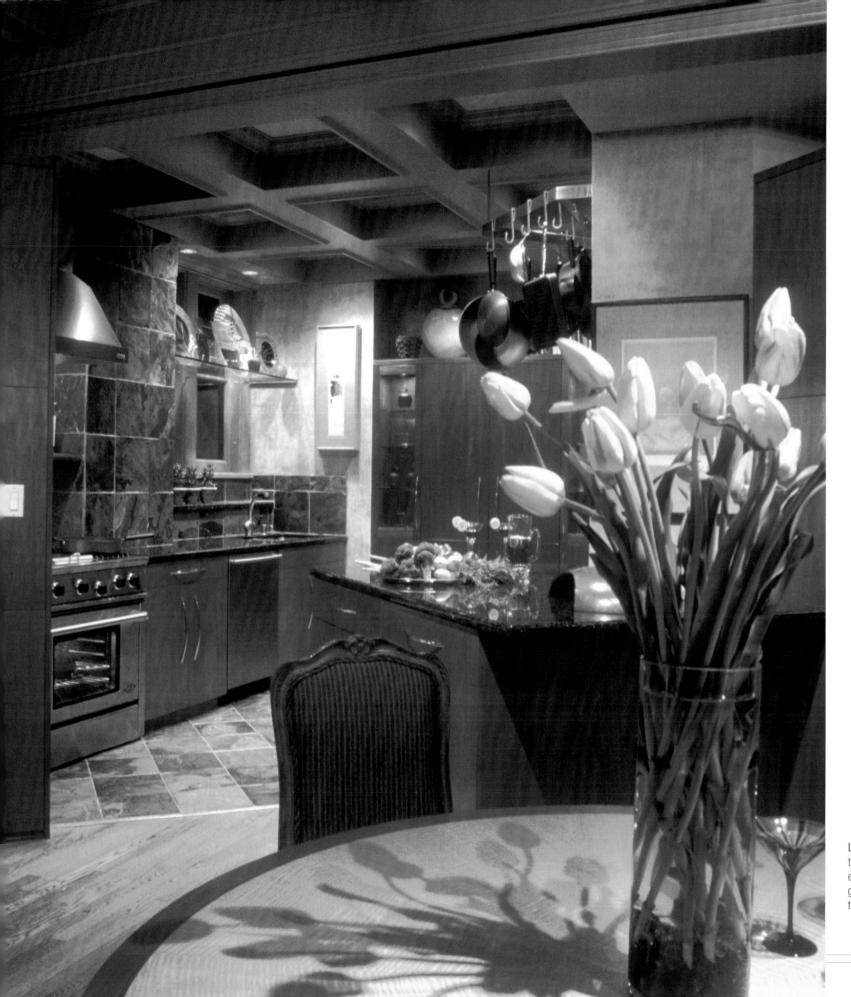

LEFT: By adding the beamed ceiling and opening the kitchen to the rest of this high-rise's entertainment space, a contemporary spin was given to this 100-year-old classic while maintaining the original charm.

John is well respected for his contributions that have significantly changed the landscape of the design industry. He is one of the founding members of the TAID, for whom he served as the first president. During his five-year term, John was instrumental in introducing and facilitating the passing of legislation recognizing the profession of interior design. In 1990, the TAID acknowledged his contributions by creating the "John Tryon Robinson Award," which is presented to individuals for their outstanding service to the profession of interior design.

John has also tirelessly served the ASID in a variety of capacities. He was national director and president of the Texas Gulf Coast Chapter, where he chaired numerous committees over the years. For his many contributions, the ASID bestowed John with the prestigious designation of Fellow in 1999.

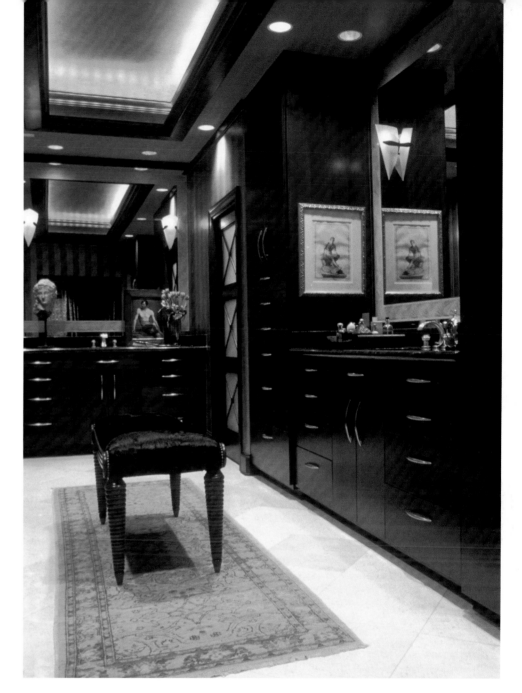

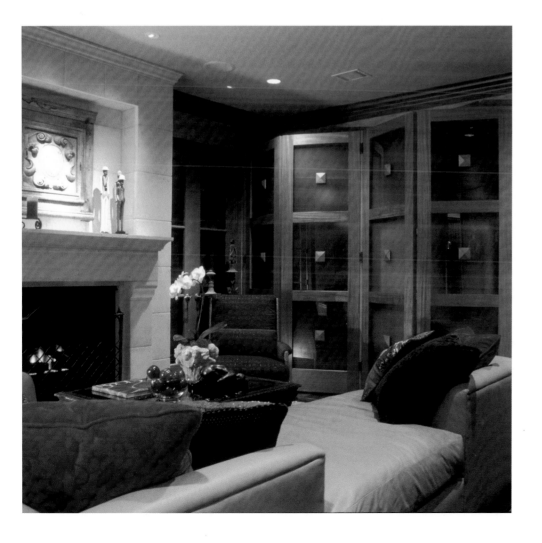

ABOVE: The rich walnut cabinetry was set off by the light travertine flooring and silver-leafed cover. An Art Deco detail was etched into the over-scaled vanity mirrors.

LEFT: A custom cherry and etched-glass screen was fabricated to conceal the entertainment center in this transitional family room.

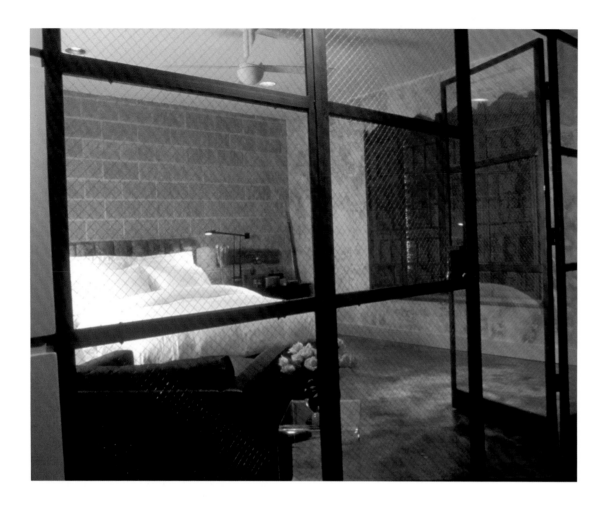

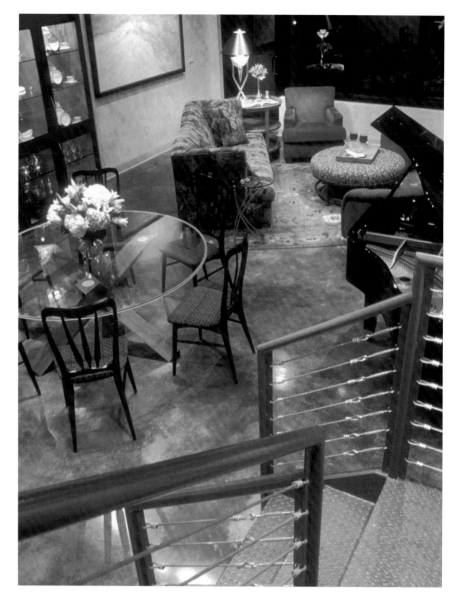

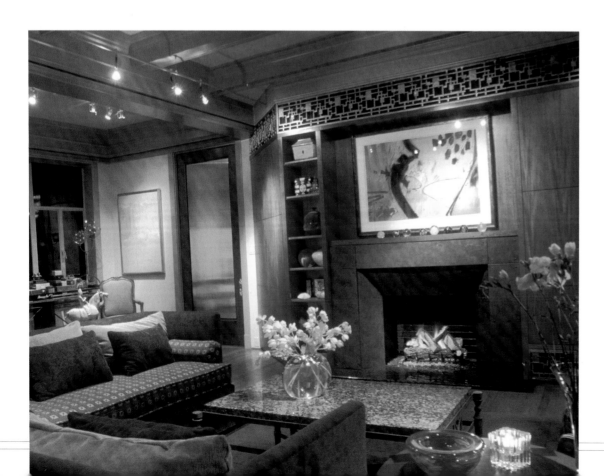

TOP LEFT: The problem of an interior bedroom's lack of windows was solved by the use of a backlit carved screen and a metal glass corridor wall.

RIGHT: Buffed, stained concrete mimics aged leather and serves as a backdrop to this high-tech loft, which features an Italian-imported dining table and heavily textured upholstery.

LEFT: Special attention to the existing beams, pocket doors and aged hardwood flooring was given during the renovation of this 1907 high-rise apartment. Custom built-ins with vintage grates were added to provide necessary storage.

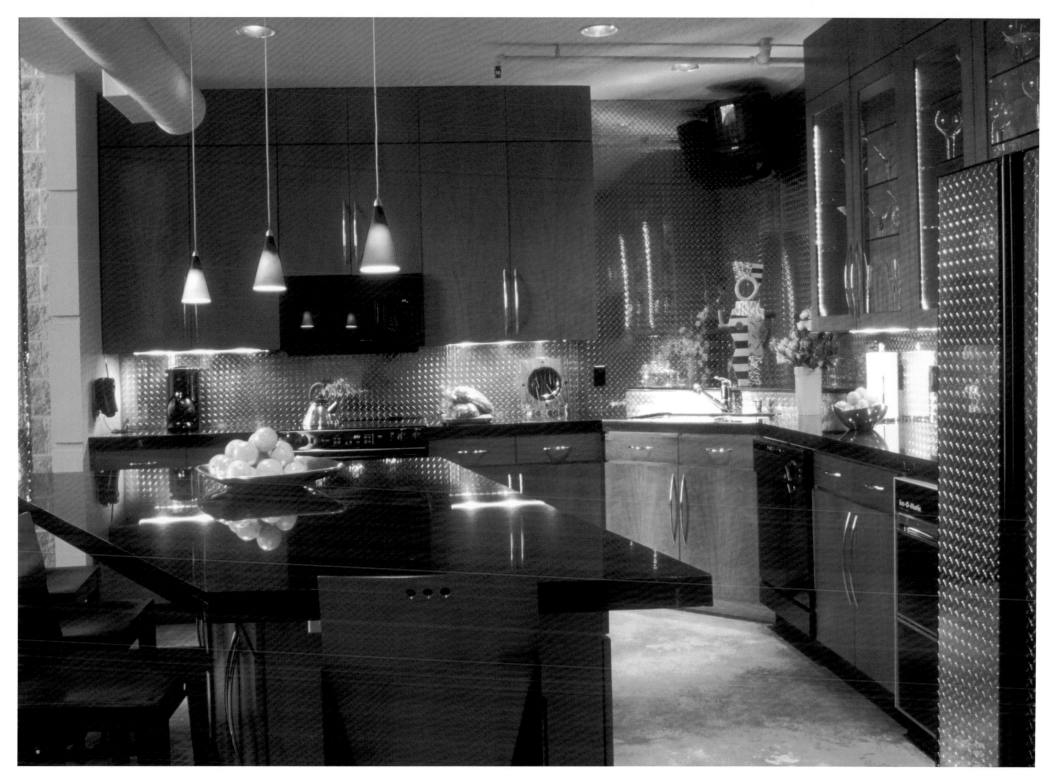

While passionately leading the charge in the industry he calls home, John has amassed a loyal following of satisfied clients who seek the signature styling of his soothing, yet functional, designs. "It's important that a space be safe and functional while also attractive and comfortable," he said. "A well-designed space can help us live more fully than we ever imagined." ∎

ABOVE: Polished, diamond-plate aluminum is used as the backsplash to complement the book-matched, custom millwork and black granite countertops.

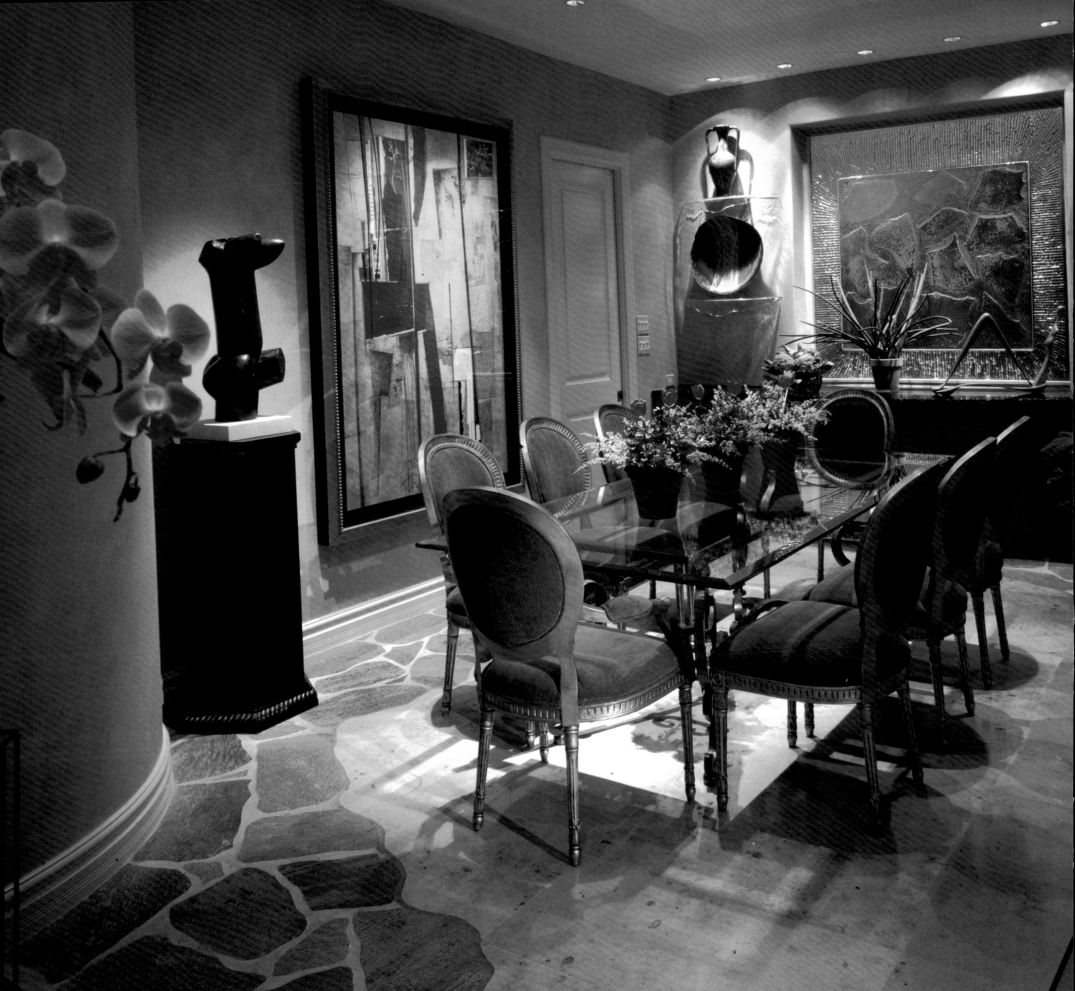

Barbara Schlattman, FASID

BARBARA SCHLATTMAN INTERIORS, INC.

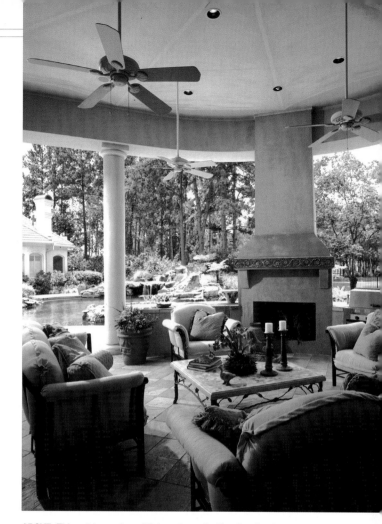

"Our environments impact how we live, work and play," said award-winning designer Barbara Schlattman of her approach to interior design. "Surround yourself with order and beauty and it will be reflected in your life."

Barbara, an ASID fellow, is a native Texan who has designed residential and commercial interiors for the past 30 years. A graduate of the University of Houston, Barbara offers complete design services through her Houston firm, Barbara Schlattman Interiors. "I enjoy working as a team with the clients, architect, landscape architect, builder and subcontractors," she said. Barbara believes that the key to a successful project is to be a good listener, flexible and open to new ideas. "I think it is fun to challenge myself, create new designs, work with varying tastes and make each project unique and special."

Barbara says that function is an essential element in creating beautiful spaces. Working closely with clients on space planning allows her to understand how they want their environments to function and feel. "I believe that space plans should reflect their personalities and requirements and they should highlight their individuality."

Frequently, Barbara serves as project manager, consultant and designer for her many office and home construction projects, which have been featured in numerous national publications including *The Wall Street Journal, Unique Homes, Ladies' Home Journal, Kitchens and Baths* and the *Los Angeles Times.* Barbara has also received several awards in the *Houston Chronicle*/ASID interior design competitions. Of particular note is a stunning atrium bathroom that received first place in the national ASID project awards.

BARBARA SCHLATTMAN, FASID
BARBARA SCHLATTMAN INTERIORS, INC.
14206 BONNEY BRIER
HOUSTON, TEXAS 77069
281.444.0240

LEFT: This dining room features a Jurastone floor accented with Kariba stone to resemble a riverbed. Glass-draped shelves flank a cast glass window.

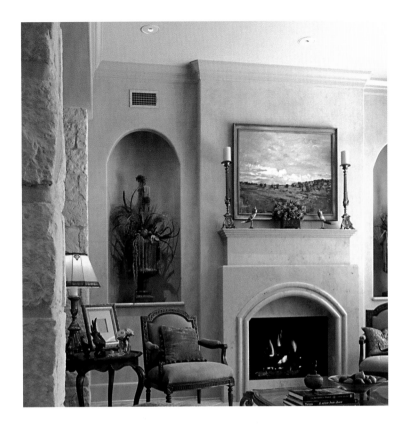

Barbara offers lighting design for each project and believes proper lighting is vital to every design. "Good lighting creates the ambience in a room, adding drama and focus to a wonderful work of art or to a specific area."

Promoting professionalism and education has been an important part of Barbara's career. She has been actively involved in the ASID, serving locally as chapter president and nationally on the board of directors, executive committee and foundation board of trustees. In addition, Barbara makes presentations and organizes programs for interior designers and architects across the nation.

TOP LEFT: Adding to the casual elegance of this living room are a custom-designed marble fireplace, an Oushak rug, lighted niches, suede chairs and textured fabrics.

LEFT: The overscaled chairs, antique horns and unfilled travertine floor give a more casual look to this comfortable dining area.

RIGHT: This atrium bath–a 35'x28' room that is frequently used for dinner parties–features a fishpond and a waterfall. The treadmill and TV are hidden behind the double doors.

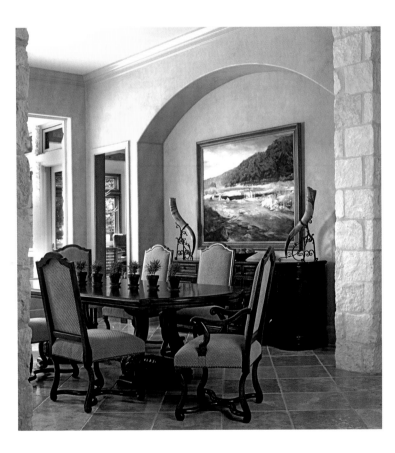

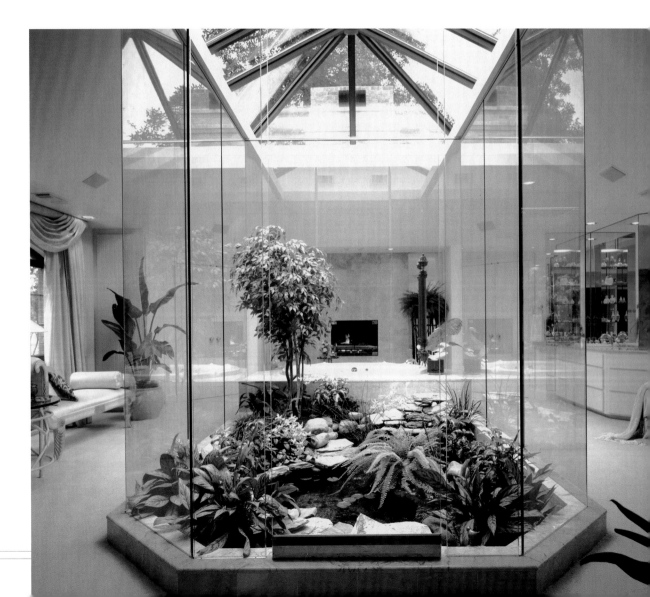

RIGHT: The custom zinc fireplace and cocktail table made of embellishments from demolished buildings live comfortably with a hand-painted sisal rug. All custom furniture was designed by Barbara.

BELOW LEFT: Jack's retreat is a cozy, private environment for reading and watching television. The mesquite floors, plaster walls and timber mantel give texture and warmth to the room.

BELOW RIGHT: This family room is appointed with strong art and unique accessories highlighted with lighting. "My idea of home is to take off my shoes and curl up on the sofa," the designer said. "This room does it all."

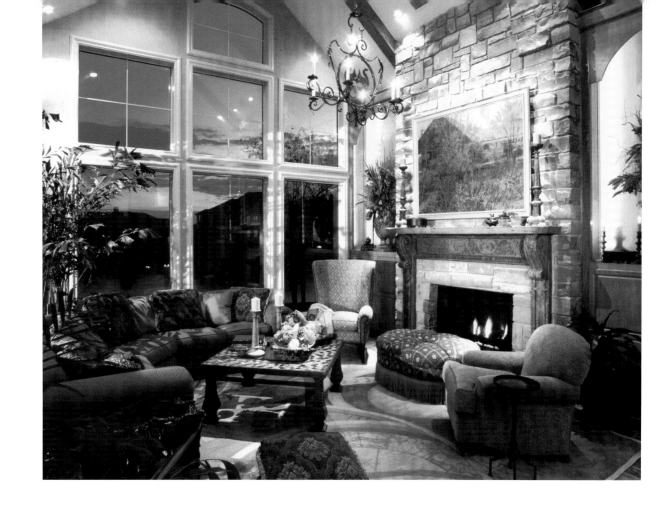

With her wealth of experience and knowledge, this multi-faceted designer continues to educate herself and expand her horizons. To stimulate her creativity, Barbara follows her passion for traveling to different places around the world that she finds intriguing. "I learn from the scale, texture and juxtaposition of materials," she said. "The great creative minds who designed these places inspire me every day."

Barbara acknowledges the importance of staying abreast of current design issues like the philosophy of aging-in-place—the ability to safely, independently and comfortably remain in one's home, regardless of age or ability level. She also believes that sustainability and green building products are vital to our future. "Creativity is only one reason why clients hire designers," Barbara said. "They want more. Clients want to know that their spaces will work for them, not only for today, but for tomorrow."

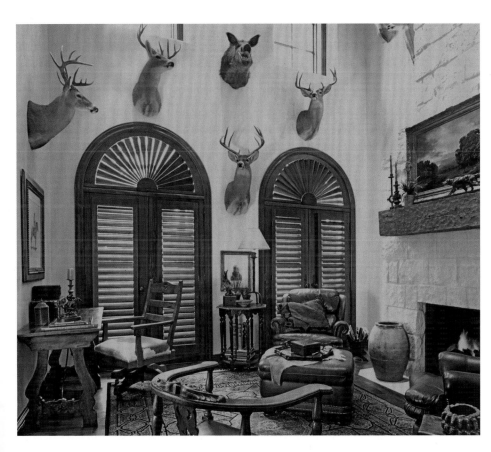

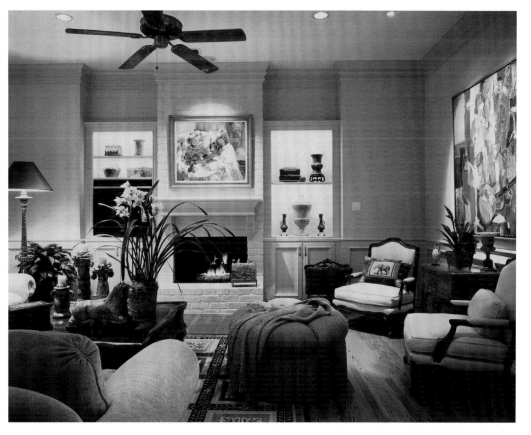

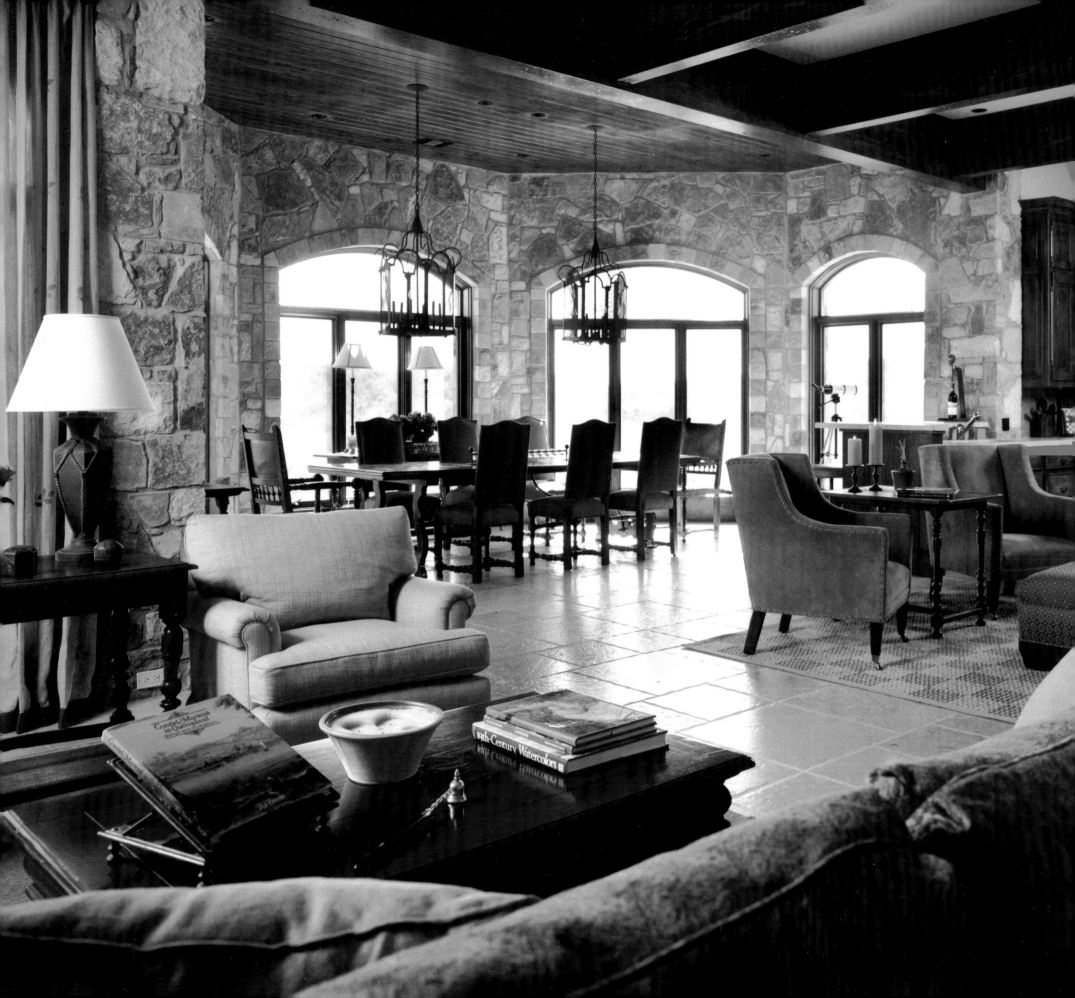

Marjorie Slovack, ASID

SLOVACK/BASS

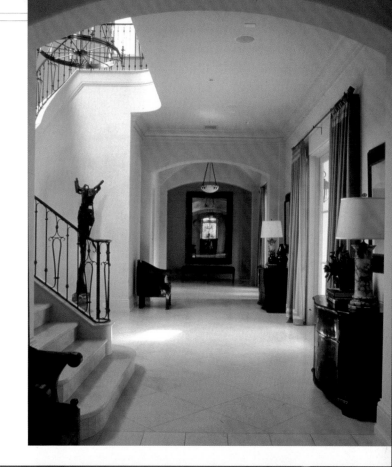

Marjorie Slovack recently celebrated her 30th year as an interior designer in the Houston area. "I am extremely lucky to be working everyday in the very subject of my obsession," she exclaimed. Marjorie and her husband John Bass, a custom homebuilder, own and operate their own "design-build-design" firm, Slovack/Bass. "We oversee each layer of the design process and pay particular attention to every detail," Marjorie explained.

Their firm focuses on the entire design process—from the initial development of plans and the custom construction to the complete interior design and final complete installation. "Combining the interior design side and the construction end has proved to be incredibly successful because it saves our clients time and money," Marjorie said of their approach to each project. "We are a dedicated team who aims to include the client throughout the entire project in order to develop a true partnership."

TOP RIGHT: Clean sophistication was accomplished with a calm palette, art and thoughtful details in architecture, surfaces and furnishings to this ASID award-winning home.

BOTTOM RIGHT: The Team - Martha Davis, ASID, Jeff Taylor, Project Management, Kalista White, Julie Veselka, Allied ASID , Lisa McCollam, Allied ASID , Marjorie Slovack, ASID, John Bass, GMB, Andrea Herrera, Admin., Jennifer Lunsford, Admin.

LEFT: This ASID award-winning Austin home overlooking the city and hilltop is the family gathering spot. Comfort, textures and the view blend with natural tones in this spacious setting.

MARJORIE SLOVACK, ASID
SLOVACK/BASS
M.L. SLOVACK DESIGN, INC.
1325 ANTOINE DRIVE
HOUSTON, TEXAS 77055
713.956.7240
WWW.SLOVACK-BASS.COM

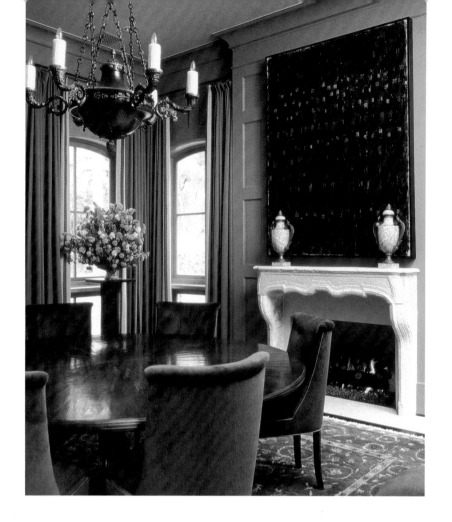

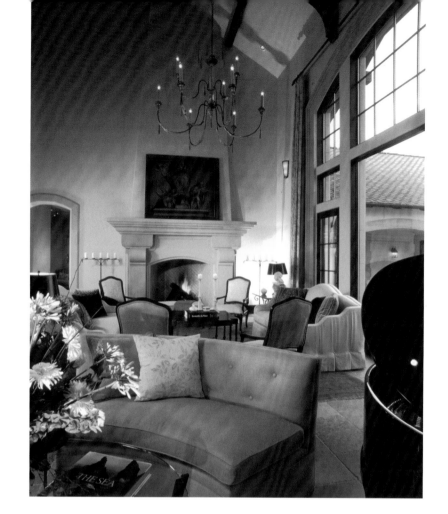

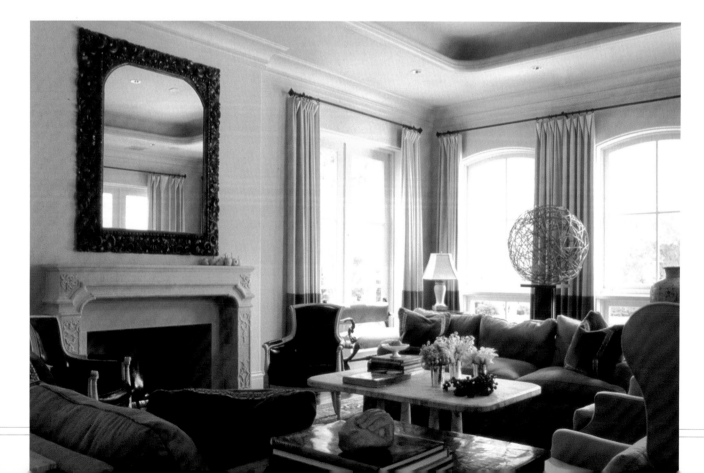

The firm is well-respected, and Marjorie, in particular, has earned a reputation as a designer of quality in both her vision and execution of the total project. "Design in its truest form is the understanding of the power of transition in our lives and how changing our spaces can greatly benefit us," she said. Marjorie added that the influence of our culture and our consciousness impact our surroundings, which in turn affects our daily enjoyments. "As a designer, it is a joy to help people first identify their needs and then create a supportive and natural backdrop for the real activities of life."

Marjorie starts each project with a grand vision of the total desired environment. Then, implementing the tools of light, shadow, hue and texture, she creates timeless, quality designs. With innate skill, a spirited desire and a respect for the natural world, the designer composes interiors that truly fit her clients. "We believe the art of quality design lies not with the momentary inspired gesture, but with the studied process," she said.

Confirmation of Marjorie's successes is the numerous *Houston Chronicle*/ASID design awards that she and her staff have received, as well as the variety of publications in which their work has appeared. Marjorie has also made significant contributions to her profession. An active member of the ASID, she is a former president and board member for this supporting body.

The consummate professional, who is dedicated to her industry, is equally as passionate about her design projects. "My goal is to consistently offer a professional level of work," Marjorie explained. "That mission, along with a clean, unique style and a defined attention to detail, is what enables our team to see and address the specific needs of each client." ■

BELOW LEFT: In this ASID award-winner design, studied, detailed architectural elements of paneling, an antique mantel, a plaster ceiling and iron gates create a "club" room feel.

BELOW RIGHT: This unusual library melds antique wood flooring with plaster walls and ceiling. Pecky Cypress paneling and beams and comfortable custom furnishings finish this welcoming space.

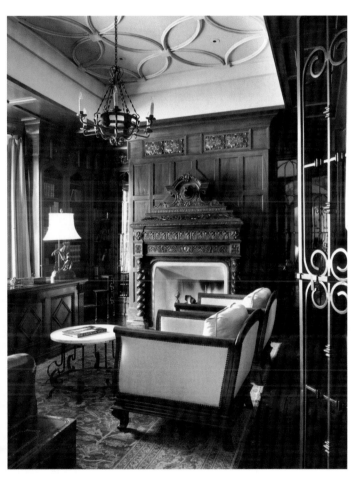

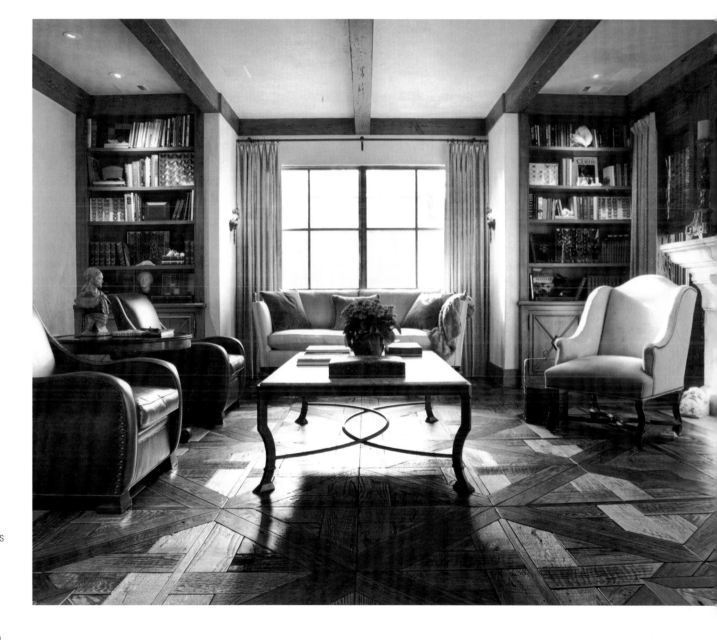

OPPOSITE PAGE:

TOP LEFT: This dramatic dining room—an ASID award-winner—is outfitted with custom table and chairs and deep-toned walls and draperies. Classic, clean elements mixed with an antique chandelier and contemporary art complete the inviting space.

TOP RIGHT: The outstanding architectural features, enhanced and softened with a pale mixture of custom furnishings and antique art, earned this living room an ASID design award.

LEFT: Cool, calm colorings create an inviting formal living space that still maintains a comfortable feel in this ASID award-winning setting.

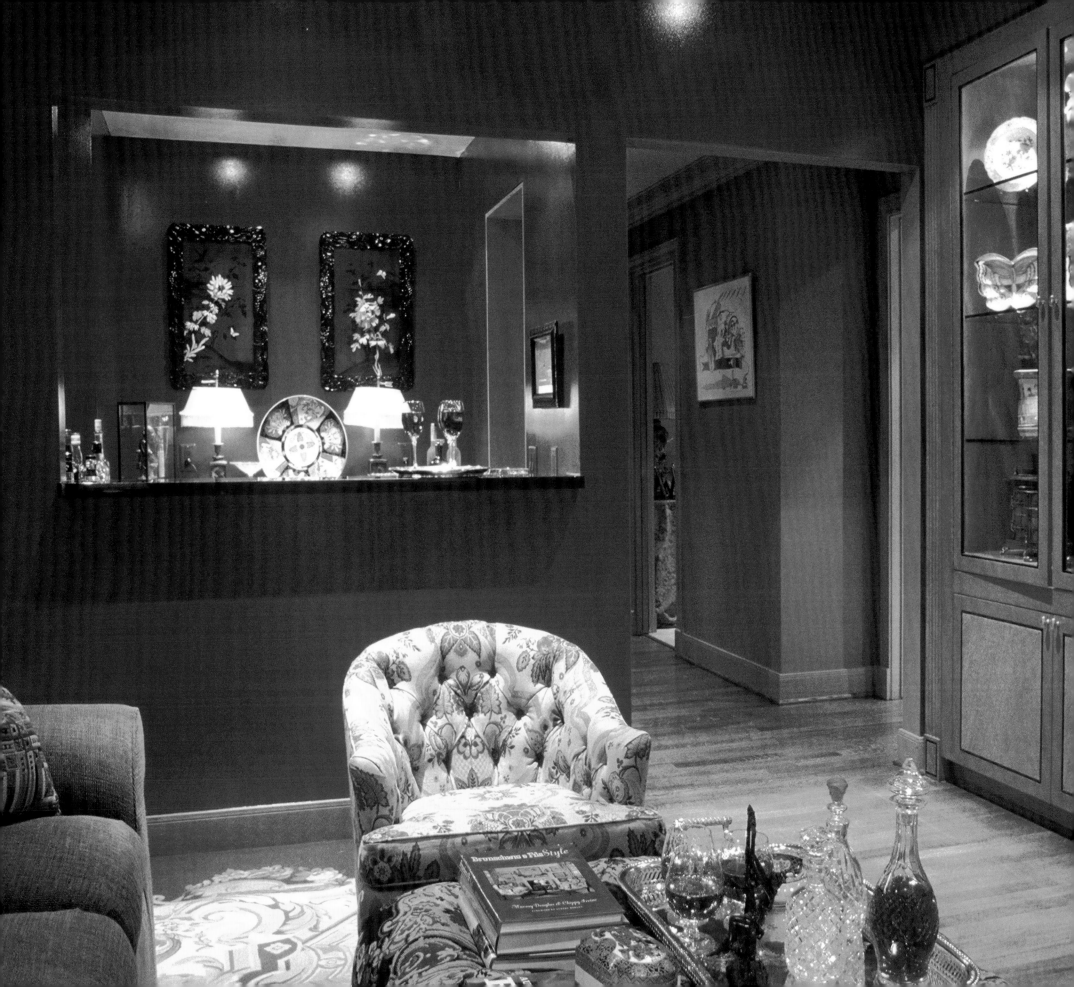

Sharon Staley, ASID

SHARON S. STALEY INTERIORS

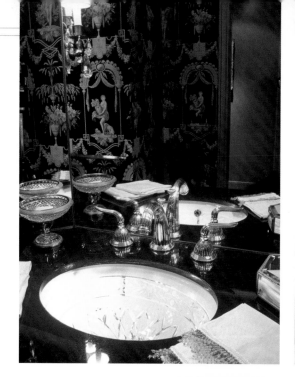

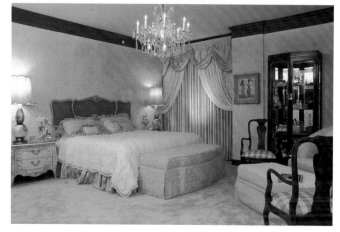

At the impressionable age of five, Sharon Staley was opening boxes and dusting furniture in her father's furniture business. By the eighth grade, she was helping arrange the store's furnishings in model homes for builders and at home shows in the Astrodome. "Because my father was kind enough to let me help out, I learned so much," she said. "I feel like I grew up in the design business."

The native Houstonian with roots in design now has over 35 years of experience assisting her own clients. Sharon graduated from Texas Tech University with a bachelor of science degree in 1971. She applies the knowledge she gained from her father with her education and training to create award-winning designs for her clients. "Good design starts and ends by incorporating the clients' needs into a functioning and comfortable environment," said Sharon. "I encourage the clients' participation throughout the entire design process. They are my most important concern."

Well known for her diversity, Sharon heads her own full-service design firm, where she handles a wide range of residential, hospitality, commercial and new home construction projects. From homes in the Cayman Islands and Santa Fe to hotels and high-rises in Houston, there isn't a challenge she hasn't met.

"Designers are problem solvers. Our job is to develop an overall plan, set goals and create a background for our clients," she explained. "They write the letter and we create the envelope." From start to finish, Sharon's firm offers a high degree of integrity and professionalism. "We work with design specialists during all phases of the project to ensure the best and most cost-efficient results."

Sharon has enjoyed a lengthy, highly successful career. Her memorable designs have graced the pages of a variety of publications, and she has won numerous accolades, including ASID President Citations, an ASID Medallist Award and a *Houston Chronicle*/ASID Design Award. Sharon has willingly served her profession by sitting on the TAID board of directors. Her contributions to the ASID, both nationally and locally, are significant—Sharon proudly served the ASID as president, and she chaired the organization's National Ethics Committee.

The young lady that started out arranging showroom furniture in her father's business has left a profound mark both in the design industry and in the interiors of her loyal clients. ■

TOP LEFT: This powder room with a new crystal sink was inspired by a pair of 18th century sconces.

TOP RIGHT: In this gameroom, an antique game table on an Aubusson rug eagerly awaits the homeowner, who has a passion for card games.

RIGHT: Serious entertaining awaits guests in this red-lacquered media room complete with a wet bar.

LEFT: This master suite features antique lace and an extensive jeweled purse collection.

SHARON STALEY, ASID
SHARON S. STALEY INTERIORS
5320 GULFTON DRIVE, SUITE 6
HOUSTON, TEXAS 77081
713.668.9689

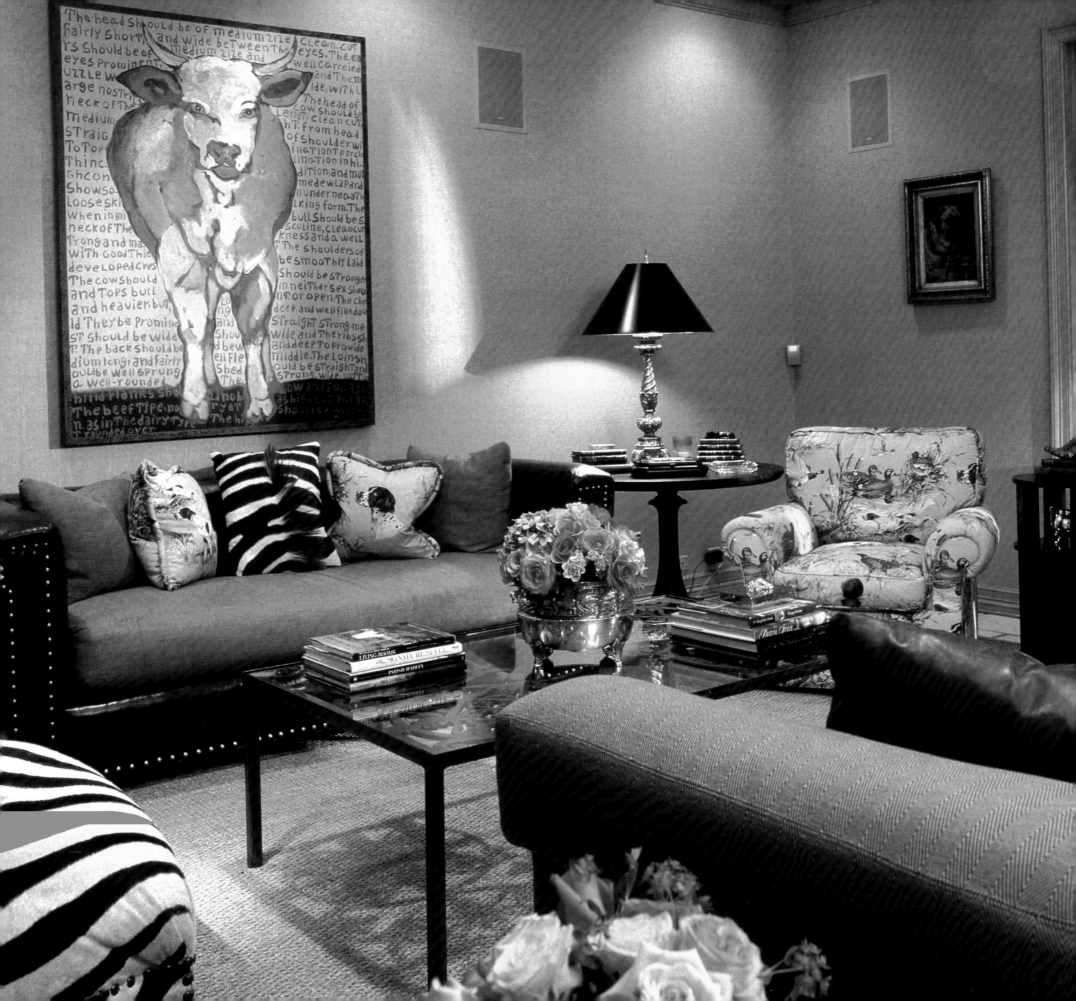

Edwina Vidosh, ASID

EDWINA ALEXIS INTERIORS, INC.

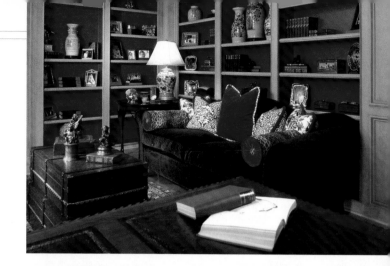

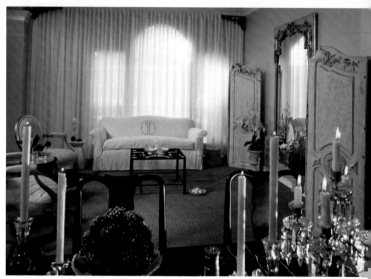

Award-winning Houston designer Edwina Vidosh asks her clients a very important question at the inception of their design consultations: "How do you want your home to feel?" She has made it her mission to help her clients identify and define their styles so she can personalize each room to meet their unique needs. "It's easy to make a space beautiful," she explained. "But it's much more interesting for each space to reflect the client's personality."

A degree in interior design from Texas Christian University and 18 years of experience enables Edwina to harness her clients' character and individualize each project. "Every house should have a place that's dressed up and a place that's relaxed," she said. "I like to layer rooms, especially bedrooms, which should be highly personalized. By combining hard and soft textures–like a hand-embroidered silk bedcover with a hardwood floor and a linen sofa–I create rooms with an inviting feel." Edwina's elegant, yet comfortable, designs often extend the boundaries of the house to include outdoor living areas.

The splendor of nature inspires Edwina's design plans, which typically include the spaces outside the walls and windows of her clients' homes. With the help of landscapers and pool contractors, her attractive interiors flow seamlessly into the outdoor living areas, creating lush environments. "I mesh the interior with the exterior," said Edwina. "I'll bring the comforts of nature inside, adding plants and flowers that soften the harshness of a design. Outside, I'll plant something red, for example, to coordinate with a red interior. It tricks the eye to extend outward and enjoy the beauty."

Her unique approach to design has earned the seventh-generation Texan numerous accolades, including glowing reviews in national publications and features in local press. While recognition for her work is appreciated, Edwina's reward comes from her satisfied clients. "I love it when, at the end of the project, my clients find their rooms to be beautiful, elegant and fitting for their lifestyles. I know then that my designs were successful." ■

TOP: This elegant study marries red lacquer accents with blue-and-white accessories to soften the room.

ABOVE: This charming living room relies on textures and antiques for an inviting setting.

LEFT: This comfortable media room reflects the tastes of the entire family.

EDWINA VIDOSH, ASID
EDWINA ALEXIS INTERIORS, INC.
3815 GARROTT STREET
HOUSTON, TEXAS 77006
713.533.1993

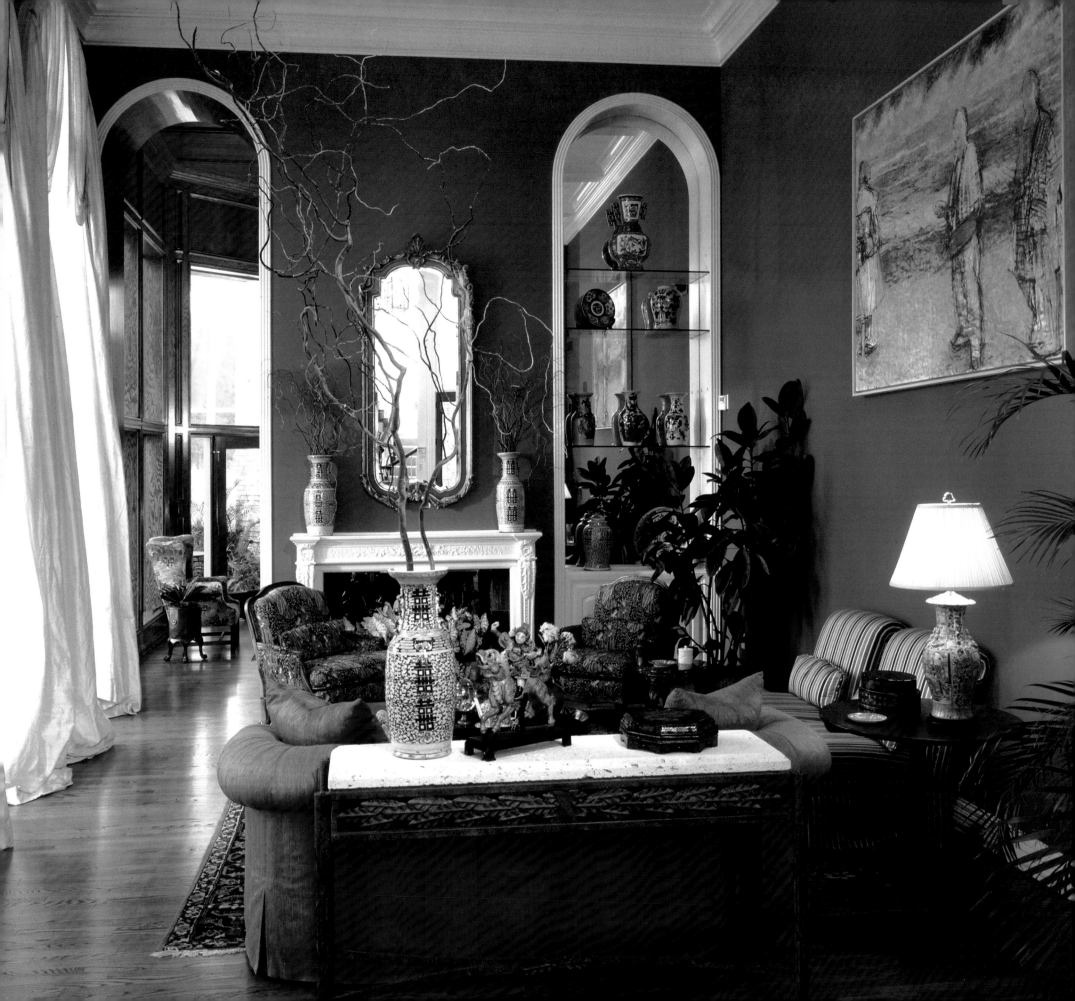

Donna Vining, FASID, CAPS

VINING DESIGN ASSOCIATES, INC.

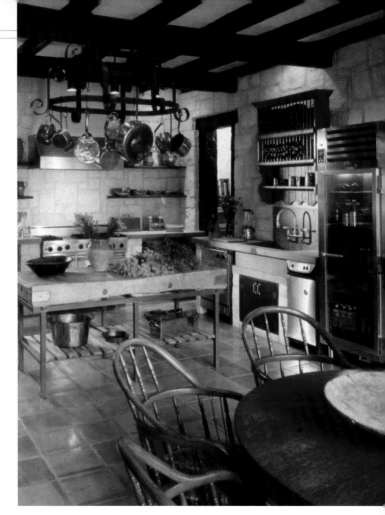

*T*he fundamentals of quality interior design remain the same," said Houston designer Donna Vining. "Begin a project with good bones, collaborate with your clients, aim for timeless quality and pay attention to details."

Donna, owner of respected residential design firm Vining Design Associates, Inc., adheres to proven philosophies while incorporating the latest research in aging-in-place, sustainability (green) and universal (barrier-free-living) designs to create warm, inviting spaces.

A Certified Aging-in-Place Specialist (CAPS), Donna champions this approach to design after observing her elderly in-laws' struggle to perform simple tasks like bathing in their own home. "I want to dispel the myth that barrier-free homes are ugly," explained Donna. "Homes with 32-inch doorways and accessible countertops, showers and hallways can be both beautiful and functional." They can also be environmentally friendly. "Green design is critical as we seek to conserve energy, reduce waste and minimize the use of harmful substances in our communities," Donna said. "Why should anyone have a headache because of their environment?"

The passionate designer, who graduated from North Texas State University with degrees in business and interior design, has received accolades for her cutting-edge designs. Recently she added a first-place nod from the *Southern Accents*/ASID kitchen competition to her long list of ASID design awards, which have been featured frequently in local and national publications.

A dedicated professional, Donna serves the ASID in several capacities, including past president of the Texas Gulf Coast Chapter and former chair of the National Council of Presidents. She has served as the president of the NCIDQ, and currently she is the executive director for the TAID.

Her participation in these organizations enables Donna to further her mission of propelling the interior design industry into the future. "All good designs should include sustainable and universal solutions and seamlessly and transparently evolve so that they enhance clients' lives forever." ∎

ABOVE: The Estancia kitchen, which won the Southern Accents/ASID First Place Kitchen award, was designed to be warm and inviting and to blend in with the Estancia, achieving a 150-year-old look.

LEFT: The fabulous blue walls, whose color was drawn from the antique Serapi rug, really bring this living room to life.

DONNA VINING, FASID, CAPS
VINING DESIGN ASSOCIATES, INC.
11418 HYLANDER DRIVE
HOUSTON, TEXAS 77070
281.320.2600
WWW.VININGDESIGN.COM

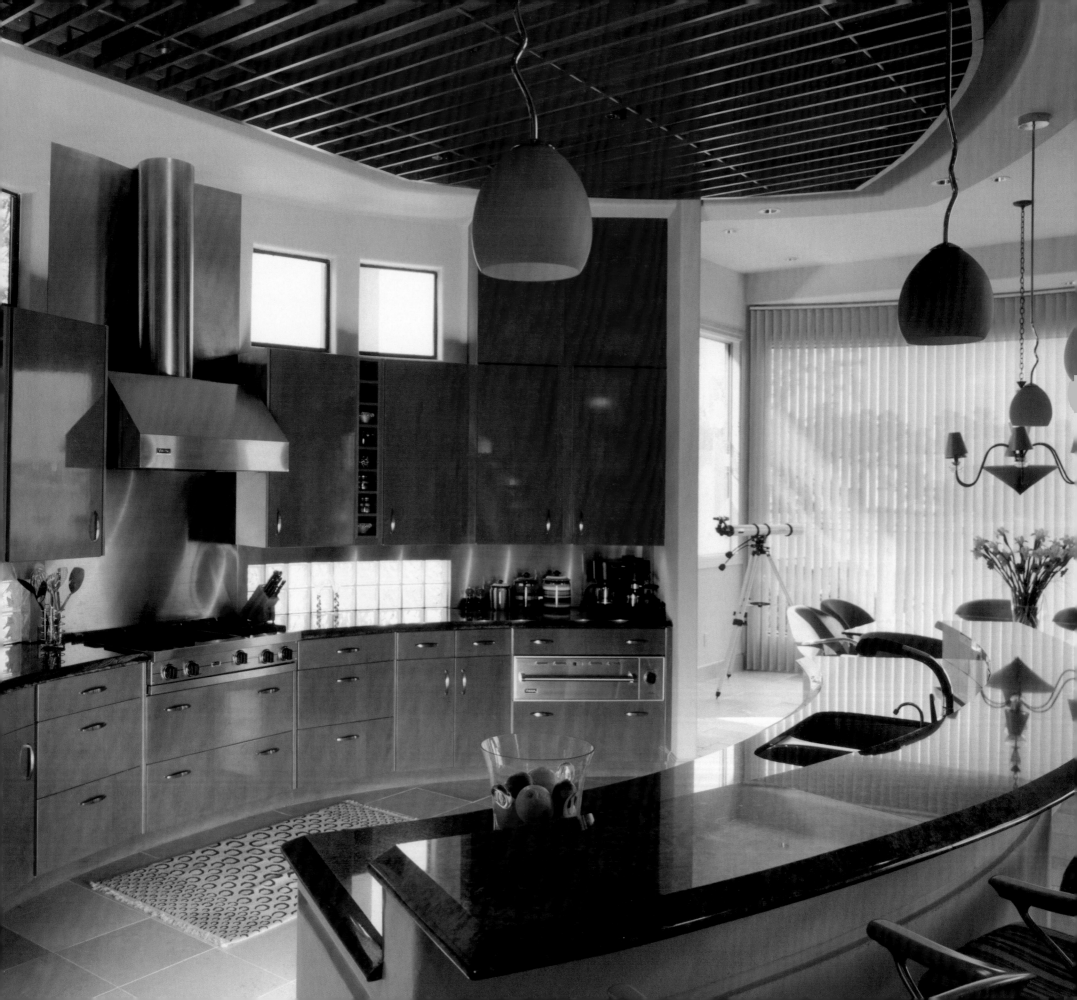

Diana Walker, ASID

DIANA S. WALKER INTERIOR DESIGN

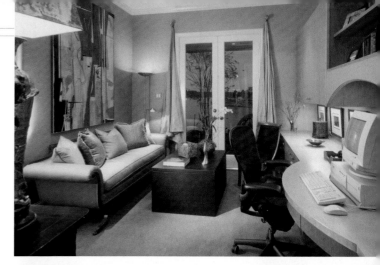

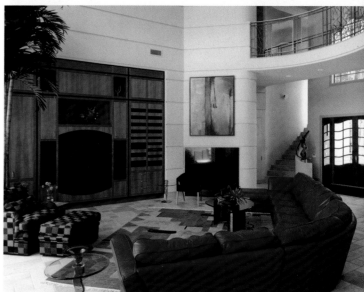

For every project, award-winning Houston designer Diana Walker strives to create timeless, sophisticated designs that express the uniqueness of each client. "I love to combine clean lines with interesting details in my design work," she said. "And I infuse all my designs with both contemporary and traditional qualities. This process enables me to create fresh, highly individualized spaces specific to my clients' personalities and needs."

Using a systemized approach perfected during her 24-year career, Diana personalizes each project after conceptualizing the client's vision. "I have always been able to visualize the finished project before committing thoughts to paper," she explained. "I have the unique ability to balance the function of the spaces with specific detail in the design elements as I develop an accurate footprint to be followed by all members of the project team."

Managing every detail from conception through completion, Diana finely tunes each project plan, resulting in a focused, seamless approach to achieving the desired results. "I believe it is essential to create an interior shell that is beautifully rich in detail before adding any furnishings," Diana said. "The specifications of a space must be properly managed throughout the design/build process. I strive for an end result that exceeds my clients' expectations."

This approach—along with Diana's excellent business aptitude, creative ability and listening skills—contributes to the success of her full-service design firm, Diana S. Walker Interior Design, which specializes in both residential and commercial projects. With a reputation for creating outstanding interiors, Diana has earned an impressive nine *Houston Chronicle*/ASID design awards and publicity in local and national publications.

In addition to managing her design firm, Diana also proudly supports many industry organizations and charitable causes. She is a professional member and a past president of the ASID Texas Gulf Coast Chapter, where she also has served on numerous committees in a variety of capacities throughout her professional career. For eight years, Diana served her profession as a legislative representative for the Gulf Coast Region of the Texas Association for Interior Design, for whom she now serves as board secretary.

The active professional with a hands-on approach to design applies her industry expertise to create ageless interiors that comfortably fit each client. "I manage the process of design to provide each client with a positive experience and beautiful spaces," Diana said. "Every project offers an opportunity to positively impact my clients' day-to-day lives" ■

TOP: This guest room/home office includes antiques, contemporary art and unique storage solutions such as customized built-ins and a hide-a-bed coffee table/nightstand–Diana's original design.

ABOVE: All interior finish details– like the expansive glass, curved walls and 24-foot ceilings–were chosen to highlight the sinuous curves of this architecturally interesting home with views of the lake from every room.

DIANA WALKER, ASID
DIANA S. WALKER INTERIOR DESIGN
3815 GARROTT STREET, SUITE 12
HOUSTON, TEXAS 77006
713.520.1775
WWW.DIANASWALKERINTERIORDESIGN.NET

LEFT: A dramatic, suspended-wood ceiling grid provides a solution to lighting, which highlights every spectacular detail of this curved kitchen.

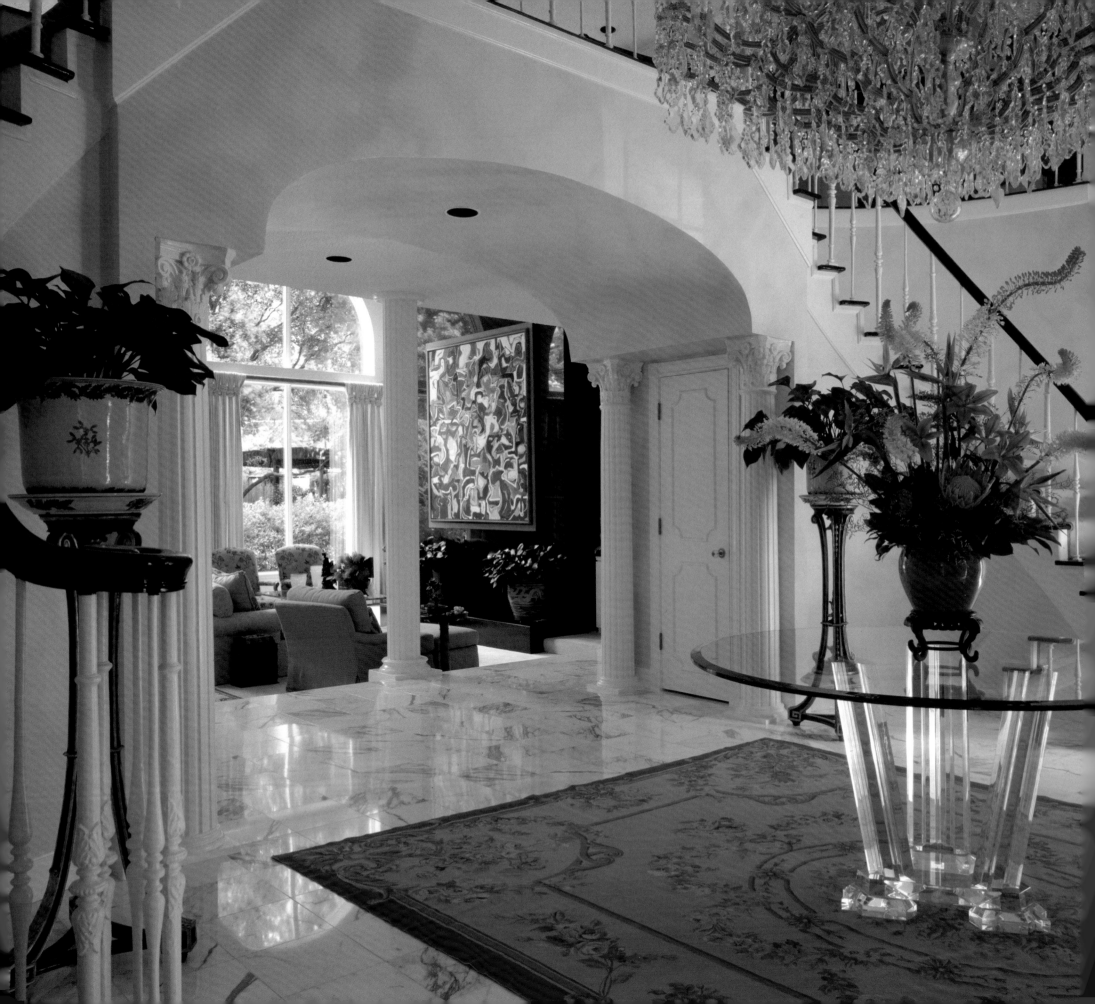

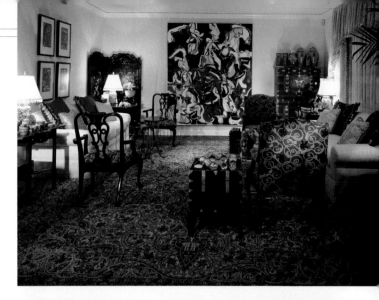

Amilee Wendt, ASID

WENDT DESIGN GROUP

Award-winning designer Amilee Wendt has amassed an impressive portfolio during her more than 25-year career. High-end residences, corporations, restaurants and hotels have benefited from the artistic flair of the noted designer and owner of Wendt Design Group in Houston.

To effectively respond to the demand for her firm's services—which include space planning, code compliance reviews, custom furnishings and complete interior decorating—Amilee relies on a strong team of professionals. "My staff and I work cohesively with our clients," she said. "We interpret their goals and envision their designs, then we partner with them to ensure that their requirements for budget are met."

This approach has led to a loyal following both locally and internationally. A five-star restaurant. High-end estates. A stylish London apartment. A renovated historic church. For every project, Amilee expertly applies the sound principles of good design, while outfitting each with timeless quality. "My designs are ageless with an edge to the future," Amilee said. "Whether traditional or contemporary, I customize each setting to reflect the personality of the project."

A consummate professional, Amilee actively participates in industry organizations. She is a member of the Texas Association for Interior Design, and she is also a professional member of the ASID, where she serves the Texas Gulf Coast Chapter as professional development director. She follows in the footsteps of her great uncle, Eugene Harris, who was a founding member of the local chapter.

Amilee has received applause for her memorable designs, including two CAPS design awards. And while the accolades are appreciated, Amilee says that the joy comes from the creative process, as eloquently penned by design icon Edith Wharton: "True originality consists not in a new manner, but in a new vision. The decorator's job is not to explain illusions, but to produce them." Embracing this philosophy, Amilee has left an indelible mark in Houston bedrooms and Hong Kong boardrooms across the world. ■

LEFT: In this view of the owner's smaller sitting area of a 75-foot living space, the foyer and formal areas feature variations of the owner's favorite colors. Artwork was installed on the two-story, granite fireplace to add a focal point to the sitting area and to also show a dramatic reflection in the mirrored wall of the dining room.

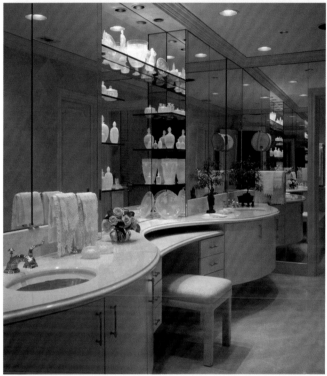

TOP: This high-rise living room features the client's collection of Asian antiques and an oversized, antique Oriental rug.

ABOVE: The renovation of this master suite bath vanity room added hidden medicine cabinets, floating glass shelving and cantilever cabinets. The wet room has a marble chair rail and marble trim surrounding the window.

AMILEE WENDT, ASID
WENDT DESIGN GROUP
2260 HOLCOMBE, SUITE 116
HOUSTON, TEXAS 77030
713.668.7474

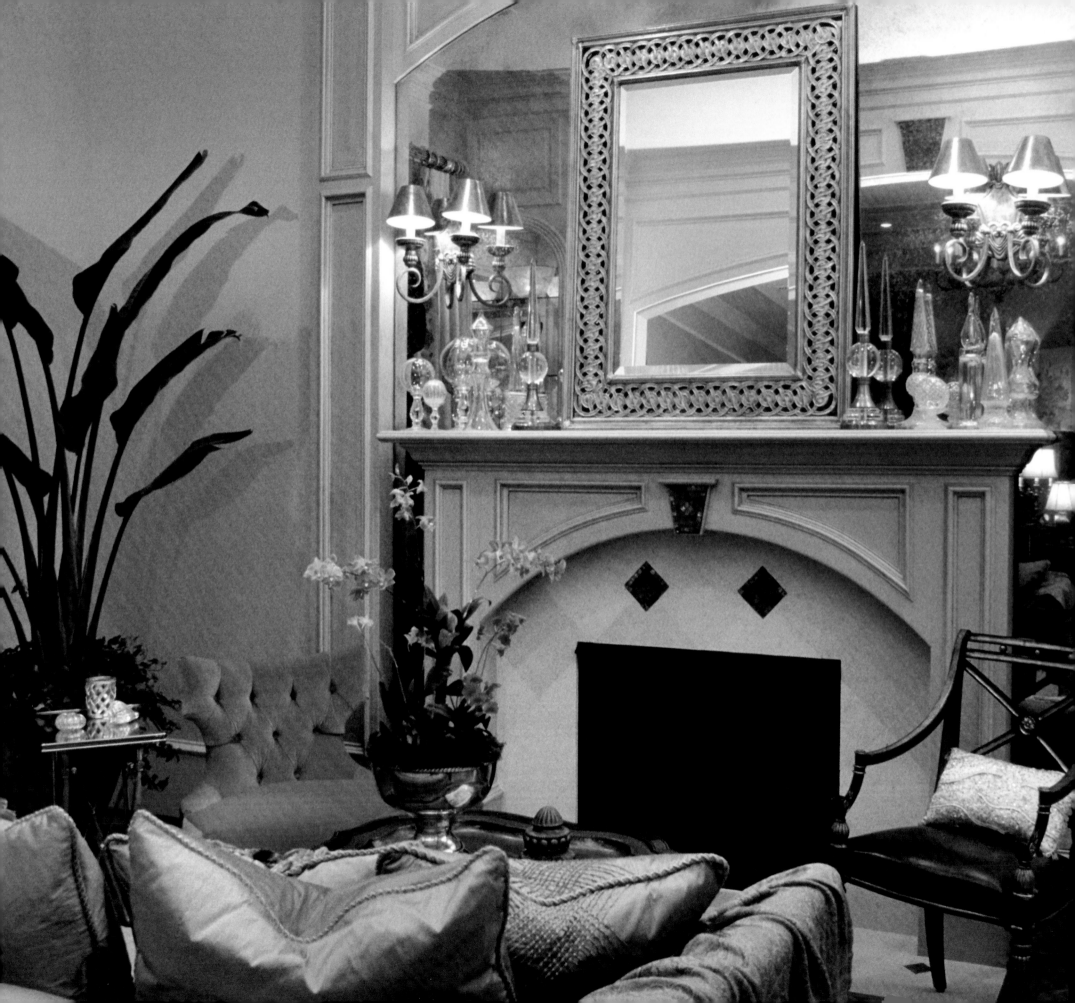

Mary Lindsey Wilson, ASID

WILSON & WILSON DESIGNS

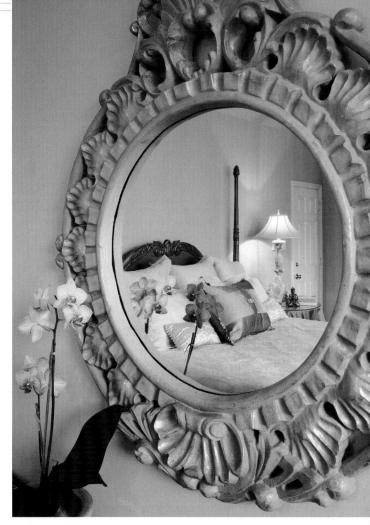

ABOVE: The gilt mirror reflects a relaxing sanctuary that is anchored by a hand-carved bed dressed with pillows created from vintage evening wear.

Mary Lindsey Wilson's passion is to support people in living beautifully. "I believe that when you transform your space, you can transform your life," she said. "I create spaces that nurture my clients' spirits by tuning into their personal visions and supporting them." Mary works closely with her clients to define their needs by asking them to envision what they really want in each room–how it should look and feel. Together, they work to create plans that suit their individual needs.

Mary's intuitive designs are inspired by color. "There have been numerous books written and studies done about how color affects us in our environments," she explained. "Color is often the primary influence in my designs; it enables me to achieve the perfect feel and energy in a room."

The design process continues as Mary urges her clients to let go of any furniture or objects in their homes that they do not truly love. "I recommend surrounding yourself with things you love and enjoy. Your home or office should be a reflection of you." Her clients' responses are resoundingly enthusiastic.

A native Houstonian, Mary has over 18 years of interior design experience. In 1989, she created her firm, Wilson & Wilson Designs, which specializes in residential design, new home construction and specialty hospitality. Mary's projects—private residences, vacation homes, offices and presidential suites in hotels—span the United States and Mexico.

LEFT: Livable luxury envelops the inviting sitting room where antique mirrors, arches and a custom mantel adorned with iridescent glass tiles peacefully reside among the soothing colors of aqua, celadon and crème and the rich textures of silk and velvet.

MARY LINDSEY WILSON, ASID
WILSON & WILSON DESIGNS
2621 WERLEIN STREET
HOUSTON, TEXAS 77005
713.667.3601
WWW.LIVEBEAUTIFULLY.NET

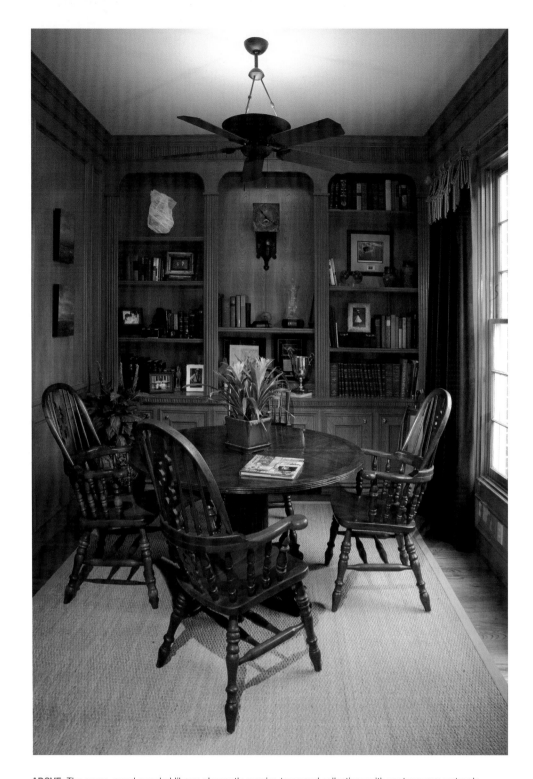

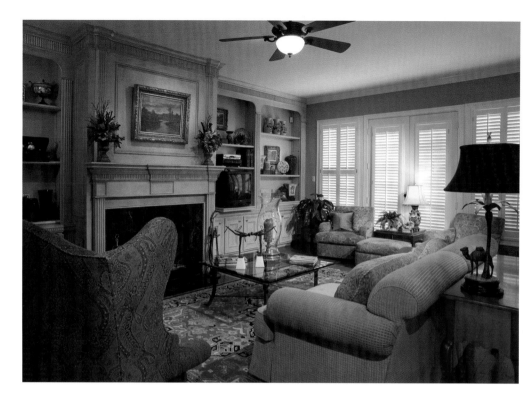

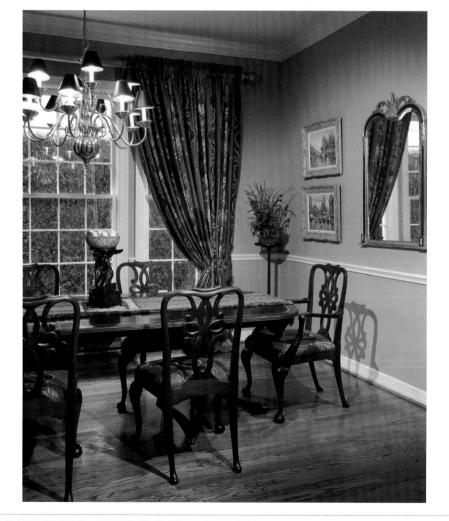

ABOVE: The warm, wood-paneled library pleasantly marries treasured collections with contemporary artwork.

TOP RIGHT: The family room's soothing palette of khaki, reds and blues was inspired by its Heriz rug. The faux mantel treatment enriches the
comfortably elegant setting.

RIGHT: The formal dining room finds antique Chippendale dinning chairs sitting near original art by Impressionist Antoine Blanchard.

Her work has appeared in a variety of publications, both nationally and locally, including *Elle Décor, Houston Lifestyles & Home &, Building Trends, OutSmart* and *Houston House & Home*.

Mary attributes her success to her ability to translate her clients' desires so that their visions become reality. "When my clients tell me that I captured exactly what they wanted and that they are absolutely thrilled, I know that I have made a difference in their lives." ■

ABOVE & RIGHT: The navy walls and custom window treatments made from vintage, hand-embroidered Italian silk create a dramatic backdrop for the antique American secretary, Chinese needlepoint rug and coromandel screen.

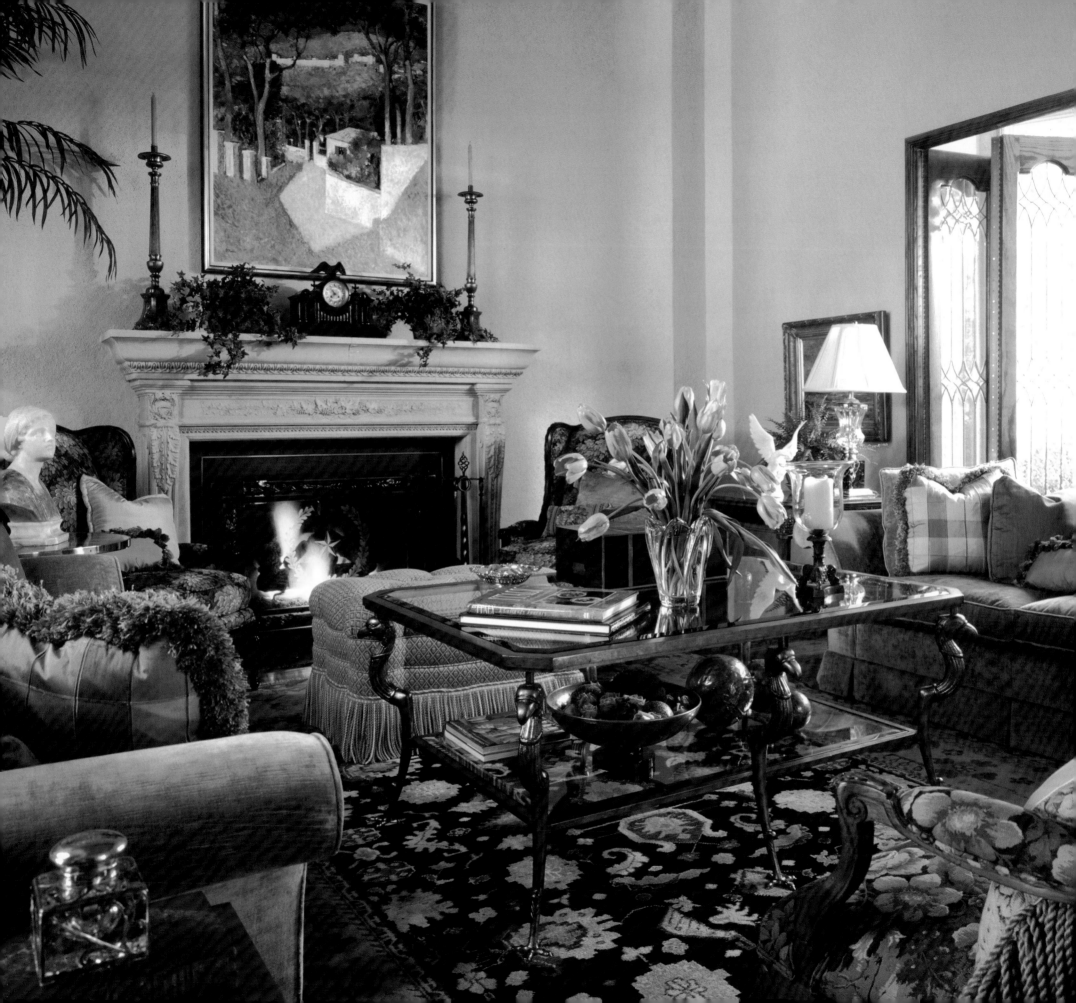

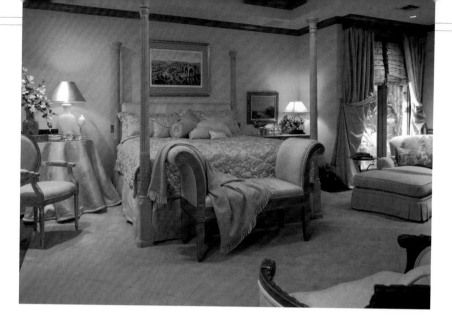

Sharon Yesland, ASID

SHARON YESLAND INTERIORS, INC.

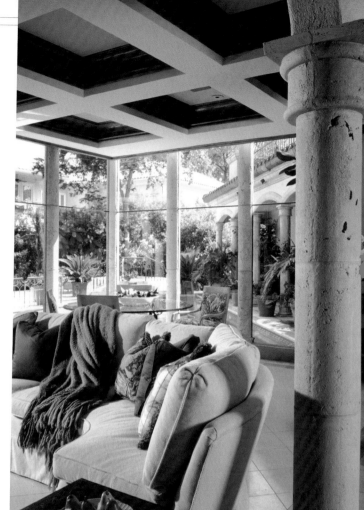

ABOVE LEFT: French doors open onto the gardens and pool opposite the bed. This restful room is bathed in soft shades of the sunrise in creamy peach and silvers.

ABOVE: This loggia appears to be in the garden, floating over the pool. The large glass-and-iron table is wonderful for "alfresco" dining, while being cooled by the air conditioning. The entertainment center is built on the wall opposite the sectional.

Under the serene canopy of a Pacific Northwest forest, Sharon Yesland, as a child, often created a series of rooms amongst the chest-high sword ferns that grew on her family's property. "We would throw blankets over the ferns and trample out spaces, creating an instant house," she recalled. "It was magical." Then at age 16, Sharon visited a family friend's home and encountered a periwinkle blue bedroom with a purple velvet chair. "The ambiance and colors were truly ethereal, transforming me to another world," she remembered fondly. "I knew then that I would become an interior designer."

Drawing on that inspiration, Sharon attended Washington State University and the New York School of Interior Design before moving to Houston. She worked as a designer for Brittain's Fine Furniture, and then three out-of-state moves took her to California and Alaska. "I designed in both states and contrary to rumors, I did not design interiors for igloos!" Sharon proclaimed. Eventually Sharon and her family returned to Houston, and Sharon joined the design team at Suniland Furniture, where she stayed for four years. "I consider those years of design experience invaluable," she said. In 1990, she reopened her own design firm, Sharon Yesland Interiors, Inc.

LEFT: Linen velvet, silks and tapestry fabrics enrich this Houston "Italian Villa" living room. The black Oriental rug, with hints of color, grounds the space.

SHARON YESLAND, ASID
SHARON YESLAND INTERIORS, INC.
5773 WOODWAY DRIVE, SUITE 299
HOUSTON, TEXAS 77057
713.782.0333

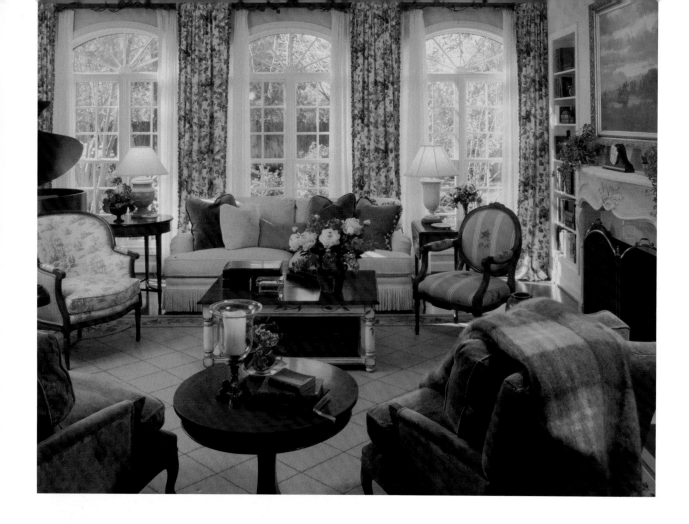

TOP LEFT: In this living space, the homeowners requested a casual, elegant setting that was styled Country French, but not shabby chic, using their favorite colors of green, pink and lavender. Not shown, antique walnut armoire and antique Steinway baby grand.

LEFT: The doors of this antique French cupboard from 1750 were reversed to show off the carving and lovely antique dishes, which add warmth and history. The interior of the cupboard was lined with a Brunschwig & Fils French cotton fabric.

Specializing in residential design, with an occasional executive office thrown into the mix, this one-woman dynamo has successfully composed beautiful interiors for over 30 years. Adhering to her belief that a well-designed home or workplace should reflect the personalities of the individuals occupying the space, she listens carefully to her clients' desires before devising her designs. "I make a sincere effort to interpret my clients' dreams, goals and needs," explained Sharon. "Design projects can take months and sometimes even years to complete; therefore, a pleasant and trusting relationship between my clients and me is a must."

Her appealing designs have been published in *Better Home and Gardens, Houston House & Home, Houston Home & Lifestyle,* the *Houston Post* and the *Houston Chronicle.* Sharon has also won a *Houston Chronicle*/ASID Design Award, and she has supported her local ASID Texas Gulf Coast Chapter by serving on and chairing a variety of committees.

Sharon's ongoing success can be traced to her early passion for color and design. "I love working with my clients, opening their eyes to new ideas and the world of color," she declared. "Beige is safe, but color adds life and personality to a home. I enjoy overseeing each project to completion, down to the last accessory!" ■

ABOVE: This study is an element of surprise! A sunny and happy room, it features—opposite the sofa—a warm, cherry French writing desk and green leather chair. A wall of book cases behind the desk is glazed in the same soft yellow as the walls. Finishing the friendly setting is a sky blue ceiling and sisal rug.

LEFT: In this lettuce-green room with J. Robert Scott silk plaid bedspread, Cowtan and Tout wallpaper and Scalamandre Damask fabric, the homeowner's existing furnishings enjoy a second life with new accessories and art, featuring antique botanicals and an oil painting reflective of their love of gardening.

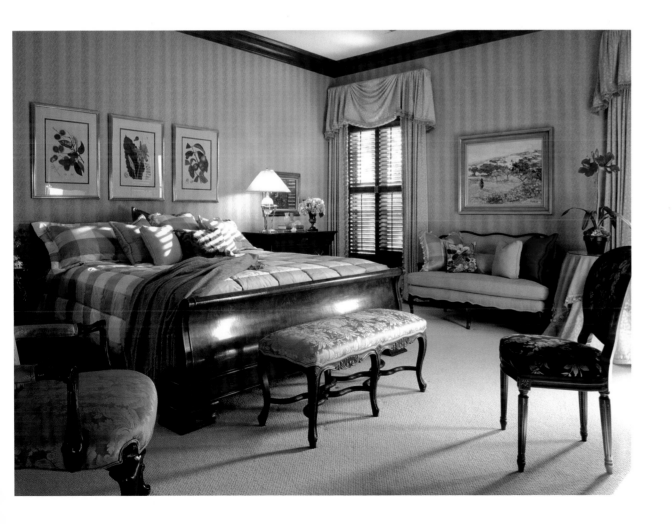

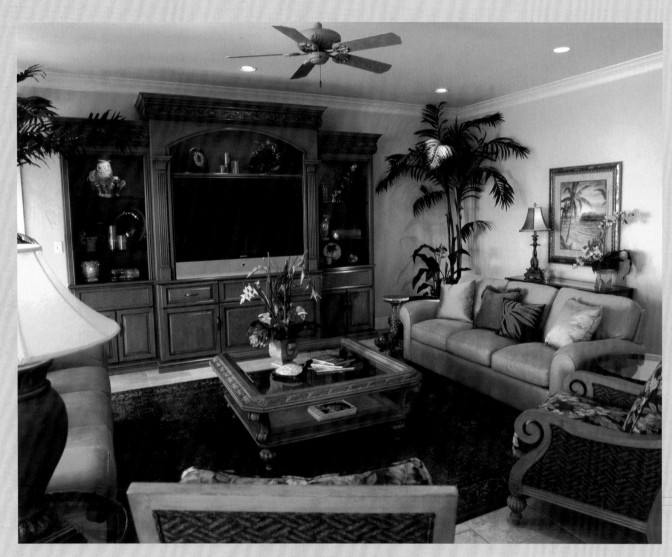

JERI GARRETT, ASID

Rio Grande Valley

Jeri Garrett, ASID

CACTUS FLOWER INTERIORS

ABOVE: This beach-front kitchen features cabinets by Woodmode and custom tile art by Pat Chapin.

LEFT: In this South Padre project built by Will Burns Construction and managed by Rick Labunski, AIA, residents can relax on furniture from Designer's Showroom.

On her first visit to South Padre Island, designer Jeri Garrett fell in love with the laid-back rhythm of the popular tourist spot. In 1980, she moved there, married and raised a daughter while growing her retail store/design firm, Cactus Flower Interiors.

Cactus Flower is now a popular fixture on the island where the large operation sells home décor like furnishings, art, accessories, gourmet kitchen necessities, bed and bath items and lighting. The store is the island's only florist, and it is home to the top design/remodel firm, as confirmed by recent nods from the *Valley Morning Star*.

Jeri—a Texas Master Florist, registered interior designer and member of ASID and TAID—says that she and her staff are fearless when it comes to interior remodeling. "We contract with property owners to extensively remodel luxury condominiums at South Padre. We've positively impacted the coastal landscape through our efforts."

Jeri has left her mark in the second homes of some of North America's wealthiest property owners. Her clients primarily reside in North Texas, Mexico, the Upper Midwest and Canada, but they own vacation properties on the island. This geographical challenge makes for an interesting approach to design. "Typically, clients aren't occupying their spaces when I design them," Jeri explained. "In fact, I have limited access to my clients and rarely do I get to see their permanent residences." This situation requires Jeri to be a strong communicator, trusted planner and avid advocate.

"I have my clients' best interests at heart and I work to protect them throughout the project," she said. "By establishing relationships with the area's finest contractors and craftsmen, I meet—or exceed—my clients' requirements for budget and delivery." Jeri can also unleash her creative side. "Typically clients want their vacation properties to be fun and fresh," she said. Often that translates into bold color combinations or a contemporary mix of furnishings. Frequently, it results in unusual details like stained teak flooring or glass tiles containing fish.

JERI GARRETT, ASID
CACTUS FLOWER INTERIORS
3009 PADRE BLVD.
SOUTH PADRE ISLAND, TEXAS 78597
WWW.CACTUSFLOWERINTERIORS.COM

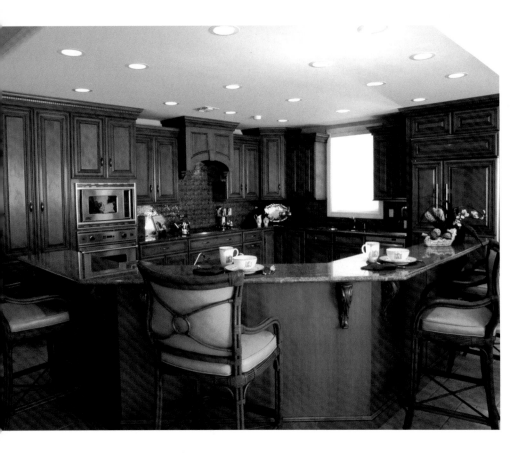

Regardless of the style, Jeri's designs are driven by her clients. "My clients are sophisticated travelers with big dreams for their spaces," she explained. "Their tastes vary as much as their cultures. It's extremely exciting to be a designer in this area."

Jeri got her creative passion from her mother, who was an accomplished designer in Tennessee, and she learned about the art of construction from her home-builder father. But Jeri didn't realize that this profession was "in her blood" until she had already graduated from college with a teaching certificate. She later applied her innate ability at designing and drawing working plans for home builders in her native state before passing the NCIDQ exam and becoming a certified designer in Texas.

TOP LEFT: This warm kitchen with cabinets by Woodmode was designed by Debbie Bode.

LEFT: Limestone floors by Walker Zanger, furniture by Drexel Heritage from Designer's Showroom and a chandelier from Currey and Company complete this dining design.

BELOW: Tile by Pratt and Larson completes this beachy bath.

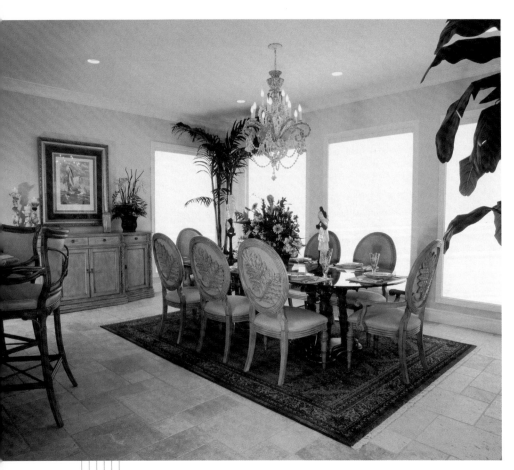

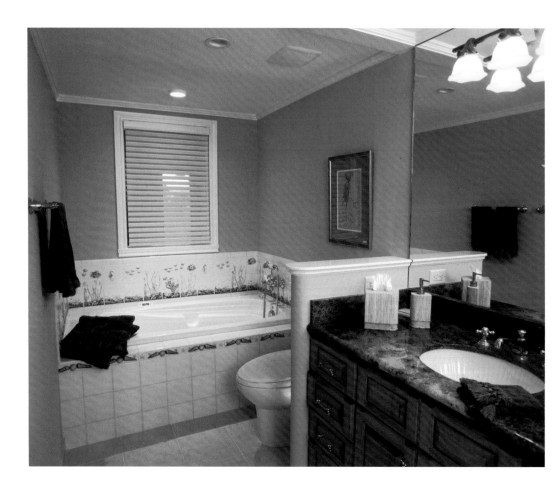

While living the life as a popular designer in Houston, Jeri met the man who was to become her husband. Together they traveled to the shores of South Padre, where she has now successfully practiced design for 25 years. She attributes her longevity to her talented staff and loyal clientele, whom she treats as she hopes to be treated. "I live by the mantra of what goes around comes around," she explained. "I work hard to ensure that my clients are delighted with their designs. My reward is their happiness." ∎

TOP RIGHT: This bedroom is home to furniture by Drexel, lamps and florals by John Richard and custom bedding by Cactus Flower Interiors.

BELOW LEFT: This coastal bath features granite and tile by Walker Zanger, cabinet finishes by Roberto Barajas, lighting by Savoy House and an Allustra Silhouette window covering by Hunter Douglas.

BELOW RIGHT: This living space finds furniture by Lexington, Braxton Culler and Precent flanking a custom entertainment center designed by Jeri Garrett and fabricated by Bob Pederson.

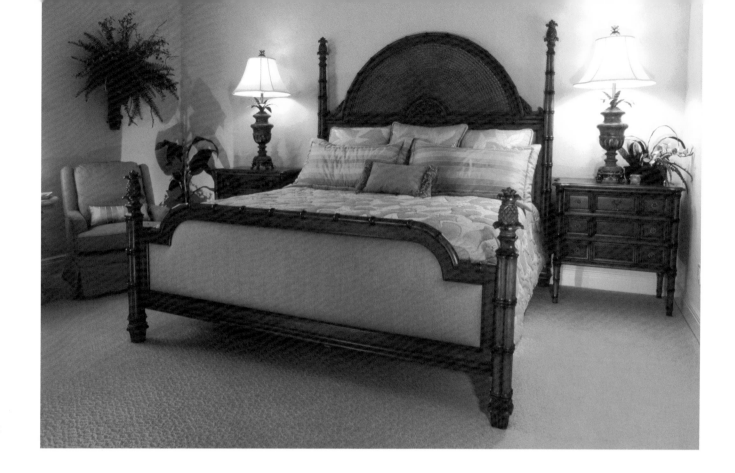

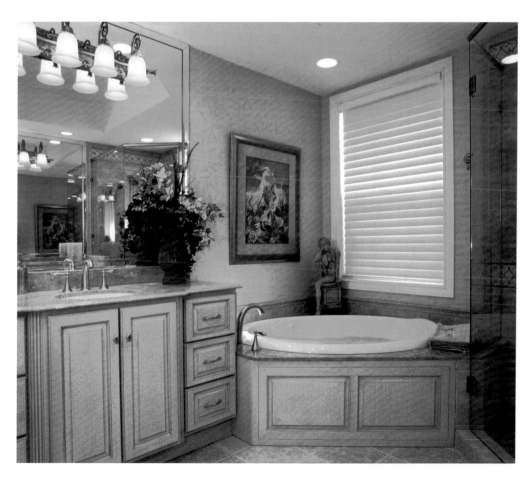

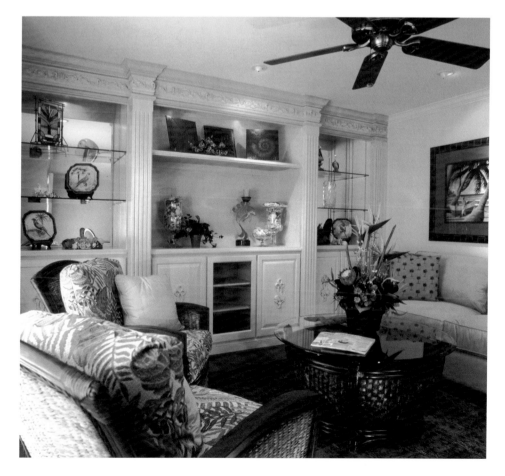

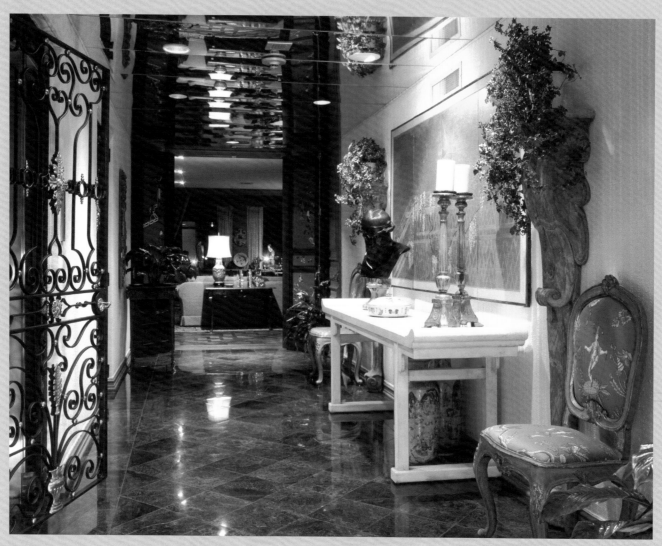

ORVILLE CARR, FASID & CHARLES A. FORSTER, ASID

San Antonio

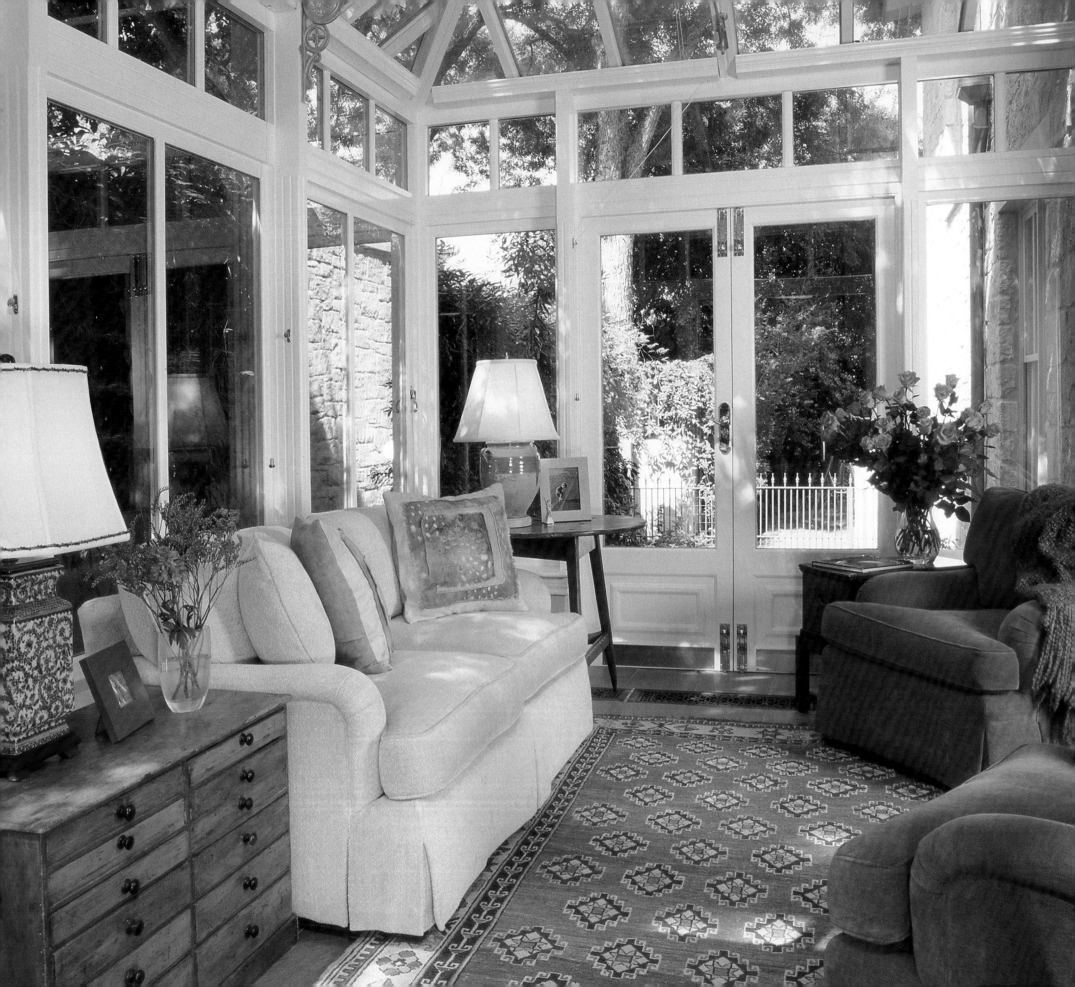

M. Robbins Black, ASID, IIDA

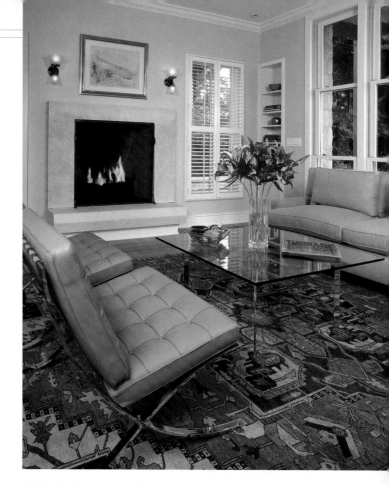

San Antonio designer Robin Black grew up in various parts of the country and in Europe, where for four years she moved across the continent with her family, traveling from city to city, absorbing the art and the beautiful buildings. She even studied for two years at the American College in Paris, where as a young liberal arts student she was given an extraordinary education from noted American professors on sabbatical. "In one class, we were instructed to go to the Jeu du Paume, find a painting and write about it," Robin recalled. Armed with amazing experiences like this one, Robin returned to the states, where she secured a degree in interior design from Auburn University in 1968.

For nearly 11 years after graduation, Robin honed her design skills on a myriad of commercial and residential projects with San Antonio architectural firm Ford, Powell and Carson. In 1980, she opened her own practice, M. Robbins Black. Since then, Robin has applied her innate talents and exceptional experience to creating award-winning spaces for residential and commercial installations.

Today, Robin's brimming portfolio primarily includes high-end residences in locations like Seattle; Salt Spring, British Columbia; Northeast Harbor, Maine; and New York, and it contains several commercial projects like three Sterling Banks and the San Antonio Chamber of Commerce. She also completely outfitted a 139-foot sailing ketch, for which she earned the Texas/Oklahoma IIDA Residential Design Award in 2002 and the ASID Texas Chapter Legacy of Design Award for Sailing Craft in 2003. In fact, these two awards join the 1980 national nod from the ASID for an historical preservation project in Galveston that transformed a cotton warehouse into a restaurant.

Robin's attention to detail and her ability to easily communicate with all members of a project team contributed to her many successes, and her passion for her career led to her involvement in professional organizations. Currently, Robin is president of the ASID Texas Chapter, for whom she has served three times as a board member. She has twice served as chair of the San Antonio Design Community, and she has been a member-at-large of the TAID and the IIDA.

Her commitment to her profession is only exceeded by Robin's dedication to her clients. "You might say I'm the keeper of the vision," the enthusiastic designer said. "It's my job to understand the desires of my clients and expertly craft their designs to completion. After all," she continued, "their happiness is my goal." ■

M. ROBBINS BLACK, ASID, IIDA
P.O. BOX 6612
SAN ANTONIO, TEXAS 78209
210.826.2100

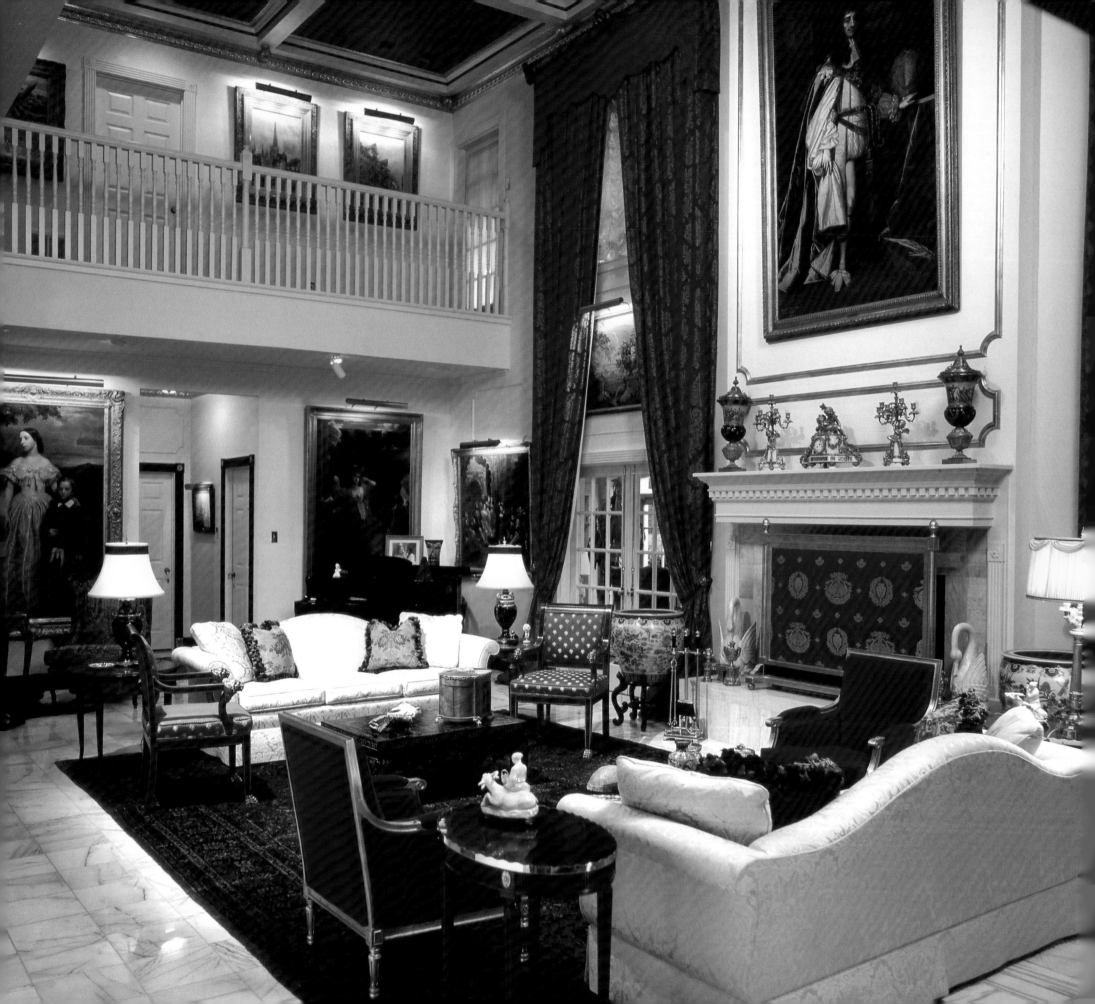

Orville Carr, FASID
Charles A. Forster, ASID

ORVILLE CARR ASSOCIATES, INC.

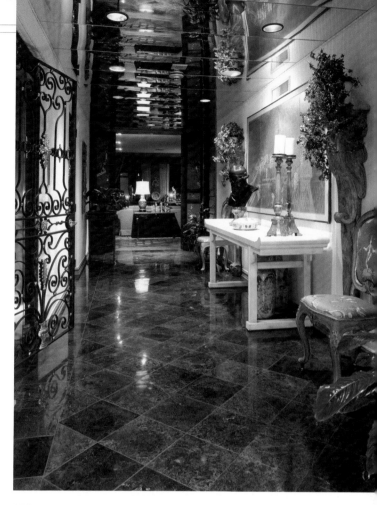

Acclaimed designer Orville Carr is legendary for his elegantly classic creations. Founder of Orville Carr Associates, Inc., one of the nation's few remaining complete design studios, Orville has left an indelible mark in the high-end residential world.

With his business partner Charles A. Forster, noted designer and president of Orville Carr Associates, Inc., Orville serves discerning clients in south central Texas. Though the team primarily designs fine homes for the area's elite, their brimming portfolio also includes top-flight offices. With a flair for pairing the unique with the extraordinary, clients seek their distinctive designs that are rich in detail and excellence. "We urge our clients to purchase timeless, quality pieces," said Orville. "Then we expertly meld them with antiques, accessories and art to create livable masterpieces."

Charles joined Orville's firm 20 years ago while on the path to becoming an international diplomat. "I had not yet realized my dream of becoming a designer," Charles said. "I changed course after my early experience at Orville Carr Associates." Orville recalls being impressed with Charles' innate talent. "I often invite interns into my studio," he said. "When Charles arrived, I saw that he was especially gifted." After his 1993 graduation from the University of the Incarnate Word with a degree in interior design, Charles became a designer for the firm that Orville founded 40 years ago.

Orville was introduced to the world of design while studying in New York. "I cut my teeth on the refurbishing of an old mansion near Tarrytown, and then I worked for prominent designer Mildred English for 15 years," he recalled. "After military duty, I landed in San Antonio, where I established my practice." Orville is not only a design fixture in his community; he is an ardent supporter of the arts and a philanthropic leader for organizations like the Southwest Foundation, the Witte Museum, the McNay Art Museum, the San Antonio Museum of Art and Trinity University. He is also a Fellow of the ASID, for which he has served both regionally and nationally in a variety of capacities.

ORVILLE CARR, FASID
CHARLES A. FORSTER, ASID
ORVILLE CARR ASSOCIATES, INC.
8015 BROADWAY, SUITE 100
SAN ANTONIO, TEXAS 78209
210.226.8251

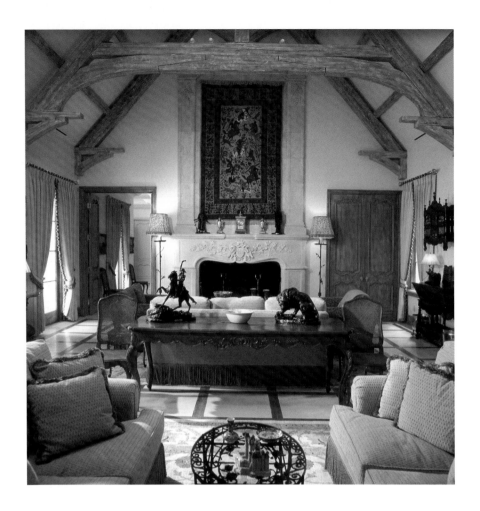

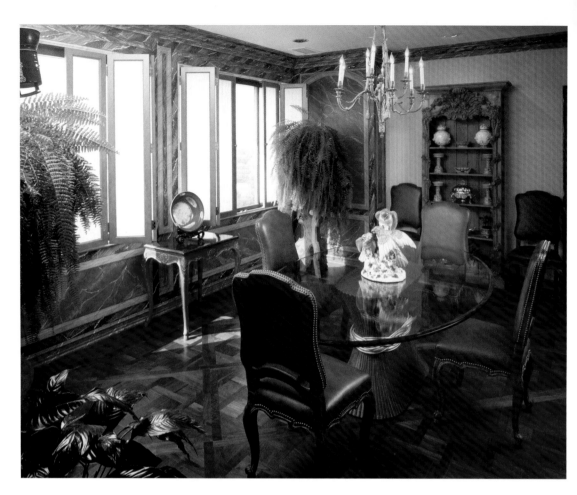

Charles is also an industry leader and civic supporter. He is a founding member of the TAID and the San Antonio Museum of Art's Artepreneuer Club, and Charles recently chaired the Texas ASID. He shares his partner's love of the arts and willingly serves on the Say-Si and Art San Antonio boards.

Orville and Charles are well-respected for their personal and professional contributions, and they are widely sought for their signature style and approach. "We openly communicate with our clients, establishing rapport that's essential to every project," Orville said. "This approach promotes trust, which solidifies our relationships and frees us to effectively fashion our clients' desired interiors with

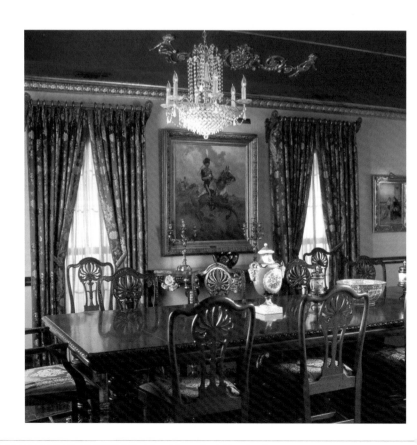

TOP: This great room has high-vaulted ceilings. Along the back wall, a hand-carved stone fireplace is accented by a hanging antique rug. The floors are stone that have been inlaid with wood, helping to carry out the natural theme for this room.

TOP RIGHT: The faux-marbled walls accentuate the beautiful wood floors in this room. Leather chairs surround a glass-top table.

RIGHT: In this European dining room, elegance is the main course. Blue floral lamps and silk drapes complement the coffered ceiling with gold crown molding and a family crest medallion.

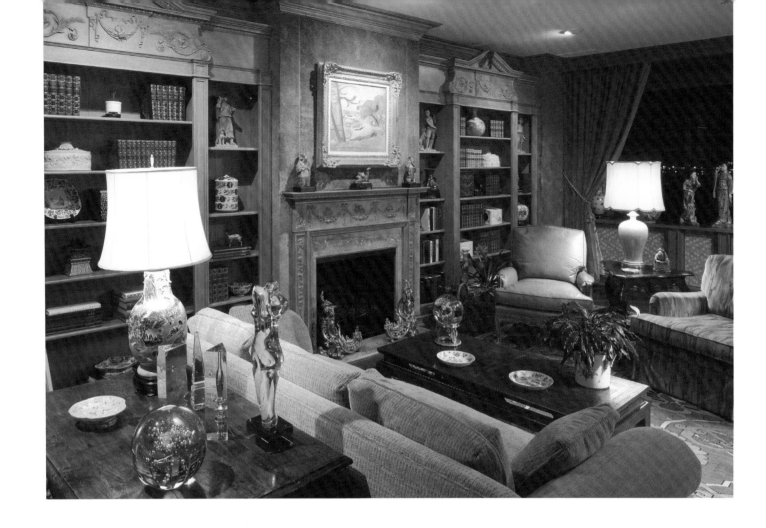

ageless taste and style." Owning a company with a large showroom and warehouse is also of benefit. "We maintain an inventory of the finest home décor, furniture, lighting and accessories," Charles explained. "Clients can 'try out' an item before purchasing, thereby minimizing the margin for error and increasing our clients' confidence."

This approach has proven successful for the distinguished firm—the prestigious designers have a loyal following of satisfied clients. "We are serving the second and third generations of several families," Orville offered. "I take great pride in knowing that they trust Charles and me with their homes. We honor that commitment by giving our clients warm, inviting settings in which to comfortably live." ■

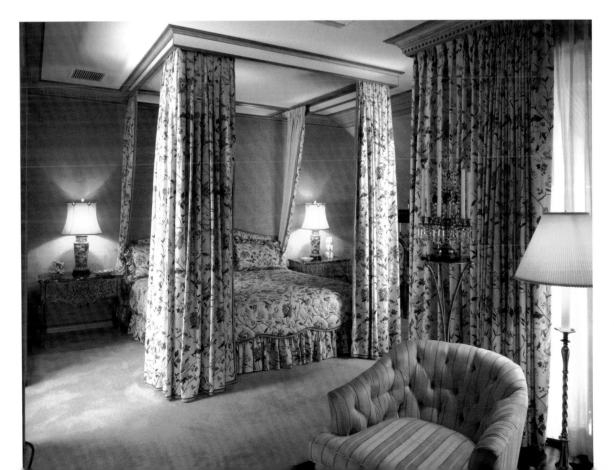

ABOVE: This study comes together with a large collection of Oriental figures. The red upholstered walls and draperies complement the area rug.

LEFT: The canopied bed with matching drapes and bedding make a statement in this master bedroom. Two marble-top night stands adorn each side of the bed. A tufted-back lounge chair and several lamps accent the room.

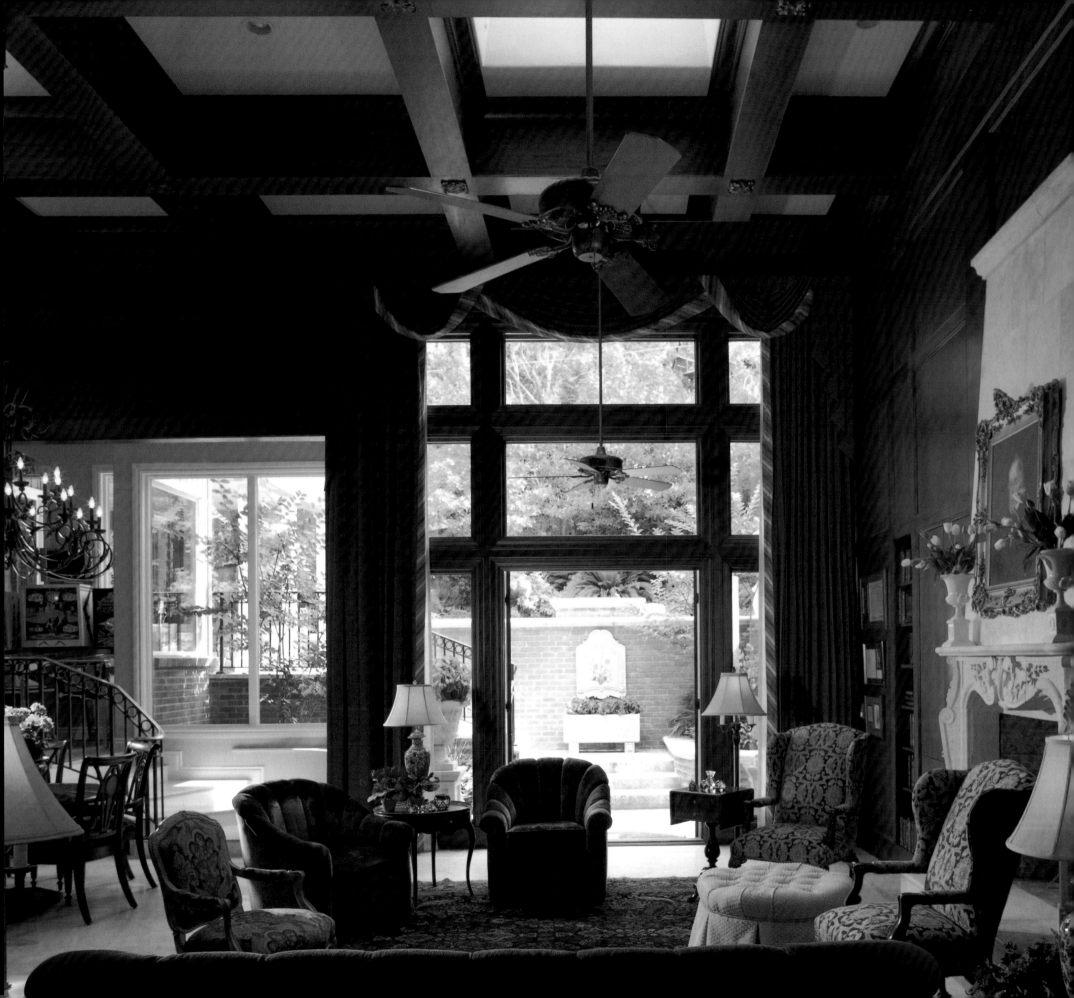

Derrick Dodge, ASID
Betsy Homan, Allied ASID

DERRICK DODGE INTERIOR DESIGN

TOP: Soft leafy greens and apricots cohesively flow through the color palette of this remodeled living room, where newly constructed lighted cabinets allow proper display of the client's extensive collection of English commemoratives. The family's Chinese Kerman rug sparked the complementary color scheme.

ABOVE: The dining room of this luxurious, private Saudi jet is richly appointed with customized seating, roman shades and furnishings. Specialty finishes include pickled-oak cabinetry, gilded French moldings and 18KT gold-plated accents.

*"G*ood design is an investment," says San Antonio designer Derrick Dodge. That's why he advises his clients to take it slow and do it right. "Furnishings create an emotional ambience for your home, your haven. Don't rush it."

Derrick's associate designer Betsy Homan agrees with this mantra. "It is best to implement a project over time using quality furnishings that will last for years to come."

This seasoned design team knows of what they speak. With more than 60 years' combined experience, they have outfitted the most stylish interiors with exceptional appointments, custom furniture and premium fabrics. Always classic and never trendy, their timeless designs mark interiors across Texas and in California, New York, Michigan and Florida. And with Betsy's 23 years' design experience in the private aviation industry, their reach extends far across the globe.

Regardless of the location, each of their designs shares the fundamentals of function and form. But every one is unique—just like the clients they serve. "It's very important for clients' tastes to be reflected in their homes," said Derrick. "It's their oases." For some that means overstuffed down pillows and family heirlooms; for others it's striking fountains and exotic materials. Whatever the desire, the designs of this award-winning team perfectly fit each client's personality.

Although the interiors fashioned by Derrick Dodge Interior Design are primarily residential, commercial properties round out the firm's portfolio. From the executive offices of national corporations to the private planes of Middle Eastern royalty, the firm answers the call for commercial projects.

But they always come home to the residential designs they love. Like the advice they give their clients, they've invested in what is important to them—the world of good design. ■

LEFT: A hand-carved limestone fireplace adds architectural articulation to this new addition garden/family room. Scalamandre red linen-velvet sofa complement the client's antique Oushak rug.

DERRICK DODGE, ASID
BETSY HOMAN, ALLIED ASID
DERRICK DODGE INTERIOR DESIGN
111 W. SUNSET ROAD
SAN ANTONIO, TEXAS 78209
210.824.1959

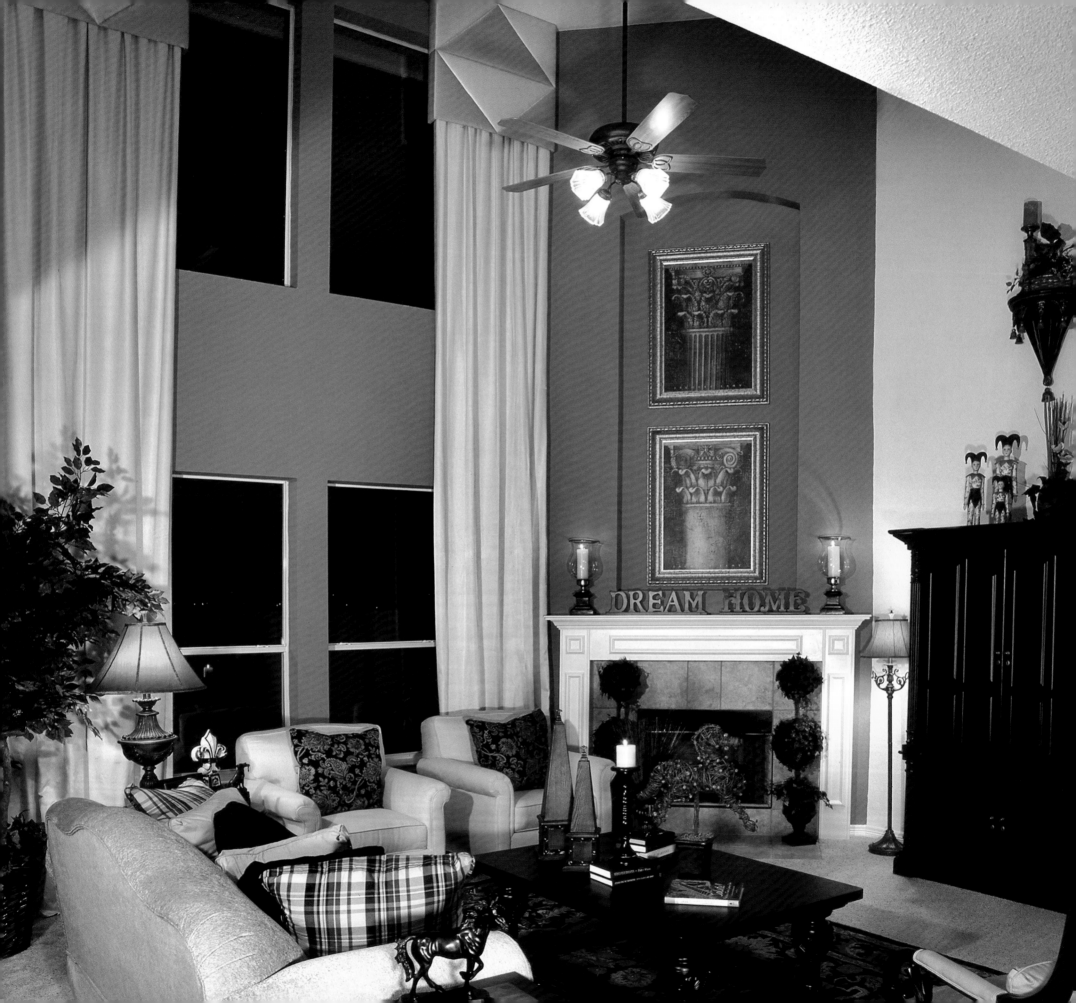

Kimberly Tisdel, ASID

BRIDLE CREEK INTERIORS

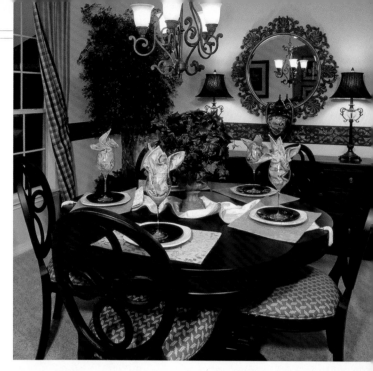

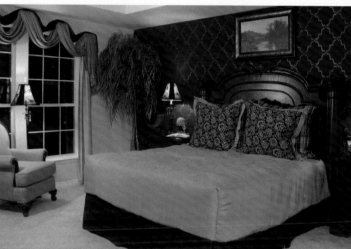

San Antonio designer Kimberly Tisdel has amassed an impressive portfolio since her 1989 graduation from Colorado State University with a bachelor of science degree in interior design. The owner of noted San Antonio design firm Bridle Creek Interiors is known for her distinctive model home interiors for residential developers, along with her exceptional designs for private residences, clubhouses and commercial offices. The demand for Kimberly's services at Bridle Creek peaked in mid-2005 when she had already installed a record 43 homes within the first six months.

The diverse designer relies on her staff of seven to help with the installations, which include just about every style. "From Asian to Hill Country rustic, traditional to contemporary, we expertly dress all styles of interiors to suit every type of buyer," she explained. But unlike most residential designers, Kimberly and team primarily create imagined lives that entice potential homeowners into buying properties. "We strive for sophisticated, yet relaxed, settings that welcome the buyer home," she said.

To ensure that her interiors remain one-of-a-kind, Kimberly never reuses elements from her jobs. Each is a fresh combination of color, furnishings and creative enhancements that enlighten the senses while delighting the client. "When the client is happy, I am happy," Kimberly remarked. "I will not fall short from that goal."

Satisfied clients fill the cities of San Antonio and Dallas, though Kimberly's signature reaches across the nation. The consummate professional with memberships not only in the ASID but the National Association of Home Builders and Greater San Antonio Builders Association, travels to wherever she's needed. "I cater to my clients' wishes," she explained. "If developers have projects out of state, I am there to ensure that the projects run smoothly and exceed their expectations for budget and delivery." This approach has earned the energetic firm the glowing reputation for which it's known. ■

TOP: Rich woods and creative lighting contrast beautifully off the stunning champagne walls of this embellished dining room.

ABOVE RIGHT: Magnificent effects on the focal wall in this master suite allure all eyes to its fabulous backdrop, which creates depth and grandeur.

LEFT: This spacious, cozy living room sings with coffee-colored walls, exaggerated window treatments and black traditional furnishings.

KIMBERLY TISDEL, ASID
BRIDLE CREEK INTERIORS
7456 REINDEER TRAIL
SAN ANTONIO, TEXAS 78238
210.520.3577
WWW.BRIDLECREEKINTERIORS.COM

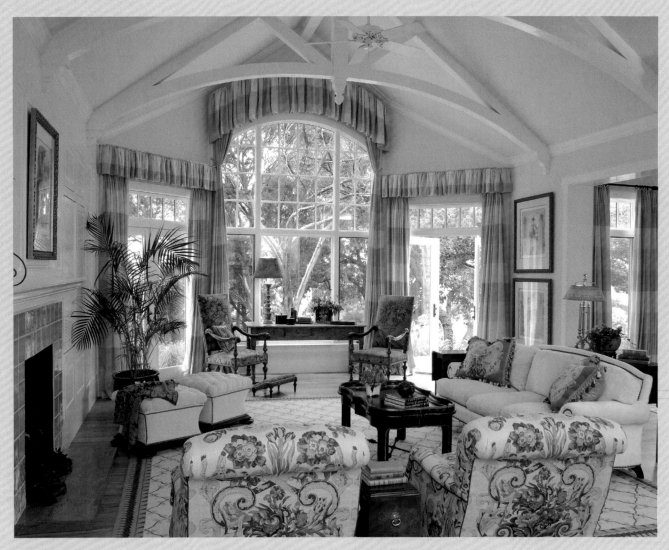

CATHERINE DOLEN, ASID, IIDA

Waco

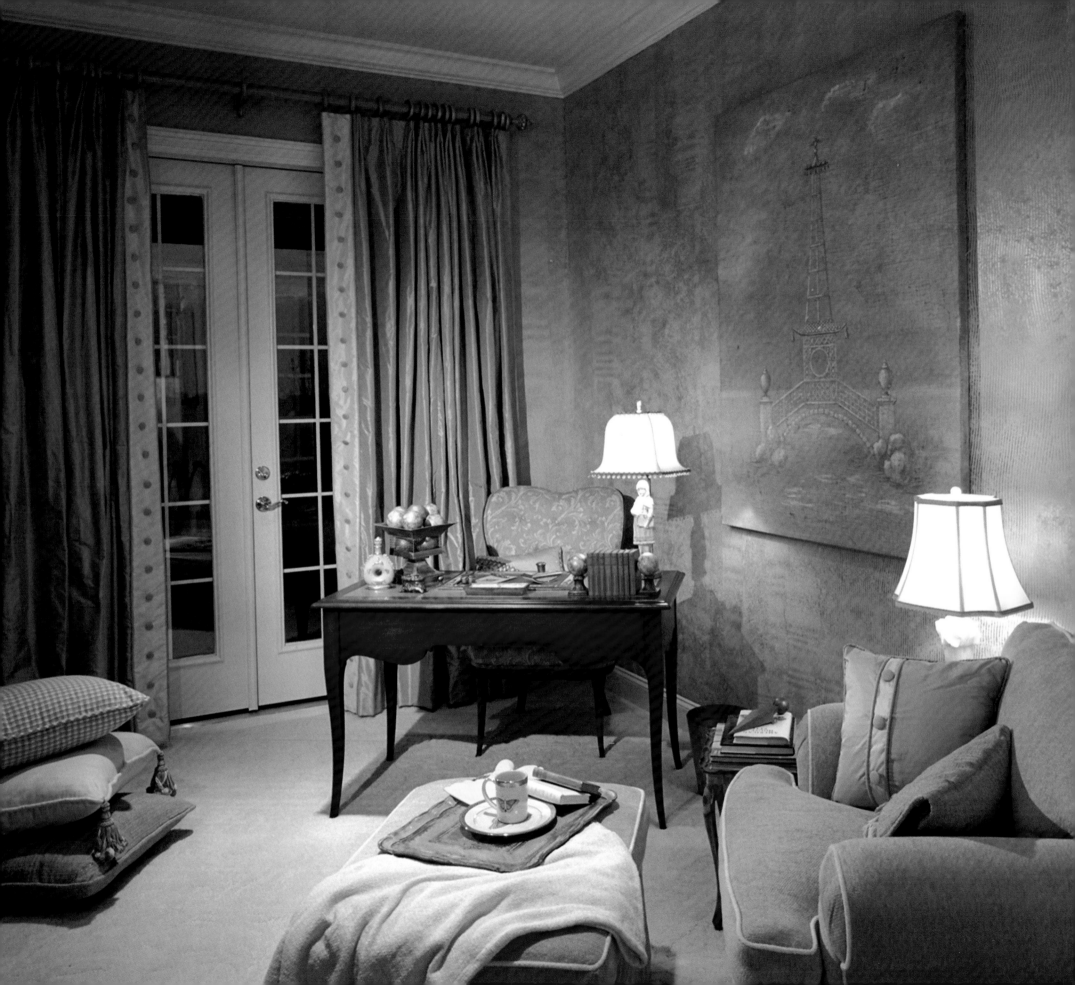

Catherine Dolen, ASID, IIDA

CATHERINE DOLEN & ASSOCIATES

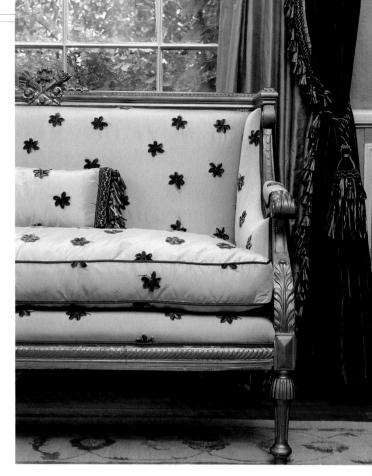

ABOVE: For this dining-room setting, an antique French settee is updated with an embellished silk fabric, silk draperies and a custom silk wool rug.

LEFT: The comfort of this small study is enhanced by the soft color palette.

Catherine Dolen believes that a home should be a respite from the outside world. That's why she approaches each design project with an open mind and a listening ear. "I try to discern from my clients what helps them to regenerate when they have only a few hours to spend at home," she said. "I incorporate their feedback to create nurturing environments unique to their personal needs."

Just as no two people are alike, neither are the interiors created by the respected Waco designer. A spectacular lake house with a hand-carved chandelier and farmhouse kitchen cabinetry. A mountain cabin with Arts & Crafts detailing. An exquisite master suite with luxurious bedding. Whatever the desire, Catherine fashions environments to match the personalities and lifestyles of the people who live and work in them.

"With every project, I try to beautifully and skillfully apply the principles and elements of design to the specifics of the project. It is important to design according to the clients' tastes, lifestyles, desires, possessions, and collections," she explained. "I believe in keeping the design pure." Editing the surroundings to eliminate superfluous elements is key to creating inviting interiors, Catherine says. "If an object or element is not adding to the overall design, then it is detracting from it. My job is to find that perfect balance."

CATHERINE DOLEN, ASID, IIDA
CATHERINE DOLEN & ASSOCIATES
4700 BOSQUE BLVD., SUITE L
WACO, TEXAS 76710
254.751.0803

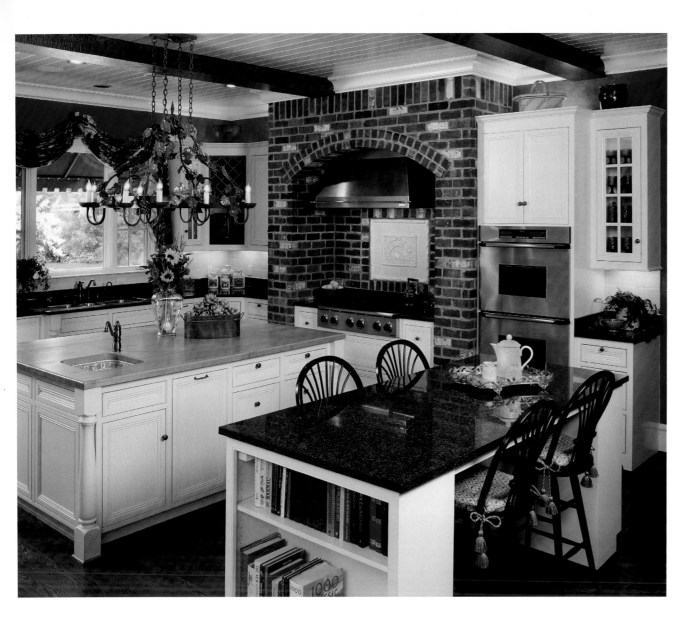

Balance is fundamental in Catherine's designs. "When I'm asked to evaluate a space that the owner feels is not working, what is often missing is balance." The scale of the furniture may be dwarfed in an oversized room. The focal point of the space may be poorly defined. Or prominent architectural details may be misused. Achieving proper balance provides serenity, which is an essential element that Catherine strives for in every design.

Catherine also believes that a proper understanding and consideration of the architectural style and the building site is critical for good interior design. "For the design to be successful and complete, it must relate to the surrounding architecture and build upon it as a theme. Knowledge of historical design and the appropriate use of architectural elements are essential to my work." So is taking full advantage of a room's exterior surroundings. "Interiors should be oriented to enjoy a great view, beautiful trees or a pleasing garden. This arrangement contributes to the tranquility of the space."

RIGHT: The antique French candelabra provides bold illumination for this master bedroom dressing table. Cream walls and fabrics accentuate the black furniture.

BELOW: This mountain retreat powder bath incorporates natural textures to create a rustic, but elegant style.

Where are these peaceful, well-designed interiors for which Catherine is known? "In Texas, Colorado, and California," she replied, "though the majority of my clients reside in Waco and the surrounding area." Primary residences and second homes fill the pages of Catherine's impressive portfolio, but they aren't the only interiors she's outfitted. "My firm also designs corporate properties such as office buildings and private practices. Typically, these projects arise from my residential work."

Formerly with a noted Dallas design firm, Catherine established her company, Catherine Dolen and Associates, in Waco in 1997. Assisting Catherine at her full-service interior design firm are staff designers Stephanie West, Allied ASID, Abigail Leonard, ASID, and Hillary Griffin, Allied ASID. Their close-knit team can take any design project from conception to completion. Whether it's planning spaces for new construction or designing interiors for existing homes, they apply their more than 40 years' combined experience into producing inviting interiors that attract attention from media and industry organizations.

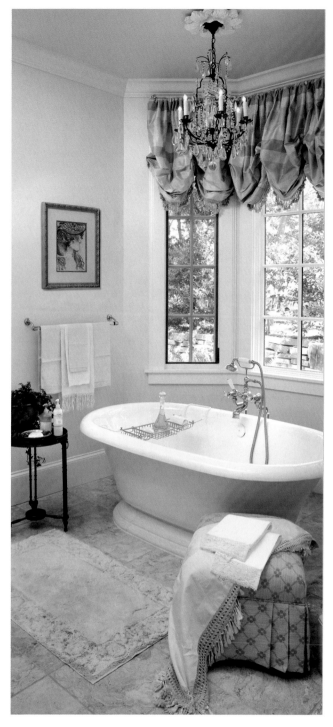

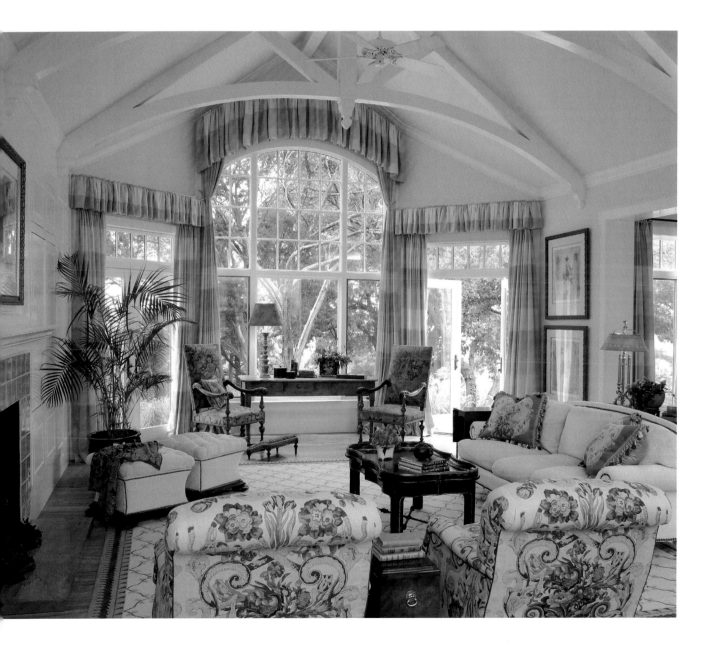

ABOVE: A simple, freestanding tub is given presence by the bay window and antique chandelier.

LEFT: Pale green walls help to create a serene environment for this lake-view house. Vintage pillows and antique chairs add interest to the room and provide a touch of color.

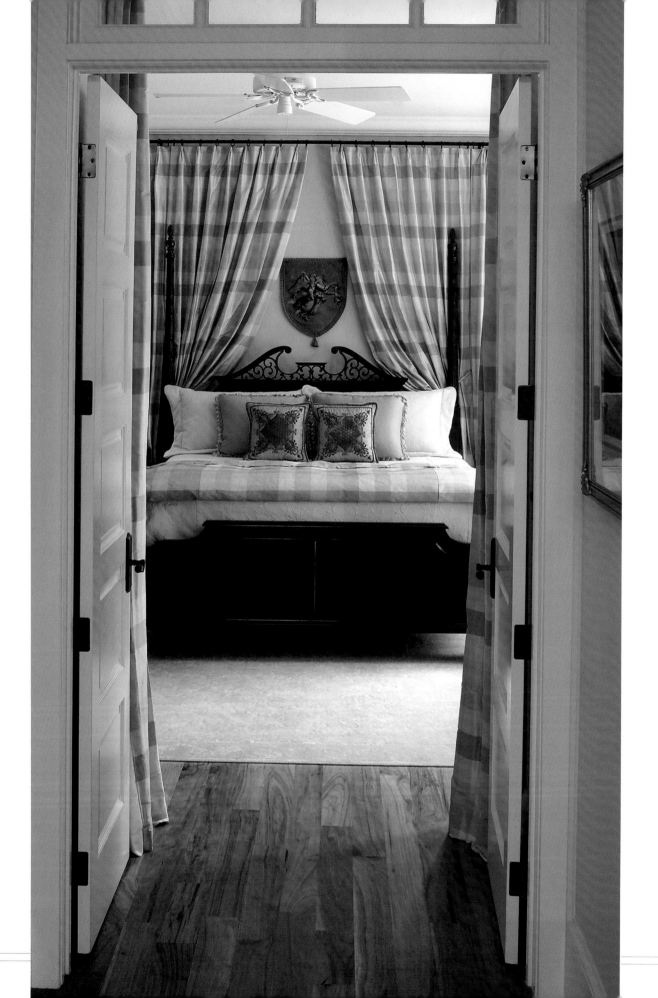

LEFT: Silk plaid draperies and an antique beaded tapestry form a striking focal point for this mahogany bed with beautiful accent pillows.

BELOW: The vivid furnishings in this living room exemplify a whimsical use of color throughout the house.

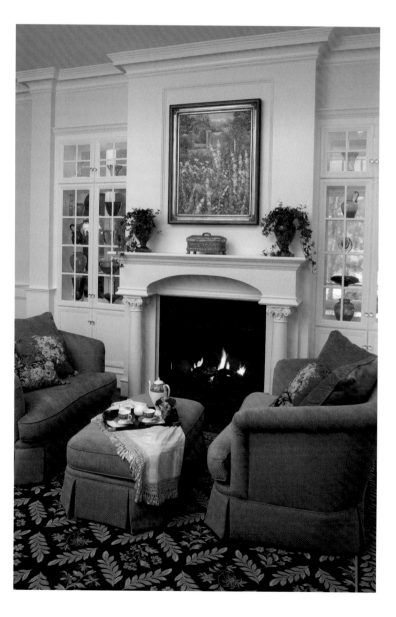

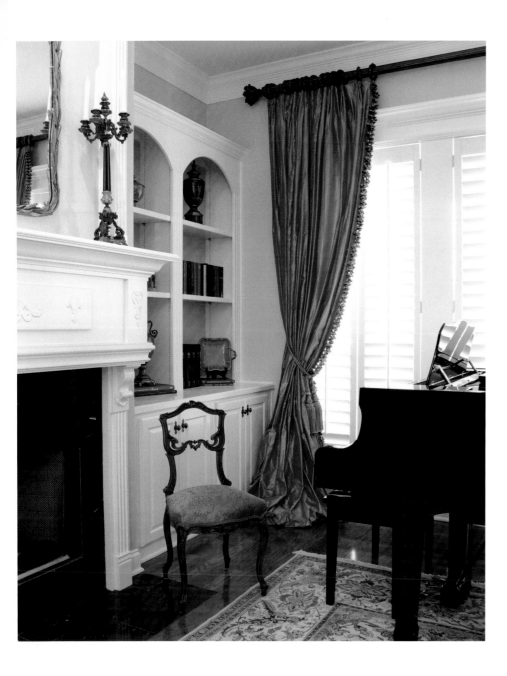

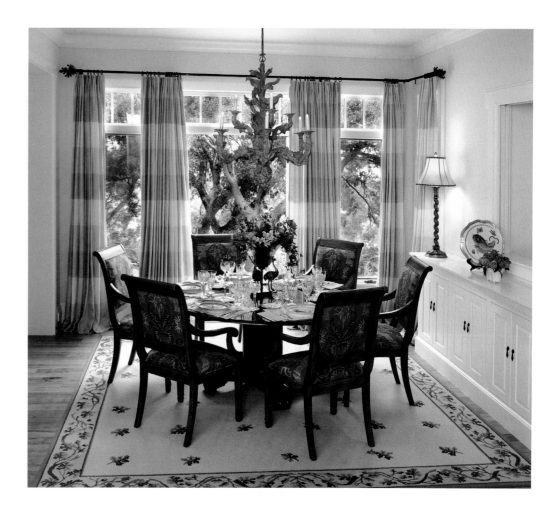

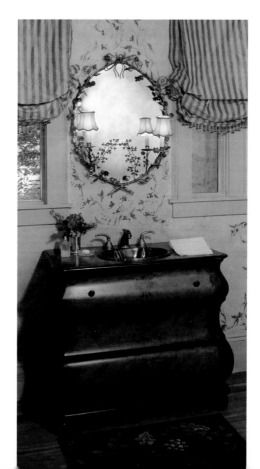

FAR LEFT: Floor-to-ceiling silk draperies emphasize the room's height, while the Persian rug adds balance and color.

ABOVE: A carved wooden chandelier creates a focal point for this dining room. The custom rug continues the natural motif of oak leaves.

LEFT: The glazed, handpainted walls accent the antique lighted mirror in this powder bath.

A dedicated professional, Catherine has educated students as a lecturer in interior design at Baylor University, where she currently sits on their Interior Design Advisory Board. She has also taught continuing education classes there, and she has conducted interior design seminars for the Heart of Texas Builders' Association. Periodically, Catherine offers Design Style Seminars to the public through her firm.

Through her commitment to her profession and to her clients, the memorable interiors she creates for every lifestyle and the distinct designs that provide comfort and calm, Catherine Dolen is leaving an indelible mark in the world of interior design. ■

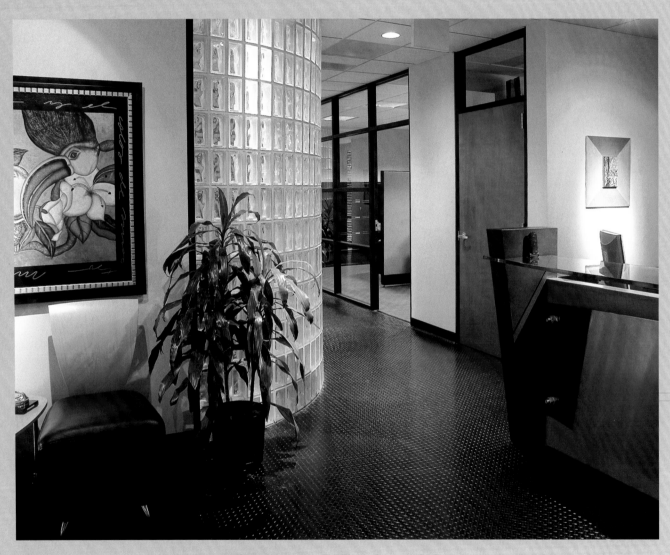

CYNTHIA LEFTWICH, ASID

West Texas

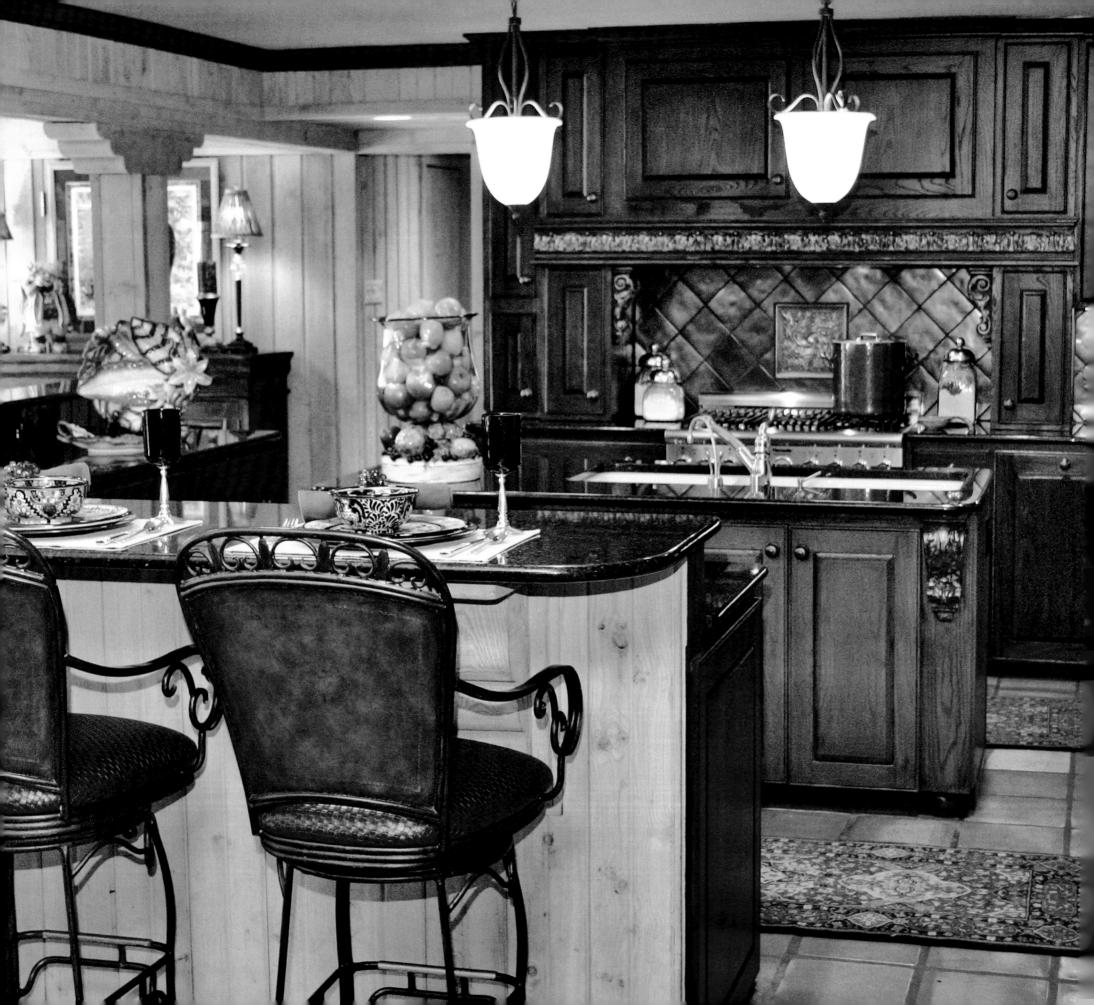

Russell L. Freeman, ASID
Ellen A. Hinson, ASID

RUSSELL L. FREEMAN & ASSOCIATES
INTERIOR DESIGN

ABOVE: The Chinese-red library sets a welcoming tone for this traditional West Texas home. The raised area off the living room showcases antiques and family heirlooms. Chair fabric by Robert Allen.

Solid relationships and professional experience are at the core of Rusty Freeman's design firm, Russell L. Freeman & Associates Interior Design.

Rusty, a respected designer and industry leader, has invested time in the interior design world he's called home for more than 30 years. In addition to helping his valued clients, the seasoned veteran has served on the state boards of both the ASID and the Texas Association of Interior Design. His involvement in these two professional organizations enables him to stay abreast of emerging issues and to facilitate change. "Through my commitment to these groups, I have helped shape the future of interior design in Texas," he said. "That's been a rewarding investment."

The time he's devoted to his community has also been fulfilling. Of particular significance is his service to the High Sky Children's Ranch, a home for neglected and abused children. Currently a member of the Board of Governors, Rusty sat on the Ranch's Board of Directors for a number of years. For his many years of dedicated service to High Sky, Rusty received the Rainbow Award. "As a father, I understand the importance of this organization, and I'm happy to give time to this worthy cause."

The same drive that propels Rusty into serving his industry and community also fuels the success of his interior design business. With the expertise of designer Ellen Hinson, the licensed pair whose primary focus is residential interiors prides themselves on building strong relationships with their clients. Doing so enables them to form solutions that fit their clients' lifestyles. "We spend quality time with our clients, learning how they live and what they desire," said Ellen. "Then we apply the principles of color, balance and scale to create designs that fill their needs."

LEFT: New custom cabinetry, metallic-tile backsplash and granite countertops, along with state-of-the-art appliances, make this remodeled kitchen a delight in which to work.

LEFT: Russell L. Freeman, Jr., ASID, Ellen A. Hinson, ASID, and Andrea Freeman, ASID.

RUSSELL L. FREEMAN, ASID
ELLEN A. HINSON, ASID
RUSSELL L. FREEMAN & ASSOCIATES INTERIOR DESIGN
2101 W. WADLEY AVENUE, SUITE 28
MIDLAND, TEXAS 79705
432.682.4477

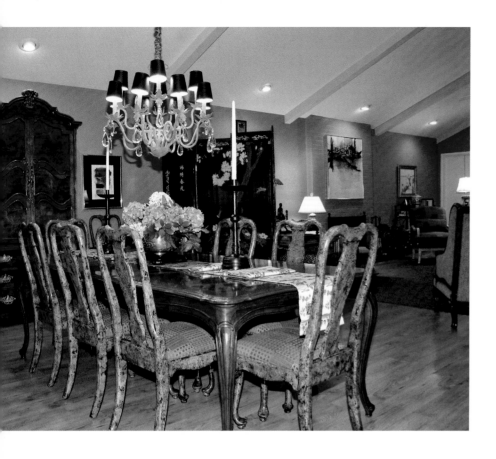

Add a dose of comfort and the result is livable interiors reflective of the people who live there. "Every space is unique; just like the clients we serve," Rusty explained. "We design for them, not us. It's our job to uncover the need and create a space that is not only functional, but warm and beautiful."

Their client-centered approach to design has led to a thriving business. With interiors ranging in style from Country French to Southwestern and everything in between, the firm tackles projects all over Texas, as well as California, Colorado, South Carolina, Florida and Mexico. Signature to their personalized designs are embellishments crafted by workrooms and artisans with whom they have lasting relationships. "We pay particular attention to detail," offered Ellen. "From original art and carved woods to intricate ironwork and custom fabric treatments, we incorporate elements that set our designs apart."

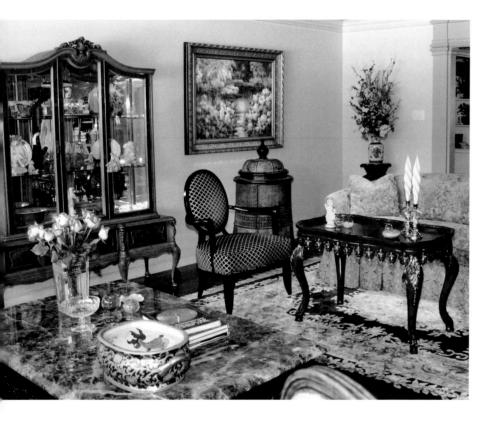

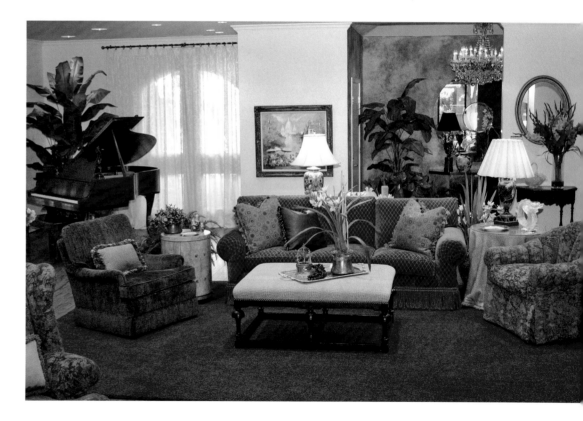

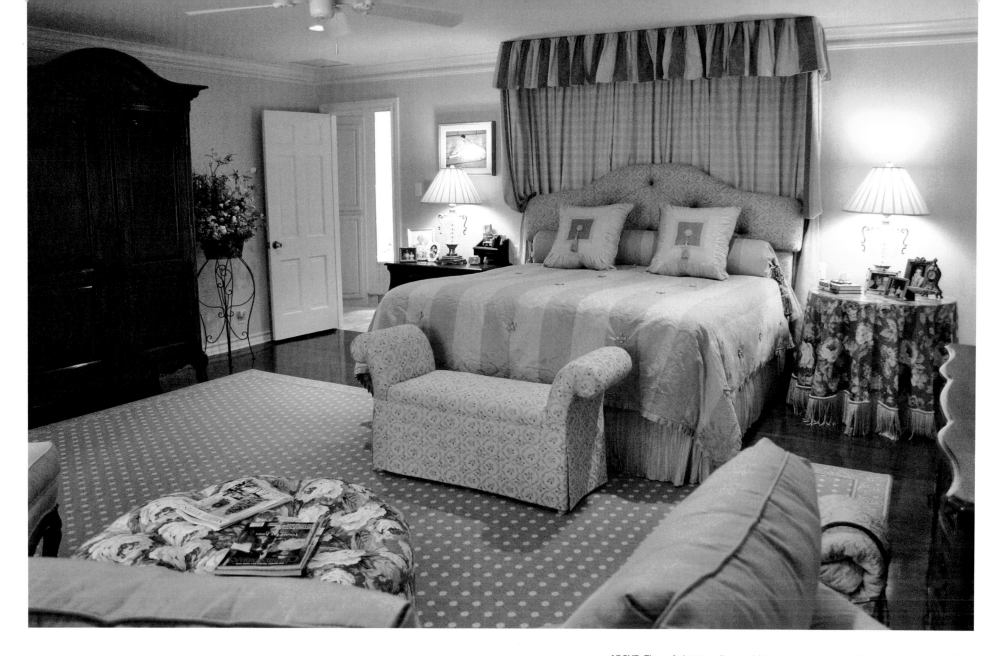

Where does inspiration for their unique designs originate? "From many sources," explained Ellen, "but primarily from our clients. Their collections say a lot about their personalities, which we integrate into our designs." A religious wall hanging rich in color and importance. A modern painting with bold, bright strokes. A beloved heirloom treasured by generations. "Whatever the item or style," Rusty says, "we can find a place for it and make it special for that client."

The desire to "do what it takes" is foundation to the energetic firm. Anchored by the design team of Rusty and Ellen—who have worked together for more than 25 years—the team of four remains small by design. "I purposely keep my firm small. It enables us to devote more time to each project," explained Rusty.

With relationships built on personalized service and proven experience, it's no surprise that the 30-year-old firm is serving the third generation of some Midland families. ▪

ABOVE: The soft, butter-yellow-and-blue color scheme provides a calm respite for this master suite, featuring Stark rugs on mesquite-finished floors, a Bausman entertainment armoire and bed furnishings by Lee Jofa Fabrics (stripe) and Robert Allen (floral).

OPPOSITE PAGE:

TOP LEFT: Wide-planked floors, an iron and crystal chandelier and strong paint colors create the background for this room, which features an 18th century coromandel screen and hand-distressed dining chairs. Dining-chair fabric by S. Harris.

LEFT: This living room was designed around the client's 18th century French display cabinet and antique Chinese silk rugs. The Barbara Barry chairs from Baker add depth to this eclectic room. Chair fabric by Nancy Corzine. Washed chenille on settee by Peacock Fabrics.

RIGHT: Oversized custom furniture and a chenille-topped Bausman ottoman form a cozy retreat in this living room accented by faux-painted foyer walls and an antique Czech crystal chandelier in the background.

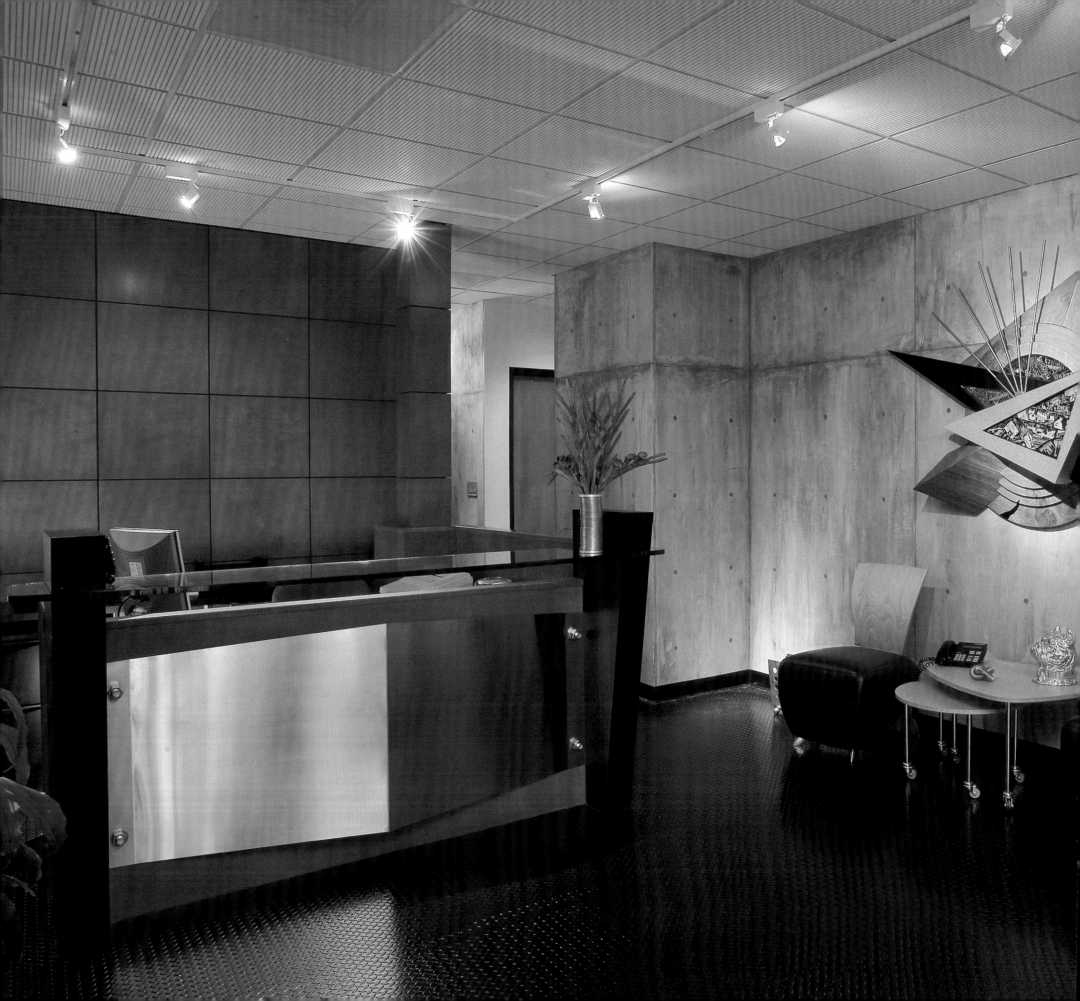

Cynthia Leftwich, ASID

LEFTWICH DESIGN GROUP

Designer Cynthia Leftwich, owner of Leftwich Design Group, is an award-wining designer and professional artist who creates environments that are not only aesthetic and functional, but healing and psychologically enhancing. "I believe your surroundings influence your daily life," she said. "That's why I identify each client's comfort level, and using a proven process, I create spaces that reflect, revitalize and inspire them."

With a career that spans 30 years, Cynthia has designed hospitals, banks, retail stores, galleries, corporations, clinics, city clubs, country clubs and numerous residences. Each interior is custom-tailored to the client's individual needs and desires. "Through research, innovation and creativity, I provide clients with environments that are uniquely their own."

Center to Cynthia's personalized designs are the principles of Feng Shui, a discipline she learned at the University of Nanjing in China. "When designing medical facilities, I learned about healing environments and environmental harmony," explained Cynthia. "Feng Shui is similar in that it incorporates balance, nature and simplicity with creative design. The result is serene, peaceful and comfortable spaces that enhance our well being."

Also present in Cynthia's interiors is the influence of artist Louise Nevelson, with whom she studied at age 19. Nevelson's sense of design, strength and candor—along with her sound advice to always work in a clear space to open the flow of energy—sent Cynthia down the path to design.

After attending Texas Tech University, Cynthia opened her business in Lubbock, where, among other things, she designed the 2004 Lubbock Symphony Show Home and Hair by Diane, which won "Salon of the Year." Publications have noted Cynthia's range of accomplishments including Baron's *Who's Who in Interior Design, 100 Designer's Favorite Rooms, Lubbock Magazine, Dallas Home Design* and the *Lubbock Avalanche Journal*. Rounding out her expansive portfolio is the inclusion of her artwork in buildings all over the country, including numerous Hyatt properties and other commercial and residential sites.

A professional member of the ASID, the TAID and the IIDA, Cynthia also mentors collegiate students, many of whom have become successful designers. Of her eagerness to help others, Cynthia replied, "This business, along with my art, is my passion and love. Whether helping students or assisting clients, my goal is to give back a small portion of the gifts that have been given to me." ■

ABOVE: The boardroom of Auto, Inc. was completely customized from the conference table to the cast glass-suspended ceiling designed for the space and made by Joel Berman.

LEFT: An automobile-inspired reception area moves with furniture on wheels, leather seating, cherry wood, rubber flooring, epoxy finishes and art that conveys the history of the company.

CYNTHIA LEFTWICH, ASID
LEFTWICH DESIGN GROUP
1410 TEXAS AVENUE
LUBBOCK, TEXAS 79401
806.749.3113
WWW.CYNTHIALEFTWICH.COM

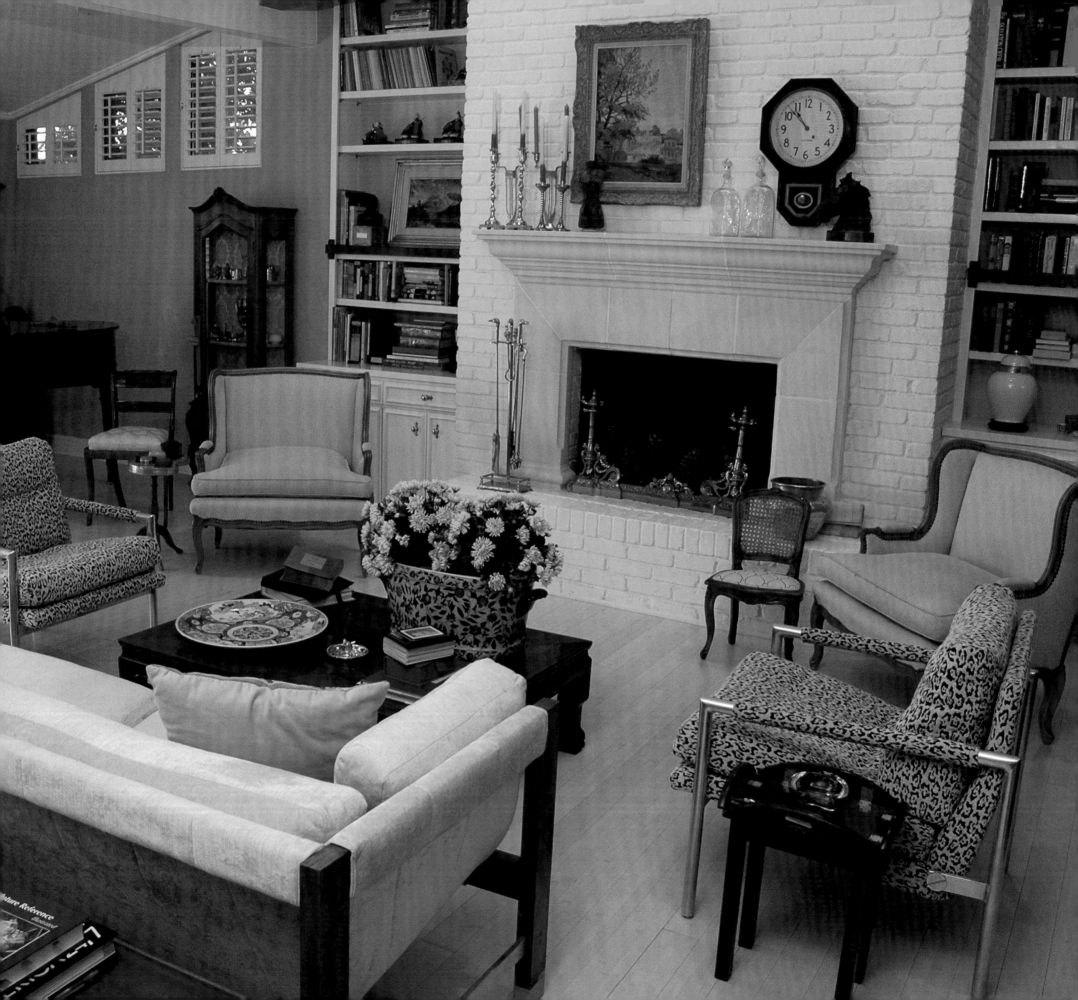

Anne Steele, ASID

ANNE STEELE CUSTOM INTERIORS

El Paso designer Anne Steele is not only an excellent designer; she is a great cook. "It's true that I love to cook," Anne confessed. "I've even traveled to Italy for cooking lessons."

What happens when Anne marries her two passions? "You might say I'm known for my kitchen designs," the practical designer said. "I use my knowledge of cooking, along with a strong understanding of my clients' needs, to create inviting kitchens with function and style."

Kitchens aren't the only room in the broad portfolio of the designer with more than 20 years' experience. She's crafted every type of interior in nearly every style. "I've designed many new homes and remodeled several existing ones during my career," she explained. "And just as every client is unique, so are their homes." From Mediterranean villas to Southwestern stuccos—and everything in between—Anne has created comfortable interiors that perfectly fit each client.

"It's my job to guide my clients through the design process," Anne explained. "Using my talents as a designer, I build on what my clients want to create livable, beautiful interiors." In fact, devising attractive interiors is the accomplished designer's goal. "I'm on a mission to make the world beautiful," Anne declared. "I've found that people desperately need the services of designers." With the influx of decorating shows, Anne says that the public believes that they can create appealing rooms themselves. "What they don't realize is that it takes more than a one-hour television program to put together a beautiful, lasting interior."

Central to Anne's welcoming designs is the appropriate use of color. In El Paso, where the bulk of her projects reside, the sun is very strong. Knowing which colors to incorporate requires an experienced eye. "I am blessed with an innate ability for selecting and combining the right colors," Anne said. "The geographical location of a residence has a profound impact on a project's color palette. For example, stronger colors work best inside El Paso homes because the light is really bright here."

ABOVE: A great look was achieved by cutting down an antique Indian table to make an extra large coffee table.

LEFT: In this remodeled room, bamboo flooring, venetian plaster and a new stone fireplace surround make a warm and welcoming living room.

ANNE STEELE, ASID
ANNE STEELE CUSTOM INTERIORS
6598 EAGLE RIDGE DRIVE
EL PASO, TEXAS 79912
915.581.2942

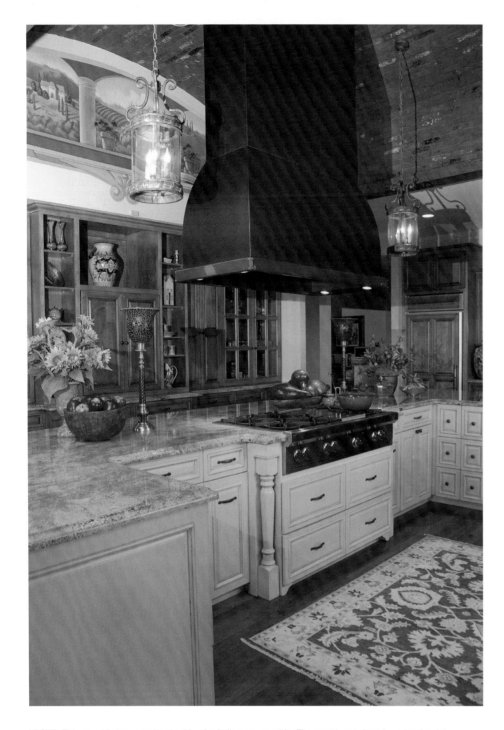

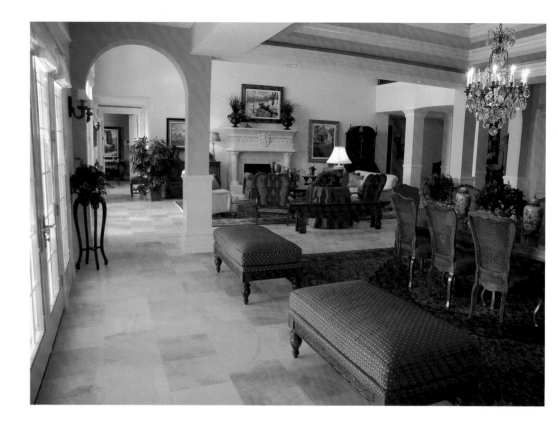

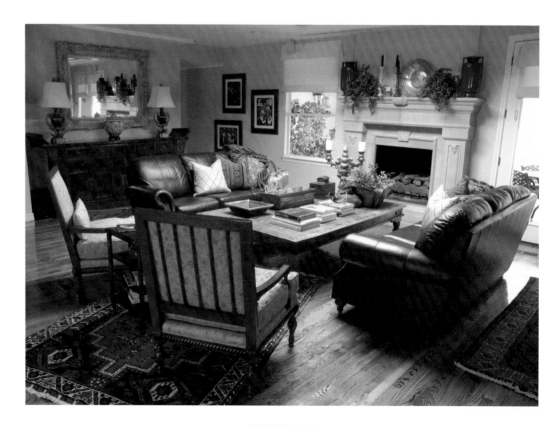

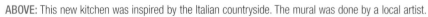

ABOVE: This new kitchen was inspired by the Italian countryside. The mural was done by a local artist.

TOP RIGHT: Large, oversized ottomans were used to accommodate the client's existing dining room table and chairs in the new larger area.

RIGHT: This living room proves Anne's theory that if you combine the right things a client loves, the room will work.

OPPOSITE PAGE:

FAR RIGHT: To save the granite countertops from an earlier remodel, new fronts and doors were changed to give an updated look.

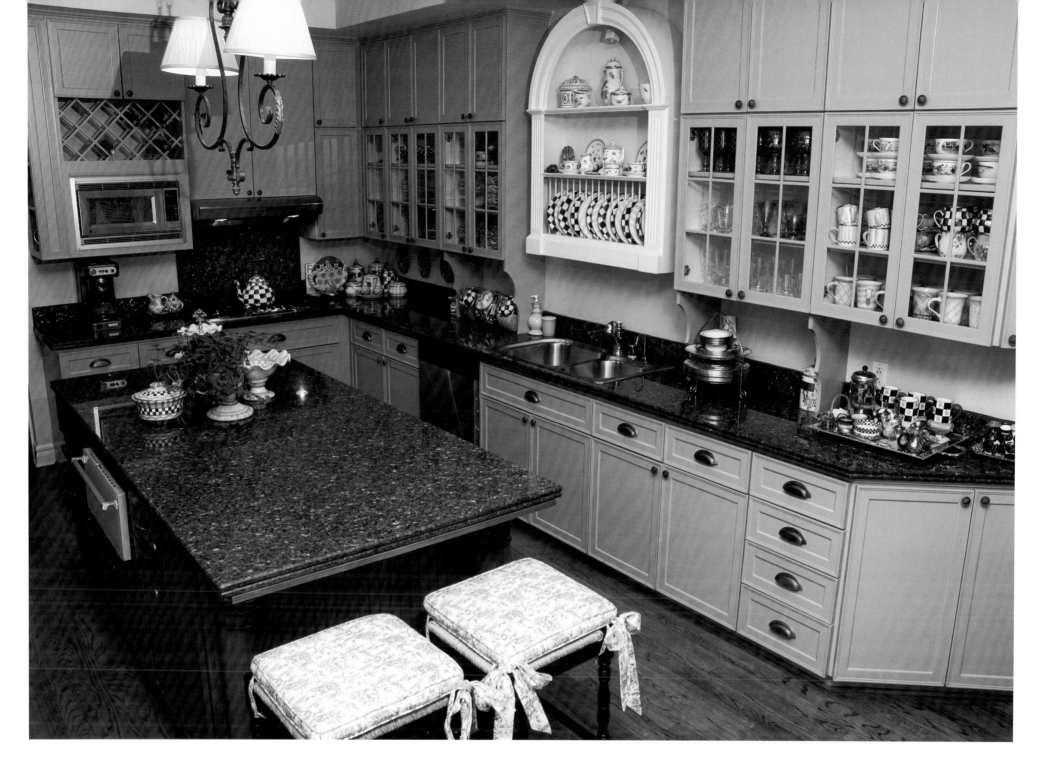

Color also sets the mood of a space. "Dark interiors, while great for media rooms, are not preferred in living areas," she explained. "I help my clients understand the power of color, and I counsel them regarding its proper use."

While El Paso primarily sees the fruits of Anne's insightful design skills, other areas also benefit from her talents. From California to Michigan, New Mexico to Colorado, Anne has left her memorable mark. "Though I do not possess a signature style, my designs can best be described as eclectic," she explained. "I combine the best of all worlds to create the timeless and traditional, not the tired and boring."

Her interiors also reflect the distinctive personalities of the people who live in them. "I strive to make my projects look like the client, not me," she said. Often that means incorporating various collections or unique accumulations. "If the client loves something, I find a way to make it work. After all," Anne said, "making the client happy is paramount to my success." ∎

Photography Credits

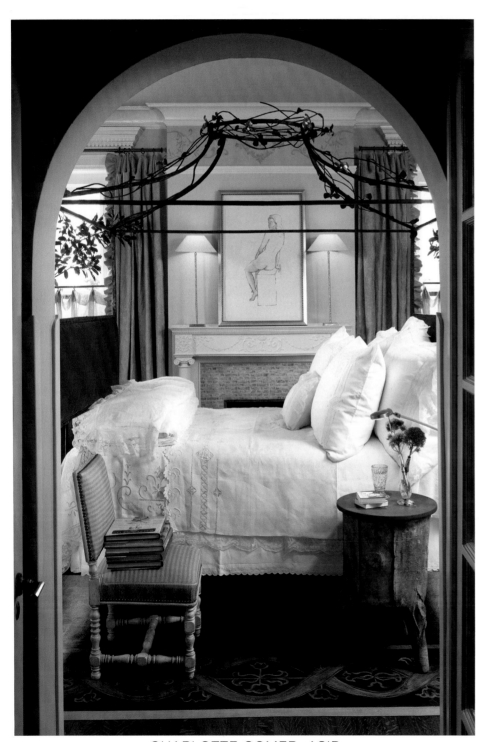

CHARLOTTE COMER, ASID

316

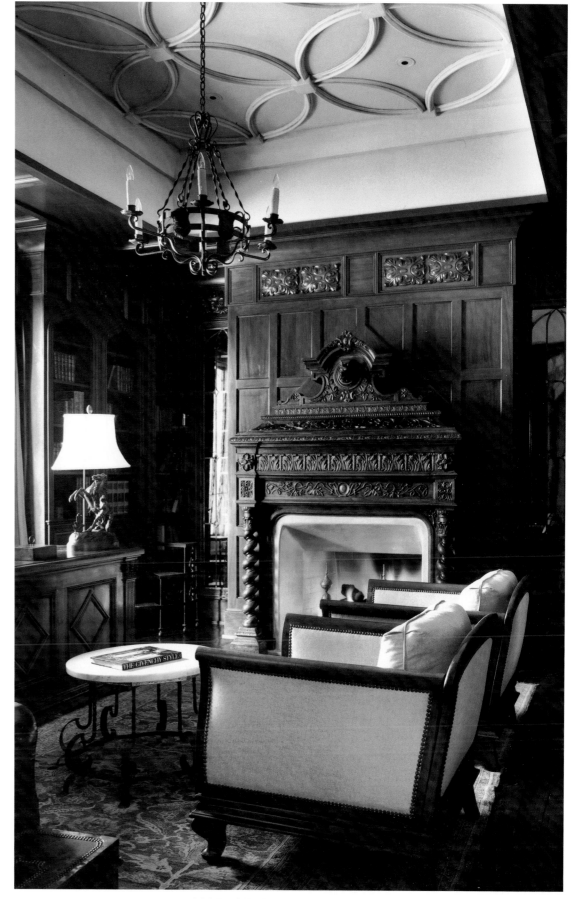

MARJORIE SLOVACK, ASID

Photography Credits contd.

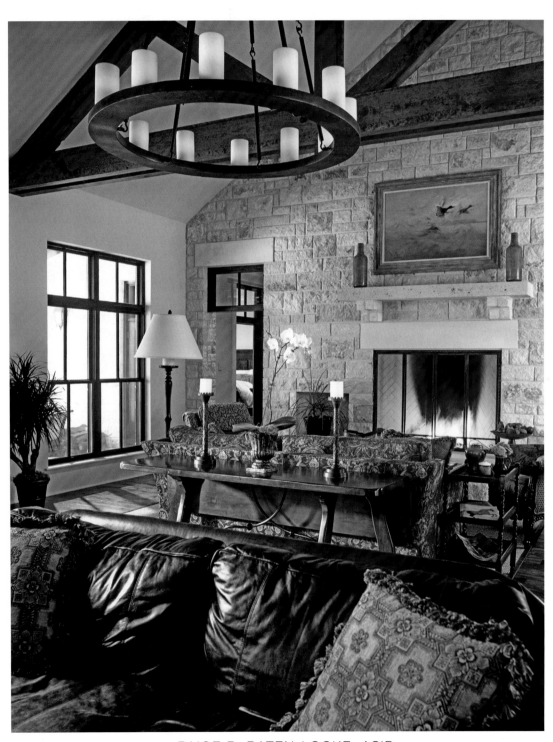

PAIGE R. BATEN-LOCKE, ASID

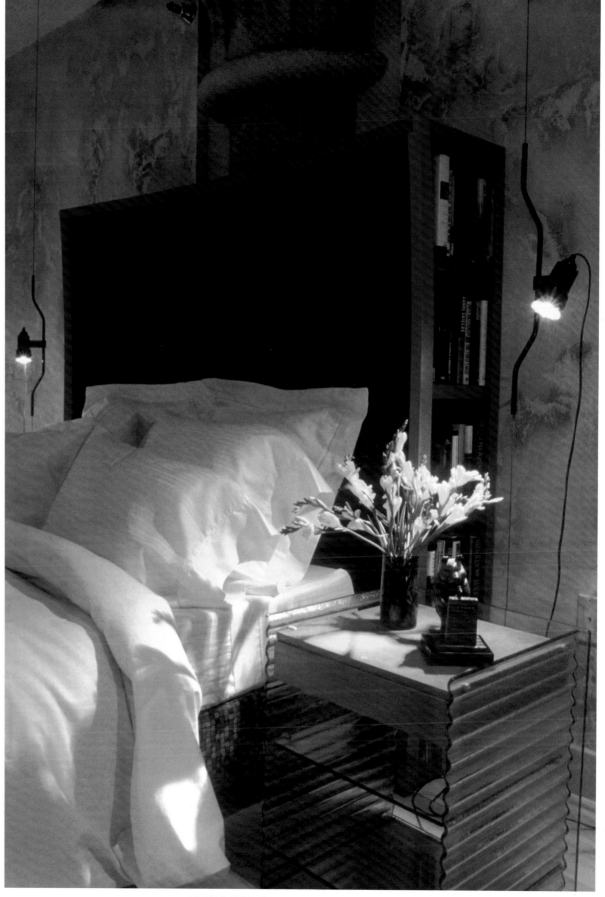

JOHN TRYON ROBINSON, FASID

Index of Design Firms